Optical Projection

OPTICAL PROJECTION

THE ... THE

USE OF THE LANTERN

IN EXHIBITION AND SCIENTIFIC DEMONSTRATION

BY

LONDON
LONGMANS, GREEN, AND CO.
AND NEW YORK: 15 EAST 16th STREET
1891

o

OPTICAL PROJECTION

A TREATISE ON THE

USE OF THE LANTERN

IN EXHIBITION AND SCIENTIFIC DEMONSTRATION

BY

LEWIS WRIGHT

AUTHOR OF 'LIGHT: A COURSE OF EXPERIMENTAL OPTICS'

WITH 232 ILLUSTRATIONS

LONDON

LONGMANS, GREEN, AND CO.

AND NEW YORK: 15 EAST 16th STREET

1891

H

PREFACE

ABOUT the year 1851 there was placed at my disposal a Lantern, of a character very unusual (at that time) for any boy of my age to possess a share in; in fact it was one of Carpenter and Westley's 'Phantasmagoria' lanterns, unrivalled at that period of transparent sheets and sperm-oil. The result was that Optical Projection, in its various forms, has been with me more or less a hobby ever since; less followed for some years during which pursuits of a more open-air character,[1] for sufficiently serious reasons, engaged more of my attention, but never abandoned, and again and again returned to with renewed interest. Mere slides of course came first, but I soon discovered for myself that things could be projected as well as pictures; and for a long time past I have found much relaxation from my literary work, in reducing various optical and other physical experiments to conditions which enable an audience to behold them upon a screen, and in devising contrivances for making the beautiful phenomena of Polarised Light more spectacularly imposing. Since the publication of a little

[1] Poultry-breeding.

work treating Physical Optics from this point of view, ample evidence has been furnished that others have felt strongly the same fascination as myself in this class of experiments.

The preparation of the following pages, as a treatise upon the more general use and manipulation of the Lantern through its entire range, in a manner that may suggest proper arrangements even where want of space or my own lack of detailed experience may prevent specific treatment, was not spontaneous on my part, but was suggested to me by Mr. Herbert C. Newton. During years past I have spent very many hours associated with him—many of them actually in his company—engaged in contriving, perfecting, testing, or adjusting scientific optical apparatus; often for myself, but more frequently for the use of others, and especially of colleges and public institutions. He was good enough to suggest on many occasions that a practical treatise from my pen, and embodying the results of my experience, would be of service; in fact he has urged the task upon me with some persistence. Whether or not I have been able to add anything of value to such handbooks as were previously obtainable, must be left to the reader's judgment. But that is the real origin of this work; and it is best to state it frankly, because it will naturally account for such description as will be found hereafter of apparatus—microscopic and polariscopic in particular —which was worked out to the best of my ability with a primary view to being constructed by the firm which Mr. Newton represents, from whom I have received

much kindness and assiduous care in my own personal requirements of this kind. Such apparatus, to express it briefly, is described here not as *their* apparatus, but as being in greater or less degree *my* apparatus, by contrivance, or selection, or modification, or personal connection with it in some way or other, even when not (as frequently the case) planned in the first instance for my own use.

But while it is best to state this quite simply, it will I trust be found that, beyond what thus became unavoidable as forming part of that very experience which is the basis of the whole, the subject has been treated so as to be of most use to all, and without any prejudice to other optical workshops of well-known character with which I do not happen to have been brought into the same personal contact. Except a very few articles or details which may be patented in various quarters, and which are well known to the trade and readily obtainable from the various manufacturers, the apparatus and arrangements here described are free to all. It is perfectly open to any reader to have them constructed by whom he chooses, with any improvements he can suggest; while it is equally open to any optician to construct them as excellently, and sell them as cheaply—or the other way if he prefers—as he possibly can.

I need only add to this explanation, that in the following pages the first person singular has been purposely adopted, as more simple and less really egotistic in a book of such necessarily strong individuality, than any

other style would have been ; and that the frequent use of italics is not for emphasis in the usual sense, but chiefly as the easiest way of marking points it is desirable to distinguish with some clearness.

I have to thank Messrs. Macmillan & Co. for permission to use the greater part of the illustrations to my previous work, entitled ' Light : a Course of Experimental Optics,' and also the publishers of Professor Weinhold's ' Physikalische Demonstrationen ' (Leipzig) and Dr. Stein's ' Die Optische Projektionskunst ' (Halle) for many illustrations from those works. Most of the others are original ; but a few have also been taken from Ganot's ' Elements of Physics,' Prof. Forbes's ' Lectures on Electricity,' some articles by Mr. G. M. Hopkins in the ' Scientific American,' and Prof. Dolbear's ' Art of Projecting ' (Boston). The very few experiments taken or adapted from the latter work, are owing to the fact that it is written with especial reference to projections with the heliostat, which is almost useless in this country. Many such arrangements I have found unsuitable for ordinary lantern use ; but where sunlight is available, Prof. Dolbear's treatise may be consulted with advantage.

My grateful acknowledgments are finally due to my old friend and correspondent, the Rev. P. R. Sleeman, for reading the proofs of the last twelve experimental chapters, during which process several suggestions and additions of value have also found their way into those pages.

LONDON: *October 31, 1890.*

CONTENTS

OPTICAL PROJECTION

CHAPTER I

ON PROJECTION

1. Definition.—Projection, in the optical sense and in this book, is the production of a picture or image—usually a magnified image—upon some kind of screen or visible plane, generally by means of a lens. The image may be that of a picture, or of some solid object or piece of apparatus. It is manifest that the excellence of the projection—that is, the brightness and distinctness of the picture on the screen— must depend upon many practical conditions, which are to be treated of in these pages. But first of all it is essential that the nature of the problem itself be really understood, if the best result is to be obtained with the apparatus at our disposal.

2. Image not formed by the Lens.—The reader would probably gather from most of the treatises upon optics, that the image on the screen which he has to produce is *formed* by the lens; but that is not true, except in a very secondary sense. The first and cardinal truth for an intelligently successful demonstrator to grasp, is the fact that all power of really forming ' an image resides in those *rays of light* themselves by which any object is visible to us.

Starting with, and here taking for granted without need-

less discussion, the almost self-evident fact that objects are visible by means of rays of light which they either emit of themselves (as in a gas-flame) or reflect back from some other luminous source (as in an object lighted up by the gas-flame), all we need assume here is that these rays are sent out in *straight lines*, in all directions which are open in space, continuing to travel in straight lines so long as they traverse the same medium, as the air, for instance. This is a familiar fact of experience, as shown by sunbeams or rays from the lantern. Now it is the fact that *every ray* which thus proceeds from any point of any object, really forms an *image* of that point of the object upon any surface on which it falls; and it should be clearly understood that if the mere bare rays of light, by themselves alone, had not this power of forming images which is here affirmed, all the lenses in the world could never do it. Not being very self-evident, this fact should be realised by experiment.

8. **All Rays form Images.**—As the reader will possess a lantern of some sort, this will afford the readiest demonstration. Place a slide in the stage, choosing one which has some well-marked and large features, and is tolerably transparent in the rest, and throw the image on the screen as usual; such as is seen every day, and which is supposed to be formed by the lens in front of the lantern. We now take that lens out, and there certainly appears to be no image upon the screen, though the rays from the illuminated slide stream out to it in plenty, and the screen is lighted up well enough, and there may be signs of colour if it is a coloured slide. But let us consider a moment. The rays of light can go now from *every* point of the slide alike, to any one point on the screen; therefore what we see now at any point on the screen will be the total of these superposed images, of all the points in the slide, from which no one stands out particularly. But we can stop all that easily. Cover over the empty brass front with a sheet of tinfoil, and in the centre of this prick a hole

with a large pin. It is different directly. Because all the rays are straight lines, only the small bundle of rays which the pinhole allows to pass from one point of the slide, can now get to any one point on the screen, and no others can get there. Simply to secure this is all that has been done ; but now it is quite another story, and it will be seen that the bare rays of light, without any lens, do form an image of the slide plainly enough.

It will be found that the light will have to be *drawn back* somewhat from its usual position in the lantern to get the best effect, and especially to make the edges of the picture visible clearly. The reason for this will appear in § 6.

It will be understood at once how the rays *crossing* at the pinhole, as in fig. 1, go from the bottom of the slide to the top of the screen, and from the right to the left, so that the image must be in-

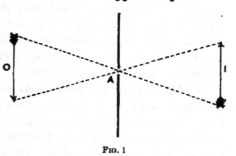

FIG. 1

verted, and we have to place the slide upside down in the lantern to make the image come right. And it will also be seen how and why the *relative size* of the image on the screen depends upon the ratio between the distance of the object, o, from the pinhole, A (fig. 1), and that of the screen-image, I, from the same point.

The image before us is but dim, because so few rays can pass through the pinhole to form it.[1] Prick four more holes at equal distances, half-an-inch out from the central hole.

[1] With a mixing jet, an ordinary landscape slide can be made clearly visible on a 12-feet disc, and with a blow-through jet 8 or 9 feet. With oil-lamps a somewhat smaller disc must suffice if the image is to be seen distinctly.

With each we get another image, and it will be seen how they confuse each other ; while if we stop all the others each one is distinct, and each of the last four is outside, on the screen, that from the central hole. It will now be understood instantly, that if we could *bend in* the rays which form the four outside images, so that they would fall exactly on the same spot as the central image, we should have again but one and a distinct image, but five times as bright as from one pinhole.

4. **Use of the Focussing Lens.**—To do this is the sole operation of the focussing lens, in a lantern or any other form of projecting apparatus. We can bend rays of light easily, by sending them at an angle through the surface of some other medium of greater (or less) density than the air ; and the greater the angle at which the ray strikes the denser medium, the more it is bent ; the amount of 'refraction' at different angles being connected by a simple law which need not be discussed here.

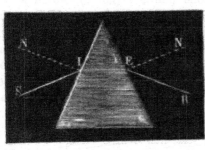

FIG. 2

We only need to remember, that on entering the denser medium the ray is bent in towards the perpendicular, and in leaving the denser medium away from it. If, then, we have a piece of glass with inclined faces, called a prism (fig. 2), to whose faces the dotted lines N I and N E are perpendiculars or 'normals,'[1] the ray S I will be bent towards the normal, to the path I E, and on leaving the prism will be similarly bent away from E N to E R. Thus it is permanently bent in, or refracted, towards the thick side of the prism.

[1] All angles in optics are reckoned from the perpendiculars or normals, not from the surfaces themselves.

A convex or focussing lens must act in the same way, because it is a piece (or combination of pieces) of glass formed so as to be thickest in the middle, the faces gradually becoming more and more inclined till they go off to an edge. It is a circular prism, of gradually-increasing inclination towards its edges. If we place such a lens in a beam of parallel rays, as from the sun, it is easy to see what must happen. The centre ray, striking the glass perpendicularly, proceeds straight on unrefracted. The next outer rays, meeting the glass at a small angle, are a little bent in towards the centre or thickest part. Then rays farther out from the centre are *more* bent in, because they strike the surfaces at a greater angle ; and so the whole beam of

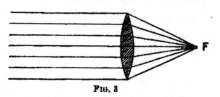

FIG. 3

rays meet practically in one point, F (fig. 8), which is the 'focus' for parallel rays, or 'principal focus.' This is the well-known phenomenon of a burning-glass.

Take the converse, however ; if the rays diverge from the luminous point F at this focus of the lens, they are refracted just the same, being converted into parallel rays. Suppose, however, that the rays diverge from a point, *f*, farther away

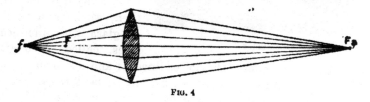

FIG. 4

from the lens than its principal focus, F (fig. 4). What must happen then is, obviously, that all the rays diverging from the point *f* will be bent in so as to *meet again in some other point*, F_2, on the other side of the lens, which point must have

some fixed distance related to the other distance, according to the refractive power of the glass. It is accordingly called the conjugate focus of the point f.

Here we have exactly what we wanted to get—a brighter image. To make it more clear, take both the slide and the condensers also out of the lantern, leaving only the perforated tinfoil with its five holes, and let the object be the light in the lantern itself, because its images will be both brighter, and will stand out obviously apart upon the screen. Now take a lens [1] in the hand, and hold it close to the tinfoil. At once the outside images will be bent in towards the centre one, and a position will be readily found in which all are exactly made to fall on one spot. Finding that position, and placing the lens there, is 'focussing' the lens. This image is obviously five times as bright as the original one, and if now the lens can be supported in that position, we may prick any number of holes, and break away the tinfoil altogether, and it makes no difference except to further brighten the image; because in the same way all the images formed by every ray are bent in to the same point, and unite their brightness in one.

This is the *only* action of a projecting lens. People talk, and even write, as if it *formed* the image, or *inverted* the image; but it does nothing of the kind. The rays themselves form the images; and their crossing at the place where the lens is, inverts the image; and all the lens does is to bend into one spot the rays (forming images) which fall upon its surface, and so to combine countless faint and jumbled images into one bright and clear one. That is the true nature of Optical Projection.

This much being experimentally realised, several very important principles at once become clear. First of all, it

[1] This lens must be of somewhat *longer focus* than the distance from the light to the tinfoil, or the light must be pushed up to the front so as to make that distance less than the lens focus.

will be seen that for any given distance of the lens from the slide or object, there can be but one distance from the screen which will properly unite all the ray-images in one. Hence, if we want to produce images under various conditions, or of various sizes, it becomes necessary to have several focussing lenses. Further consideration and experiment will establish the fact that, with a fixed object and a fixed screen, there are *two* positions in which the lens will produce an image, the focal distances being the same in each case, only reversed. The lens may be near the object, and produce an *enlarged* image; or nearer the screen, and produce a *diminished* image. We have the first case when a photographic lens is used in a lantern: the second case when the same lens is used in a camera. In almost all cases it is the first kind of focussing which is used in projection.

Secondly, it is plain that the distinctness of the projection will depend upon the perfection with which the lens bends in all the ray-images to precisely one spot. Unfortunately, it will be found that a simple lens, made of one piece of glass, does not perform its office perfectly. The different colours— be they evident, or only as existing in white light—are not refracted alike, the blue rays being bent in to a shorter focus than the red ones: this is called the ' chromatic ' aberration. And the rays striking the edges of the lens are also bent in to rather a shorter focus than those passing through its centre: this is called its ' spherical ' aberration. Also, the outer parts of the image tend to a shorter focus than the centre part: another form of spherical aberration. Where great distinctness of image is necessary, as in a lantern for exhibiting views or diagrams, we have to correct these faults by constructing compound lenses made of different kinds of glass, with or without air-spaces between. We may also use a diaphragm or limiting stop, cutting off the worst of the marginal rays, which is often done in lanterns. But in most experimental projections, where only broad features have to be made visible,

simple lenses answer every purpose, and are preferable because they stop less light; some being lost at every piece of glass by reflection from its surfaces, and by absorption in its substance.

For, in the third place, it will be manifest that the brightness of a projection must depend upon utilising in our final image a sufficient number of luminous rays. If we regard the rays proceeding from an object as equally luminous in every direction, the number of rays collected must obviously depend solely upon the *size* of the lens, and its *distance* from the object when focally adjusted : the brightness of the image will, however, further depend upon the screen-distance. By a very simple and obvious law, the light falling on a lens must diminish as the square of its distance from the object; and that on the screen, in the inverse ratio of the surface of the lens and that of the superficies covered by the rays on the screen ; both depending, as we have already seen, upon the focus of the lens.

Hence comes the utility of large lenses, which are highly advantageous for many physical experiments in projection, as we shall see. But it by no means follows that a large lens will give more luminous results in every case ; for the result depends upon collecting an adequate number of *luminous* rays, and it is by no means to be taken for granted that the rays emitted from an object are *equally luminous* in all directions : it may rather be the case that all which are luminous enough to afford us much help towards our final image, are confined to a very limited range. To understand this is the last essential point in the problem of projection.

5. **Use of a Condenser.**—We have already had a proof and example of this. When we first removed the lens and pricked a hole in the tinfoil, the margin of the image of the slide was not illuminated, and we had to draw back the light considerably from its usual position before we could make it so. The slide itself was amply illuminated, we know, for with the lens the image

was all that could be desired. The fact must be, therefore,
that the more luminous rays from the edge of the slide, while
they fell upon and got through the lens, did not get through
the pinhole until we drew back the light.

Let us investigate this further. With the slide in the
lantern, leave the lens in its place; but this time remove the
condensers instead. The slide itself is now very nearly as
brightly illuminated as before; but only the centre of the
picture is at all bright upon the screen, and we have again
the dark margin, all the more striking by contrast with the
bright centre. Considering this, we begin to understand the
state of the case. Our slide is very greatly *transparent*.
(It is not wholly so, or there could be no picture of it, nor

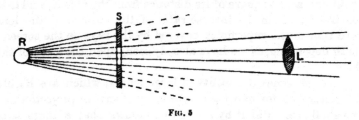

FIG. 5

could we see it.) Now, any imperfectly transparent object
scatters light falling upon it, and in this way sends out *some*
rays in all directions open in space. But the greater part of
the luminous rays which strike on it do go *straight on* from
the light in the lantern, or continue diverging; and as regards
far the greater part of the luminous rays, therefore, the case
stands as in fig. 5. Those passing from the radiant, R, through
the outer part of the slide, S, pass *outside the lens*, L, and
give no light to the final image; the lens only picks up from
the margin of the slide the few comparatively dim 'scattered'
rays. On the other hand, a central cone of bright direct rays
does get to the lens, L, and forms a good image of the central
portion of the slide.

The properties of a lens already indicated, suggested long

ago the remedy for this, in the shape of a ' condenser '—viz., a
lens used in this case merely to bend in the *illuminating* rays,
till they are brought to strike within a *given area*, or as nearly
so as possible. Taking the same case as before, suppose we
place immediately after the slide, s, a large convex lens, c
(fig. 6), which more than covers it. If this lens is of suitable
focus, the outer part of the luminous cone, which before
diverged uselessly in the directions R A, R B, is bent in so as
to pass through the focussing lens, L. The consequence is
that there is now a bright image of the whole of the slide.

This is not the best position for the condenser, because it
both impairs the sharpness of the image (which has in a

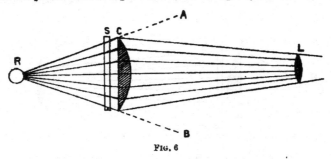

FIG. 6

manner to be focussed through it) and it leaves the slide so
near and exposed to the heat of the light. But it is men-
tioned first, because it actually was the position first given to
the condenser, and still used in those ' toy ' lanterns which
are copied by toy-makers from generation to generation ; and
still more, because it shows us that the common view of the
function of a condenser is a mistake. It is usually stated in
books upon this subject that this function is to ' condense '
the greatest number of luminous rays upon the slide. That
is not so at all ; this object could be obtained, as in the above
arrangement, by placing the slide itself near enough to the
source of light. It is not to condense rays *upon the slide*,
but to converge the luminous rays so that they shall pass

through the focussing lens ; and to understand this is most necessary to any successful projection which may be the least out of the beaten track. We shall see hereafter that, for want of understanding this, even slides and diagrams are often badly shown, and unnecessary expense is often incurred.

This understood, however, it is obvious that a much better arrangement in several respects must be to interpose the condensing lens between the slide or object and the light, as in fig. 7. The otherwise wasted divergent rays R A and R B are still bent in so as to pass through the focussing lens, L ; but a large part of the heat is borne by the lens C, and the slide or apparatus so far shielded ; and the focussing lens, L,

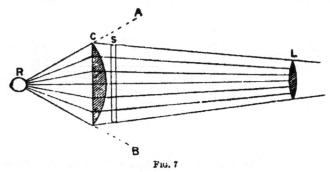

Fig. 7

has no distorting medium between it and the object. This, therefore, is the arrangement now always used in instruments of a serious kind.

6. **Management of the Rays.**—We now understand exactly why the margin of our slide in the first experiment was not illuminated upon the screen, until the light was drawn back from its usual position. There was a condenser, and the rays were sufficiently converged to pass through the lens—say a circle of two inches diameter—in the usual manner. But they were not sufficiently converged for any appreciable rays passing through the margin of the slide, to pass through the small central pinhole. By drawing back the light, they were

made more convergent so as to do this. We thus learn that for a successful projection, especially of apparatus, the position of the *condenser* relative to both the light and the object, and to the focussing lens, is almost as important as that of the latter; and may have to be varied materially, according to any of these circumstances. All the parts of the optical system must be so arranged that (1) as many rays as possible may be made to pass through or fall upon the slide or object; and (2) also pass through the projecting lens.

But it is further necessary that the rays should not be *more* converged than will cause them to pass through the lens. For lastly, we can hardly help seeing that the rays proceeding in fig. 7 from the slide s to the projecting lens L, must be considered in a double character. From the focussing or projecting point of view, they must be regarded as bundles of image-forming rays *diverging* from every point of the slide s to the surface of the lens L. On the other hand, from the *illuminating* point of view, we must regard them as *converging* bundles of rays proceeding from the condenser c to the lens L. It is natural to suppose that this dual character might lead to some want of sharpness or definition in the focussed image. In ordinary lantern arrangements, and in exhibiting slides, this is not sensibly the case, because *any* ray from each point in the slide, to any point on the lens, forms an image on the same spot of the screen; and thus the luminous rays are identical with the chief image-forming rays. But in movable projecting arrangements, the matter is of the greatest importance. Thus, the light might be so drawn back from the condensers as for all the rays to pass through the slide, and then actually converge and *cross* before entering the focussing lens.[1] All the light would then still pass through the lens, and would reach the screen in some form or other; but such violent crossing would blur the image and spoil the *even*

[1] I have seen this mistake made repeatedly in physical demonstration, especially with the electric light.

illumination of the 'disc' (or lighted area) on the screen. And in microscopic projection, where definition in the image is so much more severely tested, it often becomes necessary practically to 'focus' the light itself *upon the object*, in order that the rays diverging again from that focus as from a new point, and the image-forming rays from the object itself, may practically coincide.

Such are the elementary principles and conditions of Optical Projection. Simple as they may seem, for want solely of a due understanding of them, many demonstrators never half develop the powers of their apparatus. This does not apply only to so-called itinerant lecturers; for I have repeatedly seen polarisation and other physical phenomena projected, with the most elaborate electric-light apparatus, at what are considered the very head-quarters and principal arenas of scientific exposition, in a manner inferior to what I had been accustomed to obtain with only oxy-hydrogen illumination. These principles are the essential key to the whole of what follows; and both excellence of apparatus, and success in using it, depend upon their being thoroughly grasped, in the first place by the optician, and in the second place by the operator who uses the apparatus which the other has constructed.

CHAPTER II

THE PARTS OF A LANTERN

A LANTERN is an optical apparatus so arranged, with all its parts approximately fixed in their places, that pictures or apparatus can be exhibited on a screen with the least and most convenient manipulation. In this place we will consider only the exhibition lantern, for the projection of slides or diagrams, leaving other apparatus for separate consideration in a chapter devoted to experimental lanterns.

7. Parts of a lantern.—The diagram (fig. 8) of one of the simplest forms of lantern, once general, but now generally

FIG. 8

confined to mere toy instruments conveniently represents the essential parts, which we will consider singly. These are (1) the light L, which may or may not be supplemented by a reflecting mirror M. This, as it is the original source from which all illumination is derived, while the word ' light ' may need to be used in other senses, it will be convenient to distinguish as

the *radiant*; and as it forms no part of the lantern itself, and various kinds of radiants are often employed in turn in the same lantern (as when an experiment is worked out in a small way with a lamp, and afterwards publicly performed by the oxy-hydrogen light), we will postpone it for treatment separately, and pass on here to other details. These are (2) the lantern-body B, with its chimney or heat-vent. (3) The condenser C. (4) The stage for slides or diagrams, S. (5) The focussing lens, objective, or power, P. All improvements in lanterns relate to one or other of these parts.

8. The Body.—This has two purposes : 1, to support and keep in due relation the other parts ; and 2, to prevent any light not utilised in the projection from scattering about the room and impairing the effect. Japanned tin or sheet iron is the simplest and cheapest material, and when economy is an object, will really perform as well as anything else, provided the optical parts of the apparatus are equally good. Thus, a tin bi-unial will do all that the most expensive body can ; or an experimental lantern made in this cheap way for a science school, will come short in no part of the demonstration, and may be within reach when a more expensive one would not

be so. But besides the want of appearance, there is the objection to a simple metal body that it becomes very hot, and may manifest this fact very suddenly and unpleasantly when any manipulation is necessary. For this reason all the better lantern bodies are made of wood, lined with an iron or tin casing supported at a small distance from the wood, so as to keep the outer body cool.

The *shape* of a single lantern body may vary a great deal, and has some connection with the radiant employed. With Argand lamps (either gas or oil), which require a tall glass chimney, a body is still employed (almost of necessity) rather tall in proportion; and the earlier lime-light lanterns were similarly made, from custom. But the introduction of the Sciopticon form of lamp caused a revolution in the form of body also. There being no wick chimney, the tall chimney of the flame chamber was attached to the lamp itself, and the body of the lantern was lowered. All lanterns of the edge-wick class are now made with low bodies ; and the same are found ample for the lime-light.

The wood of the body should be perfectly plain and sound in grain, old and well-seasoned. Any ' ornamentation ' is out of place, as will be remarked upon again.

Where exhibitions may have to be made in various places, it is of some importance to have a door on *both* sides of the lantern. Most people work from the right side (as the lantern faces the screen), but this is not always possible, especially with experiments. In all lanterns used with the lime-light, each door should be furnished with a sight-hole glazed with dark *blue* glass, through which the state of the lime can be examined without dazzling the eye. For a lantern used only with paraffin oil, sight-holes are useless, the flame being examined through a sight-hole at the back of the lamp.

The back of the body also demands a word. For Argands, it is closed in entirely. For paraffin lamps it needs little consideration, the lamp itself being closed in, with the exception

of the small blue sight-hole. For the lime-light, there is
usually a perpendicular slot sufficient for the passage back and
forward of the tray-pin which carries the jets (figured in
Chapter IV.) and enlarged at the bottom for the jet itself, and
for the tray. Usually little light comes through these open-
ings; but with a powerful light it is unpleasant, and mars
the effect. When this is found to be the case, two small brass
eyes should be screwed into the back, near the top corners,
into which drop the two ends of a wire bent as in fig. 9. On

this semicircular wire is hung, by small
rings or a broad hem, a curtain of black
cloth, which quite stops the stray light,
while allowing the jets to be got at
readily.

The *top* and *chimney* also claim a
word. Paraffin lanterns have open tops,
but, if also used for lime-light, a cover
must be provided. Argands need a tall
chimney; but for lime-light lanterns such

FIG. 9

have quite gone out, and a short cowl on a bulged top is
generally used, as shown in the tri-unial figured on page 119.
If this has to be packed inside the lantern, it is very dan-
gerous to the condensers, unless carefully wrapped in cloth;
therefore, if the lantern-box will not contain it *in situ*, the
cowl should be so tapered that it will drop upside down *into*
its flange or socket, which can also be reversed on the top of
the lantern. It is very much better to make the top (always
of sheet iron) *flat*, and the top of its quite shallow cowl
also flat. This saves space and manipulation to begin with,
but has a more important advantage. In experimental work
it is often necessary to *warm* fluids and objects, and the flat
heated top offers a convenient means for doing this. Even
in slide exhibition, every exhibitor knows the difficulty en-
countered from 'dew' upon his slides on a cold and foggy
night. Such a flat top offers to him, also, a handy means of

warming his slides. If the plate itself is too hot to lay them upon, they can be readily supported on three small slabs of wood or cork. Opticians have long been behindhand in this respect, and such a low flat top has only to be known to be universally approved of.

In the United States, lanterns are sometimes made with no rigid body at all. One such which was purchased there, and used in this country by the late Mr. R. A. Proctor for his lectures, had for its base a light metal quadrangle supported on four short pillars at the corners. The front alone, carrying the lenses, was hinged to this, and a light body fitted on the base behind like the tilt of a waggon. Another common American plan (shown hereafter in Chapter XII.), is to hinge the front to the base in the same way as just described, to add two light pillars behind, on which and the front is supported a sheet-iron top, and to form the sides of black cloth curtains. The arrangement may occasionally be useful for its lightness, and for packing into a small space ; but so far I have met with none who liked it in this country, in comparison with the more solid English bodies.

9. **The Condenser.**—The use of this has been explained. A single lens is, however, only used in toy lanterns. The object is to take up as wide an angular pencil of rays from the radiant as possible, and send them through the objective. A single lens, to do this, must be of such thickness as to lose much light by absorption ; and moreover the chromatic and spherical aberration would be excessive. The use of two or more lenses accomplishes the object with a moderate thickness of glass, and also allows a large part of the aberrations to be corrected.

Fig. 10 shows the principal forms of double condensers which have been used. Two double convex lenses, c, were used by Messrs. Carpenter & Westley in the early phantasmagoria lanterns, and for many years afterwards, till very lately, in the electric lanterns of M. Duboscq. They are

abandoned now, because the aberrations are very imperfectly corrected, and there is loss of light by reflection at the edges, the curve increasing the angle of incidence. The two meniscus lenses of D were better, but never came into general use, being superseded by F, a meniscus and double convex, with the meniscus towards the radiant. This is known as the Herschel condenser, being in general form modelled on a burning-glass designed by Sir John Herschel, and was long reputed to be free from spherical aberration, though it was afterwards discovered that this supposition was due to an error in calculation. As a burning-glass, however, such a pair does give exceedingly good results ; and, correspondingly, is excellently adapted for converting the light from a luminous

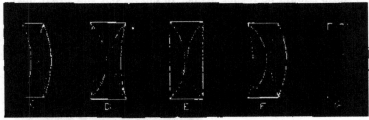

FIG. 10

point into a parallel beam. The light from a lantern has however to be *converged*, except in optical experiments ; and therefore this condenser is not so superior for lantern use ; but it does well for lanterns used with the lime-light alone, and is largely employed for such ; for larger radiants, like lamps, it is not well adapted. Its best form is that devised by Gravett, shown at G, where the meniscus next the light is made rather smaller, and the second lens is of flatter curve on the inner face. Optically, this is a very good condenser for the lime-light, its principal defect being that the bulging front prevents slides being brought up close to the margin, and hence somewhat diminishes the size which can be illuminated by a condenser of given diameter.

The condenser at E, consisting of two plano-convex lenses, was also used by Herschel, was adopted by Mr. Marcy for his Sciopticon lamp, and is the best form for all large and hot radiants. Such lamps have to be placed at a greater distance from the condensers to avoid cracking them, and are generally used with short focus objectives; the two cones of light being thus more alike in angle, two such lenses represent pretty well the optical conditions. When properly modified, this form is equally adapted for the lime-light, and is now the most usual condenser found in good lanterns.

10. Correction of the Condenser.—For oil lanterns the plain form shown at E, of two similar lenses, cannot be improved. Optically, it would be better that the lens next the lamp should be rather deeper in curve, but the great heat makes this undesirable. With the lime-light it is different, and in considering the very best form, it is well to understand the principles upon which the correction of aberrations depends. This has been very familiarly explained in the diagram, fig. 11, by Mr. Robert Bow. Here D E represents the upper half of a plano-convex lens, the faint line *h e* the outline of a double convex lens in contact with it, and *d e* a meniscus lens of the same focus. Consider now the different effect of these two

FIG. 11

latter upon the spherical aberrations, due to the fact that the marginal rays are brought to a shorter or closer focus than the central rays. It is quite plain that the focus F of the central rays, A A, will be almost exactly the same in the two arrangements—we may practically consider that a fixed point. But with the marginal rays, B B, it is different. Tracing the top one, B D, let us suppose that the lens *h* re-

c 2

fracts it to $f2$: then the distance between F and $f2$ represents the aberration of the D h combination. But, owing to the curvature, away from the lens D, of the meniscus d, the marginal ray passes through d nearer the centre than through h, and consequently its second refraction by such a lens is less on that account ; the same ray also passes through the meniscus at a less angle of incidence, which in another way also reduces the second refraction. Consequently, the marginal focus is lengthened, and the aberration is reduced to the distance from F to f.

The main factor in this correction is the bending away from each other *at the margins* of the two lenses, which is obtained equally in the double plano form, and explains its

FIG. 12

superiority to the two double convex lenses, c, fig. 10. But it will be evident that the other condition, of 'minimum deviation' at the margin, is only approximated to when the curves or thicknesses of the lenses are in some proportion to the foci on each side of the condenser (*i.e.* the position of the radiant, and the position of its image on the other side of the condenser). Hence, for a lime-light condenser, the lens next the radiant should be of considerably deeper curve, the two lenses taking the form of fig. 12 rather than of E in fig. 10. Then the spherical aberration Ff will also be comparatively smaller. A thicker lens, however, is more in danger of cracking from the heat ; therefore, as it will be obvious that a somewhat smaller diameter at $d\,d$ will collect all the bundle of diverging rays which can reach the second lens, D, this fact should be taken advantage of, in order to reduce its thickness while keeping the deeper curve (see fig. 13).

All things considered, I regard this as practically the best

model for a lantern condenser. Some opticians—including
Mr. Dallmeyer—prefer to make the lens next the slide a
' crossed' lens ; but practically there is no advantage in this,
and it (slightly) diminishes the size of the slide which a given
condenser will cover, as already indicated.

There remains to consider the chromatic aberration ; for
of course the margin of a lens acts precisely like a prism,
and makes the different colours *diverge* into a spectrum, as is
easily seen by experiment. Now these diverging rays from
the first lens, falling on the second lens, are by it more or less
converged, like any other rays diverging at the same angle.
The amount of this convergence is greater, the farther the
rays are allowed to proceed before convergence by the second
lens ; the conjugate foci are altered in relation to each other, as
in other cases. Hence there is one particular distance at which
the differently-coloured rays dispersed by the first lens are
made approximately parallel by the second lens for a given posi-
tion of the radiant ; and at this distance between the lenses,
the condenser becomes very nearly achromatic, only the nar-
rowest line of colour being visible at the extreme edge of the
illuminated disc. The exact posi-
tion is a matter of experiment or
calculation for a given glass ; but
practically, in a condenser of the
kind here described, the clear dis-
tance between the lenses is usually
between a quarter and three-
eighths of an inch for a four-inch
condenser. Such a condenser is
shown in fig. 18, and will work
exceedingly well through a wide

Fig. 13

range of foci. For *constant long-focus* work—say with objec-
tives over ten inches focus—the second lens may be a ' crossed'
lens, with the deepest curve inside, but for all-round work, two
planos will be found best, as the slide may be brought close

up. For much long-focus work, an extra condenser (also of longer focus), gives the best result.

For all usual exhibition purposes the ordinary double-plano, with the lenses in contact, answers very well; and it is only for sharp detail in the best class of photographic slides, or when it is desirable to utilise the field as far as possible up to the very edge of the disc—as in square or cushion slides—that such optical refinements acquire importance.

11. Practical Points in Condensers.—Condensers are usually made of crown glass, density about 1·516. This answers perfectly for ordinary purposes; but for the highest glass of modern exhibitions, which have to cover large screens of twenty to thirty feet diameter, sometimes at great distances, is objectionable, as the green colour absorbs light which can ill be spared in such circumstances. Chance's ' optical ' flints, of course, leave nothing to be desired in this respect, but condensers so made are very expensive; in some cases, however, they are worth while, as the glass is both more colourless, and the lenses are *thinner* for the same focus. A more common flint would answer practical purposes, and it is desirable that some colourless glass should be introduced if possible, rather than green crown. This need not make them so very much more expensive; for while ' optical ' flint must be homogeneous, and is usually wanted dense, for a condenser, a perceptible amount of *striæ* is of little practical importance, and density is not required, only colourlessness. It is utterly useless to pay the cost of optical perfection in a condenser for any ordinary purposes. A perceptible bubble in the lens next the slide, however, would be a defect of importance, probably showing as a black spot. It is very likely that many purchasers would reject a colourless lens with perceptible striæ, rather than a crown lens which showed none; nevertheless there can be no question that the first would be the better condenser, unless the striæ were excessive.

The point most commercial condensers chiefly fail in,

however, is that the lenses are not ground *thin at the edges* ; nearly all lantern-makers being far too careless in this respect. Not only is a needlessly thick lens much more likely to crack, and more absorbent of light, but it is distinctly worse in optical performance. The lenses should be ground to as nearly knife-edges as possible, being only just edged down for fixing into their cells.

Both lenses should be mounted so *loosely* in their brass cells, that they can be turned round with the fingers, else they may crack merely from expansion when heated, and they often become hotter than the hand can bear. Holes must be pierced in the margin of the cell, to allow of the escape of the aqueous vapour which always forms when the lantern is first lit. Only the back lens ever cracks from heat alone. If the crack be irregular, the lens must be replaced ; but it often happens that the crack is quite straight across a diameter, in which case the cracked lens will answer perfectly well if the crack is arranged perpendicularly, and the operator may feel certain that his lens will never crack again.

12. **Size of Condensers.**—The best general size of condensers is 4 inches diameter next the slide. The standard size of slides is $8\frac{1}{4}$ inches square, and 4 inches will cover ' cushion ' slides on such square of glass. Of course a diameter of $8\frac{1}{2}$ inches is ample for the usual *circular* slides, which give a disc of 3 inches diameter. If it is desired to cover square slides of three inches, as the corners are never *absolutely* square, it is better to have $4\frac{1}{4}$ inches diameter than $4\frac{1}{2}$ inches, because practically only a certain angle of light can be taken up from the radiant, and the larger surface this is spread over, the more it is diluted, so that for the usual size of slides, *less* light is passed through them by a large condenser than a small one. Theoretically any angle might be taken up by a condenser, but practically it is limited ; first by the thickness of the glass, which would both crack, and lose as much light by absorption as was gained in angle ; and also

by such loss from *reflection* at the edges of the first lens, owing to the high angle of incidence, that the edge of the disc would be less illuminated than the centre. Practically the angular pencil is thus limited to somewhere from 65° to 70° in lanterns for exhibiting slides.

13. **Triple Condensers.**—Condensers of three and even four lenses have been used, especially in America. . Theoretically, they admit of more perfect correction for aberrations, and a larger angle of light ; but this is complicated by the number of extra reflecting surfaces. I have perfectly satisfied myself, that for exhibition lanterns they afford no gain whatever. For large condensers, as five inches and over, and where the light is to be condensed upon ,a *small* surface, as for the projection microscope, they are of advantage, and allow us to use a pencil of 90°. Such a condenser will be described in connection with the instrument just named.

14. **The Slide-stage.**—Little need be said here about this. For a single lantern only used to exhibit simple slides and diagrams, it does not matter much how it is constructed. When, however, experiments may have to be made in the stage—as in a chemical tank, and for some 'effects' with slides—as the ascent of a balloon, it is important that the stage be *open at the top*, with the exception of the pillars needful to carry the objective mount. Also, for anything like general work, it is important that while the spring pressure-plate allows the slide to be inserted easily, for which purpose the edges should be carefully turned back to a smooth curve, the slide should be held *firmly* when in place. If it be not so, the working of any mechanism, as the handle of a chromatrope, may move the slide about in a very unpleasant manner. Both these requirements should be attended to, even in a cheap lantern of japanned tin.

15. **The Objective.**—This is the lens directly employed in the projection. A simple lens is never now used except in toy lanterns, and for physical experiments, the latter for reasons

which have been already mentioned in § 4. When hand-painted slides only were in use with oil lamps, two simple meniscus lenses combined gave fair results, because there was no detail sharp and colourless enough to manifest optical defects; but photographic slides and diagrams make conspicuous either chromatic fringes, or distortion of figure. Practically, achromatic lenses only are now used in lanterns. They may be of four kinds.

(a) *The simple achromatic lens,* or lens composed of one convex crown c, corrected by a concave of flint F, usually of the plano-convex total form, as shown at A, fig. 14. This lens

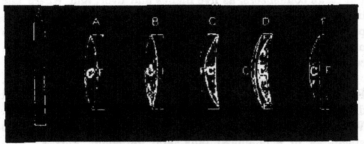

Fig. 14.—Single Achromatic Objectives

is employed with its convex surface towards the slide s. If the plane face is turned to the slide, the definition is sharper in the centre of the field, but falls off rapidly at the margin; and the image is also formed on a hollow curved surface instead of on a plane. By reversing the lens a little is sacrificed at the centre, but the picture is better and more uniform over the rest. A lens cannot, however, be made of this construction of short focus, say 4½ to 7 inches, which will give a good image.

It may be well to explain here the principal errors which have to be corrected in the objective. As regards a condenser, it has already been seen that the most noticeable result of spherical aberration is to bring the marginal rays to a shorter

focus than the central rays. But when we use a simple lens-
to form an image, there are other results from this. Referring
to fig. 15, it will be seen that the image *m m* of the arrow ᴍ ᴍ
is really brought to its focus upon a *concave surface* instead of

FIG. 15.—Spherical Aberration

a plane ; or conversely, the diagram or picture *m m* must be
drawn upon a concave surface to produce a flat image ᴍᴍ, an
expedient actually employed in early solar microscopes.

FIG. 16.—Distortions of Image

The curved image may be more or less ' flattened,' as it is
called, by adopting a meniscus form for the lens, as shown in
fig. 14 by the various achromatics ʙ, ᴄ, ᴇ. But we are now
confronted with another result of aberration, in the form of the

image. In fig. 16 let s represent the slide, a true image of which we wish to produce. Then b represents what is called the ' barrel' distortion, the usual distortion of a single lens. If we correct this merely for flatness of field, which is the easiest and most obvious error to correct, we usually get the figure *over*-corrected, producing the ' hour-glass ' distortion denoted by h. Either distortion, if perceptible, is simply intolerable in architectural subjects, lines of type, or diagrams which may contain straight lines or circles.

The correction of these various errors in lenses of moderate focus is a task of no little difficulty. The chromatic correction is a comparatively simple affair, needing simply a certain proportion, depending on the dispersions of the glasses, between the convexity of the crown and concavity of the flint ; and the object of various ' figures ' for the curves, as in a, b, c, e, (fig. 14) is to correct the spherical aberrations. The forms given in fig. 14 have all been at one time or other used for photographic purposes. They all need a stop or diaphragm on the side farthest from the slide, and c is probably the best of them ; but no single achromatic lens is capable of perfect correction for anything like short foci.

(*b*) *Double or triple achromatic lenses.*—With foci of ten inches and over, however, the spherical aberration is much less, and these lenses then perform very well, and are in common use for long-focus work. Two or even three of such long-focus lenses combined, make better short-focus lenses than single achromatics of such short focus ; and hence it is very common to furnish a lantern with three achromatic lenses of graduated long foci, ranging from nine or ten up to eighteen or twenty inches, which by combining different pairs, or the whole three, will give fair results throughout the whole range. This result will depend upon the quality and figure of course, for of these ' triple sets,' as they are called, there are both bad, middling, and good. The only way to be sure is to have a trial, which a good optician will always afford.

(c) *Triplet achromatics* have also been used. D in fig. 14 shows a triplet devised by Dallmeyer which is said to answer very well. But a more usual form, made sometimes in France, is that shown in fig. 17, a concave of flint being used between

FIG. 17

two convex lenses as in the preceding, but the whole lens assuming a double convex form. Some of these lenses perform exceedingly well. They were used a great deal by Mr. Dancer for his lanterns, and I possess a pair of them, 6-inches focus, whose performance can hardly be distinguished from that of the best of the construction next to be described. They appear to me to combine flatness of field, evenness and sharpness of definition, and ortho-symmetry of image, in a greater degree than any other single lenses, and I think it is to be desired that more attention should be directed to this construction for long-focus work. My pair of 6-inch lenses have a clear diameter of $1\frac{3}{4}$ inch, and require a 1-inch stop placed about $2\frac{1}{2}$ inches in front to produce their best effect. In this position the stop cuts off scarcely any rays of serious importance, and the image of a slide of printed matter is exceedingly good. For lenses of 9-inches focus and upwards, no stop whatever would be required, and such lenses would be much cheaper, and pass more light than double combinations.

(d) *Double combination* lenses are, however, most used in the best lanterns for short and moderate foci, ranging, say, from $4\frac{1}{2}$ to 8 inches. The type always employed is that well-known as the Petzval combination, shown in fig. 18, and in many lanterns quarter-plate photographic lenses are used for the shorter foci, and half-plate lenses for the longer. The pick of a dozen or so of such lenses will leave little to be desired; but generally a lot as imported from France by opticians is very unequal in excellence, and most of these lenses require a stop at s, which loses a great deal of light.

These photographic lenses have however the advantage, that
very often by unscrewing the double lens at the back, and
substituting for it the front lens reversed, or with its convex
side to the slide, a very good long-focus single lens is obtained
of the (a) kind.

The best lantern-makers have lately, taking this photo-
graphic lens as a basis, worked out by screen tests improved
curves for lantern use only. Such are sent out in the highest
class lanterns. These lenses reverse the two single lenses F, C,
of the Petzval system (fig. 18), need no stop whatever, and give

FIG. 18—Double Combination

magnificent definition; but, as a rule, they are *not* corrected
for photography, and the single lens can rarely be used satis-
factorily. It only remains to combine these points with the
other excellent qualities already attained; and there is little
doubt that the growing use of enlarging lanterns, or adapta-
tion of the lantern to photography direct, with the aid of the new
optical glasses now made in Germany, will enable this crown-
ing perfection to be obtained, at least in all lenses of 6-inches
focus and upwards. With lenses of 4½ inches focus, used
chiefly for paraffin oil lanterns in small rooms, to exhibit
through a transparent sheet, a perfect image of a slide 8 inches

diameter is a task of tremendous optical difficulty, and the wonder is that such approximation to it has been attained.

16. Focus and Diameter of Objectives.—The proper focus of an objective of course depends upon the size of disc which is required to be covered by a slide at a given distance, and the range of foci suitable in a set of objectives, will depend upon the range of work, or variety in size of rooms, it is intended to provide for. This is dealt with in detail in Chapter VIII. Here it is only necessary to mention the matter in connection with the *diameter* of objectives. We have seen that brilliance of image depends upon sending the rays collected on the

FIG. 19.—Scattering of Rays

object *through the objective*, and we know that only from a radiant *point* could the rays be alike converged into a given area at different distances from the condenser. With, say, a luminous spot of $\frac{3}{4}$-inch diameter, the light cannot be converged save into *an image*, proportionate in size to the conjugate focus of convergence, as shown in fig. 19. Hence, while all the light can easily be converged into a small lens at a few inches from the slide, at twelve inches it is another matter: the body of rays *must* spread out more, and require a larger lens to utilise them in the image. Besides this, a 'ain amount of the rays are irregularly 'scattered' by the

slide itself, and these scattered rays also diverge more with the greater distance. This is the chief reason why more light is required in working a long way from the screen; though light is also perceptibly absorbed by the atmosphere, especially if it is at all a damp night.

Hence it is an important question, how far this loss of light from long focus must be provided for. Some makers recommend several sets of double-combination objectives of very large diameter, at a cost of 9*l*. to 10*l*. apiece! After investigating the matter carefully, both in theory and practice, I have not the slightest hesitation in saying that such costly lenses are a sheer waste of money, of absolutely no benefit to anyone but the seller of the apparatus. Assuming the back conjugate focus of the condenser to be 4 inches (*i.e.* about 3 inches from the back of the condenser) and the radiant to be ¾-inch in diameter, nearly all the effective rays can be condensed into an objective of 2-inches diameter, up to 9 inches from the face of the front lens of the condenser. This gives a focus for a double combination of, say, 10 inches, within which there is no need of greater diameter, and no benefit from it. Beyond that a 2-inch lens will begin to lose light, but 2½-inches diameter will carry the same result up to 13 inches; and it is only when we reach distances of 15 inches and upwards that 3-inch lenses are of any real advantage. For such long foci, however, the 'double combination' is quite unnecessary, as with care in selection, single achromatics can be obtained, which will give quite as good images with far less weight and expense; and perfection should rather be sought in improving this class of lenses, especially in the triplet form described a page or two back; which will also pass more light than the double form at these long ranges.

A 'double-combination' lens of average focus—say 6 to 8 inches—and of most excellent quality, such as will give perfect definition without any stop, is now obtainable for so moderate a sum as 1*l*. 10*s*., including the rack-work mount.

I have seen such lenses most carefully tested against the most expensive of similar focus, without any perceptible difference . being discernible.

17. **Testing Lenses.**—It is no use to 'test' a lens upon an ordinary slide, for anything beyond definition and flatness of field. These points can be seen by the image of any good photograph, but the 'figure' may be quite distorted. The very best test is a cushion-slide covered *all over*, to the corners, by lines of type sharply photographed, or by black lines ruled in squares. A lens which gives an image of this sensibly alike in focus all over, and the lines or squares *straight*, especially towards the corners of the cushion, has every needful quality for projection, though the photographer must, of course, look for his special requirements in addition.

18. **The Objective Mount.**—A lantern only meant to be used at one focus needs no consideration in this respect ; into the nozzle of the lantern will slide stiffly a tube of the proper length, into the end of which will screw a rack-and-pinion mount carrying the objective. Practically, all such lanterns are made alike. The travelling exhibitor, however, often needs a very wide range of focus, perhaps from 4½ inches up to 20 inches, or more. To give him this, three methods have been adopted.

The first is to fit the front of the lantern with what are termed telescopic draws, as shown in the tri-unial lantern on p. 119, into the front of which the objective rack-mount screws. No plan has been more usual than this; and if the draws are of first-class workmanship, and fit tightly, it works well for a greater or less time. It is, however, very difficult to pull such draws out, and at least one leading lantern optician has found it desirable to insert a pair of strong metal handles into the front draw, in order to give more strength to the pull. Sooner or later, however, the draws are apt to wear a little loose, and then the front end sinks out of the true optic axis under the weight of the objective.

A modification supposed to remedy this was brought out in 1888, and consists in fitting every draw with a rack-and-pinion. A worse plan could not possibly be devised; it has every defect any mount could have. It is heavy, it is expensive, and it is worse than the original, inasmuch as all stiff rack-and-pinion tubes are apt to ' grind ' sooner or later, and wear loose more quickly than plain ' draws ' alone would do. I only mention this mount as one to be scrupulously avoided by anyone who wants his lantern for practical work.

The third plan, which I regard as the only good one, is rigid, simple, and the cheapest and lightest of all. It consists in somewhat lengthening the lantern nozzle A and tube B sliding into it, so as to give there alone an adjustment of

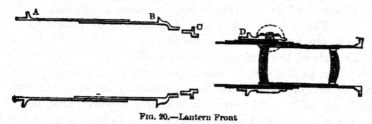

FIG. 20.—Lantern Front

three inches. Into the outer end of the tube B screws a diminishing screw-collar or adapter C, into which again, for all moderate foci, is screwed the rack-work mount D. This racked mount does not, however, carry the objective directly, but is only a casing, into which the different objectives, mounted in simple smooth tubes, are fitted to *slide*. This gives another sliding adjustment of three inches. Thus the original mount alone, even if the shortest and longest focus are double combinations, will give a range of focus from six to twelve inches, which will cover the needs of the great mass of exhibitors ; with a single achromatic lens it practically becomes over thirteen inches. If, however, very long focus is required, the adapter C is removed, and in its place is screwed a *lengthening* adapter (fig. 21) of any required

D

length, which is best as a single tube, but may be a double sliding one as shown in the figure. In the first case the whole

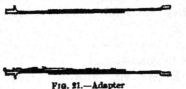

Fig. 21.—Adapter

is perfectly rigid, and perfectly simple; and lengthening tubes may either be ordered with the original apparatus, or, if suddenly called for by some extraordinary occasion, could be fitted in all large towns in a few hours, by any working optician worthy of the name.

This method of construction is being gradually adopted by most of the lantern-makers who really have much experience with the instrument.

CHAPTER III

THE RADIANT

THE qualities desired in the radiant are brilliance and whiteness of light, and that this light be concentrated into as small a space as possible. The perfect radiant would be an intensely luminous *point*, which would give the most equal illumination and the best definition. The radiants used in practice by no means come up to this ideal. They comprise (1) fatty oil lamps, (2) petroleum oil lamps, (3) gas-burners, (4) the lime-light in its various forms, and (5) the electric light.

19. **Fatty Oil Lamps.**—Except in small toy lanterns, it is seldom we now find these lamps employed; but for many years they were the only radiants used at all, even in public exhibitions of dissolving views. With hand-painted transparent slides they did good work, too; giving usually discs of eight feet diameter on transparent screens. They will not

give such a disc with modern photographic slides; but they are still used to some extent, on account of their comparative freedom from risk of fire. Only such lamps are allowed in lanterns for the navy; and they are useful in hot countries, where things become dry like tinder. Some kind of fatty oil can also be generally obtained when nothing else can; and hence these lamps are sent out to missionaries.

Such lamps are of two kinds: viz. with the cistern beneath, as part of the lamp, and with a separate cistern; but the wick arrangement is, with little modification, similar in both. This is what is known as a 'solarised' Argand, external and internal metal cones concentrating an upward current of air upon both inside and outside of the wick, so as to give intensity to the light. The oil may be either sperm, or colza, or olive, and greater whiteness and solidity of flame is generally obtained if camphor is dissolved in it. Fluid oil can be used alike in either form of lamp; but when the cistern is beneath, so as to keep hot while burning, either *tallow* or *solid paraffin* will also burn excellently if first melted. The last—solid paraffin so melted—I think gives the best light of all, but it may not burn equally well in all lamps. Such solid fatty matter cannot of course be used in cistern lamps, like fig. 22, which are now most usual. The glass chimneys of these lamps must be pretty tall, and are tapered towards the top.

FIG. 22

There is little difficulty in getting a light of about twenty-eight candles with these lamps; and as the flame is transparent, this can be increased to about thirty-five candles by using a reflector, which is always done. This must not be parabolic, but circular, the centre of curvature being the flame itself; the rays are then reflected back in the same path, and go to the condenser just as if emitted by the radiant. The

power of a reflector entirely depends upon this, and upon the reflector taking up enough rays to illuminate to the edge of the condenser.

To get a good light, the glass chimney and the reflector (best of silvered glass) must be polished bright. A rather loose or woolly wick must be used (the hard wicks used in petroleum Argands will not answer for fatty oil), and, if new, carefully *dried* before a hot fire, or in the oven, before use. Several hours must be allowed for the oil to soak up in a new wick, and always the lamp is better for warming before the fire, previous to use. Lastly, after trimming a new wick, light the lamp and let it burn several minutes ; then blow it out. It can now be trimmed really clean and smooth, as it could not be before. When finally lit, let it burn a minute or so moderately, and then turn up as high as possible without smoking.

20. **Petroleum Oil Lamps.**—Paraffin or petroleum oil could be, and was, burnt in some of the preceding lamps, but there was little gained by it, and the first real advance in illumination was made by Mr. L. Marcy, of Philadelphia, in the lamp (and lantern) introduced into England by Mr. Woodbury under the name of the Sciopticon. In this lamp two flat wicks, about two inches wide, were placed with their *edges* towards the condenser, outer flat cone-pieces directing the air upon the flames, and driving them very close together. The heat of each flame intensifies its neighbour, and the result is a very brilliant light, very ' solid ' also, owing to the depth of wick behind it. The Sciopticon two-wick lamp was found equal to 60 or even 70 candles, and gave a really good disc of 9 feet with photographic slides. Its chief fault is, that the space between the wicks generally manifests itself as a rather darker streak up the centre of the screen.

Partly to avoid this, and partly to get more light, a third wick was soon suggested. This was stated by Mr. Marcy to be inferior to the double wick ; but general experience has not

borne this out, and three-wicked lamps, giving a light of 80 to 90 candles, are of all forms the most popular. Four and even five wicks have since been introduced by different makers, with slight variations in the arrangement of the wicks, some placing four wicks parallel, ||||, and others in **W** form. By these means a light of even 110 candles has been reached, and for some purposes these lamps are useful; but the heat is intense, and the light does not increase in the proportion of oil burnt. Also, with every wick the difficulty increases of getting the lamp to burn *steadily*; and the three-wick is generally preferred, unless the utmost light is really necessary.

A three-wick lamp is shown in fig. 23. Mr. Marcy's general plan has been practically followed in all, the wicks A (here shown parallel) being placed in the middle of a rather large flame-chamber, roughly shaped like a cylinder, with its end to the condenser. The

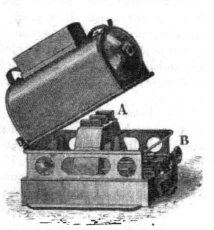

Fig. 23.—Refulgent Lamp

draught depends upon a tall chimney fitted on over the opening in the top, and generally made in two lengths, telescope fashion; for a good draught is essential to these lamps. The ends of the flame-chamber are closed by a glass in front, and a reflector behind with a coloured sight-hole in the centre; but this reflector is too small to be of any practical use, in any lamp I have seen. Each wick has its own milled head, as shown at B (in this figure of course they are three in number), and at the other end of the rectangular tank or cistern beneath, is a screw cap for filling with oil.

With more light the heat was greatly increased, and for some time it was found very difficult to prevent constant cracking of the glasses in front of the flame-chamber. In the Sciopticon, this glass was removed to a good distance, and the heat was less: but the triple lamps were constantly cracking, until the introduction of what were for many years known as the Newton patents. The first of these consisted in making apertures in the front of the top of the flame-chamber, between the glass and the chimney. So far from letting hot air out, as many supposed, the strong draught *drew cold air down*, and kept the glass cool enough to prevent cracking, except in rare instances. Mr. Newton's later improvement was, however, the most effectual, and consisted in heating the originally flat squares of crown glass in iron tubes, till they took the curve of the tube, and then annealing them. This allows the glass to spring or curl with the heat, and I believe no such glass has been known to crack, whereas no annealing was found to absolutely prevent the breakage of flat glasses.

To ensure a good light with these lamps, of whatever make, the following directions must be attended to. The wicks should in most lamps be put in new about seven inches long. Each wick must be fed in and pressed a little, while the milled head belonging to it is turned *backwards*, or to the left, when the ratchet will catch the wick and draw it down into place. As in the preceding case, the wicks must always be carefully *dried*. Trim off as evenly as possible with *sharp* scissors. The next thing is to unscrew the cap at the front end of the cistern, and *fill this with oil*. I mention this, because I have received actual proof that persons have positively lit these lamps and expected them to burn with no oil at all! The quantity is generally about three quarters of a pint for three wicks, and a pint for four; but the cistern should be filled nearly up. The common trash often sold as 'paraffin oil' should not be used; much of it is *not safe in any lamp*, and none of it gives a good light; what are known as

best 'refined' or best 'crystal' oils at the shops, or the higher-priced 'safety' oils, are what must be employed.

The least quantity spilled will of course cause unpleasant smell, the top or flame-chamber may be lifted up by the hinge, as shown in the figure, and the wicks lighted so soon as they are saturated with oil, not before : it is better if this be done inside the lantern, as the chimney (drawn out to its full length) can then be at once placed upon its seat. In most lanterns the lamp is fitted by the makers to push in from the back as far as it will go, but a little room to adjust to and fro is an advantage. A most important point is that the lamp should be thus lighted, and the flames turned up to about an inch only in height, *about ten minutes before* it is really wanted : without this precaution a steady flame cannot be had, and countless failures are traceable to neglect of it. When the whole lamp has thus become hot, the outer flames may be gently turned up first, then the centre one or pair, so raising the flames *slowly* till four or five inches in height, with the centre rather the highest. If either flame smokes at the top of the chimney, it must be slightly turned down again ; and there will be trouble from unsteadiness in this way unless that preliminary burning be attended to which I have described. Broadly speaking, the rule is to keep the flames as high as they can go without smoking, the outer ones rather the lowest ; and if *gradually* warmed and adjusted as here directed, they will remain steady with little trouble.

After use once, the wicks should be smoothed before lighting again, by rubbing off the superfluous charred part with the finger or a bit of linen. Only occasionally may a little trimming with scissors be necessary, and a set of wicks will last a good while. After every time of using, all superfluous oil must be poured back into the tin, or it will gradually diffuse itself all over the surfaces of the lamp, and it will be impossible to avoid offensive smell. Of course the glass in front of the flame-chamber, which is loose for removal in all lamps, will always be kept clean.

21. Gas Burners.—A great deal of class demonstration may be done, and views well exhibited on a disc of seven feet diameter, with an Argand gas-burner; and it is a very great convenience thus to be able to get to work, or to decide the details of a projection, with only a flexible tube from some gas-supply (for supply see § 27). A Silber, or Sugg's London Argand, will give a light of about twenty candles with London, and twenty-eight with cannel gas. This may be increased to about thirty and thirty-eight candles by the use of an adjusted reflector, as described under Oil Lamps, § 19. A Welsbach incandescent burner also gives pretty good results, but is awkward on account of the great depth of the burner beneath the radiant portion. It is rather superior to an Argand in equality of intensity, an Argand flame being most luminous at the edges, where the flame is seen edgeways. For this latter reason an Argand burner is no use in microscopic experiments, even on a small scale, there being *two* extra-luminous edges to the flame, an inch apart.

22. The Lime Light.—The radiant in most common use for public exhibitions will be the subject of separate chapters; but a few words may be added about

23. The Electric Light.—This is of two kinds, the arc lamp and the incandescent lamp. The former will be treated of in Chapter XII., and is chiefly confined in use to the lantern microscope, and physical experiments. Such a powerful light is quite useless for exhibitions, unless the disc to be shown exceeds thirty feet in diameter.

The other lamps, which consist of an incandescent filament of carbon, have lately been applied with some success to the ordinary slide lantern, and where the electric current can be laid on, is a very convenient and handy radiant. The ordinary loop filament diffuses the radiating part too much, and is also too feebly luminous; but the Edison and Swan Company have brought out a lamp in which the carbon is bent into a close grating covering a space of about half an inch square, which

is perfectly suitable for the purpose. This lamp (fig. 24) is supplied for ten shillings, equal to either about 50 candles or

00 candles power, and a handy fitting for holding it, shown in fig. 25, is sold for a few shillings more. The current required will be from three to six ampères according to the candle power, and the E M F will range from thirty-five to fifty-five volts. When properly incandescent, it does better work than a petroleum oil lamp of equal power, owing to the better concentration of the light. With a battery, the appa-

FIG. 24.—Incandescent Lamp for Lantern FIG. 25.—Fitting

ratus is cumbersome; the Schanschieff form being probably the best to use with it, but being out of the question over fifty candles. But whenever a current may be generally available, these lamps will doubtless come into use, giving both the easiest and cheapest form of illumination.

CHAPTER IV

THE LIME-LIGHT

IN one or other of its various forms, the lime-light is far more largely employed than any other for serious lantern-work of all kinds, and is only likely to be superseded by such advances in electric lighting as may make an electric current available in public buildings generally, without burdening the lecturer with the provision of generating apparatus. It is cheap, easily managed, and perfectly free from danger when its principles and methods are understood.

Till very recently, it was the almost universal practice to use the oxygen from a gas-bag under pressure, and this method is and will be still so general, that it is convenient to begin with it.

24. Gas-Bags.—These are of three kinds. A thin kind, made of jeanet treated with india-rubber solution, has scarcely any wear, and even for low pressure such are bad economy. Much better are those usually known as ' best black twill,' and generally used. It pays best to purchase these for all forms of the low-pressure jet; and if of thick make, which can be judged by the thickness at the edges, they are pretty durable even under heavy weights. But the best of all are made of sheet india-rubber, cemented between two fabrics. These are the most expensive, but wear so long, that for anything like hard wear they are far the most economical in the end. As india-rubber ' perishes ' in time, however, for only occasional use it may be better to use the cheaper black twill, and when necessary procure another.

When a bag leaks, so long as the leaks are circumscribed and definite, it may be patched so as to last a considerable time longer. At india-rubber shops, a shilling tin can be purchased of ' india-rubber solution,' which is principally the

gum dissolved in naphtha. Having procured a piece of thin
waterproof—the kind of which nursing aprons are made—and
cut a piece to cover the leaky place with a good margin, the
solution is smeared all over one side of it, and over the space
on the bag it is to cover. It must be left for half an hour to
two hours, until it has become very sticky or 'tacky,' when
the patch is applied, all air worked smoothly out, and the
patch then left under a heavy weight, with a soft cloth
collected into a pad between, to equalise and apply the
pressure. The leak can generally be found by the smell, if
the bag is filled with house-gas and pressure applied.

Definite leaks can be stopped in this way, especially such
as may be caused by mischievous boys sticking pins into a
bag; but when they get numerous it is a sign that the india-
rubber is worn out generally.

The cubic content of a wedge-shaped bag is of course
found by multiplying its three dimensions and taking half the
product; but the bulging of the bag when full, will add from
one to two feet more. A size $3 \times 2 \times 2$ feet will keep all
ordinary jets going in a bi-unial lantern for two hours, but is
not sufficient for the powerful jets presently described. To
be certain there is plenty of gas is a very great comfort; and
to be uncertain, very much the other thing.

Gas should never be kept in a bag any length of time.
Oxygen acts rapidly upon the material; but independently of
this, no gas can remain pure, owing to that wonderful process
of diffusion through the material which physicists call *osmosis*.
A bag filled with perfectly pure oxygen, will contain a portion
of air in some hours' time, and any bag tight in the morning
is perceptibly slackened by night. Supposing gas to be left
over one night, to any amount, there is no reason, if con-
venient, why it should not be kept, and merely filled up for
the next night; but beyond this gas should never be kept, or
the light will be perceptibly affected.

Bags keep best in a moderate temperature, both cold and

heat being injurious. I believe they wear out chiefly by the opening and shutting in turn *at the creases*, where leaks nearly always first occur. Hence they keep better, if convenient, laid flat between their boards, than if folded up, which makes extra creases to wear out. If they have to be folded to go on a shelf, as is usually the case, they should be folded once only as *loosely* as possible, the sides being tucked properly in. The taps should be left *open*. Whenever bags are stiff with cold, they should be softened by *gentle* warmth before use; the creases will rapidly wear through in a hardened bag.

The very large and heavy taps used by some makers are to be avoided, as are nozzles with a projecting rim on the end. A moderate nozzle, with fluting all round, either the same diameter or gently increasing back from the tip, is best. Most taps are, however, smaller than they should be in the bore. Few are more than $\frac{1}{4}$ inch in aperture, and they manifestly ought to be the same as the rubber tubing. This is a point really needing the attention of manufacturers.

Lock taps are made, to prevent accidental or wanton turning of the tap in transit. It would be much simpler to have a plain lever on the plug, instead of a thumb-piece, the lever being set parallel to the nozzle *when the tap is closed*. Then it could be simply bound round with the nozzle by some string, and would be safe. If there is no way of securing the tap, it is best to take a piece of rubber tubing which strains tightly on the nozzle, double over the end and tie tightly, so as to make an *outside* stopper, which is slipped on. Such precautions are only needed, of course, when full bags have to be taken about.

With a bag full of oxygen, the next step is to force this out with some regularity of pressure, to do which the bag is placed between a pair of pressure-boards, the top one of which is loaded with weights. In all forms of the lime-light with only one bag filled with oxygen, pretty much the same

pattern is used, as shown in fig. 26, which speaks for itself. It is only necessary to say, in case a pair of boards is home-made, that the pair must not come closer at the hinges than half-an-inch apart, to

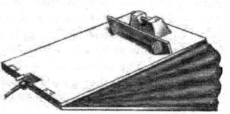

allow for the thick-ness of the bag when flattened. If this is not attended to, the boards will not shut, or use the last por-tion of the gas. In case of an emergency,

FIG. 26.—Bag in use

a bag has been ere now laid on the floor, and a black-board, or the ends of a couple of reversed forms, hinged down to the floor by two pairs of staples or hooks driven into floor and board respectively.

25. **Tubing.**—The best soft grey or red vulcanised tubing should be used; common harsh grey, or cheap red, spoils very soon. Tubing with spiral wire inside must be scrupu-lously avoided; the wire soon rusts, breaks, and chokes and perforates the tubing. There should be a clear $\frac{5}{16}$ bore for oxy-calcium jets, and not less than $\frac{3}{8}$ for high-pressure jets. The ordinary 'stout' thickness answers, but successive coilings after use generally twist and kink it up after a bit, especially the red. For anything like regular use, therefore, the cheapest in the end is good soft tubing of best quality and *double* thick-ness. Fig. 27 is an exact section of what I use. It is more than double the price of the common tube, owing to the weight of material; but there is immense wear in it, it never kinks, and it may be slipped on a nozzle in any posi-tion without choking the bore at a bend.

FIG. 27

Occasional extra long lengths of tubing are joined up by slipping the shorter pieces over the ends of a few inches of brass tube. All such pipes and nozzles should

make a *tight* fit with the tubing; but if there is any doubt about this, small strong vulcanised rings (of which the lanternist should always have some in his box) will make all secure. It is a better plan, however, for a travelling operator to carry some yards of compo gas-pipe for bringing up distant supplies of gas.

26. The Oxy-Spirit Jet.—All forms of the lime-light in which oxygen alone is used under pressure, are generally called the 'oxy-calcium' light. Of this there are two main forms. The first is where a fine jet of oxygen is blown through the flame of some volatile fluid, usually methylated spirit. This form of the lime-light was invented by Lieut. Drummond in 1826, and was formerly largely used, but is now chiefly employed in country villages where gas is still unprocurable. The present usual form of this jet is shown in fig. 28, where a cistern A B outside the lantern, adjustable on a rod by a clampscrew F, feeds the

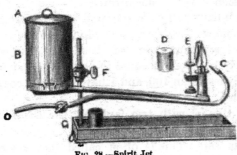

Fig. 28.—Spirit Jet

alcohol to a small circular wick, through the flame of which, almost non-luminous in itself, the oxygen is blown by a nipple c, pierced with a very small bore, on to a cylinder of lime D, which can be rotated on a spindle E, and adjusted at different distances from the flame. G is the stopcock to control the oxygen from o. A very good light, equal to a disc of twelve to fifteen feet in diameter, can be obtained in this way, provided the jet be adjusted as described (see § 28) a little farther on. If the cistern is arranged, as it generally is, outside, where it cannot be dangerously heated, no possible accident can occur with this jet except by upsetting the fluid. All the

surplus should be invariably poured back when the exhibition is closed.

Mr. S. Highley used to insist on the advantage of employing a double *flat* wick turned edgeways to the blast, trimmed or cut nearly to the slant of the latter, and the wicks a little separated, so that the oxygen blew up a little slanting trough of wick. I was never convinced of the benefit of this, and the ordinary jet is good enough for any of the places where it is ever used.

I do, however, believe that gain follows the adoption of Lieut. Drummond's original form of lime. He always used a small *spherical ball*, about ¾ inch in diameter, supported on a platinum wire. Heat is wasted on a large mass, which is utilised in incandescence when concentrated on a smaller fragment; and the small balls will bear very well for the requisite time the action of this weakest form of the lime-light.

What are called soft limes give the best light, and with average jets this may be taken as equal to about 120 standard candles. It is rarely less than 100, and I have known it coaxed to nearly 150 candles.

For the use of this jet with two lanterns, see *Dissolving Views*, § 56.

27. The Oxy-gas Jet.—This is often called the 'oxy-calcium' jet, and also the 'safety' jet, or the 'blow-through' jet. None of these names are distinctive, and I prefer that chosen, as indicating that oxygen is used with 'gas' from the ordinary meter supply.

The flow of house gas must be pretty free, and it seldom answers simply

FIG. 29.—Gas Nozzles

to slip the end of a rubber tube over the nipple of a common burner. In many halls there is a nozzle provided somewhere, specially for such purposes. If not, the nipple of a burner

is unscrewed with a pair of gas-pliers, when a gas-nozzle of one or the other pattern shown in fig. 29 (each of them being provided in both standard sizes of screw-thread) can be screwed in or on in a moment, and will give a good supply, with a nice descending start for the rubber-tube. A gas-flame being provided in this way, a jet of oxygen is then blown either through its centre, or across it. This jet must, therefore, have *two* gas-tubes, and be controlled by two taps.

The oxy-gas jet is used in four forms, the principles of which are shown in fig. 30. That marked A is most usual, a small stream of oxygen being blown *through* the centre of the flame from an open tube of gas, which it will be convenient to call ' hydrogen ' henceforth. No explosive mixture can

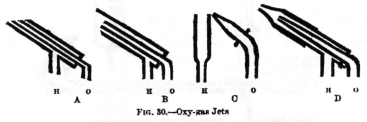

FIG. 30.—Oxy-gas Jets

take place with this jet, but when the oxygen has been turned off for a little time, the hydrogen may creep down the oxygen orifice a little, and cause a slight ' snap,' if the oxygen is turned on again suddenly. Very gradual turning on of the oxygen will avoid this, or a very small quantity of oxygen left on will do so.

The B form is the same, except that the oxygen terminates ¼ inch or more below the top edge of the hydrogen tube. Hence there is a little better mixture, and rather more light. This form is, however, a little more apt to ' snap ' out the light, if, after being off some time, it is turned on suddenly. A small supply of oxygen left on, or an oxygen ' bye-pass ' (see § 58), is almost necessary to avoid this with certainty. The general form of both these jets is shown in fig. 31, but the lime-turn-

ing movements described under the mixed jet are often applied to them.

The C form is less common. Here the hydrogen flame comes from an open perpendicular nozzle, and the oxygen is blown across it. This form of jet gives larger wings of hydrogen flame outside the jet which plays upon the lime, and consequently heats the lantern more; but it is impossible to 'snap' it, as the hydrogen cannot get down the oxygen tube.

In the D form, a dome with a smaller orifice contracts the hydrogen flame, through which the oxygen is blown. The

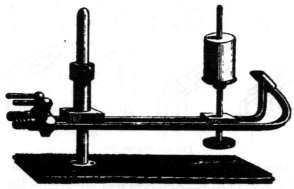

Fig. 31.—Oxy-gas Jet

consequence is a better mixture, a smaller flame, and when properly adjusted a better light; but this form, like A and B, is liable to 'snap' unless the oxygen has a bye-pass. Perhaps it can hardly be called absolutely a 'safety' jet, as it manifestly approaches somewhat to the 'mixed' character. It is barely conceivable that under some conditions a mixture might occur sufficient to cause a violent snap; but I never heard of such an accident occurring. This is probably the form that an experienced operator would prefer to use, for its more contracted flame and better light. The best form for a novice is C.

28. **Adjusting Oxy-gas Jets.**—These forms of jet will easily give 200 candles, and with care have reached 250 candles, and more. In many cases, however, they never give what they might for want of a proper adjustment, which is a matter of more nicety with them than with mixed-gas jets. The same remark applies to oxy-spirit jets, and the adjustment is practically the same in both cases.

The most general error is to use *too much weight on the bag.* It seems considered the correct thing to put on a 56-lb. weight in any case, but in many instances 28 lbs., or only a few lbs. beyond, will give a better light, and the too fast rush of the oxygen through the gently-emitted hydrogen actually cools the lime. The distance of the lime from the jet is also all-important. These points cannot be adjusted in the lantern, as every change in position there affects the *optical* adjustments also, and thus disguises the result as regards brilliance. The jet should therefore be taken out of the lantern, and placed so that its naked illuminating effect upon the screen or a wall can be seen. Then experiments should be deliberately made : first as to oxygen, and then as to the distance of the lime from the orifices. This will probably not differ much either way from half an inch ; but it will be found that an eighth of an inch will make a great difference. At each change in distance, however, it may be found that a different flow of the gases gives a better light *at that distance* ; and it has to be ascertained what distance, properly adjusted by tap and pressure for its proper flow of gas, gives the *best* light. That is the adjustment for this particular jet, and, once made, is made once for all. It is, therefore, worth while to take trouble over it.

What are sold as ' soft ' limes are best for oxy-gas as well as spirit jets, but ' excelsiors ' do also very well. The lime is little acted upon by the comparatively moderate heat, and a lime-spindle which can be turned by a milled-head underneath, as in fig. 31, will answer if economy is desired. But any of

the lime-turning movements presently described can be applied to them.

The jets next treated of can, with care, be also used as oxy-gas jets, as by-and-by mentioned.

29. The Mixed-gas Jet.—This term is often abbreviated into ' mixed ' jet, and signifies that the two gases are actually mixed in proper proportions before combustion at the orifice ; for in this jet there is but one, to which both gases in a mixed state are conveyed. It gives the most powerful and whitest light, in a smaller space ; and is easily reduced to any degree desired ; and for the same amount of light, uses less gas. It is, therefore, the form used in first-class lantern exhibitions, and gives far the most brilliant results in optical and physical experiments, while for high microscopic powers it is indispensable. There is a widespread notion that it is ' liable to explosion,' which has been partly fostered by the errors of opticians, and their mistaken so-called ' safety ' arrangements. But the conditions of safety are now well understood ; and while it is not a jet to be trusted—if, indeed, any jet ought to be—to the manipulation of clodhoppers, schoolboys, or absolute novices, with those who understand it the mixed jet is the most simple to manage and easy to control of any, and perfectly safe.

Both gases have to be used under approximately equal pressure, and the first arrangement employed was to mix pure hydrogen and oxygen, in the proper combining proportions, in one vessel, expelling the mixed gas through a minute orifice. It is often stated that this method gives the most brilliant light. That is a total mistake. No light was ever obtained in those days nearly equal to what is obtained now ; while the mistake led to a series of explosions which it was *impossible* to prevent with any certainty, and which gave the mixed-jet a bad character. Mr. Newman used a nipple of one-eightieth of an inch bore with success for some time ; but directly he changed it for one slightly larger—about

E 2

one-sixtieth of an inch—his reservoir burst like a bomb. Hemming packed a tube with fine wires, on Davy's principle; and a series of layers of fine wire gauze was also tried; finally the gases were bubbled through a water-chamber. Sooner or later the gases thus mixed exploded through them all.

As a matter of fact, the gases *are not burnt in a jet in their combining proportions*, when properly adjusted by the taps for the most brilliant light ; nor is the available heat developed what was once supposed. The heat-energy liberated by the combination of H and O_2 into water, can be calculated easily ; but no sooner is water formed, than a considerable portion of. that energy is absorbed in again dissociating it. A certain amount of mechanical *current*, conveying the gases to a certain *distance* away from the orifice, may and does, therefore, increase the effective heat, as does a certain amount of external free hydrogen flame, which aids in the same object of carrying the water away in vapour.

Even now it is almost impossible to burn either pure hydrogen or carburetted hydrogen (house-gas), and oxygen, *in their combining proportions*, without explosion, though with modern apparatus this latter will be only the '.snap' of a small and harmless explosion in the jet-chamber itself. Take any mixed jet, and gradually turn on the oxygen ; almost invariably, just as the surplus flame of the hydrogen is absorbed, *the jet will snap and go out*. Before this, the light will have diminished considerably ; and it will be found that the most brilliant light is always obtained with a considerable surplus of the hydrogen. That surplus is greater as the bore of the nipple is larger ; and those manuals are wrong which state that the gases are burnt ' in equal volumes.' With large orifices, nearly ten feet of house-gas may be required for eight feet of oxygen, and it will be found that at the best light there is always a loose flame of hydrogen playing about the lime. With this increase of hydrogen from

the larger bore, the distance of the lime must also be in-
creased, to get the best result ; so that whereas a small bore
may do best with the lime almost close to the metal, a large
bore may require a clear space of an eighth of an inch (or a
quarter of an inch measured in the oblique line of the jet)
from the centre of the orifice to the lime.

The first step to safety was therefore to store the two gases
in separate bags, when the quantities could be adjusted
according *to the light itself*. The mixture at the back of the
nipple became, while the light was better, far less explosive ;
so that a moderate speed of exit would prevent a ' pass-back '
of the flame. Explosions at once became rarer, and confined
to accidents or carelessness. For instance, it was usual in
those expensive days of chemicals, to keep unused gas in the
bags ; and if any bag should be filled up *with the wrong gas*,
it is easy to fancy the result. Even recently a fatal explo-
sion at a theatre was traced to this cause. A mistake of this
kind is inexcusable ; and if the reader cannot trust himself
never to make such, he should not meddle with oxygen in
bags at all. The two bags may be of different colours, or, if
both are black, the tap of the hydrogen-bag should be
coloured, or a large H and O should be painted on the bags.

Another danger was found from the liability to unequal
pressure on two bags, as it was usual to place each in a pair
of pressure-boards like fig. 26. Fire-irons and fenders were
often used as weights, or a lad might be asked to sit upon the
top board. Hence there was a danger of the gas under
greatest pressure, sent to the nipple faster than it could
escape, being driven back so as to gradually mix with the
other gas under less pressure. Every alteration of the weight
on a bag was thus a precarious experiment, and occasional
explosions were practical proofs of the necessity to start with
the bags about equally full, and under equal pressure, and to
keep them so to the end. For the pressure of gas differs a
great deal as the bag gradually discharges, and it is of im-

portance that the reader should understand this, and the terms in which pressure is described.

Pressure is stated as so many 'inches'; meaning of water. This is measured very simply by what is called a U-tube, shown in fig. 32. A glass tube is bent into U form, deep enough to measure any pressure likely to be met with—say eighteen inches from the top to the bend. One end is corked, with a bit of tube passing through the cork on which can be stretched a vulcanised tube from the bag; and a scale of inches is drawn between the legs of the U, measured from a zero-line across the centre. Water is poured in at the open end till it stands level at the zero-line. Then the tap from the bag is opened, and the pressure sends down the water in that arm of the U, driving it up the other by an equal amount; and the *difference* of levels is the *pressure* of the gas. House-gas in London is generally rather under two inches, *i.e.* it drives the water down 1 inch on one side, and up the other. A gas-bag of 36 × 24 × 24 size, under 1 cwt. pressure, when drum-tight, may have almost any pressure, as the tension of the bag is added; but when this is gone off after a few minutes, the pressure is usually about 9 inches; when the bag is about three-quarters empty, this is generally gone down to about 4½ or 5 inches.

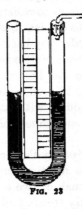

FIG. 23

It will show the kind of danger to be guarded against, to describe the only explosion—a very slight one—which ever happened to myself, almost at the beginning of many years' use of the mixed jet. I was using up half a bag of oxygen in determining a ticklish experiment, and had filled the coal-gas bag considerably too full in proportion, so that it was quite one third full when the oxygen was nearly exhausted. Absorbed in the experiment, I did not notice that the board was practically 'down' upon the flattened oxygen

bag, and unconsciously kept balancing the decrease of oxygen by turning off the hydrogen tap, to keep at its best the waning light, when—bang! There was an explosion almost as loud as a pistol-shot in the nearly empty oxygen bag, rolling off the weights on to the floor, and tearing the boards apart at the hinges. There being hardly any oxygen pressure to resist, the hydrogen had gradually forced itself back into the last few cubic inches of oxygen; and as there was hardly any back-pressure at the nipple to resist a 'pass-back,' the result was the explosion. Owing to the small quantity in the bag, no other damage was done, the bag itself not being injured, and being often used afterwards; it expanded enough without rupture, only the hinges giving way from the suddenness of the shock.

Lesson.—Never work a bag down quite empty with the mixed jet. Observe how low the boards come down when empty, and always leave off while there is an inch or two to spare. Also, *so soon as you have to be frequently turning off the tap of one of the gases at the jet* to restore a fast decreasing light, it is a proof that the pressure is diminishing rapidly in the other bag; if you go on, mixture may occur, and it is time to stop. With decently competent management in other respects, this is the grand rule of safety, but I have never seen it stated in any lantern manual.

80. **Double Pressure-Boards.**—To resume practical details, the last step to safety was the abolition of all difference in weights by the use of *double* pressure-boards as shown in fig. 38. By this arrangement one bag is placed over the other, under the *same* weights, and it no longer matters what these weights are, so long as they are sufficient to keep up pressure.

In making these boards, the hinged ends of the two outside ones must be wider apart. The two bags are not placed in contact, because full bags would slip; but either a middle board, or a piece of stiff sail-cloth is connected to the

hinged end, and extends between the boards as shown. They are often made on what is called the 'skeleton' plan, for lightness in travelling; a mere framework being covered either with a trellis of thin hoop-iron, or with a sacking laced up as old-fashioned bedsteads used to be. Solid boards, however, need not be much heavier, are much cheaper, and for home or at an institution are to be preferred; in the latter case they should be made with a flat board between. When a piece of canvas is used to separate the bags, it is best to pass a buckled strap round the back of the bags from top to bottom, to pre-

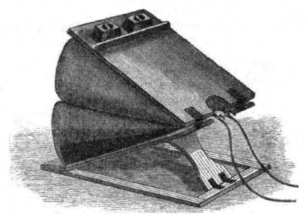

FIG. 33.- Double Boards

vent them slipping backwards till the bags have flattened out a little, after which there is no tendency to this. A pair with a board between needs no straps.

It is necessary to raise the front or hinged ends of the boards considerably while the bags are full, or the top will be too steep for the weights to press upon. From this arises a risk, not of explosion, but of a vexatious accident which has been known to occur. The middle board must be nearly level with full bags, as in fig. 34, and it will be seen that in this position the weights w are supported well at c within the

base-line A B. But when the bags have worked down as in
fig. 35, the weights are farther back in proportion, and so
far as the back edge of the bottom board is concerned, *over-
hang the base.* If this is not provided for, the weights may
therefore tip up the whole concern backwards, and roll off,
when there will be sudden darkness and a serious fright,
though no further accident could happen unless there had
been mixture in one of the bags; if there had, of course the
removal of pressure would produce an immediate explosion.
I never heard of this latter happening; but of the other I
have, and it is unpleasant enough.

The boards must therefore be let down on the floor when

FIG. 34 FIG. 35

the bags are about half emptied, or else the 'base' must be
so lengthened behind the back of the bottom board, as to
guard against all danger. It is quite easy to do either.
Solid boards are generally made without any separate base,
for simplicity, a support being hinged to the front at A, fig. 36,
which may be a pair of light legs with a connecting strip.
Then a stretcher-bar, s, may be hinged near the back end of
the lower board at B, resting on the cross-piece connecting
the two legs; and if a hole in the end of the stretcher drops
over a wire pin projecting from the cross-piece, at C, it is
impossible for the legs to slip from under the boards. When

half empty, the stretcher is lifted off the pin with the toe, and the front end of the board being gently lifted (there is hardly any weight on this end) the legs can be pushed back underneath in the same way, and the front gently lowered on to the ground.

Skeleton boards are usually made with a base as in figs. 88 and 37, the legs or support being hinged to the front of this at B, and also to a point some distance back at A, on the under side of the bottom board. When the front is elevated, this arrangement brings the back of the bottom board forward to C, where it is kept from slipping back by iron pegs slipped into a hole at each side. The base extending back to D, provides security against an overturn ; when half empty the pegs

FIG. 36 FIG. 37

are withdrawn by an assistant, and the boards gently lowered and slid back.

To get a good light (and it is also an element of safety) fair pressure must be used. On a small screen a sufficient light may often be had with 56 lbs., adding another towards the close. But for a large disc, a pair of bags $86 \times 24 \times 24$ will require two $\frac{1}{2}$ cwts. to begin, and a third to finish with ; and larger bags—say 42×32, for larger orifices, will need three such weights to begin, and a fourth to finish. If gas is no object, even more may be used with gain to the light, but not in proportion. I believe the profitable limit to lie, *with proper jets*, somewhere between 12 and 15 inches pressure. Of course, if jets are used with a lot of so-called

' safety packing,' it is impossible to say what pressure may be needed to drive the gas through them.

81. **Safety arrangements.**—This brings us to the most important point. *The one, the sufficient, and the only security* for safety with the mixed jet, is the certainty of pure unmixed gases in the bags to start with, and next, a good and fairly equal pressure on both bags, with sufficiently free vent at the nipple of the jet to make sure the gases shall *always be flowing outwards*. This is simple, easily understood, and, when understood, easily carried out. *No other safety arrangement can be depended upon*, and if it is depended upon, to the prejudice of proper management in these respects, may be even worse than useless. Self-acting valves which allowed passage outwards, but not back, were soon invented, and are still sold. I am not prepared to say that they are inoperative, for there is evidence that, *experimentally*, they have prevented explosions which otherwise must have occurred. But such arranged ' experiments ' rarely represent the conditions of unforeseen accidents ; and such occurred more than once in spite of these valves. They also obstruct the flow of gas, which is one safeguard. But the real mischief is, that people who use these things usually *depend* upon them ; and that means real danger. Packings of gauze in the jet are absolutely useless, if the gas behind is in a really explosive condition. The packing of granulated pumice presently described is indeed a real stop to explosion, so long as it is in order ; but it checks pressure materially, and a few ' snaps ' in front of it may so disarrange and alter it by repeated shocks, as to render it useless. With the double pressure-boards, a cool and intelligent operator ensures that explosive conditions *cannot occur*, and that alone is true safety.

82. **Forms of the Mixed Jet.**—This brings us to the forms procurable of the mixed gas jet, its faults and difficulties, and the construction which will give the best results. Daniel's form, one of the first made, resembled the blow-through jet D

of fig. 30, except that the outer orifice was contracted to a small aperture. It gave a fair light for those days, and is used now sometimes, but the mixture almost at the very orifice generally causes a whistling when much light is attempted. The jet next introduced, and still very often seen, had a plain lime-spindle like fig. 31, but the two gas-tubes were conducted side by side into a chamber, packed with layers of gauze. This gauze is always getting rusty and obstructed, to the detriment of the light, and actual increase of the danger of mixing behind; and it is unpleasant for both operator and audience to be obliged to be continually opening the lantern door to turn the lime round with the fingers.

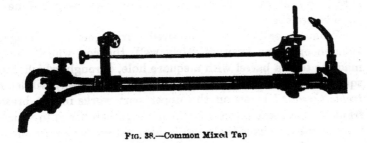

FIG. 38.—Common Mixed Tap

For under the greater heat and stronger blast of the mixed jet, even 'hard' limes are rapidly burnt into holes, or 'pitted' as it is called; and a fresh surface must be exposed to it every few minutes, or the blast may be reflected back from the concavity on to the condenser, and crack the lens. Hence a cogged lime-turning movement was speedily introduced, resembling fig. 38, by which the lime can be rotated from the back of the lantern. This is the common trade jet of the present day, and will answer fairly well for small apertures, say up to 1 mm. diameter, if the gauze is removed, or only one piece left in the chamber. The mixing-chamber usually found is however too small for a really powerful light; and as the circular plate which supports the lime is simply

rotated by the cog-movement on a screwed pin, it not only has a tendency to stick fast, but it scarcely rises with an entire revolution, and the movement has to be continued for many rapid revolutions to bring a fresh ring of the lime surface into play. Hence a good ' blow-through,' or oxy-gas jet, will often equal the light of such a mixed jet. The performance can be greatly improved by clearing out the gauze to leave a free passage, and attending to the jet as presently described. But more than 350 candles can scarcely be got from such jets, and with this gain in power the inconvenience of adjusting the lime becomes much greater, as it has to be oftener made. A good lime-turning movement should *raise* the lime sufficiently, at every revolution, to bring the required new zone before the jet.

What is called the 'improved' arrangement amongst London opticians answers fairly well, the cog wheel being made to turn a barrel with a square hole, through which the squared lower end of the lime spindle slides freely, whilst a *treble-threaded* screw on the upper part works in the brass frame of the combination. The mixing-chamber into which the gas-tubes deliver the gases is also rather larger in these jets, which can often be made to give a very good light, especially by taking out the gauze. If they do not, or if more light is desired, or if, as is often the case, they whistle or roar under good pressure, they must be attended to, and it is always worth while to spend a little trouble over a well-made jet. The tap-plugs should be taken out to see that they are not choked by tallow, as is sometimes the case. Whistling or roaring is generally due to some roughness in the nipple, or end of the tube bearing it. To remove this the nipple should be taken off, and a watchmaker's broach twirled round in it, which will smooth out the bore itself; and any roughness in the larger bore below, or at the end of the tube, should also be cleaned down with a tapered steel rimer. Finally a steel needle should be taken, rather smaller than the bore, and twirled well between

coarse emery cloth pinched upon it with finger and thumb ; this will surround the needle with circular scratches, making it in fact into a fine round file, to be carefully used inside the bore, by which the latter can be made as smooth as glass. This will in most cases stop the noise. If more light is wanted, we must *burn more gas* to get it, and the bore may be enlarged with the broach to any size desired, before polishing, if the jet will allow, for it will be found that a certain chamber will only allow of a certain size of bore without noise.

In making systematic experiments as to the light possible from the oxy-hydrogen jet, I found, therefore, that it was essential to employ a larger chamber if it was desired to use a really large bore. And with any jet which has a large chamber, let us suppose it is a circular cavity $\frac{3}{4}$ inch in diameter and the same in depth, a large bore may be used. Very likely, however, after all has been done to clear and polish the nipple, there may still be noise, and this is generally due to *eddies* in the gases caused by the form of the chamber. This will probably be as in fig. 39, and the sharp corners at A B cause the noise. By tapering off these, especially at B, as shown by the same letters in fig. 40, silence will generally be procured, and this is, therefore, the chamber I have adopted for my mixed gas-jets. With it there is no difficulty in employing nipples $\frac{1}{15}$ of an inch in bore, beyond which there appears little, if any, gain in light. Such a chamber and nipple will easily reach 700 candles with the photometer, and over 800 has been recorded.

FIG. 39 FIG. 40

The outside of the nipple, however, also claims attention.

With most of the jets commonly sold it is far too thick and clumsy at the tip. Such a thick end positively obstructs the light from the lime, and by preventing the smooth access of air to the outside of the flame, it further diminishes the power of the jet. The nipple should, therefore, be carefully tapered down to a thin edge. Small bores up to $\frac{1}{20}$ inch can be tipped with platinum, though this is not necessary ; but with large bores, unless the platinum is carried over $\frac{1}{2}$ an inch down, the brass will be melted away from it. For large bores *solid plain brass* nipples are therefore best. It is well to have at least two nipples of different sizes, and they should screw on so nicely as to be gas-tight without cement, for interchange when desired.

After all possible pains, a powerful jet such as above described, will sometimes ' sing.' In that case it can usually be quieted by dropping a wire ring on the bottom of the chamber, laying on that a disc of perforated zinc cut to fit the chamber, and keeping that down in place by another ring, cut so as to spring tightly. But the best arrangement of all I have found to consist in a few alternations of thin discs pierced as fig. 41, separated by rings, as devised by Mr. Lancaster. With a chamber properly tapered at top and bottom, as shown, this is quiet under any reasonable pressure, and gives a perfect mixture and a powerful light, which can sometimes be pushed as high as 1,000 candles. After exhaustive trial of many experimental chambers most carefully made for me by Messrs. Newton, this is the form I have finally adopted as the best.

FIG. 41

It must be clearly understood that the object of this packing is not ' safety,' which is never ensured by such means, but solely a *quiet and thorough mixture* of gas in the chamber.

If the empty chamber will work quietly, it is 'nearly as good. Either is *a true safety arrangement*, because if by any carelessness an explosive mixture did occur, it would occur *first in the chamber*, which would ' snap ' the jet out at once.

I only know one other experimenter who has systematically investigated the increase of power in jets. I refer to Mr.

Albert W. Scott. After various experiments, he finally made the nipple itself into a chamber, as in fig. 42. The two gases meet in one supply aperture, C, which is plugged by a stopper pierced with several holes $\frac{1}{16}$ inch diameter ; the gas thus enters the nipple chamber in several small streams. His nipple first enlarges as at B in a conical shape for $\frac{3}{4}$ inch in length, till $\frac{3}{8}$ inch in diameter ; it then again contracts more gradually through a length, A, of $2\frac{1}{2}$ inches to the orifice. It will be seen that the general principle is much the same as in my chamber, tapered at top and bottom. Such agreement is practical proof of the truth of our conclusions as to the best general construction for the mixing portions of the jet. I do not, however, find that Mr. Scott's form gives such a *silent blast* as the larger mixing chamber figured above, or so powerful a light.

Fig. 42

The best lime-turning movement, in my opinion, for practical work, of all that have come under my notice, is that shown in fig. 43, which was originally devised by Mr. J. Place. The long steel spindle has a longitudinal groove cut, which slides up or down over a feather in the cogwheel ; and there is also a long-pitched spiral groove which gives the required motion. To this Mr. Newton has added a small wheel on the manual rod, in which notches are cut at proper intervals. A spring detent bears against these notches, so that the exact spot at which the lime should be held is

felt by an almost imperceptible click. The whole lime is thus traversed in one continuous spiral from top to bottom, each halting-spot on the surface being exactly marked out. The whole jet is shown in proportion, with the further addition of a ' cut-off ' arrangement devised by Mr. A. Pringle, in fig. 65, p. 118.

Mr. E. G. Wood has also constructed a jet with a click or check mechanism, so arranged, that when a second revolution of the lime takes place, the places where the jet impinges are half-way between those of the previous revolution. In this

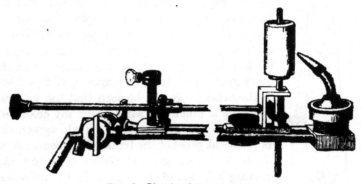

Fig. 43.—Lime-turning arrangement

way less perpendicular motion of the lime becomes necessary. There is another screw motion, with a separate handle, for adjusting the distance of the lime from the jet. The jet itself is packed with gauze, and the tube and nipple are bent like an elbow, which Mr. Wood considers to produce a better mixture of the gases. As will be seen, my experiments—and they have been long and many—have led me to a different conclusion on this point, and moreover such nipples cannot conveniently be employed of different sizes, which is very desirable. The lime-turning movement is, however, ingenious and good, and this jet would doubtless be more widely used

F

were it not for its cost, which is more than double that of the preceding.

Mr. Wood has further applied to his jet a shield or jacket of copper surrounding the lime at a little distance, except a space cut out in front for the play of the jet and for radiation, which he strongly recommends as increasing the light (by confining the heat), keeping the lantern cool, and avoiding cracking of the lenses. There does appear to me a perceptible gain in the two latter points ; but I am unable to trace the least gain in light, and the copper hinders the state of the lime from being seen through the side of the lantern. The shield can be applied to any jet by such as desire it.

88. Attachment and Fixing of Jets.—The figures already given show the principal methods of adjusting and fixing jets in the lantern. Far the most common is a tray of thin sheet-iron or stout tin, as shown in fig. 28, from the back end of which stands up a steel rod, over which the socket of the jet slips and can be secured in any position by a screw. The edges of the tray slide backwards and forwards in guides, so as to draw back the jet to any distance from the condensers. The sliding adjustment has to be rather loose, and with the view of obtaining more accurate motion in the line of the optic axis, many opticians mount the rod on a wooden board of mahogany, as in fig. 81, and I have also seen a jet mounted to slide along tubes. I find that wood, however carefully seasoned, is very uncertain in its behaviour in any but a single or bottom lantern, owing to the heat ; hence, metal plates with dove-tailed edges are better. My own opinion is, however, that the slight amount of freedom or ' play ' in the ordinary tray is, for ordinary work, an advantage, facilitating ready adjustment of the light.

I also prefer myself, for common exhibition work, to have no fixing of the jet whatever, beyond one screw to pinch on the rod. Many think differently, and various opticians make their jets with a fork-piece projecting sideways from the front

end. Then, by having a perpendicular screw fixed in the board or tray, on which two milled flange nuts screw up or down, embracing the fork between them, the front part of the jet can be easily fixed in any position, either perpendicularly or sideways. This can be applied for five shillings to any jet. For those who prefer it, opticians have also fitted jets like a compound slide-rest, with vertical and two horizontal screw movements. These are useful for optical or microscopical work, but for plain lantern-work worse than useless. The clamp-screw of the jet is not, however, put in the right place by most opticians. It is best near the *bottom* of the socket, instead of near the top, as usual, where the very act of tightening the screw alters the adjustment. At the bottom, tightening the screw has not this effect.

I have never found much trouble in fastening the jet with a single screw in the socket. But if there is any, it can be effectually overcome by an expedient pointed out years ago by Mr. Samuel Highley, of *filing a flat* (fig. 44) on the opposite side of the rod to that on which the screw acts. Just the sharp edges of the flat must, however, be filed off slightly, or they will score the brass socket and hinder adjustment.

FIG. 44

84. **Inclination of the Nipple.**—For slides the nipple should make an angle of 40° to 45° with surface of the lime. For optical work, or for the microscope, where the jet has to be brought nearer the condensers, about 85° is better, or the nipple will cast a shadow on the lower part of the condenser. Both to avoid this, and also because there is a perceptible gain in light, the supporting rod, and consequently the lime, should be *inclined forwards* about 20° from the perpendicular. This both brings more luminous rays to bear, and takes the nipple still more out of the way, and the gain of light is very perceptible.

It will be seen that there is a great deal to be attended to

before we can obtain the greatest illumination the lime-light is capable of affording. These hints are the result of long and sedulous attempts in that direction, with a view especially to microscopic projection. There will remain still what scientific observers term 'personal equation.' With the very same apparatus, two men will not get precisely equal results. I have always found that if unusually fatigued, I could never myself get the same light, by a perceptible quantity. A steady and delicate hand in adjusting the taps has much to do with this, and there are differences in this respect between different people.

85. **Limes.**—While very soft 'chalk' limes give rather a better light with oxy-calcium jets, the very hardest are needed for the mixed. 'Nottingham' and 'Excelsior' limes are both well known. Both vary somewhat in quality; the best of both are excellent, but the Excelsiors are apt to crack across under powerful jets. The other does not, but only lately has the so-called 'Nottingham' lime (which really I believe comes from Ireland) been obtainable turned true, and this for some work is essential.

86. **Substitutes for Limes.**—Many attempts have been made to avoid the turning necessitated by the pitting of the lime. Magnesium oxide made into a paste with water, dried, and then exposed to gradually increasing heat, is said by Dr. Roux to stand the jet for hours; but he cannot have used jets of much power, for I find no superiority whatever over lime, though the light is very fair. A mixture of calcium sulphate and magnesium oxide, which has been recommended, is no harder, but I have sometimes thought either this or the former might behave better if silicated by mixing with solution of some silicate instead of water.

The only material hitherto used which really stands the jet is zirconium oxide. This was stated many years ago by M. Du Motay to be 'the most luminous' as well as most refractory of all substances, and the statement has been

repeated by subsequent writers. Were it only true, all diffi-
culties would be solved; but I am sorry to have to dispel
such expectations, after frequent and exhaustive experiments,
as regards any zirconia hitherto commercially obtainable.
My own hopes were high after reading the opinion of the late
Dr. Draper of New York,[1] that zirconia equalled lime in
'intrinsic brilliancy;' but I can only come to the conclusion
that neither he nor Continental physicists who have so praised
it, ever really knew what a good light is, as I understand it.
I have tested three different zirconia samples of English
manufacture, and three of Continental (including one from
Schuckardt of Görlitz, stated to be prepared especially for the
lantern). The result was the same in all—the light was
distinctly reddish in colour, and *far inferior* to that of a
lime cylinder with the same jet. Mr. H. G. Madan was kind
enough to test the matter photometrically, with the result
that the best of these zirconias only gave a light of 1 : 2·88
compared with lime. I have since ascertained that Du
Motay's own pencils really gave about the same results.

Zirconia does decidedly better when used in very thin
discs, instead of the jet playing on the end of a cylinder;
for it is most extraordinary for its non-conducting power,
and the most powerful jet will only illuminate a small surface
and for a small depth in the pure material. The best
substitutes for limes I have been able to obtain by pur-
chase are a mixture of zirconia with a small quantity of
some other substance—probably alumina—prepared under
the superintendence of Dr. Linnemann by Smith and Hænsch,
of 4, Stallschreiber-Strasse, Berlin, in discs about $\frac{3}{8}$ in. in
diameter and $\frac{1}{12}$ in. thick, held in platinum capsules mounted
at the end of a brass rod. The light is not equal to that of
lime, but is very fair, and nearly *white*. The discs will stand
a great deal of work, and are very convenient for many pur-

[1] Dr. Draper's own process for purifying zirconia, and his observations on
its use, will be found in the *American Journal of Science*, xiv. 208.

poses. They are sold in the capsules at 10s. each. For long experiments I have found them very acceptable, in spite of their inferiority in illuminating power.

· Only very recently, in fact since the above paragraphs (which have been modified in consequence) were actually in type, in a more pronounced form my hopes have been revived. Observing in a paper [1] by Mr. G. H. Bailey, D.Sc., of Owens College, that his purest zirconias prepared for other purposes, were distinguished by luminosity and a slight *bluish* tinge in the incandescence, I communicated with him, and he was so kind as to send me three separate samples, weighing 12, 15, and 18 grains respectively. There were difficulties in the manipulation, chiefly from shrinkage when first ignited, which have prevented me (by premature breaking up) from as yet ascertaining the full incandescence of these samples; but I found them all absolutely free from any trace of silica ' glaze,' and satisfied myself completely that the light was in truth perfectly white (if anything slightly bluish) and far superior in quantity to that of any previous zirconias I had obtained. I also proved unmistakably that the incandescence of this material was much superior when the small thin disc is only supported by a thin *ring* of platinum, to that when the sample was mounted in one of the above-named capsules emptied for the occasion. Such discs, about $\frac{1}{2}$-inch in diameter (more is useless) will each require about 1 gramme or 15 grains of zirconia, previously calcined in the heat of the OH flame itself to complete the shrinkage.

Provided therefore that samples of zirconia of approximately equal purity to these can be supplied at any price commercially practicable, the material does hold out hopes. The real difficulty is to *entirely* get rid of the silica, and these specimens alone, of all I have had, showed no trace of glaze after heating. As already stated, my own experiments are not yet completed, and it remains still to be ascertained how

[1] See *Proc. Royal Society*, xlvi. 74.

far it may be possible to supply such material; but as the subject has occupied my own attention for years, and has also interested others, I have thought it better to give, however briefly and imperfectly, the very latest information I have regarding it.

37. **Management.**—We will now suppose the two bags full, and all apparatus ready at hand. The first step is to place the bags in the boards, and it is best to place the *oxygen at the bottom*. This is the direct opposite of the usual direction, but I am certain of its correctness. It ensures a shade more weight (that of the top bag and board) on the oxygen, and the result is, that if any change in adjustment of the gases does take place unnoticed, it will probably be in the direction of too much oxygen, which will snap the jet, put the light out, and so give notice. Then the weights are placed on, and if necessary *tied* on, the vulcanised tubes connected with the jet-nozzles (dissolving and cut-off taps will be described in Chapter VIII.), and *both taps of the jet turned off*. Generally the two taps will be different colours, or one will have a hole through the thumb handle; if not, care should be taken that *the same side be always used for the oxygen*, in order that the hand may always go to the proper tap by instinct.

A lime should now be placed upon the pin, first clearing out the hole from dust by turning a match round in it, and wiping off all loose powder by a good rub with the tissue-paper in which it was wrapped. For handling limes, and especially for removing a used-up or cracked

Fig. 45.—Lime-tongs

one, the lime-tongs shown in fig. 45, made by bending a strip of sheet-brass, will be found very convenient.

Both bag-taps are now turned on, and the hydrogen jet-tap may be turned on a little and lighted, giving flame enough

to play gently rather more than up the lime, which is to be slowly turned round a minute or so to warm through. Then turn on rather more hydrogen—say about half—and a *very little* oxygen; just enough to slightly diminish the flame, and increase the heat, so that the lime is *heated red-hot* easily. The whole lime is again carefully subjected to this heat, which is a great security against cracking. More oxygen can now be turned on; then as much hydrogen as it is intended to use (full, if the extreme light be desired), and finally the oxygen is turned on until the best light is obtained. It will be found that the merest hair's-breadth of adjustment will make a difference, and the taps should, therefore, always be kept nicely fitted, and lubricated with a *very* little tallow (unsalted) or sperm oil. A powerful jet generally 'roars' till the oxygen is adjusted, but quiets when the two are in proportion.

The best light is not obtained till the jet has played upon the same spot for half a minute or so; after that it remains very steady for a couple of minutes. Then, as the cavity deepens, it deteriorates; and if kept too long on a deep pit, the flame may be reflected back again, and crack the condenser. Some limes will stand many minutes; and when a box is found very good, it is well to keep it for particular occasions.

With the bags in proportion—that is, hydrogen about five volumes to four of oxygen—and equally full, the taps will scarcely need any subsequent alteration; but if the light does go down a little, the necessary adjustment must be made from time to time. At the close, or if anything goes wrong, let the first thing be to *turn off the oxygen*; and cultivate from the first a fixed, invariable habit of doing this. Remember, also, when the bags are half empty, to let down the boards as already described.

At the close of all, see that the *jet is out* and the bag-taps turned off before removing the rubber supply-pipes from the lantern nipples; else possibly the light might remain long

enough to ignite the stream of gas, which for a moment would probably be directed towards the lantern. I once knew this happen, and should such a flame reach an *oxygen* bag with any quantity of gas in it, the result would probably be a combustion of the bag itself so furious as to be almost explosive, and highly dangerous.

With care the mixed jet can easily be used with only oxygen in a bag, and gas from the main, instead of employing an oxy-gas jet. In this case the bag must be lightly weighted —only fifty-six pounds being placed on. I often use the jet thus in experiments; but it should only be thus used by experienced persons.

CHAPTER V

PREPARATION OF GASES

88. Hydrogen.—It is unadvisable to make this gas. It has been often stated to give a better light, but careful experiments made at the old Polytechnic proved that this was a delusion, even with similar-sized nipples. No difference could be perceived; and double the quantity of oxygen is needed, besides the expense of the hydrogen. A bag of gas can easily be sent by rail, if necessary; or a bottle of compressed coal-gas, at the present low prices, will be less trouble and cheaper than making pure hydrogen, besides saving half the oxygen. There are also the oxy-spirit jet, and the oxy-ether and oxy-carbon lights (Chapter VII.) to fall back upon. There are however a few out-of-the-way places where it may be necessary to use hydrogen for lack of other materials.

A glass bottle may be used as a generator, but a leaden one is more usual. It is furnished with a movable cap, bearing a long tube reaching nearly to the bottom and with a funnel at the top, and a delivery-tube coming from the cap; the general arrangement resembling an ordinary wash-bottle, or

as in fig. 49, which would answer very well with a funnel at
the top of the long tube. Care must be taken that the top
is air-tight. Into the retort is introduced about half a pound
of granulated or scrap zinc, and through the funnel is then
poured about a pint of dilute sulphuric acid ; about one· part
of acid to six or seven of water. This should be previously
mixed, to avoid heat in the retort. The gas as it comes over
is passed through one wash-bottle (§ 42) about half full of
water, as in washing oxygen ; but great care must be taken
that all atmospheric air is allowed to escape. To ascertain
this, a light is applied to the gas, which should take fire ; but
to avoid explosion, a piece of rather fine wire gauze should
be bent into a kind of loose cap, and held over the end of the
delivery tube. When the gas inflames quietly, the bag is
connected up as usual, turning on the tap at the same
moment. If the evolution of gas fails before the bag is full,
a little more acid may be poured down through the funnel :
or if done very gradually the acid may be added from the
first in this way. Any metallic zinc left may be preserved
for the next occasion. In turning off the bag-tap when full,
the very next moment remove the delivery-tube ; but be
careful it does not discharge near any light.

Should zinc not be obtainable, clean iron filings, or small
nails, may be used instead and in the same way.

89. Oxygen.—Till lately oxygen gas was universally pre-
pared by every habitual user for his own requirements, and
so much is still made from chlorate of potash that it is
necessary to describe the best methods of managing that
process. It has been stigmatised as dangerous, but is not
at all so when properly conducted. There are certain *possible*
dangers, it is true ; but, guarding against these, the operator
may proceed with perfect confidence.

The only practical method of preparing individual supplies
of oxygen consists in heating over a furnace a mixture of
potassic chlorate and manganese black oxide ; or in lieu of

the latter, which only acts mechanically, some use fine washed sand, or even red oxide of iron, to avoid a possible danger lurking in the black colour of the manganese, which has been known to be adulterated with powdered charcoal. Should this be the case, the carbon would probably ignite with the heat, and, burning in the evolving oxygen with explosive violence, produce what may be called a *carbon* explosion in the retort. A similar explosion once occurred when the manganese had become, not adulterated, but accidentally mixed, with antimony sulphide. From a known source, no dread need be felt; but in case of doubt a drachm of the mixture should be placed in a dry test-tube and heated over a Bunsen burner. It will always crackle, and a few tiny sparks may be seen; but if *large and bright* sparks appear, or anything like a small explosion be heard, it should be rejected.

Any sand or iron oxide, if these are substituted, should be known to be perfectly cleaned. Of the chlorate itself, the common commercial quality is quite pure enough; but for similar reasons, every parcel purchased should be spread out upon a large sheet of the *Times*, and any bits of wood or straw carefully picked out, should any such be visible.

40. **The Oxygen Retort.**—The mixture—of which immediately—must be placed in a retort, of which three kinds are sold. First, a copper one, the dearest to buy and the worst to wear of any. Secondly, a conical flat-bottomed one of sheet iron (fig. 46), which is perhaps the most usual, and fairly durable. It should have a safety-tube at the top, in which a cork can be placed, as well as the delivery-tube. This latter should be of a good diameter, as a certain quantity of the powdered manganese is carried up into it by the rapidly evolving gas, and a small tube might choke, when too great a rush of gas might produce a sort of mild *confined pressure* explosion. The cork in the safety-tube will sufficiently guard against this, blowing out if necessary and letting the gas escape; and there is no fear if the delivery-tube is examined after every operation,

and, if necessary, an iron rod passed right through it, and any manganese that may have collected cleared out. By attending to this, I used for years delivery-tubes composed of half-inch gas-pipe, but three-quarters would be a better size, and even this should be examined.

Fig. 46. Oxygen Retorts Fig. 47.

The third kind of retort is of cast iron, made of various shapes, such as fig. 47. I have also known a small Papin digester fitted as one. Cast iron is most durable of all, and such are usually fitted with very large delivery-tubes; but the greater thickness of metal requires more heat.

41. The Mixture and its Use.—Such a retort, with the requisite quantity of mixture, is placed on either a fire, or, what is far better, a Fletcher's ring gas-burner, whose flame can be regulated according to the evolution of gas. The mixture often advised, of two parts chlorate to one of manganese, is pretty steady in evolution of gas, but apt to carry much manganese into the delivery-tube. Four parts of chlorate to one is much faster, but requires watching, or the gas will come with a rush and blow out the cork, wasting the oxygen. Till the gas begins to come, the flame may be full on, but directly it begins to come pretty fast, must be turned down considerably, or this 'rush' will ensue. That is the

difficulty; as with these proportions, if the gas is 'rushing,' and the flame be lowered, the flow *does not diminish* for a minute or two. Hence the probable behaviour must be *anticipated*, as it were. This needs experience, and the beginner should make his gas cautiously till he has gained it, which will only take him rather more time to fill his bag. Steadiness of action can, however, be attained by further adding to the mixture *common salt*, for which hint I am indebted to Mr. E. Holland. Take, say,

Chlorate of potash	. . .	2 lbs.
Manganese oxide	$\frac{1}{2}$ lb.
Salt	6 ounces.

In this mixture the chlorate is to be *powdered* as well as the other ingredients, and the evolution of gas will answer almost instantly to the lowering of the flame, and thus be under perfect control. This is therefore the mixture I recommend: chlorate, 8 parts by weight; manganese, 2 parts; salt 1½ parts.

When chlorate is used with manganese alone, it must not be powdered, but used in the rough crystals; and 1 lb. of the chlorate—the only active ingredient—must be allowed for 4 to 4½ cubic feet of oxygen. Powdered chlorate, without salt, is liable to cause violent rushes. It may also be noted that finely *granulated* manganese is better than powdered, as not choking the delivery-tube at all; but it is seldom easy to procure, and the powder need cause no inconvenience.

Using the necessary caution, it often happens that when the charge is about half exhausted the evolution of gas stops for a while, and even the full flame fails to start it again for some minutes. It will resume, however, and during this second stage there is little need of caution for fear of a rush; the full heat is generally needed to the end. For its thorough manageability, however, I strongly recommend the salt mixture.

42. Purifying the Gas.—Oxygen thus prepared from commercial chlorate is not fit to pass direct into the bag. It is hot, and must be cooled; it will contain a great deal of free chlorine, and must be purified, else both bag and brasswork will be rapidly destroyed. And it is very seldom *properly* purified. Properly purified and dried, new jets and taps should be used half-a-dozen times without any sign of

Fig. 48.—Arrangement of Purifier

green corrosion being visible on the bright brass. I speak from experience.

The hot gas is passed through at least one cooler and purifier, as shown in fig. 48, connecting the delivery-tube of the retort by a piece of vulcanised tubing with the pipe which goes nearly to *the bottom* of the purifier, and the tube which leaves the *top* of the purifier, with the gas-bag or the next purifier. Where only one purification is attempted, the whole arrangement is shown in fig. 48, the gas bubbling up through

the fluid. The tube passing *into* the purifier should go nearly to the bottom of it, and about two inches from the bottom end should be perforated with six or eight holes about $\frac{1}{16}$ inch diameter, that the gas may enter the water in small streams. Care must be taken to make no mistake about the proper connections, as shown in the figure.

Many people pass the gas simply once, through water, in this way. This will *cool* it but not *purify* it; and it also carries it damp into the bag, to the latter's rapid destruction. To absorb the chlorine, sodic carbonate (common washing soda) or potassic carbonate (salt of tartar) may be dissolved in the water, and answers fairly well; but the way to perfectly neutralise it is to use caustic soda. With this, the same solution may be used several times, if at home; the quantity is not very material, using, say, a couple of sticks of the caustic to a Winchester quart bottle. One washing is not, however, enough; two purifiers are necessary to get really pure gas, connecting the delivery-tube from the first with the entering pipe of the second.

Formerly sheet-metal purifiers were used; but it is advisable, if not necessary, to see just how fast the gas is coming over, by which the heat under the retort is to be regulated, and hence glass bottles have long been usual. These are generally made as in fig. 48, with screwed caps, through which the entry and delivery-tubes passed. But there are two far better methods. The first is to employ vulcanised 'Woolff' caps, through whose nipples the brass pipes are passed, and which simply stretch over the open mouths of wide-necked Winchester quarts. These will also act as safety-vents for too great a rush of gas, allowing either some leakage, or blowing off altogether if it were necessary. But the best and handiest fittings of all are made as in fig. 49. Here B is a brass tube about one inch in diameter, closed in at the top, into which closed top the brass entry-pipe (A) is brazed. Into the side, at (C) the delivery nipple,

of brass pipe, is also brazed. Over the open bottom end is stretched half of a piece of stout vulcanised rubber tube, (DD), about two inches long. The other end of this rubber stretches tightly over the ordinary size of any narrow-necked bottle, using when at home Winchester quart size. When from home, however, ordinary wine or ale bottles can be used, and thus only the small fittings need be carried about.

When only two bottles are used, the second should only be half full, in order that as little spray as possible may pass away with the gas. Still the latter will be damp, and should be further dried; and for years I have used, after the second purifier, a piece of large glass *tube*, corked at the bottom, and over the top of which stretches another of the fittings shown in fig. 49. The entry pipe goes nearly to the cork, and most of the aqueous vapour is there finally deposited.

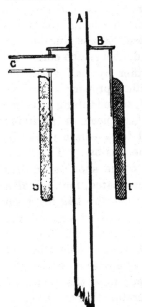

FIG. 49

This is what is meant by properly purified and dried oxygen gas. If the two bottles and drying-tube are arranged on a little shelf, or in a box, with their connections ready made, such a really efficient apparatus gives no trouble whatever, beyond renewing the alkaline solution now and then. Should the third or drying chamber not be employed, the gas can be tolerably dried by placing the gas-bag which is being filled upon a table, while the rest of the apparatus is below on the floor; a great deal of the moisture will then be deposited in the tubing connecting the bag.

Such being the detail of the process, a few words will be useful as to its general conduct. It is convenient to make a

quantity of mixture, and keep it in some metal vessel; a circular tin with hinged cover, such as is sold for biscuits, answers admirably. It is also convenient to keep in the tin an iron gardener's trowel to shovel up the mixture, an old tin canister cut to such a size as will exactly hold the charge found sufficient to fill the bag, and a tin funnel with a large spout. Starting with a retort both clean *and dry*, it takes but a moment to shovel up enough mixture to fill the canister, unscrew the head of the retort, funnel in the charge, roughly level it by giving the retort a shake, replace the top, and screw it home; a properly-made retort needs no washer or other packing. The retort is then placed on the ring-burner, which itself is controlled by a tap, the delivery-tube connected with the entry-pipe of the first purifier by half a yard or more of vulcanised tubing, all the purifiers properly connected as described, and another length of vulcanised tubing attached to the final delivery-nozzle of the last piece of purifying apparatus, the other end being placed loose where it can be instantly slipped on the nozzle of the gas-bag. The Winchester quarts should be full nearly to the shoulder, unless the second is left half full as before indicated, for lack of a drier. Then light the burner. Meantime, the bag has been flattened and rolled, so as to expel the contained air, and the tap then closed. In a minute or two bubbles will begin to ascend in the purifiers, but these at first are merely heated air, driven over by expansion. Soon they come more steadily, and then a match should be held ready near the mouth of the last rubber tube. When the operator thinks about as much air is driven over as filled the vessels, he should strike a match, and when well caught blow it out, holding the red coal in the stream of gas from the end of the tube.[1] If oxygen is beginning to come over, the coal will brighten

[1] Care should be taken to hold the tube horizontally, and the match *in front* and not *over* it. A case has been reported in which the burning end of the match *fell in* and ignited the rubber, resulting in a fierce combustion.

G

again into a blaze, in which case the match is thrown safely away, the end of the tube slipped over the nozzle of the bag, and the bag-tap *instantly* turned fully open. Then the speed of the gas must be noted, and the rest of the preparation proceeds as described.

The bags should be filled tightly, unless for immediate use. When full, the tap is turned off, and the tubing detached the very moment afterwards. The next step is to detach the first piece of tubing from the delivery-pipe of the retort, and *this must be done before the heat under it is diminished.* The reason is, that if the flame were lowered first, for any appreciable time, the cooling would reduce the pressure, and so suck back a portion of fluid from the purifier. Such might possibly result in a *steam* explosion, which has been known to happen from such a cause, but of which there is no business to be any risk at all. When the retort has cooled down a bit, the top should be unscrewed, water poured in, and the contents washed out, adding one or two waters till there is no blackness left to speak of. It saves much time and trouble to wash it out *at once*, while warm, and the residue corrodes the iron if left in. When washed out, the retort should also be *dried* out, which is readily done on the hot plate of a kitchen stove.

CHAPTER VI

COMPRESSED GASES.

For years oxygen and hydrogen had been used for the lime-light compressed in iron cylinders furnished with screw valves to their nozzles, the gas feeding the jet by its own pressure until this was gradually reduced to that of the atmosphere. Such

Should a full bag ever be tested in this way, and the match fall in, the result would be such rapid combustion as to be tantamount to an explosion. There should not be the slightest risk run of such an accident.

a cylinder cost little more than a bag, while the gas in it did not deteriorate by osmosis, and might be kept for months. But these bottles were very heavy, and the charge of 8*d.* per natural cubic foot for each gas was prohibitory as regards general use with the mixed jet, amounting to 18*s.* 4*d.* for 20 feet of gas, against about 2*s.* 6*d.* to an exhibitor who made his own oxygen, and filled the other bag from the nearest gas-pipe. The gradually diminishing pressure also necessitated a constant turning on of more at the screw valves; so that to work a mixed jet required a skilled hand to manage the light alone, and dissolving was very difficult, the least mal-adjustment of the dissolver generally causing such accumulation of pressure behind as to blow off the rubber tubes. The use of cylinders under these conditions was almost *nil* for the mixed jet, though a cylinder of oxygen would often be purchased to save the trouble of making it, or to take it portably to the place of exhibition, where it would be used to fill a bag, which would then be worked in the ordinary way.

43. **Use of Cylinders alone.**—With the oxy-gas jet it was different. Only one of the gases had to be compressed and paid for with this system, and for it cylinders came into more or less use. For such jets very precise regulation is not required, and a little more can be readily turned on from time to time. Even now such jets are often used in this simple way, direct from the cylinders and without regulation. In working thus, the cylinder is simply secured as near the jet as possible (in order to use a short length of elastic tube), and connected with it as if it were a bag. Some advise tying on the tube at both ends with strong tape as strongly as possible, but this is not advisable, as if too much pressure is turned on, the tube itself is apt to be ripped up with rather a loud pop, which might startle the audience. The best plan is to turn back outside an inch or so of each end of the rubber tube which will tighten the ends quite as much as is desirable.

The house-gas is connected as usual, and then the oxygen is turned on very cautiously till there is enough supply. Whenever the light goes down appreciably, a very little more is turned on; a bottle containing 6 cubic feet being sufficient, with care, to last a single lantern nearly two hours.

Without care, however, it will not do so; and it will be found particularly easy to use all the oxygen in less than one hour. Care must be taken to use as little as is sufficient, and to turn on as little more as possible at one time. It is only further necessary in using oxygen thus, to be careful *never to turn off the oxygen at the jet*. If this be done, the full pressure of the cylinder rapidly accumulates behind the stop-cock, and blows off the rubber tube. There is not the slightest danger in this; but it causes a serious waste of gas, which may unpleasantly shorten the exhibition.

Before compressed gas could come into at all general use with all kinds of jets and lanterns, it was necessary to improve the cylinders, to provide efficient regulators of the pressure, and to reduce the price of the gas.

44. The Cylinders.—These are now made of a fine quality of steel, less than one third of the weight and bulk of the iron once formerly manufactured, much higher pressure being employed. The common pressure for full cylinders is 1800 lbs. to the square inch, but every cylinder is tested to more than double its utmost real pressure before being used. The following are fair average dimensions and weights as now made.

Capacity	Size	Weight
6 ft.	$12 \times 3\frac{1}{4}$ in.	8 lbs.
12 „	$18 \times 3\frac{7}{8}$ „	18 „
20 „	32×4 „	21 „
40 „	$32 \times 5\frac{1}{2}$ „	38 „

The worth of a cylinder depends entirely upon the excellence of its valves, and a great many of those advertised at unusually cheap rates are not to be depended upon, but gradually allow the gas to escape. I have repeatedly known

this to be the case; but good cylinders will retain their full charge for a year or more.

45. Testing Contents of Cylinders.—It is exasperating to find no supply of gas at the critical moment, and this makes it important to know how to ascertain the amount really on hand. The opticians use a Bourdon pressure-gauge, which is screwed on by a union-joint, and gives the pressure instantly, then by calculation we get the quantity. Usually the cylinder is 'full' to its capacity at 1800 lbs.: if so, the following will be the content, at other pressures, of the sizes commonly in use.

1800	1500	1200	900	600	300
feet	feet	feet	feet	feet	feet
6	5	4	3	2	1
10	8¼	6¾	5	3¼	1½
12	10	8	6	4	2
20	16⅔	13⅓	10	6⅔	3⅓
40	33⅓	26⅔	20	13¼	6⅔

Constant exhibitors will find a gauge, costing about 2*l*. 10*s*., well worth the expense, and it is the only method of knowing what quantity of hydrogen or house-gas is available; but where oxygen alone is used, it is sufficient, as was pointed out in a letter by Mr. C. H. Cathcart, simply to *weigh* the cylinder. A cubic foot of oxygen weighs as much as 1·48oz., or 1oz.=0·7 cubic foot nearly. If therefore the cylinder be private property, let it be weighed when empty, and the weight marked, or a note kept. Deduct this net weight from the weight at any given time, and,

Difference in oz. × 0·7 = cubic feet of gas.

Thus, suppose a 12-feet cylinder weighs empty 13lbs. 14½oz., and after an hour's use on one evening, we want to see if there is enough to last again. We weigh it, 14lbs. 10½oz.—difference 12oz. Then 12oz. ×0·7=8·4, or nearly 8½ feet of gas. When a cylinder is not known, we may assume it is

full when received, and weigh it so. Then the *decrease* in weight in ounces multiplied by 0·7 will give us the amount of gas used or escaped, and of course tell us what is left. Any pair of scales that will weigh within half an ounce, is sufficiently accurate for this simple method of estimation.

46. Pressure Regulators.—To use two bottles of compressed gas in comfort, however, with only the one usual assistant, it was absolutely necessary to deliver it to the jets at approximately constant pressure automatically. Many attempts were vainly made in this direction, both in England and America. It is perfectly easy to maintain a constant pressure at the outlet, whatever the pressure behind, so long as an outflow is kept up unobstructed. But all early contrivances simply kept up a constant *difference* of pressure between the two sides of the regulating valve, and directly the outlet was turned off (as at the jet) the pressure rapidly accumulated behind till the rubber tubes

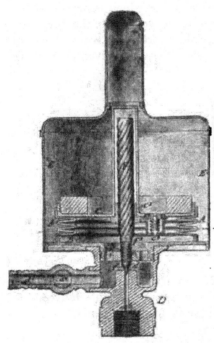

Fig. 50.—Beard's Large Regulator

blew off. It was necessary to contrive that when pressure thus began to accumulate, it should totally *close* the supply from the cylinder, and take the strain off the frail rubber tubes. This has now been accomplished in several different regulators.

The first was invented by Mr. R. Beard, and is shown in section in fig. 50. It screws on to the cylinder at D, from which the small orifice is closed at d by the valve f. The gas lifts this valve and enters the bellows A A, which rise with the pressure, but are weighted above to the pressure desired. The top of the bellows has a collar c^1 screwed with a very long pitch, in which the screwed pillar F turns easily as the bellows rises. Below the long-pitch screw F which is merely to *turn* the pillar easily, is a slow-motion screw f^1, the turning of which in its corresponding collar forces the valve down into its seat and stops the supply: thus at a given pressure the

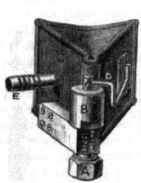

FIG. 51.—Clarkson's Regulator

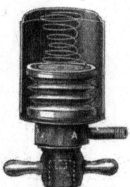

FIG. 52.—Beard's Small Regulator

cylinder is cut entirely off. In practice, while any jet is in use the supply is balanced; and leaves by the delivery-tube and tap d^2 and d^1. E E^1 is only an outer casing to protect the internal parts from injury.

This regulator worked efficiently, but was expensive, (costing about 3*l.*), cumbrous, and heavy. Next season a form known as the 'Clarkson' regulator was brought out, and is shown in fig. 51. The bellows in this case is shaped like a gas-bag, and is made of strong india-rubber framed on steel rods at the edges. The sides are compressed by a strong spring, D, adjusted to the pressure required, and work to and

fro on a spindle, B, at the edge, through which the gas enters at A, and which has a valve so constructed, that when the bellows opens to a certain point, the gas is cut off entirely.

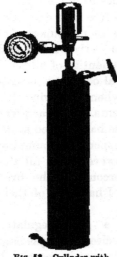

It passes to the jets by the nozzle E. This regulator only measures about 3 inches each way, works very well, and costs about 25s.

Mr. Beard has since brought out a small regulator, costing 30s., shown in fig. 52, which is about one-third the actual size. This also works with a central valve, but, instead of a screw, has a curious sort of 'lazy-tongs' arrangement, which need not be particularly described. The material fact is that there are now at least two regulators in the market, measuring only a few inches each, which simply screw on to the cylinders, and then keep the pressure practically uniform, and allow the jets to be regulated just as usual, or even to

FIG. 53.—Cylinder with accessories

be turned off. Beard's is generally found most satisfactory. Fig. 53 shows a cylinder of compressed gas with a pressure-gauge, one of these regulators, and a screw-key, all in position.

47. Price of Oxygen.—By a fortunate coincidence, no sooner had efficient regulators been provided, than the price of compressed oxygen was cheapened by the introduction of Brin's process for manufacturing it. In this process retorts are charged with pure anhydrous barium oxide, which is raised to a low red heat, when common air carefully washed and purified is pumped into the retort. The oxide under these circumstances takes up more oxygen from the air and becomes dioxide, when the nitrogen is conveyed away ; after which, on raising the dioxide (BaO_2) to a still higher temperature and reversing the air-pump, the dioxide is reduced again

to BaO, and the oxygen given off. The process thus uses up no chemicals whatever, and becomes simply mechanical. The immediate effect was to reduce the retail price of oxygen to 4*d.* per cubic foot, and in large quantities to much less.

Brin's gas is always perfectly dry, and free from chlorine ; and when also free from nitrogen, appears to me superior to *average* chlorate gas, though not to gas properly washed and dried (see p. 78). At first, however, the quantity of nitrogen left in it varied materially, and on several occasions I have been greatly disappointed with the light when employing this gas for microscopic or physical experiments. So much was this the case, that some London opticians have turned again to chlorate gas, and gone to the extra expense of pumping that at the lowered rate. I believe, however, that all the practical difficulties have now been overcome by the Brin Company, and the more recent cylinders I have had of their gas have been all that could be desired.

48. **Using Condensed Gases.**—With a good regulator screwed upon the cylinder, this is used precisely as a gas-bag. The regulator may be set at any given pressure in reason : I recommend 9 inches for ordinary lantern work, and 14 inches for high-power work. It has already been remarked that with blow-through jets no regulator is absolutely required, provided no taps are ever turned off, and all the regulation be done *at the cylinder valve.* But with the regulator the cylinder may be turned on, and the jet regulated by its taps as usual : also the jet may be turned completely off if needed. At the same time it is not wise to subject the mechanism to the immense pressure for longer than neces- sary ; therefore if the light is wanted off for more than ten minutes the cylinder-valve should be turned off, and it is well not to turn it on till just before the jet can be attended to. As a rule no further attention will be required, the pressure being maintained much more uniform than from bags; and it will be kept up till the gas left in the cylinder is no longer

sufficient to do so. It is most convenient to arrange a pair of cylinders upright in a little packing-case, which stands firmly on the floor behind the lantern, and is also convenient for carriage; but when one cylinder only is used, it is often laid flat on the table, if one is used as a stand for the lantern. It should, however, be tied to prevent rolling off.

For a blow-through jet the pressure is better adjusted to only 5 or 6 inches.

49. Dangers of Compressed Gas.—The use of gas in cylinders was said by some persons to remove all danger. Experience has not quite borne this out, though what danger there may be, appears to have attached to the persons engaged in pumping it, and not to the consuming public. Years ago, a cylinder exploded at the Royal Institution whilst being filled, and examination showed that the intense heat caused by the rapid compression had ignited some particle of carbonaceous matter, and that this had in turn *ignited the iron itself*, which readily burns in oxygen. This is now guarded against. Another bottle burst when sent to have a 'stuck' valve loosened, because the workman put it on the fire! No vessel would, of course, resist such an idiotic proceeding, which is scarcely likely to happen again. I have heard of no cylinder failing in England, whilst in the hands of the public; in testing, a certain portion of course do so, and are accordingly rejected. A pressure-gauge has burst, with serious, though not fatal results; and it is safest to have such gauges well secured against, at all events, broken glass.

The only practical danger is in *mixture*. A terrible and fatal explosion at Dublin, in the early part of 1889, was caused by oxygen being pumped into a *hydrogen* cylinder for an emergency, the cylinder on being sent back being filled up again with hydrogen. It was the vendor himself who was killed; and he knew, and had been actually warned of, the state of affairs and the danger, running the risk rather than lose a few cubic feet of gas! And a similar accident—also

on the works, not in public use—has since occurred in the north of England.

No oxygen ought ever to be pumped into any but the usual *black* bottles; and no hydrogen or house-gas into any other than *red* bottles. These are the two colours accepted by the trade and general consent. I also insist very strongly, that no pumpers have any right to fill up a bottle, without first seeing that all pressure is let off. These rules give safety, and no other rules do so; as to little contrivances sold for customers to ' test ' their gas, a large proportion of operators have not knowledge enough to use such things. If an explosion occurred, and fatal results followed, and it were proved that the pumpers had broken the first of the rules just mentioned, the culprits ought to be, and I believe would be, held guilty of manslaughter. Since the explosion just referred to, all firms of real standing now act upon both; and while it is necessary to point out where any neglect has caused accident, it may be well to repeat, that not a single accident has yet happened to any *user* of the gas in England up to this date, out of thousands of cylinders. It is, indeed, difficult to understand how any accident can happen without criminal carelessness on the part of the firm supplying the gas; the few accidents which have occurred ' in the trade ' itself, having pointed out the only sources of danger very clearly. The 'mixture' which might possibly occur with bags, if carelessly handled, is by the high pressure of the cylinders rendered, with them, practically impossible.

CHAPTER VII

THE OXY-ETHER AND HYDRO-CARBON LIGHTS

50. The Oxy-ether Light.—For many years lamps have occasionally been employed in laboratories which burnt the vapour of some volatile fluid in place of gas; and recently such

vapour has been employed in lieu of hydrogen or house-gas in the oxy-hydrogen jet. The fluid first employed was sulphuric ether. To vapourise this by heat would be terribly dangerous; but it is found that passing fine streams of air through an adequate quantity of fluid carries over with it a sufficient quantity of vapour to burn as a combustible without being explosive. The same occurs with a stream of oxygen; therefore if the oxygen supply (from bag or cylinder) be divided into two branches, one of these passing through the ether will convey combustible vapour to the jet, whilst the other branch may be adjusted to supply the most calorific proportions at the nipple, in the usual manner already described.

The oxy-ether light is thus adapted for use in just such halls, without gas, as found employment for the oxy-spirit jet, but with the advantage of a far more powerful light. This light has been chiefly brought into notice in England by Mr. W. Broughton, of Manchester, and the late Rev. F. Hardwich, who have worked a great deal in concert; and in the United States by Mr. Frank Ives, of Philadelphia, who advocates a different form of apparatus.

Mr. Broughton adopted a *tank* of ether, using first of all an apparatus essentially like a wash-bottle for washing oxygen,

FIG. 54.—Plan of Tank

but forcing the oxygen through a number of very fine apertures. This failed to saturate with vapour, and gave a flickering flame. Next, a tank was used with horizontal divisions, the oxygen being compelled to travel backwards and forwards gathering vapour. Finally, both Mr. Broughton and Mr. Hardwich adopted a tank furnished with perpendicular

partitions reaching from the bottom to the top, and in *plan* arranged as in fig. 54. This being partially filled with ether, the space above the fluid left a long sinuous course for the gas to traverse, which gave full saturation.

With this tank the oxy-ether light is certain and safe under skilled management. But it appears to possess special dangers of its own, and the few oxy-hydrogen explosions which have happened during late years have been with this form of light. Not one has been directly fatal ; but in the *panic* after one at Chadderton, a poor child was trampled to death. In that case I am convinced that, by some carelessness, ether had been allowed to trickle down the connecting tube to the oxygen-bag itself, thus converting the oxygen into an explosive mixture. This accident produced two extra precautions in the apparatus used.

51. Safety Chambers.—One of these was the pumice safety-valve or chamber of Mr. Broughton, which is the only *real* safety-chamber I am acquainted with. It is made by filling a brass tube about half an inch in diameter, and say three-quarters of an inch in clear length, with pumice-stone granulated into particles of a certain size. This is best prepared by passing pounded pumice through a double sieve of wire gauze, using gauze No. 40 and No. 50. The coarser particles are stopped by the top sieve, and those too fine go through the lower ; the particles remaining between are the proper size. The pumice is kept in place by a piece of wire gauze each end of the chamber, resting on shoulders or flanges ; and the chamber should be made so as to take to pieces easily for refilling, and, if used with rubber tube, with nozzles over which this can be stretched.

No ordinary explosion can pass a chamber thus packed, *whilst in order*. Rigid experiments by the Rev. F. Hardwich have determined this. But if a vigorous ' snap ' (which is a small explosion) should take place in front of the pumice, and be stopped by it, the latter may be partially pulverised and

disarranged by the shock, so as not to resist a second one in
the same degree. This has been proved experimentally; and
therefore these chambers should always be examined, and if
necessary refilled with fresh-sifted material, after any notice-
able 'snap' of a jet, or at reasonably short intervals even
when none may have been noticed. Also it is to be observed
that, as the violence of an explosion will depend upon the
amount of gas in front of the chambers, these should in all
cases be used *as close* to the nipples as possible. They should
never be used at the supply nozzles of the dissolver, but on
the nozzles of the jet; and where this light is habitually
used, the safety chamber should be arranged *under the nipple
itself*, with only a very small empty chamber above. Here
also it should be constantly examined. This makes the only
real 'safety' jet I know; but the obstruction to the flow is
great. This, however, can now be overcome by the higher
pressure at command from cylinders.

The other precaution was to add gas-chambers *above* the
tank—one from which the oxygen passed to the surface of
the ether, another into which the vapour passed before
leaving by the exit-tube. Thus, if the tank were jarred or a
little tilted, ether would not run back, but be stopped in these
chambers. At the end of 1887, however, another explosion
occurred with a tank thus constructed, under circumstances
which for a time baffled speculation. The tank was purchased
in Feb. 1887, and worked well the rest of that season; but
when got out in Nov. 1877, it behaved differently. Before
any pure oxygen was turned on at the jet, the latter heated
the lime red hot; and this got worse and worse, until finally
a severe explosion ruptured the tank, in spite of two pumice
chambers attached to the dissolver. The probable reasons for
the explosion passing these have already been pointed out;
but the explosive condition of the tank itself puzzled everyone.
It was carefully examined by several, including myself; but
none could discover any apparent leakage which might have

led to the ' short circuiting ' of the oxygen-stream, and thereby caused that predominance of oxygen which had somehow, it was evident, filled the gas-space over the tank with explosive mixture, instead of merely combustible vapour. At last the tank was ripped entirely open, and examined by an engineer very closely, when all was explained. In the soldering of the partition which divided the safety chamber over the tank (as last described) into two, as an entering and exit chamber, a *very small leak* was discovered, with traces of corrosion. It is probable that this at first was absolutely imperceptible, but had gradually enlarged during the summer months ; and the result was that a certain amount of oxygen passed directly to the exit chamber, without passing over the ether at all.

FIG. 55.—Ether Tank, side view

The remedy against this danger, as was immediately pointed out by Mr. Hardwich, was to *entirely separate* the two chambers as in fig. 55. With this construction, another such accident would be impossible. With regard to the soldering of the partitions in the tank, any single leak between two compartments would not have very much consequence ; and it is the sides and *top* of the partitions which would need special care. A little leakage at the bottom of the tank, which should be the last side to put on, would have no result, since there would always be ether above that level, unless it were actually exhausted, which never ought to occur.

52. **Porous Generators.**—Mr. Ives constructs his generators differently, filling a metal tube of two inches or more

diameter with a roll of woollen material. This is closed by
gas-tight caps at each end, with proper nozzles. Ether is
poured in to saturate the woollen, and the oxygen passes
through the roll. The usual form of this generator sold in
England is shown in fig. 56, the tube being double, each
length with its own roll of saturated material, the two being
connected by a U piece of brass tube. But in his own last
construction Mr. Ives prefers a *single* tube about 14 inches
long, which is laid flat, and has a nozzle with stop-cock pro-
jecting up at each end. He also now prefers to use petroleum
ether, which in the United States is a more common com-
mercial product than in England, and volatilises at a lower

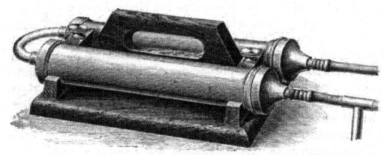

FIG. 56.—Porous Generator

temperature. It also contains no alcohol or water, some
small quantity of which is always found in common ether.
That is an advantage, but the lower vapour-point I regard as
so far a drawback, sulphuric ether itself giving quite sufficient
trouble in this respect to make its storage and carriage a
matter of some anxiety.

Mr. Ives maintains that his generator gives better satura-
tion, and is safe from danger, there being no liquid to flow
back, or scatter about if an explosion should occur. The last
claim appears to be just, and on the whole I should prefer
this method; but experiments in England show that the best
saturation is given by the tank, tank-vapour requiring

decidedly more oxygen at the jet than vapour from the other generator, and this test being conclusive. A tank can also be made to contain ether enough for any reasonable time, while it is difficult with woollen to saturate the vapour sufficiently for more than an hour and three quarters.

53. **Management of the Ether Light.**—I consider either generator, as now made, to be practically safe with experienced operators, and especially with such as understand the inherent risks of using volatile fluids. But it is clear that these risks are a serious addition to the ordinary risks of the mixed jet ; and for this reason it is not to be desired that the oxy-ether light should be widely used by the ordinary class of operators. I cannot condemn it wholesale, as Sir Henry Roscoe has done, especially in the porous form ; for I should use it without hesitation if I wanted high power where I could not get gas. But since the oxy-spirit jet supplies light for most purposes in country rooms, and compressed gas can be procured for others, the ordinary exhibitor would do well not to run the extra risks of a process, which he will not probably thoroughly understand all the dangers of. As the oxy-ether light will, however, probably continue to be used to some extent by skilled operators, in certain circumstances, a few words are necessary regarding its practical manipulation.

In the first place, the oxygen pressure must be good. The oxygen has to supply *two* branches of tubing, and in addition, each current has to be driven through the resistance of the pumice chamber, which should always be employed. Where this light is habitually used, the pumice chamber must be examined, and if necessary replenished from a store of sifted material kept always at hand, *at short intervals*. If a bag is used, at least 1½ cwt., and 2 cwt. to finish, will be needed for a good light ; if a cylinder and regulator, from 9 to 12 inches pressure.

In the second place, the ether used must be of a certain purity, known by its specific gravity, which should not exceed

H

0·917 to 0·920. Heavier ether owes its density to alcohol and water. Only the ether being vapourised at the end of an exhibition, that which remains is of inferior quality, and will saturate the gas less perfectly. It must always be poured out of the tank at the finish, and if the quantity be not large, the safest plan is to throw it away. It may, however, be kept (separately) and used with fresh ether once or twice. After twice, I consider the residue should be rejected. Petroleum ether certainly has the advantage in this respect. Either must be stored in as cool a place as can be found.

No tap or connection having to do with ether vapour can be lubricated with any kind of grease, as the ether rapidly dissolves it. Connections may be screwed up gas-tight with soap, or washers of leather and soft lead. Taps may be lubricated with vaseline. Rubber tubes are also acted upon, and should be, therefore, of the thickest and best, and as short as possible, placing the generator on the table, if one is used. Any heat from the lantern will promote saturation.

Large nipples *cannot be used* with sulphuric ether, the jet ' snapping ' with them. The aperture should not exceed 1 mm. bore. This of course limits the light, though it is nearly equal to the oxy-hydrogen jet of the same bore.

The connections are easily understood. The tube from the oxygen supply is divided into two at a T or Y joint. One branch of this goes to the oxygen nozzle of the jet or dissolver, the other to the ingress end of the generator. There should be at least six inches from the fork of the Y to the generator, and there must be a stop-cock between them. From the egress end of the generator a nozzle, also furnished with a stop-cock, goes to the hydrogen nozzle of jet or dissolver. Every connection should first be made with *all* taps turned off, and the bag duly weighted. The bag or the cylinder is then turned on, the latter with a regulator of course ; next, the tap between the fork and the generator. Finally we turn on the hydrogen

tap of the jet, and after a few seconds, to let air escape, turn it off again for inflammable vapour to leave the lantern. Turning it on again we apply a light, which burns in place of house-gas. All the 'pure' oxygen taps, from the fork onwards, are meanwhile turned off.

It is always to be remembered that full *saturation with ether vapour* is the condition of silent *combustion* and safeguard against explosion ; the explosive mixture with oxygen only being allowed at the jet itself. The test of this is the *condition of the flame*. While all is safe, this is white or yellowish-white. As oxygen increases, this changes to deep yellow, and finally to a purplish or blue colour. This last shows *an explosive condition*, and whenever it occurs with what stands for the hydrogen supply alone, proceedings should at once be stopped. This test refers to naked flame only. When the lime is adjusted close to the jet, even a dangerous mixture may appear to burn yellow, and therefore it is best always to light the flame first, at a distance from the lime. If it is a good light colour the lime can be adjusted and warmed, after which the oxygen is gradually turned on and adjusted in the usual manner, till the brightest light is attained. As the work proceeds, however, if it be found that the pure oxygen *has to be gradually turned off*, it shows that from some cause saturation is becoming more and more defective, and work should be stopped and the light put out. To proceed under such conditions is dangerous.

At the end of work, the hydrogen tap of the jet may be turned off, so that the surplus oxygen 'snaps' the jet and puts it out. The condition of safety is to turn off at the jet first, and never at the bag or cylinder till the light is out.

When two lanterns or a bi-unial are worked with this light, it will often be found that the dissolver (see Chapter VIII.) will not work properly without some alteration. No oxygen byepass whatever must be allowed, as is often done with the

H 2

gases (see same chapter). On the other hand, the hydrogen bye-pass, when used for ether vapour, must be more free than usual, and if it is a groove round the plug, as in many, this may have to be filed deeper. I have seen it stated that a dissolver cannot be used, but there is no difficulty if properly adjusted.

54. Oxy-Carbon Light.—Mr. Albert Scott recommends the use in a similar manner of benzoline, used in a porous saturator which is *heated* by a lamp to promote volatilisation. This fluid, like rhigoline or petroleum ether, belongs to the paraffin series, whose formula is C_nH_{2n+2}. Mr. Scott claims for this modification that a larger nipple can be used, and that a better light can be obtained than with mixed gases ; also that by passing even coal-gas through the fluid before burning at the jet, so as to 'enrich' the gas with hydro-carbon vapour, using the mixed gases otherwise as usual, a considerable gain in light is obtained, concentrated in a smaller spot. This would be a very valuable gain for microscopic work, and I felt much interest in the question ; but after careful trial together, both Mr. Herbert Newton and myself came to the conclusion that not the slightest advantage could be observed. When experimenting with the oxygen passed through warmed benzoline, we experienced sharp though small explosions, and Mr. Scott himself writes rather flippantly of what he calls 'pops.' I agree with him that these 'pops' are of no real danger with his form of generator ; but certainly no audience would tolerate them, or be free from panic if they occurred ; and it is manifest that the need of *heat* to get sufficient vapour to form a non-explosive compound, is an additional item of risk about this method. I suggested to Mr. Scott the use of gasoline, which is a more volatile mixture than benzoline, of the same series ; and this was adopted with benefit ; but I should prefer to use rhigoline, a more volatile fluid still, and needing no heat, as is done by Mr. Ives. I also suggested the use of benzol or benzene, as richer in

carbon ; and Mr. Scott says that this fluid gives the smallest spot of all ; but it requires the jet as well as generator to be heated.

It is remarkable that Mr. Ives also claims a smaller spot for the same light than when using mixed gases ; but at such trials as I have had any opportunity of witnessing, I was not able to trace this, nor was it the opinion of those present that the light was any better or more silent than that obtained by good operators with mixed gases, as Mr. Scott claims. On the other hand, it is indubitably true that *full apertures* can be used with this series of oils, and the utmost power of the mixed jet (with such apertures) thus obtained, with only a cylinder of oxygen in the way of gas. As to the claim, however, that still larger apertures can be used with hydro-carbon vapour than with mixed gases, I have never heard of Mr. Scott using more than $\frac{1}{13}$-inch, whilst I have found no difficulty (with the jet described in Chapter IV.) in using $\frac{1}{10}$ nipples with mixed gas, so that this idea is certainly a mistake. It is possible that different operators may obtain rather different results. While, however, there may be occasional convenience in being able to obtain the most powerful light from one bag or cylinder alone, I fear that any apparatus needing heat will be regarded with little favour, and that Mr. Ives's rhigoline or petroleum ether will be the general choice amongst this class of liquids.

CHAPTER VIII

LANTERNS AND THEIR MANIPULATION

55. Single Lanterns—Lanterns for the simple exhibition of single slides are now practically made of one or the other of two patterns. If a petroleum-oil lamp is used, either always, or occasionally, the lantern-body is usually made

of sheet-iron (fig. 57). In the better class this is enclosed rather loosely in a wooden case. Such lanterns are usually

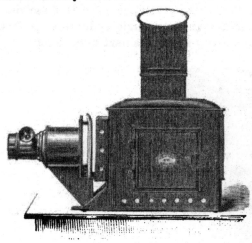

worked (with oil) very near the screen, a combination-lens of 4½ inches focus being most usual. As regards thus using a single lantern with an oil-lamp, nothing need be added to what has been said in Chapter III., except that all the lenses will, of course, be bright and clean, or, if

FIG. 57.—Iron Lantern

not so, will be fresh wiped *with a wash-leather*, kept for that purpose alone in a collar-box, or something of that kind, and religiously preserved from grease. A wash-leather once greased anywhere, is of no further use until washed. The lamp is fitted to its proper place, and it only has to be trimmed and attended to, and the slides properly focussed with the rack and pinion.

When such a lantern is used with a tray and jet instead of the lamp, again all the needful directions for the management of the light have been given in Chapter IV., but it will be necessary now to carefully *centre and adjust* the light in the manner described under § 62.

A single lantern made for limelight only, however, is generally constructed differently. The body itself is made of mahogany, and it is the lining of sheet-iron or tin which is attached to this: there is usually an all-brass front, with a

sliding nozzle, and the whole pattern will closely resemble fig. 58. Such a lantern is often fitted with various objectives and a lengthening tube; and except as regards dissolving views, or dioramic effects, exhibits single slides in as perfect a manner as the more costly apparatus next to be described.

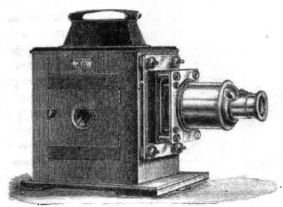

FIG. 58.—Single Mahogany Lantern

56. Dissolving Views.—This well-known effect or one picture imperceptibly melting into another, when first introduced, created an extraordinary sensation, but is produced in a perfectly simple manner. The fading and the coming slide each require a lantern, so that *two lanterns* are necessary: then the light is simply cut off gradually from one lantern, whilst it is as gradually turned on in the other. There is literally nothing else about it.

The popularity of dissolving *as an effect* is largely a thing of the past; but the method will be always used by exhibitors to a large extent, from its convenience in changing slides, the coming slide being placed ready in the dark lantern, ready to be dissolved into the other when required. The cases where it is of real value, are *dioramic* dissolving views; such as where a ruin, first seen by day, changes gradually into a

moonlight scene ; or a ship, to the same ship on fire ; or summer to winter. These effects retain all their charm, and many sets of such can be procured ; but dissolving one slide into quite a different one has no meaning, and, indeed, needs constant care to avoid now and then absolutely ludicrous sequences.

57. **Registration of Slides.**—The perfection of dissolving depends upon absolutely perfect *registration*, as it is called. That is, every line of the picture must dissolve precisely into its corresponding line of the other slide, and in more ordinary changes, at least each disc should precisely correspond with the preceding. To ensure this, in the first place the two objectives must be of precisely the same magnifying power ; and this should not be taken for granted without actual proof, which is best afforded by two duplicate plain diagrams, or slides of printed matter. In the second place the two lanterns must be carefully adjusted that their discs may coincide upon the screen. And besides all this, the slides themselves must be carefully ' registered.' A hired set of slides can never be shown in perfect registration for want of this last, which is impossible with such a ' scratch ' set.

The best lanterns are, and should be, fitted with stages which have adjustable screw stops, by which the precise places of the two discs can be adjusted. If this is carefully done, most slides will register fairly as regards their discs, and this degree of registration satisfies what we may call the average exhibitor. Further even than this, the mere discs may be *absolutely* registered by a plan sometimes adopted of exhibiting the slides (packed or carried loose) in a frame or carrier with an aperture *slightly less* than the slide itself shows. This slight contraction of the visible surface is sufficient to cover any little inaccuracy in the slides.

Another method is, for the operator to watch carefully the disc of the new slide whilst the light is only just sufficiently turned on to show it almost imperceptibly, and then

move it into the exact position. Now and then an operator can do this without the audience perceiving it; but nearly always the movement in adjusting the slide can be seen after a while, and is very unpleasant.

No such expedients give sufficient precision for the fine dioramic effects aimed at by the few exhibitors who have a reputation for their *exhibitions*, as well as for what, apart from this, may be most excellent lectures; I mean such exhibitions, for instance, as those by Mr. Malden. Very often in these an 'effect' must be 'flashed' on instantly, in most precise position—as, for instance, the flashes from the guns in a bombardment, or the sudden change to an explosion. There is only one way to get this. First of all, the two or three lanterns must be precisely centred, by an equal number of precisely similar test-slides kept for the purpose; three photographs of a diagram showing simply horizontal, perpendicular, and diagonal lines all crossing in a common centre, answer admirably. These must be most precisely superposed, so that any one may go into either stage indifferently, and when once centred on the screen, be interchangeable without affecting the precise superposition of the images, when once the stage adjustments are also accurately made. Then every slide must be framed separately, and adjusted *in its frame* by slips of paper or card, until all the usual 'shake' or looseness is taken out, and the slide fixed precisely in its frame. Then lastly, if the slips of paper or card, when humoured as far as possible, are not sufficient to adjust it sufficiently, the wooden frame itself is adjusted so as to centre the slide on the screen. Sometimes the frame may need a slip of card stuck on; or it may need a thin shaving taken off. Now all is certain; but hours and hours are patiently spent in thus adjusting a set of new slides, before the season really commences.

The almost microscopic adjustment of the lantern-stages is not so necessary, provided only the slides are always used so that each slide always goes *into the same stage*. To ensure

this, a programme should be written if this method is adopted; but as the sudden splitting of a lime might possibly upset the order, it is better to carry out the system thoroughly, and register both lantern and slides; moreover, the lantern registration is done once for all.

For dissolving views with oil lanterns, these must be used side by side, and both lamps must be kept full on, as it would be impossible to turn the lights up and down. Generally a shade, going off at one side into taper teeth like a comb, travels across each lantern nozzle, so as to cover and uncover each in turn; the two shades being connected so that as one covers, the other uncovers. Plans have been published for using one oil lantern over the other, but none such are really safe, or tolerable in use.

58. **Dissolving Taps.**—Two lanterns with Argand gas-burners will work dissolving views very well on a small scale. The lanterns must still be side by side; but the dissolving can in this case be done by a tap which turns one light down whilst the other is turned up, both lamps being ' on ' whilst the tap is half-way. Such a tap is additional to the tap on the burner itself, and is known as the 'dissolving-tap.' In

Fig. 59.—Three-way Tap

this case it is what is called a ' three-way tap,' shown in fig. 59, there being three branches. The centre one comes from the gas supply, and the lever of the tap directs this into one or the other of the two channels, the amount being regulated by their own taps.

A similar tap is used for dissolving the oxy-spirit jet described on p. 46, but in this case the tap governs the *oxygen* supply, the spirit-flame being left on. This flame is too weak to give any perceptible image of the ' dead ' slide upon the

screen, but the turning on of the oxygen brings out the light in all its brilliancy.

All kinds of jets with two gas or vapour tubes are worked with a dissolving tap, which in this case must be a 'six-way' tap, as two gases, or their equivalents, are supplied to each lantern in turn. This is the form practically known as a dissolving tap, and was first invented by the late Mr. Dancer, of Manchester. It is now made in two principal patterns, one of which, the 'star' tap shown in fig. 60, was simplified out of Mr. Dancer's model by Mr. Malden. In this tap the supply-

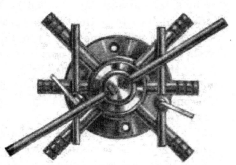

FIG. 60.—Star Dissolving Tap

tubes are stretched over the horizontal nozzles on each side, and each side of the plug has a channel cut in it which just reaches to the apertures over and under on each side, leading to the two jets. Thus when the lever is half-way both lanterns are 'on,' but any movement to either side cuts off one jet. If both gases, however, were cut off altogether, the jet would be put quite out; and to avoid this there is a small tube with a stop-cock in it, connecting the two jet-nozzles on the *hydrogen* side. The effect of this is to allow a small quantity of hydrogen (adjusted by the small stop-cock) to pass from the 'on' nozzle, to the nozzle which is cut off, so as to keep a small gas-flame, quite invisible as regards the screen, alight in the cut-off lantern. Such a subsidiary stop-cock is called a 'bye-pass.' To avoid any 'snapping' when a lantern is turned on, there is often a bye-pass made in this dissolver for the oxygen supply also, and the diagram shows both. An oxygen bye-pass must be very little indeed, so as

to barely affect even the hydrogen *bye-pass* flame ; else it will snap the jet out.

The connections of this dissolver are sometimes found rather confusing, but are easily understood with a little thought. Both the channels revolving in the same direction, but on opposite sides of the plug, it will be seen that when hydrogen is turned on to the *top* left-hand nozzle, oxygen is turned on to the *bottom* right-hand nozzle. It is easily understood if we remember that the two nozzles are ' on ' which are *covered by the lever* in either position. This tap does however, involve very long india-rubber tubes between the

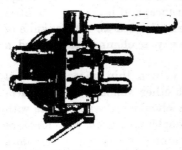

tap and the jets, and on this account I prefer the other form, shown in fig. 61. In this dissolver each supply nozzle, with its pair of jet nozzles, is on the *same* side of the plug, but one above the other. Therefore both jet nozzles are on the same side for each jet, and the pair of nozzles are ' on ' towards which the lever is turned. The hydro-

FIG. 61.—Plug Dissolving Tap

gen bye-pass is often provided by cutting a small groove, beyond the supply channel, right round the plug ; but a connecting tube and stop-cock, as in the ' star ' form, is better. I have my own tap so modified that the jet nozzles project at an angle towards the front, which is an improvement, further shortening the rubber tubes. This dissolver can, if preferred, be affixed sideways to the back of the lantern, so that the nozzles point upwards to the top jet and downwards to the bottom one, and very short rubber tubes then suffice.

A third form of dissolver consists of two separate three-way taps arranged side by side.

Dissolvers often want adjusting. The apertures may be too small to supply a good jet, and both these and the channels

in the plugs may need considerable enlarging. Some years ago no tolerable result could be got from the lantern in use at the then Victoria Coffee Tavern. After doing what I could with the jets, the light was still greatly insufficient for the long-screen distance of 70 ft., with a disc of 20 ft. diameter, and on examining the 'star' dissolver I found the apertures and channels ridiculously small. I enlarged them to rather more than double their former area, after which the light was quite satisfactory. The bye-pass of a tap may also need alteration; and finally, it is advisable that the hydrogen channel should be slightly longer than the other, so as always to turn on the hydrogen *in advance*, and leave it on a little later, and this may not have been attended to. A penknife of good steel will cut or scrape away a channel easily, and a suitable file will do the rest.

All taps are best lubricated with a thin smear of *animal* fat or oil, except those used with ether vapour. The connections between dissolver and jets should always be made with the best rubber tube, and all should be left *in situ*, and not disconnected except when cleaning or greasing becomes necessary. Care must be taken to grease sparingly, or the grease may clog the passages.

In all cases where a dissolving-tap is used, the tubes from bag or bottle, or pair of such, are attached to the supply-nozzles of the dissolver, the jet-taps turned *off*, and the supply to the dissolver turned *on*. Then turning the dissolver on to each jet in turn, that jet is adjusted separately as to its position, and the gas-supply regulated by the tap or taps on the jet itself. Any future re-adjustment is also made by the taps of the jet concerned.

59. **The Bi-unial Lantern.**—This is the usual and favourite exhibitor's lantern, more of this pattern being used than of any other. Fig. 62 represents the usual model, fitted with the optical fronts recommended on page 33. Generally the two lanterns are made really in one, as here shown; but it

is not at all unusual to make them so that the top one can be separated, and placed by the side of the other, to use with oil lamps. In any case the two doors should be separate. It saves a sovereign to have doors only on one side of the lantern; but it is very much better to have them on both sides, as it is impossible to tell in what corners or positions the lantern may have to be worked. To make the two discs coincide upon the screen, each of the metal plates carrying a

F͟I͟G. 62.—Bi-unial Lantern

front is hinged, so that the two optical systems may be inclined to each other and adjusted by screws, any slight side adjustment necessary being made in the stages. The inclined front carries the condenser and slide as well as the objective, so that the whole is kept in one optic axis.

The bi-unial is much the most convenient form of double lantern, as the slides can be manipulated freely, and if necessary by two persons, or by a hand at each end. It is also

lighter and more compact than two separate bodies, and it can now be had at all prices, from plain japanned iron body and fronts, or wooden lined body and japanned fronts, to highly finished brass fronts. But as a great deal of money is often wasted on such instruments, a few words may be useful concerning what is worth paying for and what is not, which will apply to the tri-unial lantern in even greater degree. I have known a sum nearer 150*l.* than 100*l.* paid for a triple lantern and apparatus, nearly half of which was absolutely thrown away as regards any useful object, whilst the brass-work did not fit !

First of all, it is safest to avoid all apparatus distinguished by pretentious names or high-sounding adjectives, in any language ; choosing such as is made and sold by opticians of real standing, simply on their own reputation and guarantee. Of such there are no lack, and I have invariably found such apparatus cheaper, as well as more satisfactory. I do not say there are no exceptions to this rule, since even good houses may be led away in this advertising age ; but upon the whole it will be much the safest to follow it.

In the next place, lanterns should be avoided which have a multitude of ornamental mouldings or inlaid work about their wooden bodies. This is not only useless, but worse than useless. It adds weight, and the heat in the lantern will sooner or later find out weak spots in it, and make the mouldings warp and twist ; that is, if the apparatus be at all regularly used. A simple body, of good sound plain mahogany or other wood that can be depended upon not to warp, should be chosen, and really looks better, besides being cheaper, than tawdry ornament, which is out of place. On the other hand good fitting and finish about the doors, their sight-holes, the lining, &c., should be looked for. But especially the brass-work should be examined for good sound *workmanship.* By this is meant not lacquer and polish, but that the sliding parts fit nicely and yet smoothly ; the rack-work acts

pleasantly yet without shake; the screw-work screws and unscrews with accuracy and certainty. Thick and heavy brass-work generally masks poor workmanship.

What is best worth having in the way of objectives, has been described in Chapter II.

60. Focus, Distance, and Disc.—It will be fully understood from our first chapter, how the same objective which gives a 12-ft. disc at 24 ft. away, will give a 24-ft. disc at 48 ft. All details will be best gathered from the following table, showing the distance required to get a disc of given diameter with lenses of given focus, with slides of the usual 3 inches diameter. The foci given are real or virtual foci, and in double combinations what is called the 'back focus,' or distance of the back lens from the slide, will be less.

Disc wanted	Focus 4½ in.	Focus 6 in.	Focus 8 in.	Focus 10 in.	Focus 12 in.	Focus 15 in.	Focus 18 in.
feet	ft. in.	ft. in.	ft. in.	ft. in.	ft. in.	ft. in.	ft. in.
9	13 6	18 0	24 0	30 0	36 0	45 0	54 0
12	18 0	24 0	32 0	40 0	48 0	60 0	72 0
15	22 6	30 0	40 0	50 0	60 0	75 0	90 0
18	27 0	36 0	48 0	60 0	72 0	90 0	108 0
20	30 0	40 0	53 4	66 8	80 0	100 0	120 0
25	37 6	50 0	66 8	83 4	100 0	125 0	150 0
30	45 0	60 0	80 0	100 0	120 0	150 0	180 0

Or the following formula may be useful, as giving the data for any other slide than 3 inches. Calling the clear diameter of the slides in inches, *slide*, the objective focus in inches *focus*, distance from screen in feet, *distance*, and the diameter of *disc* in feet : then,

If we want the *distance* the formula will be,

$$\text{Distance} = \frac{\text{disc} \times \text{focus}}{\text{slide}}$$

If we want the *disc*, the formula is,

$$\text{Disc} = \frac{\text{distance} \times \text{slide}}{\text{focus}}$$

If we want approximate *focus*, it will be,

$$\text{Focus} = \frac{\text{distance} \times \text{slide}}{\text{disc}}$$

As regards foci of objectives, the most generally useful set of three would probably be 6 in., 10 in., and 15 in., or thereabouts. A 4½ in. lens is rarely wanted except to show through a transparent screen, when space is limited. The most useful single lens will be 6 in. or 8 in. I think myself 6 in. is the best upon the whole; and if ever a 6-in. lens is made as suggested on page 29, so that one component can be used alone for longer focus, as in some of the best of the photographic lenses, a 6-in. lens would do a vast range of work, as the single focus would be about 10 or 11 inches.

61. **An Exhibitor's Work.**—We will now suppose an exhibitor arrived with all his apparatus in the place where he is to exhibit slides, with a bi-unial lantern. Let us briefly see what he has to do, and how he will set about it.

His very first step will be to get up his screen, for which however we will refer to the following chapter. In the next place he has to choose his position, as just explained, according to his focus and the size of the disc he wants to show.

The position being found by a tape-measure, or stepping, the lantern will be unpacked and placed in position, generally on its own box (but see next chapter). Next, if it is a cold and damp night, and there is a fire or stove anywhere handy, it is wise to take out the condensers and put them to warm, and also the box of slides, opening the cover to let them dry. If gas is wanted for blow-through jets, the next step is to bring the supply from the most convenient place up to the lantern (see p. 47), and then the oxygen bag, or otherwise the pair of bags, are placed in the boards, or the cylinders placed securely where they will be used, and the regulators screwed on. Then we see that all taps are turned *off* on both the jets, and make the rubber connections. If the lantern has to be

I

worked in the middle of a room, it is very important to reserve enough space for the gas-bags or cylinders comfortably, and to have this space *protected* by making a kind of fence with some of the seats, within which no one is allowed to come. If it is a juvenile audience, it is important to get some elder lad appointed to act as sentinel over this.

The connections are made as in the diagram, which shows a star-tap (as the most puzzling). The hydrogen is connected from the bag or cylinder to the nozzle across which the *bye-pass* is fitted, if only one; otherwise to the one known to have the longest channel. (If the jets both persist in snapping out, with a tap that has two bye-passes, it is probable the gases are taken to the wrong nozzles supplying the dissolver, and that, from the unequal length of channel, the hydrogen cuts off before the oxygen). In the diagram, the hydrogen goes to the left, the oxygen to the right-hand nozzle. The tubes carrying from the dissolver to the jets may be connected to either top or bottom lantern, as regards one of the

Fig. 63.—Connections

gases, provided the other gas be connected to correspond. In the diagram the top hydrogen nozzle goes to the top jet, and therefore the *bottom* oxygen nozzle must connect to the same jet. With the other form of dissolver (fig. 61) both nozzles on the same side go to the same jet, and the cylinders or bags connect with the centre pair, and no mistake can be made by a person of ordinary sense.

The lantern lenses will now be wiped over if necessary,

and the condensers replaced when they have been removed for warming. If bags are used they will be weighted, and the tap of the hydrogen bag or cylinder turned on ; where gas from the main is used it will be already on at the dissolver. The latter being turned on to both lanterns, limes will be placed on the pins, first clearing their holes, and wiping off all loose powder with a bit of paper ; and the nipples of the jets will be adjusted to the known distance if needful. Turning each hydrogen tap half on in succession, the jets will be lighted, and the flame turned down moderately, when the limes will be turned round and warmed. When well heated throughout, one lantern will be turned off by the dissolver, and the ' on ' lantern have its jet adjusted for brightness according to the details in Chapter IV. The next step is a very important one.

F.G. 64.—Adjustment of the Light

62. Adjustment of the Light.—The lime has now to be got into the position which gives a disc *evenly illuminated all over.* This can only be properly done in one way. Any slide

is placed in the lantern, and the objective being *slid* into
approximate focus with the rack about half-way, is properly
focussed with the rack itself; then the slide is removed,
leaving nothing in the stage. The jet is now to be adjusted
according to the appearance of the bright blank disc on the
screen. Starting with the lime about 8 inches from the back
of the condensers, the disc may present any of the appear-
ances in fig. 64. If it resembles A, the lime must be moved
to the *left* ; if like B, to the *right* ; like C, it must be *lowered* ;
like D, it must be raised ; always moving it to the side *oppo-
site* to the dark shade, till whatever light or shadow there
may be, is central on the disc. It may now resemble E, when
the lime must be moved *nearer* the condenser ; should the
centre be dark and the edge bright, it must be drawn back.
When properly adjusted the disc will be even and bright all.
over, as at F.

Amateurs often fail in this adjustment of the light, through
attempting to accomplish it with a slide in the stage, by which
it can never be done properly. The only way is that here
described. The lantern first adjusted had better be the
bottom one, which is first to be given its proper inclination, so
as to show its disc centrally on the screen. Should the lime
have to be moved much to or from the condenser, it may need
a little re-centring, as this movement will take it a little out
of the optic axis, which is inclined somewhat to the slide of
the tray. Before the other lantern is similarly adjusted, its
disc must be made to coincide with the other on the screen.
It is necessary to centre the limes *with the pressure full on*
which is to be used; because if centred with a lighter pressure,
when more is used the luminous surface extends farther up
the lime, which is equivalent to raising the jet, and would
throw it out of centre.

Both lanterns being adjusted, the apparatus is ready ;
except that when the condensers cannot be warmed previously
at a fire, dew will form upon them in cold weather, and time

must be allowed for the heat of the jets to drive it off. If the time is at hand, this will be the next proceeding; but if there is some time to spare, it is best to turn off the gases at the bags or cylinders (the oxygen first), only taking care to re-light in time to get the condensers dry. Or a still better plan is to use a 'cut-off jet' as described in the following section. The final proceeding is to see that the slides are in order and placed handy, and the reading lamp placed ready if one is used; when all may be left till required.

It hardly need be remarked, that it is not enough to insert the slides upside down. For diagrams, or dioramic effects, just as much care must be taken to have them the right way as regards 'right and left,' and when exhibiting through a transparent screen, this will be opposite to what it is when an opaque screen is used. It is therefore most important to have all the slides *conspicuously* marked, the same way, so that they may be seen in the dim light of the exhibition hall.

On a damp night, if there is no time to dry the slides, there may be much trouble from dew upon them. To avoid this, each slide should, if possible, be warmed in turn on the top of the lantern, for which a flat top is so useful.

63. Cut-off Jets.—It is very common for a lantern exhibition to have an interval in the middle, and it is a matter of some consequence to be able to start again with all the lighting adjustments ready just as they were left. One lantern being turned off by the dissolving-tap still leaves the other 'on,' and we do not want to turn off the gas at the source, or to alter the taps at the jet, which would cause a slight 'hitch' when the lantern was first used again. All such inconvenience is avoided, and other obvious useful purposes served, by having one of the jets fitted with its own 'cut-off,' as invented by Mr. Andrew Pringle, which allows a single lantern also to be cut off, but left ready for immediate use in the same way. Fig. 65 shows this cut-off as added by Messrs. Newton & Co. to one of the jets already recommended on p. 64. An

additional tap is interposed between each of the usual ones and the mixing chamber. These taps are geared together by cogged wheels on the ends of the plugs, so that both are turned simultaneously by a bevelled cog-wheel worked by a spindle from the back of the jet. The plugs are so fitted that when the key at the back is turned as far as it will go in one direction, the jet is full on so far as these taps are concerned ; and when turned the other way the oxygen is cut entirely off, and the hydrogen all except a bye-pass. When full on, the light is adjusted precisely as usual by the usual jet-taps ; therefore, when turned off and on again, this adjustment is found pre-

FIG. 65.—Jet with Pringle's Cut-off

cisely as it was left. With a lantern thus fitted at an extra cost of about 15*s.* per jet, such an intermission occasions no difficulty whatever.

Another ' cut-off ' jet has been constructed by Mr. Oakley. Each plug of the ordinary taps has a screw piercing down the centre from the top, into the gas-way. The gases are adjusted by screwing these down so as to obstruct or free the passage, while each tap can be turned entirely off at pleasure, the hydrogen tap having a small channel all round as a bye-pass. The two taps have, however, to be turned separately, and some care is requisite to keep the adjusting screws gas-tight.

64. **Tri-unial Lanterns.**—By adding a third lantern to the top of a bi-unial, we get the tri-unial lantern, as in fig. 66,

which shows one fitted with shutter for the curtain effect,
(p. 122), and telescopic mounts. In nearly all cases the top
lantern is made removable, as here represented, so as to be
useful as a single lantern, and allow the remainder to be
packed lighter, as a bi-unial.

With the exception of the dissolving apparatus, there is

FIG. 66.—Tri-unial Lantern

little to add about the tri-unial. The object of the third
lantern is solely to allow of further dioramic effects, with sets
of slides made to exhibit such in combination. For instance,
dissolving into a snow scene may be done with two nozzles ;
but to do so combined with the effect of falling snow, can only

be done with three, and is a charming effect. Except for such extra effects, and for exhibitors who really use these, and know how to produce them, and can give care and skill to registering their own stock of slides for them, the triple lantern is a sheer waste of money ; and the greater part of those purchased are never really utilised.

The centre nozzle of a tri-unial is kept ' square,' and the whole lantern must be first tilted or adjusted by it to the centre of the screen, and this jet first got in order. Afterwards the top and bottom lantern discs are made to coincide with this, and then their jets similarly adjusted. It must not be forgotten that a triple lantern necessarily uses more gas.

All that has been said about bi-unials, concerning workmanship and simplicity of form (with however high finish) applies in a still greater degree to triple lanterns. I have seen one, regarded with evident pride by both maker and owner, which was a fair load for a cart, and must be a grievous burden anywhere but as a fixture in some hall or other. It should be remembered that these instruments have at least to be taken out of their cases and put back again.

65. Triple Dissolving.—The chief point to be really considered about a tri-unial lantern, is the system of connections and dissolving that shall be adopted. After a great deal of ingenuity, a single dissolving tap was invented, which by turning a lever to the proper lettered places on a disc, would bring any single lantern or pair into play. Such a tap costs about three guineas, but is not practical, as there is not light to read inscriptions during an exhibition. The only really practical tap of this kind I know of, is known in the trade as Noakes's Triple Dissolver. In this tap there are two sets of holes and two levers : one to ' set ' the tap as required to any pair of lanterns, and the other to do the dissolving. The setting handle can be adjusted in the dark with perfect certainty by touch alone, and the other action is quite as simple ; bye-passes can also be arranged as required.

General experience, however, does not go in the direction of any triple dissolver, but prefers an ordinary bi-unial dissolving tap for a pair of the lanterns, and a separate four-way tap (fig. 67) for the other one, which turns on or cuts off both gases as required.

A very usual plan is to have pieces of brass tubing plugged at the top, fixed up each corner of the back of the lantern, cut where the top lantern joins on, but connected with

FIG. 67.—Four-way Tap

an inch or two of rubber so as to act as one. The supply-tubes are stretched over the bottom ends of these pipes, and small side nozzles level with the dissolving taps connect with these. Rubber tubes connect the dissolving taps with the jets as usual. This is decidedly the most popular plan; but some experienced exhibitors prefer for each lantern to have its own single four-way tap, governing its own jet alone, supplied from brass mains as in the preceding case. Each tap has a double arm (that is, one extending on each side of the plug), and the upper pair of arms are connected by a brass rod on one side, and the lower pair by a rod on the other ends. The rods pass through sockets with pinching screws fixed on the arms, so as to work any given arm at pleasure, or slide loose when the screw is slackened. The result is that either the top pair or bottom pair of lanterns can be dissolved together at pleasure, the third being left independent for separate use. Or the pairs can be changed in a moment from top to bottom pairs if required.

66. **Bi-unial and Lantern Effects.**—A bi-unial lantern is necessary for many other effects than dissolving views, as

already hinted. A common addition to the better class is what is called a 'curtain-slide' of brass. This is a single brass shutter passing through both stages, and so adjusted (by screws) that just as much is shown on one disc up to a sharp edge, as is covered on the other. When raised or lowered, the effect is as if one picture *pushed* the other up or down. With statuary, a slide representing a curtain is used in one lantern, while the shutter draws up to reveal the statue. Or a curtain-slide is often used thus at the beginning and end of an exhibition. ·

The other usual effects fitted to this class of lanterns are 'flash-shutters' and 'tinters.' The first is a shutter of brass over the front of each objective, to shut off a lantern suddenly, or open suddenly, when the light is full on. Many dioramic effects, such as an explosion in a bombardment scene, must be 'flashed' on instantaneously to have any effect; a 'bang' being made in some way at the same time, for which a large gong does very well. Occasionally an axle is fixed between the two nozzles, on which revolve two arms with a shutter at the end of each, which can be moved out of the way when not required, but are adjusted to give the required 'flash' before the scene comes on. Personally (my experience being, however, very small, and quite as an amateur in these matters), I prefer to trust to the hand alone, held in front of the nozzle before the light is turned on, and which can be withdrawn in an instant, and with no risk of failure.

Tinters may add very much to the pleasing effect of plain photographs, if used with suitable subjects. Thus, a warm tint is easily thrown over a foreground, and a blue tint over the sky, or sea and sky, or on a moonlight scene. Tinters are of two kinds. Fig. 68 shows the most common. It fits on the nozzle of the objective, and any different colours can be fitted in the top and bottom shutters, while an opaque shutter outside can also be folded down, so as to gradually extinguish the picture altogether.

This is a favourite attachment to the single lantern also, as the screen may be darkened while the slide is instantaneously changed; for it may be taken as a universal rule in lantern exhibitions, where 'effect' is any object, that *the white screen should never be shown.* To do so makes the slides appear much less brilliant than if no such bright light intervenes.

FIG. 68.—Tinter

The other plan is to cut slits through the sides of the lantern body near the front, so that large pieces of coloured glass, or gelatine films between two glass plates, can be slid in and out of the lantern close to the back of the condensers. This plan is more costly, and weakens the lantern, but has an advantage in not interfering with definition, as the edge of a glass plate in front of the objective does to a small extent. But the 'saving of light' mentioned in some catalogues only exists in the imagination of the compilers. The apertures in the body are closed by narrow brass doors when not in use. By using one or more sheets of coloured gelatine between glasses, any depth of colour may be had for tinting purposes, with either form of tinter.

Statuary is best exhibited with all the slides blocked out with black, and *dissolved* into blue tint, a little of which may be left on with the statue if preferred.

Slide Effects are described in Chapter X.

CHAPTER IX

SCREENS AND OTHER LANTERN ACCESSORIES

WE have in the last chapter supposed the lantern in position, and the screen up ; but there are a few matters yet to be considered before we can dismiss practical exhibition work with such an assumption.

67. **Screens.**—There is no dispute at all as to what makes the *very best* screen, for all kinds of lantern work. It is, a fine smooth surface of white plaster of Paris, and next to that a smoothly whitewashed wall, finished with whiting, and not with lime. Such a surface is both white and *opaque*, reflecting back nearly all the light which falls upon it. Such a surface, as far as I have been able to ascertain from rather rough tests made with polarised light, gives fully 50 per cent. more light than the best white sheet, and 25 per cent more than the very best faced screens that can be made.

In public institutions, therefore, and especially where physical projections sacrificing much light are made, it is well worth while to reserve a proper space of wall at the back of the platform for such a surface, and to prepare it by a thin coating of fine plaster, carefully whitening thereafter as required. Even for ordinary lantern lectures it would be well worth while, as no one will question who has once seen slides projected upon such a surface 25 feet square. It is a matter of continual surprise to me that, now demonstrations by the lantern have become so customary in all halls and institutions, steps are not taken to provide for their best effect, in a simple and economical manner which nevertheless far surpasses anything possible to a casual demonstrator. The white surface can easily be draped over when not required.

In Germany it has been the practice for some time to pre-

pare portable plaster of Paris screens in an iron frame, of about 5 feet diameter, for microscopic projections; and in this way results have been obtained, which otherwise the instruments employed would have been incapable of producing.

The next best are portable screens of flexible material *faced* with some similar opaque coating. For any very special occasion indeed, the best plan is to have a sheet made of the required size—it is never worth while taking the trouble unless the screen is wanted at least 20 feet square—out of the stoutest unbleached calico, and tack it tightly on a light wooden frame put up in the hall, so that it is tense all over. Then the whole should first have a coating of size; and when this is dry, several coats of the cleanest whiting mixed also with size. Screens thus stretched, and distempered for the occasion, give such a good effect, that it is worth while to take the pains for any public affair of special importance; and as the sheet itself is portable enough, and will do over and over again, the cost is not great. For a course of lectures in an important place, where the screen can be left up, such a plan will amply repay the trouble.

I have read in different books that a screen of this kind can be prepared which will roll and unroll upon a roller, and keep clean. My own efforts have failed in making any, after many trials; but it is possible that some workmen with technical skill in distemper might succeed in such a screen. I know that the old Polytechnic screen was prepared in some such way; but that always appeared to me a very dirty one, and rather an example to be avoided than otherwise.

For ordinary lantern work, a simple screen of white linen or thick calico answers all purposes so long as it is kept clean, and it can be washed when necessary. This sort of screen, being the most portable, is used by travelling lecturers more often than any other. Up to nearly 10 feet square, material can be got for a screen in one piece. Above that it must be sewn together, and this must be done very carefully indeed, to keep

from creases or buckles. The seam should be judiciously placed. It is best to run horizontally, but in any case should not cross the middle. For a 15-feet screen a seam 10 feet from the top would be best ; a 20-feet sheet would be best made of one piece 10 feet wide, and 5 feet top and bottom. The eye naturally goes to the centre of the picture. and in this way the seam is less conspicuous.

The brightest portable screens are those made of some flexible material and faced with white paper, the latter being still better faced with some opaque material. For this latter improvement demonstrators are indebted to Mr. John D. Mason. This gentleman—himself an experienced lanternist—was kind enough to take a great deal of pains in obtaining various samples of white paper for me, with a view to a screen for microscopic projections. The best of these were a perceptible improvement over any faced screen I had been able to obtain before, but neither of us were satisfied, and I suggested trying distemper *on the paper*. I tried various preparations, and Mr. Mason others, but with the common result, that anything really white speedily flaked off the surface. At length it occurred to Mr. Mason to apply to the paper-hangers for samples of their mineral-faced papers; and some of the best of these I found to give a brilliance considerably beyond any surface of paper alone, while the expense is only about 50 per cent. more than of any ordinary paper-faced screen. It is not equal to a wall surface, but comes the nearest to it of any portable screen I am acquainted with. These screens have since become well known to, and highly approved of. by all the best London opticians. The largest I am aware of was 20 feet square, and it is much to be wished that halls which cannot or will not provide a wall surface, should provide a screen of this kind, to be rolled up when not in use. For an expense of a very few pounds once for all, lecturers would then be spared the most anxious and troublesome part of their preparations, and the effect of their pictures would be much

enhanced. Such a screen, faced with mineral matter, perceptibly improves the light for microscopic and physical demonstrations.

Small occasional screens are often needed in experimental work, and sometimes in a drawing-room. The cheapest and handiest material for such, is a piece of Whatman's continuous drawing cartridge paper. This can be obtained 60 inches wide of any length for a few pence per yard, and may be attached to a small roller.

68. Transparent Screens.—For common lantern work, the thinnest material in one piece ten feet square may be used, strained tightly, and wetted before the exhibition. The simple fact that the picture ' shows through' in this way, sufficiently accounts for the superiority of plaster or opaque surfaces over a sheet. A thinner muslin material is also employed, and this will have to be joined with as fine and imperceptible seams as possible. A transparent screen more than ten feet square is never used.

Transparent screens were very usual in early lantern days, when nine-feet discs were all that could be ventured upon. They are generally now confined to folding-doors in private houses, or semi-microscopic exhibitions.

The best transparent screen for microscopic work is one made of *tracing paper*. This can be had in continuous rolls 5 feet wide, and a screen of this width, with a light portable frame, is both very handy, and gives some charming results, though not equal to an opaque screen in illumination. Such a size is even large enough for pleasing drawing-room exhibitions with oil lanterns, which can be made on this scale without leaving the room in darkness.

69. Sizes of Screens.—The limits of transparencies have been stated. Faced screens are always mounted on a rod and roller, just like a map, and hence more than 12 or 14 feet wide is awkward to carry. For a hall there is no limit to these screens beyond the size of the wall on which they have to be

stretched in the making. For physical demonstration more than 10 or 12 feet is not required ; for microscopic work 12 to 14 feet is better. Both for the latter, and also for pictures, it is to be noted, that some margin *improves the effect* ; thus, a 12-feet disc will look much better on a 15-feet screen, than on a 12-feet screen. Regular lecturers .who use sheets, generally prefer to have two ; one 12 to 14 feet, and the other 18 to 20 feet square. If only one is used, 15 or 16 feet is the most useful size.

70. **Erecting the Screen.**—This is the most anxious piece of work of any to a peripatetic lecturer. When his screen is up, he feels at ease. He never knows, in a new place, what conveniences he may find, or what awkward arrangements he may have to get over. If the place is often used for such exhibitions, his first thought is to look aloft, as he is pretty certain to find a couple of eyes or hooks some distance apart, left by some one or other of his predecessors ; for it is an understood courtesy amongst lecturers, that any such hooks or eyes, once placed in awkward positions, are left to smooth the path of successors. If these are found, then, and are at a height and distance which fairly suit the size of sheet he means to use, he has only to find a ladder tall enough, and his task is easy. The eyes must be high enough to raise the bottom of his disc above the heads of the audience, and enough apart to be some inches wider than his sheet—how much wider matters little to him. If there are no such attachments, he must put them in himself ; so that it is always wise to make sure first of all, if necessary, that a ladder long enough is available. As to the eyes and hooks, with screwed ends, no exhibitor travels without these. If or when the top pair are all right, the exhibitor's next step is to screw a pair of *hooks* into the *floor*, a foot or two wider apart than the bottom corners of his · sheet, and just under where these will be.

There are various ways of fixing up the sheet itself. My experience has been of such an amateur character that it may

not be worth much ; but I prefer a row of brass rings sewn
a foot apart along the top of the sheet, through which is run
a piece of the finest and best sash-line, turned at each end
over a grummet ring, the line being long enough for the two
rings to come an inch or two beyond the corners of the sheet.
One corner of the sheet is tied up to its ring with a bit of
twine ; the other corner to such a position that when the line
is stretched, it slightly stretches the sheet also. The sides
of the sheet have sewn to them, every 18 inches, eyeletted
brass hooks like fig. 69, which can readily be made with a
pair of pliers. I also have a pair of small
wooden pulley blocks, each with an iron hook
for fixing ; and two long pieces of the same
best sash-line already mentioned, each with
a hook at one end.

FIG. 69

In getting up the sheet, each piece of line
is rove half-way through one of the pulleys, so that both ends
will hang down to the floor when this is raised ; and both
pulleys are then hooked on to the eyes fixed up aloft, with the
lines hanging down. When both lines are thus arranged, the
sheet is placed underneath, and so far opened that only the long
folds across remain unfolded. (A sheet should be always folded
up first into long folds all across it, and only then folded over
short, so that when these short folds are undone, it lies on
the floor its full width). The two hooks are hooked into the
grummet rings at the ends of the top line, the lines are hauled
up till this is stretched reasonably tight, and then the lines are
made securely fast to the hooks fixed in the floor.

The final step is to take two long pieces of stout twine, and,
fastening or hooking one of these into the top hook on each
side of the sheet, 'lace' downwards on each side between the
hooks and the line (which should be if possible about a foot
outside the sheet), thus drawing the sheet out tight and flat.
Finally, we draw down the two bottom corners, and fasten
them to the hooks below in the floor. It is as well even to

K

have a hook or two along the bottom of the sheet, which, if necessary, can be laced to another piece of line stretched between the hooks in the floor: but this last is seldom done.

It is more usual to sew rings on the sides instead of hooks; but in that case the lacing twine has to be passed through every ring; whilst with open hooks it can be 'caught' through them in an instant, and the lacing only takes a third of the time. Some exhibitors prefer the line at the top edge of the sheet to be sewn or hemmed to it; but I prefer the loose line (1) because the stretch of the line and sheet can always be precisely adjusted this way, and is sure to be evenly distributed all along the line; and (2) because if the line has to be renewed, there is less trouble. Some again never use pulleys, but pass their lines direct through the eyes aloft. This, however, greatly hinders proper stretching, and increases the force necessary to be used, besides wearing out the lines by friction. Moreover, a pulley can be fitted with studs to fit on a pin at the end of a long pole, so as to be hooked on to its eye aloft even if no ladder is available.

Small pulley blocks suitable for these purposes are easiest obtainable at the class of shops often called 'model dockyards,' where parts of naval models are sold.

Occasionally it may happen that the eyes, or only available places for them, are at the sides of a wide hall, many feet away from the edge of the largest sheet that can be used, and at such a distance that the top edge would sag down a great deal, with the tightest stretch that can safely be put upon the lines and pulleys. The remedy is very simple. After getting the sheet as high as is safe, two slender wooden strips are procured and placed as struts or props under the line, about a foot outside the sheet on each side. In such a case the sides will be laced to these props.

Faced screens are furnished with three rings on the rod at the top, and if necessary can be got up in the same way, drawing up a line run through these rings. Of course no

lacing is required, but it may be advisable to tie the ends of the bottom roller by pieces of twine to the floor. The ring at one end of the top roller should always be *tied with twine to the line*, to prevent the screen slipping about in raising or lowering. Care is necessary in lowering, to let the two sides down alike, a third person in the middle rolling up the screen tightly as it descends. If the screen has to go on a wall, three nails will be all that is required.

A water-tight wrap of oil-cloth or macintosh should always be provided for a screen of any kind, unless a sheet packs in the lantern-box.

Portable frames for erecting screens can be procured of all opticians, but are most suitable for the smaller sizes (say 10 feet and under) in private rooms. A common form is shown in fig. 70, the poles being built of three short pieces connected by tubular sockets on the ends, so that the stand for a twelve-feet screen will pack into a case about 4½ feet long by six inches square. These stands are to be had fitted with pulley-rollers at each corner, when they are equally suitable for either a sheet or a paper-faced screen ; the latter being simply hung, while a sheet is first strained over the pulleys, and then laced to the poles by twine or tapes.

FIG. 70

Another simple plan for elevating a roller screen, is to provide four pieces of pine-wood, each 7 feet or more long, and about 8 × 1 inches in section. Quarter inch holes are bored every three inches for a couple of feet from each end, and four bolts with flange nuts are provided. Then two of the pieces can be clamped together by two of the bolts, so as to make one prop, and these props can either be simply stood on end and secured by guy-ropes, or may be fitted into base-pieces, or may be furnished with buttress-pieces at the

bottom. The top roller of the screen itself keeps them the proper width apart.

A tracing-paper screen is always furnished with a portable stand, so constructed that if necessary it can be placed upon a table.

Transparent calico screens are usually stretched across the space occupied by folding doors. This is easily done by lacing twine *lightly* to large tacks, or even stout drawing-pins, which can be removed without leaving any conspicuous sign.

71. **Light for the Lecturer.**—Most of the opticians supply a sort of fold-up desk, which shades the light from all but the copy of the lecture; but such apparatus is now out of date,

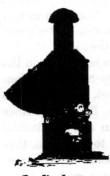

being superseded by a simple lamp. If this is properly shaded, somewhat as in fig. 71, which is a pattern very widely adopted in general, with little variations in detail, all necessary purposes will be equally secured, and some sort of desk or table can always be procured. These lamps can be had with a red glass signal to the operator at the lantern, who watches for this direction when to change the slide; and at option with a signal-

Fig. 71.—Lamp

bell also. A bell, however, is a nuisance in a lecture. Of late the excellence and cheapness of electric bell apparatus has introduced the fashion of carrying a wire from lecturer to operator, which operates a very small signal bell for him alone; but even this is audible unless the lantern is worked from a box or gallery. A signal by red light is the best. Any signal should be given some seconds *before* the change is required. Of course any operator acquainted with the lecture knows when to change without any signalling at all.

72. **Stand for the Lantern.**—It is a great comfort when the lantern can be worked from a gallery or box at the othe~

end of the hall. Failing this, the lantern has to be somewhere in the body of the hall, and must be raised considerably above the floor, in order that all the rays may pass clearly above the heads of the audience.

Nearly all the opticians figure in their catalogues some kind or other of tripod stand upon which to mount the lantern, resembling closely the portable stands used for travelling cameras. I would warn the inexperienced against such things, as a source of serious danger. It is easy to get a stand of this kind which appears perfectly firm; but the spreading legs are much in the way, are apt to be forgotten in the dark, and more than once have caused the whole concern to be tipped over, to the damage of many pounds' worth of property, besides the humiliation of the catastrophe. I never knew any experienced exhibitor who would run such a risk. Moreover, such a stand affords no accommodation for the slides.

All habitual lecturers prefer to stand the lantern upon the *lantern-box*, or cabinet, which is arranged to be entirely open at one side when the lantern is taken out, and furnishes a convenient receptacle for the box of slides, limes, and other odd matters required. If any sort of plain and substantial table can be found in the place for the box to stand on, that is the best, and the extra room is always useful. Every room where exhibitions are frequent, ought to have such a table, unless there is a box or gallery as just mentioned. If still more height is desirable, the table may be elevated on a couple of seats or benches, so placed that a couple of the legs stand on each. Such benches, when used, should be arranged *across* the room, when they will comprise the front side of the square or fence which has been already mentioned as so desirable when working in the body of a room.

But sometimes there is either no table, or only some polished library affair which the authorities will not allow to be used. Mr. T. C. Hepworth, a well-known and experienced lecturer, showed me several years ago a plan he had adopted to meet

such difficulties, and which enabled him to laugh at them. He carries with him four iron legs $1 \times \frac{6}{16}$ inch in section, turned out at the bottom into a toe, through which is a hole, by which all four feet are *screwed to the floor*. That is essential, as otherwise these narrow and somewhat spreading legs would be liable to the same danger as the tripod stands above condemned. The upper ends slip into iron sockets carefully fitted to them, and screwed to the four lower corners of the lantern box. The box has only to be mounted on these legs, and these latter screwed to the floor, and the whole is complete. If more height is required, the legs can be stood upon a couple of benches in the manner above mentioned; and there is no practical danger then of an upset, as the seats themselves define the places which the feet occupy.

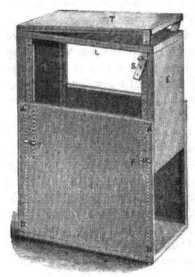

Fig. 72.—Rising Cabinet

Another expedient often employed belongs to the next paragraph.

73. The Lantern Box or Cabinet.—This can be made in many different ways, and should always be carefully thought out by the owner himself, in relation to his own apparatus and wants; as a great deal of his comfort will depend upon it. Fig. 72 shows a general method often adopted, in order to serve as a higher stand for the lantern. The main body of the box is open at both ends and at the top, and the ends E E, carrying the lid of the box L, slide up and down in grooves A B, A B, near the ends inside of the two sides; or it is better if the grooves are

not cut out of the wood, but formed by guide-strips fastened on. On each edge of each end-piece is fixed a strip of brass pierced with holes, by which the lid L can be secured at any required height by the fastening screws F, which pass through holes in the sides of the lower box. The lid of a box thus constructed can be fixed at nearly double the height of the box when closed, and this height is generally sufficient when the box alone is elevated upon forms or chairs.

At the back end of the lid of the box is hinged another top board T, which can be secured at any necessary angle by screws which act upon the brass sectors s. On this board the lantern is placed. All boxes should be fitted with a hinged double top of this kind, which saves time and trouble on every occasion in tilting the lantern.

With such a box as fig. 72 the lantern must be put in at one end. In plain boxes it is usually put in and taken out at the side. This should not open on fixed hinges, but have ' catches ' at the bottom, fastening in at the top with a snap sunk-ring latch, and lock and key. The object of this is that the side may be taken entirely away and leave the box open.

The internal arrangements will depend upon the apparatus, and individual preferences. An optician in large business usually has several people in his employ who are sent out to give entertainments ; and each of these is often allowed to have his own arrangements, which will differ considerably. The main object is, of course, to pack away all the apparatus conveniently, and every cabinet should have one drawer or compartment for the lime-box, matches, screw eyes and hooks, gas-nibs, gas-pliers, and any other odds and ends which should be always at hand. Another will be needed for the lamp, and another for the tubing, unless this is packed in the lanterns. The slide-box, on the whole, is better carried separately : but if a sheet is used it is much better in the box if possible. One case I have seen was arranged as a large square shallow box, the open side (when in position) taking

off as a square *lid*. The bi-unial lantern was laid down in
the box on its side, little compartments filling up all vacant
spaces between the brass fronts, &c.; and finally the sheet,
folded to fit, was laid over all, and served as a soft packing to
keep the whole from rattling. The box was made this way
to allow of the sheet being thus laid on the top last of all.

If the lantern has lengthening tubes and extra lenses,
precise fittings should be provided for all these; and 'packings'
should be carefully arranged, with proper cloth linings, to
keep the whole in place quite free from shake. A box thus
carefully packed is far stronger than one in which the lantern
is at all loose; and as the weight of a bi-unial or tri-unial
is considerable, an extra sovereign spent on the cabinet is true
economy. It only remains to add, that the cabinet should
be arranged so that all the jets, dissolvers, and their rubber
connections may be left in place; and that a measuring-tape
should by all means form part of the contents.

CHAPTER X

SLIDES, CARRIERS, AND EFFECTS

74. Slides.—Very little need be said about ordinary slides
for the exhibition lantern. They practically consist of four
kinds: there are plain photographs, tinted and painted photo-
graphs, and hand-painted slides. These latter have been in
so much less demand of late years, owing to the excellence of
the better painted photographs, that they are not easy to pro-
cure now-a-days; but they are still to be had by paying for
them.

Really good plain photographs are charming, and some of
the very best have been produced by amateurs. The main
thing is the extent to which the half-tones and atmospheric

effect of distance are rendered ; but I have seen many lantern slides by my friends Mr. Washington Teasdale and Mr. Hepworth, which were really exquisite pictures, and would have been simply spoilt by being coloured. Mr. Hepworth has fully described the processes he uses in his ' Book of the Lantern,' and also the practical details of tinting photographs ; and those who wish to attempt this branch of art with special reference to *lantern* purposes, cannot do better than consult his work ; the subject does not belong to these pages.

Painted photographs comprise the chief bulk of the slides exhibited, and may be either wretchedly bad or exquisitely good. It is very greatly a matter of price ; though not altogether, since a high price may be and often is charged for inferior work. On the other hand, however, a low-priced coloured slide cannot be good, since excellence depends upon having a good photograph in the first place, and then upon spending a certain amount of skilled handwork over it, by a competent artist. Really good hand-painted photographs of landscapes cannot be produced under from 5s. to 7s. 6d. each, according to the detail in the subject ; and it is a marvel to me how they can be finished for that. By this, however, I mean really beautiful pictures, such as are shown by exhibitors of high reputation. Figure subjects cost much more, if well executed. Coloured slides are sold at a much cheaper rate for children's exhibitions and such-like—an average price being 8s. 6d., but these are a different kind of thing altogether. Hand-painted slides may cost any money.

75. Carriers for Slides.—It has been already explained, that for the highest class of exhibitions each slide must be separately framed, that it may be exactly ' registered.' Many opticians who let slides for hire, which is usually done at from 1/6 to 2/6 per dozen, according to their quality, also prefer to send them thus framed, as less liable to accident. But it is not really needed for the ordinary class of dissolving-view exhibitions, and it saves a great deal of space and weight if

the glass slides alone are carried in a grooved box, and used
in some form of frame or ' carrier,' inserted in the slide-stage
of each lantern. Of these carriers there are many kinds.

The simplest is a solid frame, with a grooved opening into
which the slide drops from the top. This kind of carrier has
to be withdrawn from the lantern every time a slide is changed,
inverted to drop the old slide out, and then re-inserted with
the fresh one. About this there is some risk, and these
carriers are gone out of use since better ones have been
made.

Another form, more used some years ago than now, is
known as the panoramic carrier. In this the wooden frame is
the exact length of three common slides, and is clear from
end to end, but has only one mask or opening in the middle,

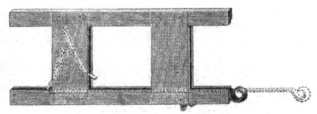

FIG. 73.—Beard's Self-centering Carrier

of the proper size. The carrier is left in the lantern, the more
firmly fixed the better, and the slides are slid in, so that when
a *second* slide is pushed in after the first, exactly even with
the end of the carrier, the first or middle one is in place. A
third is pushed in similarly ; and after that, as a fresh slide
is pushed in, care must be taken to catch the slide which is
simultaneously pushed out. The chance of forgetting this is
a risk about the panoramic form of carrier, which also has
the great drawback of requiring both hands at the instant of
changing. By having one end of the panoramic carrier cut
into stops at different distances from the end, different sizes
can be used after each other and still be centered. On rare

occasions this is an advantage, but the panoramic carrier has no other merit in my opinion.

If different sizes have to be shown in the same lecture, the best carrier is probably that known in the trade as Beard's self-centering carrier, shown in fig. 73. Whatever be the size of the slide, it has only to be placed upon the brass runner at the bottom and pushed up till it stops, and it will be in the centre of the stage.

The best and simplest carrier for any single lantern, or bi-unial, is, in my own opinion, the simple one shown in fig. 74, but it is only possible for slides of uniform size. There are two grooved frames with openings at the top, into which slides can be dropped, the two combined sliding freely from side to side in an outer frame which remains immovable in the stage.

FIG. 74.—Double Carrier

There is a stop at each end, so that when the inner frames are pushed up to either end, one frame is centered. The slide done with is out on one side, and can be lifted out by the fingers and the next one dropped in, at any convenient moment. Once dropped in it is ready, and a push in changes the slide in an instant. To prevent the dropping in of the slide making any noise, it is well to jam in a narrow strip of india-rubber (*flat*) on the bottom of the bottom groove.

This carrier is an especial comfort to the scientific lecturer, especially if he has himself to stand near his lantern, as often happens. The assistant has only to concern himself to have the next diagram *ready* in the frame not in use ; and can then bring it on in place of the other in the twinkling of an eye, or

the lecturer himself, if standing near, can do it with a touch of his hand. The blank screen is never shown. A single lantern is often fitted with an arrangement for gradually darkening down to complete obscuration in front of the objective ; and in that case also this carrier is best, because *in one moment*, with no possibility of hitch or mistake, the slide can be changed while the screen is dark, and the new one will then emerge out of the darkness. This simple effect is thought by many to be quite as pleasing as the now familiar dissolving views.

This carrier cannot unfortunately be used with two lanterns side by side, for obvious reasons. In that case perhaps the best form is that shown in fig. 75, where the inner frame

FIG. 75.—Carrier for Pair of Lanterns

travels to and fro in the same way, but can only be in position when pushed in, and has to be drawn back and out for the slide to be changed.

There are other carriers, some patented ; and any optician with a large lantern business can show an assortment, or at least representations of such from catalogues ; but the above are in my opinion the best.

76. **Mechanical Slides.**—These are of many sorts, and can only be mentioned here, a very large variety being merely of a comic character. They seem still to maintain their popularity amongst certain audiences, and are worth at least enumeration, as the effects produced may at any moment furnish some useful hint for more serious purposes. (See for an example Chapter XV.)

Slipping Slides have a portion of the picture painted upon a separate glass, which can be suddenly drawn along in the frame so as to produce some startling change. To allow of this, such slides have only a wooden edge frame like a slate frame, the picture being painted on an oblong piece of glass contained in this, and the rest blacked out. A familiar example is some figure carrying a dish; the 'slip' will draw forward and cover the head, whilst another head appears on the dish. Or figures will change heads, and so on. More seriously, the 'effect' of an explosion is sometimes done as a slipping slide.

The *Uncovering Slide*, as it might be called, is the same thing worked slowly, but may be single or double. Of the single form an example may be cited in the gradual lengthening of a comic figure's nose. A higher type of the double form may be found in the gradual unfolding of a carnation from the bud, with perhaps the final appearance of a fairy in the centre. In these cases the complete subject is painted on the foundation glass, and carefully fitted blacked screens are gradually drawn away on one or both sides. A flash of lightning is shown in the same way. Or the moon may emerge from behind a cloud, which, with a good dissolving-view 'effect' of moonlight, exactly registered, is very fine.

Panoramas speak for themselves, the moving parts being painted on a long slip of glass without frame, which is gradually drawn along in grooves over the fixed portion. (In all these movable slides it will be understood that the painting on both pieces of glass must be on the *inner* surfaces, which are nearly in contact; else the two could not be tolerably focussed together.) Vessels are often made to traverse a sea-scene in this way, or trains may be introduced; or if the slide is made vertical, a balloon ascent may be shown in the same way.

A very charming variation of panoramic slides is to have a series of good landscapes painted as a panoramic slip, moving across a mask carefully fitted to coincide with the

open space of a window or verandah, which is kept on the
screen from the other nozzle of a bi-unial lantern. The effect
is as if the panorama were passing the window; but of course
this manner of exhibiting uses a great deal of gas, both
lanterns being on all the time.

The drawback to panoramas is, that having to be specially
prepared they are expensive; and the long unprotected slips
are rather liable to breakage.

Lever slides have the movable portion painted on a
circular glass mounted in a turned brass rim which rotates in
a circular socket, and which can be thus rotated through a
certain arc only, backwards and forwards, by a lever projecting
at one side. This kind of movement is used to represent an
animal stooping its head to drink and lifting it again, a child
swinging or see-sawing, a man breaking stones with a ham-
mer, and similar alternating movements.

Rackwork slides are essentially of the well-known chroma-
trope kind, wherein two symmetrical geometrical designs are
rotated in opposite directions, each being mounted in a cir-
cular brass rim rotated by a toothed pinion. Straightforward
chromatropes, as they might be called, are easy to understand;
but few would imagine the startling *change* of effects in some
skilful designs, which may be found in the stock of any
London optician noted for this class of work.

The same movement is applied to many other slides.
Single racks represent mills, swarms of bees, sleepers swal-
lowing rats, &c. Double racks represent fish in an aquarium.
and the magnificent effect (when well executed) of a fountain
with moving water. Single or double racks are used to
produce the ascending smoke and flame of conflagrations or
volcanic eruptions.

A combination of rack and levers makes an exquisite
representation of waves in motion, with the riding of vessels
upon the heaving water.

The highest type of rackwork slide is one constructed

with a series of circular racks so as to show the motion of all the members of the solar system, which can be admirably done.

Roller slides have a small roller at the top and bottom, over which some flexible material is drawn in one steady direction by turning a handle. A black band pierced with small holes gives a snow effect, care being taken that the lantern showing the snow is not worked *brighter* than experience has proved to be best in effect. A transparent material painted in lines and set rather diagonally, will give a rain or hail storm.

77. Dioramic Effects.—Even this brief summary will be sufficient key to the variety and realistic effects obtainable for use with the lantern. Just as a suggestion and application, let us enumerate what may be done with one single landscape, with slides properly registered. It may be worth while to do this; because, with all the increase in instruments calculated to produce it, there seems in the present day a general disregard of that fine *dioramic effect* of which the lantern is capable, and which I cannot but think would be appreciated were it adequately represented to the public, as in the days of the old Polytechnic.

Let us suppose, then, an English landscape, with a windmill, and mill-pond in front. It may be first thrown on the screen in the fresh green of an English spring. Presently the mill turns round, then the scene dissolves (without appearing to change) into the warmer hues of autumn, and one or two swans glide gently over the glassy lake. The scene dissolves again into a tempestuous night, the sky covered with clouds, and little light getting through from the partly turned-down lantern. Flash after flash of lightning breaks across the dark sky, followed by peals of thunder (produced by shaking a square of sheet-iron), and finally a 'rain-slide' is thrown on the scene, the sound of the storm being well represented by pouring some barley into an appropriate

vessel, and a flash or two of lightning being still continued. Finally these effects are changed for one showing the moon emerging from behind a cloud. This must be done *very gradually*, and while the moon-slide is thus worked the scene is gradually dissolved into a bright moonlight scene, with the light effect upon the water. After a few moments a ' snow-slide ' is put in, and when this has fallen for a few seconds the landscape is again dissolved into a winter scene, with snow upon the landscape and ice upon the pond, on which skaters execute their gliding movements ; or this last may be done when the scene is again changed to a night and bonfire effect, with lights in the mill windows.

Such is an example of what may be called high-class dioramic lantern exhibition ; and if the different slides match and register *exactly*, the effect is indescribably beautiful. All depends upon that, and also upon having an adequate staff of assistants, for one alone could not possibly conduct all the various operations described. Two would often be required at the lantern itself, irrespective of any acoustic effects ; and in some cases the work would be better done with four lanterns than even three. At the Polytechnic as many as six were occasionally employed, but four would probably perform all·that was necessary even in such imposing spectacles as the siege of Delhi, which awakened so much admiration at the time.

78. **Experimental Slides.**—Besides scenic slides and effects, there are some often shown which are of a semi-experimental character. If two pieces of perforated zinc, or of wire gauze, are mounted in a double-rack chromatrope frame, they produce very interesting effects. Another slide known as the Kaleidotrope, consists of a piece of thin metal pierced with small holes, and hung by a pivot at the centre to the end of a coiled spiral watch-spring. When this is twitched by the forefinger, the metal both spins round and vibrates on the spring, and the effect is many apparently moving circles of

light upon the screen, interlacing with one another, and due to the persistence of vision. Beale's Choreutoscope rapidly substitutes different attitudes of the same figure, and thus gives the effect of motion, a favourite subject being a dancing skeleton; but this effect is better rendered by an apparatus used by Mr. Muybridge, in which the figures are rotated, whilst the Choreutoscope draws them along in a straight line.

A simple application of the pantograph has produced a lantern sketcher, which in clever hands is very attractive, sketching out a design upon the screen; and there is also an ingenious slide called the Cycloidotrope, sold at 30s., which by a combination of mechanism produces upon the screen, cutting them through smoked glass with a tracing point, most beautiful geometrical patterns of cycloidal curves. Real experiments belong to the latter portion of this work.

- - - - - - - - -

CHAPTER XI

ACCESSORY INSTRUMENTS

SEVERAL instruments are frequently used with ordinary exhibition lanterns for public entertainment, which demand a few words before proceeding to the scientific class of projections.

79. **The Kaleidoscope.**—This beautiful invention of Sir David Brewster for showing the symmetrical effects of multiple reflection, was adapted to the lantern by the late Mr. J. Darker. As is well known, two mirrors have to be fixed so as to meet at an angle which shall be an aliquot part of a circle. They are fixed in a tube as at A (fig. 76), and the effect is that the phenomena between them are repeated symmetrically all

L

round the circle as at B. For the lantern, the tube encasing the mirrors has a lens at each end, as in c, the tube with the pair forming an objective, which takes the place of the ordinary one, and focusses in a sliding jacket any object in the lantern stage. A rackwork slide containing some loose pieces of coloured glass, beads, and other small objects, between two glasses, is usually employed; but a revolving chromatrope also gives magnificent effects, and ears of bearded wheat or barley or oats, a loosely webbed feather or two, a key, bits of lace, &c., will give interesting pattern s.

The kaleidoscope requires very special management. It is placed in the lantern so that the mirrors stand with the

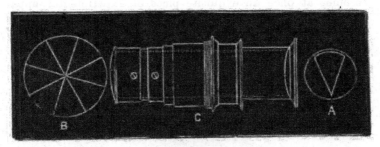

FIG. 76.—Kaleidoscope

edges upright like a V, and is focussed on the screen to its proper slide, or whatever is to be used. The effect, however, is at first a mere nothing—scarcely visible. The lime-jet has now to be *raised on the rod* for a distance found by experiment, but which usually lies between $\frac{3}{4}$ inch and $1\frac{1}{8}$ inch. The disc on the screen brightens up at once; and the light has finally to be carefully adjusted, both as to position and distance, so that all the segments on the screen are illuminated as *equally* as possible. Generally the instrument has also to be turned or adjusted a very little to the right or left, to avoid patches of darkness and get the best effect.

The lantern kaleidoscope *entirely* depends for success upon

this careful adjustment of the light. The rays, passing through the objects, strike rather downwards upon the mirrors, and are again reflected rather upwards; and in many instruments the effect is better if the front lens is somewhat inclined, so as to be perpendicular to the course of the rays. The kaleidoscope should always be warmed before use, to prevent dew upon the mirrors, if the night is at all cold.

I have seen a beautiful lantern kaleidoscope, specially constructed by Mr. Darker, in which the mirrors were adjustable by a screw to *any* angle through a considerable range. Such a form must necessarily be expensive; but an instrument of this kind is far removed from a mere lantern toy, and becomes at once an exquisite piece of experimental apparatus for demonstrating the laws and phenomena of multiple reflection.

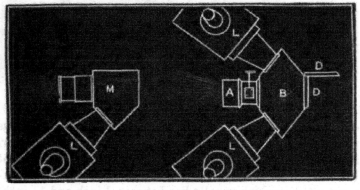

<div align="center">

Fig. 77 Aphengescope Fig. 78

</div>

80. Opaque Pictures.—Another simple instrument for exhibiting *cartes de visite* and other opaque objects, such as the works of a watch, is often called the Aphengescope—the mania for giving Greek names to lantern affairs is inexplicable to the ordinary mind. The usual arrangements are shown in figs. 77 and 78, one being adapted for two lanterns, and the

other for a single one, which latter, however, even with the lime-light, does not afford sufficient illumination to exhibit a *carte de visite* more than three or four feet in diameter. Taking the double arrangement in fig. 78, the two lanterns L L are turned *away* from the screen, the objectives removed, and their two nozzles fixed to holes cut to fit them in the box B. To the back of this box the two grooved doors D D are attached by a common hinge, so that when one door is closed the other is outside for the attachment of a new slide. One of the lantern objectives is fitted on the front of the box at A, and the *carte* or other object is shown by the light reflected from its surface, as shown by the dotted lines. The single instrument M shown in fig. 77 acts on precisely the same principle, but with only half the illumination.

A new pattern has been lately introduced by several English and Continental opticians. The body of the lantern itself is so constructed that when the objective is removed, a reflector can be introduced in front of the condenser, which throws the light back to a place above and behind the condenser, where there is a fitting to receive objects or slides. In front of this stage for opaque slides is another opening to which the objective can be attached. There are thus two positions in which the objective may be used, the ordinary one, and one above for opaque slides, an oblique reflector being always necessary when these are shown.

Coins and medals show very well with the opaque lantern.

81. **Microscopic Attachment.**—The ordinary form of projecting lantern is itself a microscope, since it projects upon the screen a magnified image—generally about 50 diameters—of the slide or object. There is no difference whatever in principle between doing this, with a lens of say 6 inches focus, and producing an image of 2,000 diameters with a lens of $\frac{1}{4}$-inch focus. The practical difficulties are connected with that management of the rays discussed in Chapter I; and these are very great as we approach the higher powers. Up to a

certain point, however, they are not formidable, and we will mention here some simple problems and forms of apparatus.

Fig. 79 represents the best form of the simple and old-fashioned microscopic attachment, which has been furnished by all opticians for many years. A still commoner form is sold, with only one slide-stage instead of the two here figured. In either case, the ordinary objective is unscrewed from the lantern front, and this attachment screwed in its place. It is usually furnished with two objectives, each composed of a couple of plano-convex lenses with their convex sides together, stopped down in front; but I have known two meniscus lenses used with their convex sides to the object; and there is no doubt that with care in select-ing the curves, and in proper spacing apart of the lenses, these simple objectives will do very fair work. I used a 2-inch focus lens of this kind for some time for its large field, even in the instrument hereafter described, with good results. Generally the foci supplied range from $2\frac{1}{2}$ and $1\frac{1}{4}$ inches, to 2 inches and 1 inch. These objectives *slide* into the rack-front, and thus roughly adjust focus, precisely as the lantern-front recommended on p. 88, the higher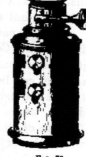

FIG. 79

power having of course to be pushed farther into the tube.

With the single-stage form of attachment, all that can be done is to roughly focus the object on the screen, and then draw back the lime-tray a little, and adjust it to and fro in the lantern, till the object is most brilliantly illuminated, which will be when it is just at the focus of the cone of rays from the condensers. This will also, for reasons already pointed out, be the position of best definition. The object may, however, be rather too large to be covered by such a focus, and if so the exhibitor must alter the focus a little to get the best result he can. These results, with a good operator and a good jet, may be very fair up to the limits of the powers supplied, which are

better as a rule for this class of work than achromatics. Such an object, for instance, as the head and tongue of a bee, can be shown with the higher of the two powers very fairly, as regards the general structure.

There is *great heat* at the focus of the cone of rays, and the microscopic attachment should therefore never be used for more than a few seconds, without a large glass trough, filled with saturated and filtered solution of alum, being first placed in the ordinary slide-stage of the lantern.

For exhibiting ordinary microscopic slides a wooden frame is used, somewhat similar to the ordinary frames of lantern slides. It is made to fit the stage of the attachment outside, and the ordinary 3 × 1 inch micro-slides inside. This frame has a movable end, by which the slides can be inserted in it as required.

With the double-stage instrument as shown in the figure, more can be done. The two stages were meant to place slides in position for the different powers; but the second stage is far better used in another way. In the centre of a wooden slider made to fit the stage, mount a plano-convex lens as near 1½-inch diameter as the slider will allow, and 1¾ to 2-inches focus. Whenever the 1-inch or higher powers are in use, place this lens, with convex side to the lantern, in the stage nearest the condensers. Adjusting the lime by hand as before, a great increase in light will now be gained, the cone of light being brought down into a smaller space. It will be found that decent results can now be obtained with higher powers, even as high as ⅔ or ½ inch, which will exhibit fairly such an object as the tongue of a blow-fly. Ordinary microscopic lenses may be used, with the help of a simple adapter.

82. **Improved Microscopic Attachment.**—This attachment was first constructed by Messrs. Newton & Co., to produce the foregoing results in a more handy way with ordinary achromatic microscopic objectives, and with something of the power of the instrument hereafter described. It screws in the same

manner on to the lantern front in place of the ordinary
objective, and is supplied with a secondary condensing lens
behind the stage. For those not accustomed to optical adjust-
ments, it is better that this lens should be *fixed*, making
adjustment of the light as far as possible by hand, with the
lime-tray alone. For those capable of using it, however, it
is better to have this condenser fitted in either a sliding or
rack-and-pinion adjustment, both of which forms are supplied.
Then by pushing this lens close up to the slide, the illumina-
tion resembles that of the lantern condenser itself, and covers
a field nearly equal to its own surface—say a circle of $1\frac{1}{4}$ inch
diameter; while by drawing it back till it focusses upon the
slide, a smaller surface is
much more brightly illu-
minated. The stage, in this
form of attachment, is en-
tirely open, and consists of
a rotating diaphragm-plate
pierced with apertures of
appropriate sizes for the
various objects, which are
held by simple clips. The
objective fitting is screwed

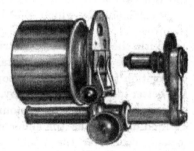

Fig. 80

for ordinary microscopic objectives, any of which may be tried,
and used if found sufficiently flat in field. If none such can be
found amongst the owner's own objectives, the most suitable
powers are the $2\frac{1}{2}$ inch, $1\frac{1}{2}$ inch, and $\frac{8}{10}$ inch from the list o
the larger instrument described in Chapter XIII. Fair results
can be obtained with powers as high as $\frac{4}{10}$ inch.

Since its first production, this attachment has found such
general acceptance, that some form closely resembling it can
now be obtained of almost any respectable optician, with or
without certain modifications presumed to be improvements.
Of most of these the reader may be left to judge for himself;
but he should be distinctly cautioned against one, viz. a

mechanical stage. The average ' *Shop*tician '—a very different being from the more serious *optician*—is very fond of an instrument with as many screws, and racks, and ' adjustments' as he can possibly crowd upon it. Many a purchaser is fond of the same ; and by all means let the one sell as much as he can, and the other buy as much bright brass as he likes. But the serious worker is of another sort ; and him I would warn that all useless lumber of the kind is, to an ordinary operator in the dark, simply a source of embarrassment and distress. I have worked too long at this subject not to be familiar with all manner of stages ; and affirm without hesitation, that a mechanical stage is not only useless, but a positive hindrance, for all but a limited class of work which will be mentioned in due course.

An attachment of this kind will do a great deal of really interesting work, including a large range of that fascinating modern pursuit, *photo-micrography.* The great bulk of ordinary pond life is within its powers, the beautiful *volvox* can be shown nicely, and a very respectable exhibition can be made of the circulation of the blood in a frog's foot, &c.

Leaving details respecting serious microscopic exhibitions for more full treatment in Chapter XIII., it is only needful to add here, that in all attempts at such, *special care must be taken in centering the light,* as a very slight deviation from the optical axis will cause a great falling-off in the results. It is also needful that the lime-tray should move truly to and fro, *parallel to the optic axis* of the lantern ; because at every change of power, or whenever the operator sees that the effect is not what he knows the instrument to be capable of, he should try, by moving the lime-tray a little, backward or forward, whether he cannot get a better illumination. Very often he will find that he can ; and, generally speaking, the lime will have to be *rather more drawn back* as the powers get higher. If the tray does not slide truly, therefore, the lime cannot be truly axial in both positions.

Lastly, let it be repeated, *never to forget* the alum trough in the ordinary slide-stage. Without this, ordinary balsam-mounted slides will be melted, and living objects rapidly killed by a heat nearly boiling.

For micro-projections of a higher class, the reader is referred to Chapter XIII.

CHAPTER XII

APPARATUS FOR SCIENTIFIC DEMONSTRATION

88. Demonstrating Lanterns.—Any good ordinary lantern can, by a little modification, be made effective in almost any class of demonstration. It may have a good microscope fitted to it, as described in the next chapter, interchangeable with the ordinary front. With a slide-stage open at the top, it will project chemical and other tank experiments. With accessory apparatus such as is presently mentioned, it will perform optical experiments. And by withdrawing the front, and arranging small apparatus in the rays from the condenser, it will project that apparatus. But for certain preponderating kinds of work, certain forms of lantern are best adapted; and for constant work, especially in educational institutions, the form of lantern should therefore be determined with reference to the kind of work to be chiefly done.

The modification and use of the lantern in a cheap and simple way to project pieces of apparatus as well as slides, was first systematised in the schools of Germany. Fig. 81 represents such a German school lantern.

The essential points are that the flange-nozzle is entirely removed, only an open spring-holder stage being left in the front of the condensers; that the objective is mounted in a separate support, which can slide along the double-rail stand

or base ; and that a small table, adjustable for height, can also be fixed anywhere on the same base. On this table any piece of sufficiently small apparatus can be adjusted, and projected as if it were a slide. The objective is surrounded by a shade to keep stray light from the screen. Ordinary

Fig. 81.—German Lantern

slides or diagrams are placed in the spring holder, and projected as usual.

This arrangement has been a great deal popularised in England by Mr. W. Lant Carpenter in connection with the Gilchrist Lecturing Trust; and where actual physical apparatus, and diagrams, are the principal subjects of projection, it can hardly be improved upon for handiness, cheapness, and simplicity ; but it is not so well adapted for optical and acoustical experiments, on account of the stray light. Fig. 82 is an American modification of it, arranged with a special view to

portability. The rails and legs are here dispensed with ; the lantern body is a mere frame hinged together, with a metal top, and covered round when in use with thick black cloth ; and the whole is placed on a table. The jet is also modified for compactness, the usual long metal tubes being dispensed with. Otherwise the lantern is essentially the same as the German model.

Lanterns of this type, either mounted on rails, or for

FIG. 82.—American Lantern

simply placing on a table, with little unimportant variations in detail, are now supplied by all the leading opticians.

For optical experiments chiefly, and incidentally for other physical demonstrations, the most popular pattern in public institutions till lately has been the well-known Duboscq lantern (fig. 83), fitted usually with the electric light. The square body is of sheet brass, and is mounted upon four brass pillars. There is a flange-nozzle fixed to the body ; and the special feature of the arrangements is, that the condensers are fitted in the back end of a large tube which slides freely backwards and forwards in this nozzle, the character of the beam being

modified by *sliding the condensers to and from the light*, instead of moving the light to and from the condensers. An adjustable slit, and a circular revolving diaphragm of apertures, fit into the front of this sliding tube. An ordinary front for showing diagrams can be interchanged with the optical flange when required.

This arrangement of movable condensers is convenient for *purely* optical experiments, and for focussing with the well-known Foucault and Duboscq regulators, which would be difficult to adjust in relation to a stationary optical system, and which as a rule are only employed intermittently. But for anything like a continuous arc light, the lantern itself is much too small, and has occasioned many very unpleasant burns: and optically the arrangement is unsuitable to any other projections than those with beams or pencils of light, because to get a good disc, in which to exhibit either diagrams or apparatus, is exceedingly difficult with it. To put it in another way, it is chiefly suitable for experiments without an objective. For any range of demonstration, there is need for more optical power than this lantern affords.

FIG. 83.—Duboscq Lantern

In some cases this increase of power may be best obtained by using two or more single lanterns, one of which might have a front on the Duboscq plan, and another carry an ordinary lantern stage and front for diagrams, or other fittings. For powerful arc lights the bodies should, however, be much larger.

Two ·detached lanterns have some obvious advantages, where detached or side experiments are of frequent occurrence. But in perhaps the majority of cases the demonstrator, equally with the exhibitor, may find it most advantageous to employ a bi-unial or even tri-unial arrangement, modified, however,

FIG. 84.—A Microscopic Bi-unial

according to his special purposes. This is especially the plan where the lime-light is the radiant employed. The simplest case is perhaps that of a medical school, which may desire to supplement the demonstrations of such a lantern microscope as is described in the following chapter, by photo-micrographs

and other diagrams. A suitable bi-unial, the simplest modi-
fication of the ordinary form, is that in fig. 84, and will per-
fectly suffice for such purposes, where physical experiments
are not required,

My own bi-unial lantern, being required for experiment,
as well as exhibiting slides and microscopic projections, was
designed differently. The bottom is supported on four brass
pillars, each 4 inches high, which allow gas-pipes for coloured
flames, or any other apparatus, to be readily introduced from
below, while a black curtain round these pillars, and another
round the back of the lantern, stop all stray light when re-
quired, the dark blue sight-holes being also covered by brass
shades. The top lantern is rarely used for anything but slides
and diagrams, and another similar front for the bottom one
converts the whole into an ordinary dissolving lantern when
required. This lower front is interchangeable with the
microscope front ; or both can be removed, leaving the bottom
lantern free for parallel-beam work or physical projections.
The base-board is also made to slide out, or close up shorter
as required ; and although the whole lantern is too small to
make regular work advisable with the arc-light, the jets are
so removable that the lamp presently described could be used
if required. The wooden body is of teak, *darkly stained* and
dull-polished. I believe the instinct which leads a scientific
demonstrator to desire something which *looks different* from
the ordinary ' magic-lantern ' of the itinerant lecturer, to be a
sound one ; at all events I plead guilty to the weakness, while
the dark wood and brass pillars have actual advantages in
practice.

Such a lantern is not, however, suitable for constant work
with the arc-light. A very well-known pattern of double arc
lantern is Ladd's, better known as the Browning model, shown
in fig. 85, where two nozzles, one reserved for diagrams, and
the other generally fitted on Duboscq's sliding-condenser plan,
centre on the same arc-light at the centre of the circle. This

is a good arrangement for one *fixed* position in a theatre, if the optician understands his business and arranges matters so that the arc-light is at a focus which gives an even disc at the given distance ; but if this is not attended to, a good disc of clear diagram will rarely be obtained. It is also best suited for old-fashioned lamps, with the carbons in perpendicular line, and was in fact first designed for spectrum-work, the nozzles being so arranged that, without moving the lantern, the rays deflected by the prisms should fall on the same screen as diagrams projected direct. To accomplish this, however, the same dispersive power must always be used : otherwise the lantern must be made to revolve upon the circular rim supported by the pillars.

When thus modified, however, it is better to have at once a tri-unial lantern, which is the most complete instrument of all, when properly constructed. The first attempts in this direction were not successful, the

FIG. 85.—Double Electric Lantern

three nozzles being arranged on three adjacent sides of a hexagon, copying an old exhibition arrangement by Canon Beechey. The objection to it is, that, whichever nozzle is directed towards the screen, another, or two others, also project in front, and interfere with manipulation. This fault is a grave one, and such lanterns have never come into use. The first

one I am aware of, constructed on sound principles, was
planned and carried out by Messrs. Newton & Co. for the Santa
Clara College of California, on the plan represented in fig. 86,

FIG. 86.—Tri-unial Electric Lantern

and shown in ground plan, with its lamp, in fig. 87. Here the
three nozzles (which in this case carried a projection-microscope
capable of 5,000 diameters, a diagram front, and an optical
front with all the usual accessories) are arranged at equal

intervals round the whole circle, so that whichever points forwards, the others are backwards, and out of the way. There are three doors with shuttered sight-holes of darkened glass, between these nozzles, so that the arc can always be examined either from the back in the optic axis, or from either side. The foundation circle is supported on four strong pillars, standing rather outside the body, for steadiness; and the whole body revolves easily and truly upon this circle,

MICRO. FRONT
Fig. 87.—Plan of Lantern

and may be fixed at any angle, while a spring detent ensures that each front ordinarily finds its exact position. Furnished with the electric lamp and focussing-table next described, this form of lantern is the most complete, convenient, and powerful instrument for scientific demonstration with which I am acquainted, and has been adopted by the Royal Institution.

A lantern made on this plan for the arc-light must be pretty large on account of the heat, as the lamp may be in

M

action all the time, or nearly so, with one nozzle or the other ; for any front can be brought into operation as simply and easily as by turning a dissolving-tap. But it has also been constructed on a smaller scale for the oxy-hydrogen light, which in this case is best fitted with three rectangular adjusting motions. As such a lantern may be occasionally used with a moderate arc lamp without detriment, and the arc is really only required for occasional purposes, unless a long high-power microscopical demonstration be on hand, such a smaller pattern would be sufficient for the majority of institutions. The larger pattern is preferable where a current is available and used constantly.

84. **Arc Lamps.**—The Duboscq lamp is too familiar to need description. It is only fit for battery use, and for intermittent experiments, being incapable of giving a really steady light. An equally serious fault is the length of the arc between the carbons, the centre of the radiant being dark, between two luminous poles. With about forty Bunsen or Grove cells, however, this lamp answers the purpose for ordinary optical experiments, and to get an even disc with it is possible, though it requires more skill than most assistants possess. Mr. Cottrell, formerly demonstrator at the Royal Institution, stood almost alone in his power of getting a fairly steady and well-centred light with this form of regulator.

The lamp known as the Suisse-Serrin is a very much better lamp of this class. It uses larger carbons, and I have known it, in the hands of my friend the Rev. P. R. Sleeman, give a nearly steady light for a continuous half-hour. For battery use only, this is an excellent lamp, and by setting the positive carbon somewhat behind the other, the evils of a double radiant can be partially avoided.

For the dynamo currents of modern days, however, this lamp is not well adapted, and many regulators now in the market give better results. I have seen very good work done

with the small-sized Siemens' differential lamp, and also with the Gülcher, which is very steady if a proper resistance coil be interposed in the circuit. Others also doubtless give good results. But the most important point in an optical lamp is the concentration of the radiant into *one* luminous point. All the usual lamps fail in that particular; and in perfecting the arrangements of the electric projecting microscope, especially, I was continually baffled by the confusion caused by the *two* luminous points or poles, which was only partially remedied by setting the positive carbon behind the negative. For some time, pointing this out, I endeavoured in vain to induce various makers to construct an optical lamp with carbons inclined at an angle of 30° or 40°, after the manner well known in the hand-regulated 'projector' lamps often used at sea.

Being finally advised by Professor S. P. Thompson to adopt for other reasons the Brockie-Pell lamp for microscopic work; and finding upon inquiry that Mr. Brockie had already constructed for Mr. Phillips a simpler arc lamp for lantern use, adjusting the arc by the *potential* of the current, in which the negative carbon worked up by a kind of candle-spring to a fixed stop, so as to 'keep in focus,' while the arc could be readily adjusted to any current within reasonable limits, I urged upon him very strongly to further perfect it for some microscopes then constructing at Messrs. Newton's, by giving the carbons the slant just alluded to. He at once undertook to do this (my sole suggestion in the matter), and the final result of the additional alteration was a lamp whose external appearance can be seen in the representation of the electric microscope on p. 209. This, as an *optical* radiant, is far the best I am acquainted with; and up to this date is, I believe, still the only focus-keeping regulator-lamp whose carbons occupy the proper inclined position. It is extremely portable, steady upon its base, very simple in mechanism, and its cost is only fifteen pounds. It is not the lamp usually

called the Brockie-Pell, but of much simpler construction ; and the same lamp can be adjusted from about 7 to 15, or from 10 to 20 ampéres of current, according to its size. I have seen it work for two hours without a single ' blink.'

The effect of the inclined carbons is shown in fig. 88. The lower carbon is still set in front of the upper or positive carbon, according to the length of arc. This brings the ' crater ' considerably to the front of the carbon, while the incandescent portion of the negative carbon is behind, and invisible from the front. Hence the radiation *to the condensers* is reduced, as shown in fig. 88, to that from the crater, while

that crater radiates much more directly and powerfully ; the general result being, not only the one radiant point, but that of so much greater power, that a lamp which would usually be called of 2,000 candles' power, gives to the condensers at least 3,000 in proportion. The gain in all microscopic and high-class

FIG. 88

optical work cannot be over-rated.

The management of this lamp is very simple. The upper carbon, first set by experience the proper distance behind the other, is pushed down by hand till it just touches the lower one without pushing that down ; as the current when switched on must draw it down a small distance in the usual manner by an electro-magnet, and so strike the arc. The position as to height of the point of the lower carbon, and therefore of the arc, can be adjusted within considerable limits. The current will first have been ascertained, at least approximately. If the current is sufficient to work the lamp to its full power, the milled head which regulates the arc, seen behind the upper carbon pillar on the top of the lamp case, is turned to

the right nearly as far as it will go ; if not, each full revolution
to the left will lower the potential from 1½ to 2 volts. The
arc having been struck, the lamp is run a little till it has
attained the length desired ; when the regulator is turned
very gently to the left until the mechanism gives a 'feed,'
with the accompanying click. When this is adjusted, the
lamp will regulate itself. Only if the current is very small
for the lamp, may it be needful to push down the lower carbon
a very little, so that the arc struck may be from the first
shorter : afterwards the procedure will be the same. For
smaller currents smaller carbons will of course be used. Hard
carbons should be used for the negative, and soft-cored ones
for the positive pole. The collars against which the lower
carbon is forced by the spring are provided of various sizes
according to the carbons, so that the point protrudes the
required distance.

The only purpose for which this arrangement is not suit-
able, is vapourising substances for spectrum projections, which
require vertical carbons and the crater at the bottom. The
needful modification which allows the Brockie lamp to be
used for this also, is described in the proper place.

The Brockie lamp does, however, require a continuous
current ; and I confess that I dread the growing tendency to
alternate currents, as regards all work in public demonstra-
tion. A lamp can easily be made to work with such currents ;
but as there is no positive 'crater,' the *special* radiation from
one cannot be had, and we can only hide one of the two
luminous poles at the expense of fully half the light. This
is a real difficulty, only at present to be overcome by storage
batteries. Moreover the manipulation occasionally necessary
in all optical work, is liable with alternate currents to produce
very unpleasant consequences. Should a continuous current
of, say, 10 ampéres at 50 volts give an accidental shock, though
unpleasant to most persons at the moment, it would have no
further effect ; but the same current taken alternately would

give a shock to the system the effects of which would be felt
for hours. Demonstrators, at all events, have reason to look
with dread and dislike upon the extension of the alternate-
current system of lighting.

For high-class optical work, and especially microscopic
work, in which one millimetre of misplacement will make a
great difference in effect, even a Brockie lamp should be
mounted on a stand constructed like a slide-rest, with three
rectangular screw movements worked by milled heads. The
lantern represented in fig. 86, p. 160, is shown so mounted,
the extra cost of which, substantially made in gun-metal, is
about 10*l*., but which is well repaid in the perfect facility
with which the incandescent crater can be brought back to
focus in any direction, or moved in the line of the optic axis
as required. The illumination in a lantern thus furnished
is magnificent, and perfectly steady.

A switch for the current should be provided on the base of
the lantern itself. It should never have to be felt for, or
looked for, elsewhere. Any alternate-current lamp should
only be handled with gloves, for a shock from such, as already
hinted, is very serious. That from a continuous current is
simply unpleasant. A lamp always works best with a rather
larger current and a corresponding resistance added to the
circuit. A small gas-jet is a great convenience inside an
electric lantern.

85. **Vertical Projections.**—It is very often necessary to
throw the projection of fluid surfaces, &c., vertically upwards,
afterwards reflecting it to the screen ; and the same arrange-
ment is very convenient for working out a diagram before a
class. This is generally effected by some form of the *vertical*
attachment devised by Professor Morton, and shown in fig. 89,
a similar arrangement by Stöhrer of Leipzig being shown in
fig. 116, on page 227. The lantern condensers are arranged
so as to throw a parallel beam, which by a large reflector at an
angle of 45° is deflected vertically, where it passes through a

third plano-convex lens, which converges the light, and over whose face is the field of the instrument. A pillar at the side supports the focussing power, a ring allowing various powers to be used : and the same ring-fitting carries a second silvered reflector, turning on an axis so as to throw the image at any desired height on the screen. If a sheet of fine ground or smoked glass be simply laid over the face of the large lens, a diagram can readily be worked out, and is often better under-

FIG. 89 FIG. 90

stood when so worked out, than if projected complete. It will be still more transparent if the glass is first rubbed with a very little paraffin oil.

Some opticians substitute a right-angled reflecting prism, but the second reflection from a silvered mirror is practically imperceptible except in white line diagrams drawn upon really blackened glass. For such a prism is advisable, and is always employed in Duboscq's form of the apparatus.

An effective apparatus can be made very cheaply as in

fig. 90. The reflector is here simply set in a wooden cubical box, with the side which is turned towards the lantern condensers left open. A rod at the side carries a plain lens in one of the sliding fittings presently figured, and another sliding socket carries the reflector.

The illumination is not even and good with such attachments, unless pains are taken to accurately adjust the first reflector as regards the parallel (or slightly diverging) rays from the lantern condensers. To ensure this the lantern itself is often fitted up by Hawkridge, and other American opticians, as in fig. 91. Here the two first lenses of a triple condenser are mounted in the body of the lantern, which is supported on pillars; while the third or converging lens is fitted in a plate hinged to the top of the lantern front. This plate has at one side a pillar or standard, which carries the focussing power and second reflector. For vertical work, the lantern is arranged as in the diagram, the front plate and lens being supported in a horizontal position by a movable triangular box, to whose hypotenuse side is fixed the reflector; but when ordinary work is required, this box is removed, when the plate drops down to a vertical position, with the focussing power out in front as usual. The second small reflector is

Fig. 91

then removed, when the lantern projects direct. Several of these lanterns have reached England; but there seems a sort of national 'fashion' in apparatus, and so far as I am aware, they are thought rather awkward in use by their possessors.

Messrs. Newton & Co. have constructed a bi-unial lantern

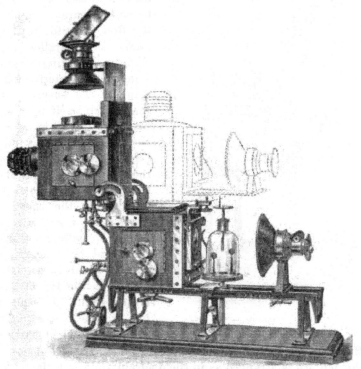

FIG. 92.—Newton's Vertical Bi-unial

which produces vertical projections in another way, shown in fig. 92. There are two separate lanterns, the top one so *hinged* to the bottom one that the top lantern can be turned back in a moment, so as to rest against stops and point vertically

upwards. An adjustable mirror can then be attached by a very simple fitting, and will reflect the image upon the screen. The objectives of both lanterns are mounted on the detached system already described for physical work. One lantern is therefore always ready for ordinary work of any kind, while the top one can either be used in the same way (the whole as an ordinary bi-unial exhibition lantern if necessary) or can be converted at a moment's notice to vertical purposes. A screw is provided to keep the tray and jet from dropping out of the proper position.

I was at first apprehensive that the heat of the jet, when thus brought under the condenser, might prove a fatal objection to this arrangement; but it has not proved so, provided the jet be kept *in work* while the lantern remains vertical. If the jet is turned off so that the flame of coal-gas, released from the pressure driving it down, rises *upwards* towards the condenser, a crack will probably result; but it is easily avoided with this caution, and more brilliant projections are thus obtained than in the other way.

86. Erecting Prism.—For the mass of physical experiments the ordinary inversion of an image does not signify, and is readily understood by the audience. For thermometric and some other experiments, however, it becomes of importance, and in such cases is obviated by the use of a prism, as described by Bertin, Müller, and others. Fig. 93 shows the action of a right-

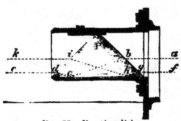

FIG. 93.- Erecting Prism

angled prism P used in this way. The ray *a b* is refracted to *c* and there reflected, and again refracted as *d e*; while *f g* is refracted to *h* and there reflected, coming out as *i k*; thus the top and bottom rays are inverted, and the image is erected. The best position for the prism is where the cone

of rays from the lens is reduced to its smallest diameter at the apparent crossing-point.

A right-angled prism is ordinarily employed, but is not the best form, as a large portion of the prism at the apex P is quite outside the field of all inverted rays. By making the prism with all this waste portion truncated, the same effective field can be obtained with a much less massive piece of optical glass, and the cost thereby much reduced. Another method is to employ a greater angle than 90°, and Zentmayer adopted an angle of 126°, which utilises all the field to the apex. Such a large angle, however, loses appreciably more light by reflection; and, on the whole, I consider the best results are obtained by a combination of the two methods, adopting an angle of about 105° and truncating the prism sufficiently to have no surplus glass.

An erecting prism should not be used unnecessarily, as its adjustment takes time, and there is considerable loss of light.

87. Optical Front.—For general use in optical and some other experiments, a special focussing front is desirable, of construction some-what different from the ordinary one for exhibiting slides. I have found the arrangement shown in fig. 94 very convenient. A B is a

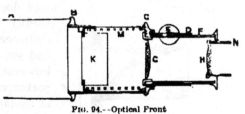

Fig. 94.--Optical Front

tube or fitting which fits nicely into the lantern nozzle like the usual one for diagrams. B C is a tube 3 in. diameter which screws into a collar at B, and having a rectangular opening E cut through both sides to serve as a slide-stage. The opening should be 1¼ inches by 2⅜ inches, so as to receive easily slides over 1 inch thick, and 2¼ inches wide. These slides are pressed to the back by a flange L, forced against the slide by a spiral

spring M, and worked by the hand through two studs working in slots at the top and bottom of B C. Into another collar at C screws the jacket D of the focussing tube, which may either slide nicely, or have a rack and pinion E. The lens tube F is about $2\frac{1}{4}$ inches diameter, and carries a combination power of two lenses, the back one a plano-convex 2 inches diameter, plane side towards the stage, and 5 or 6 inches focus (both are convenient), and the front lens rather over $1\frac{1}{4}$ diameter, about 8 inches focus. This lens H screws into a collar from which projects a nozzle, N, $1\frac{3}{8}$ external diameter. The exact diameters are, of course, not material. A rack and pinion has advantages and disadvantages. The advantages are obvious. On the other hand, a sliding movement may be made very pleasant if cloth-lined, has more range, and allows of easy withdrawal of the power, and substitution of a slit or series of apertures. With a rack front this substitution has to be effected by unscrewing the jacket from C, and substituting a plain jacket to carry those fittings.

Such a front is very useful for a great deal of work in optics and acoustics. Though the lenses are simple, it is free enough from aberrations for practical purposes, and is the best power for a polariscope. On its smaller slides a great deal more light can be condensed; or a slit for spectrum work, or an aperture for diffraction, can have sufficient light condensed upon it to work 'direct' for many experiments, without any other lenses. Finally, when the power is removed, and a slit or aperture placed in the front of the jacket, by inserting in the stage E a cylindrical or spherical lens mounted like a slide in a wooden frame $4 \times 2\frac{1}{4}$ inches, the aperture or slit can be easily adjusted in the focus of the lens, and the utmost amount of light thus brought to bear upon the phenomena.

88. **Parallel Pencils.**—With the arc-light as a radiant, no further arrangement is required for small parallel pencils than to pass a parallel beam from the condensers through the most appropriate hole in a circle of apertures. But with the

lime-light greater brilliance is often desirable, especially with such a projection as a Barton's button or a Lissajous' combination figure. Even a polariscope, with field of, say, $1\frac{3}{4}$ diameter, is improved in performance by sending all the light from the condensers through such a field. This is easily managed by a reducing system of lenses similar to that shown in fig. 95, but the convex and concave lenses being of greater foci and diameter, and so adjusted (with a movable adjustment is desirable) that when the radiant and condensers are arranged for a parallel beam, and the system inserted in the flange-nozzle, the rays converged by the convex lens are re-parallelised by the concave within two inches diameter. A parallel beam of two inches is convenient for many purposes, besides giving greater brilliance to polariscope projections.

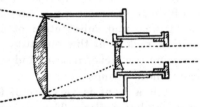

FIG. 95. -Pencil Attachment

But still more useful is a smaller arrangement of the same kind, in which the condensing lens is of about $1\frac{1}{2}$ inches diameter and 2 inches focus, and the concave paralleliser about $\frac{3}{4}$ inch diameter, with removable caps or apertures from about 2 mm. to 16 mm. fitting in the front, as in fig. 95. The light from the condensers is slightly converged upon the back lens, and by this further converged upon the concave, where it is parallelised as a small pencil. By such an attachment a very brilliant pencil of light of any diameter from 16 mm. downwards can be obtained with the O. H. jet. The rays will of course scatter or diverge considerably, even when parallelised as far as possible ; but in acoustical projections this is an advantage rather than otherwise.

Such a 'pencil' attachment has another use. By removing the concave paralleliser (which should be removable) a strong *conical* pencil can be thrown through a very small hole, in

whose diverging rays large shadow projections will be well
defined, as described in Chapter XIV.

Such an attachment can either be fitted into the jacket C D
of the optical front (fig. 94), or if the back lens be made of
longer focus, it may simply be fitted into the small end nozzle
N of that piece of apparatus.

89. **Optical Accessories.**—For general focussing and other
purposes there should be provided, wherever physical demon-
stration is attempted, at least two rod or pillar stands, made
by screwing a half-inch brass tube into a heavy foot, covered

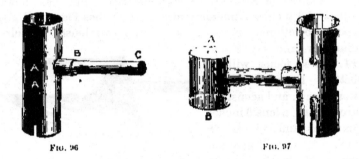

Fig. 96 Fig. 97

at the bottom with baize. On these should slide tightly
sockets as shown in fig. 96. Small holes, A A, are bored trans-
versely through the tube of each socket, and saw-cuts made
from the ends of the tube down to them ; then a slight pinch
in a pair of gas-pliers will tighten the fit at any time. To
one side is soldered the smaller tube B C. All these are one
gauge, so that every piece of apparatus will fit into any
socket-tube B C, and turn round in it to any position. One or
two sockets should be provided modified as in fig. 97, a perpen-
dicular socket A B being soldered at the end of the projecting
spur-tube. The gauge of the aperture in A B is to be the same as
in B C of fig. 96. Thus any piece of apparatus may be placed
therein and be capable of turning on a perpendicular axis.

Into sockets thus arranged we can fit any apparatus, by

mounting it like the glass prism shown in fig. 98, with a spur-like rod or tube A B, which fits in the sockets of the pillar-stands. Though such a prism does not give sufficient dispersion for many spectrum experiments, it is very convenient for elementary ones.

One or two *focussing lenses* should be mounted in the same way; but it is better, and shields stray light from the screen, and thereby improves the projection, for each lens to be mounted with a rim or shield of blackened tin round it, about two inches wide. The size and focus of the lenses depend upon the size of room, and screen distance. For class-rooms a lens of 3 inches diameter and 8 to 10 inches focus will give good projections. For a larger scale, two lenses 4 inches diameter, and say 9 and 14 inches focus, will be better. For good diffraction effects, and acoustical projections, a lens 6 inches diameter and 14 to 18 inches focus, will give superior effects, the long focus giving more room to work.

Fig. 98

A *plane mirror* formed of a piece of good plate looking-glass about 6 × 4 inches, should be mounted in the same way, the spur projecting in the plane of the mirror from the middle of one of the longer sides. For some experiments a larger mirror may be useful.

Occasionally a somewhat steadier mount than these sliding sockets may be needed. In that case there is nothing better than the usual *telescopic* stem with a tightening collar, screwed into the centre of a very heavy foot, and with a socket of the usual gauge drilled perpendicularly into the top end. This socket should have a set-screw in one side, so that any apparatus can be fixed fast in the socket.

90. **Stands and Manipulation.**—The mounting of a demonstration lantern requires some consideration, much more

freedom of movement and of access being required than is needed in the mere projection of slides. Very often, unless the lantern itself is a revolving one, it must be readily capable of being turned about at various angles with the screen.

A simple and effective way of working is to place lantern and accessories on a bare and smooth wooden table, whereon

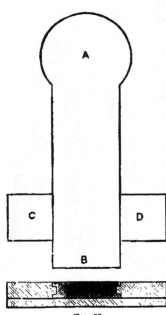

FIG. 99

each lens or other piece of apparatus can be adjusted *ad libitum*. Such a table should never be covered with cloth or baize, as this would destroy all freedom of movement; but if appearance be desired, it can easily be draped round, and its surface dead-blacked or ebonised. If the condensers used for physical work are of the proper height, the lantern needs no more than a circular base, on which it can turn easily, to be clamped in any position by a screw under the table. The heaviest lantern may be mounted so as to turn easily, by letting a revolving metal plate carrying the lantern, with a shallow groove in its under surface run upon a few bicycle balls.

Otherwise it is convenient for the revolving base to be mounted on three short legs, so as to form a short tripod, which stands upon the table. Each leg should in this case have a piece of india-rubber cemented on the bottom, so that the tripod may 'bite' and remain steady. The subsidiary apparatus may still be placed about the table as before, if the heights are adjusted for such an arrangement. But it is more

convenient, as a rule, to prolong the revolving base as in fig. 99, into a board about 9 inches wide and three feet or more in length, A B, while another cross-board, C D, can be slid along as shown in the section below the figure, so as to form a T-piece of the same level, at any distance from the lantern within the compass of A B. The use of this arrangement is very obvious. Suppose we are projecting the surface of a soap-film. This film will stand diagonally across A B and reflect the light to the screen approximately in the direction of C D; and the transverse board C D gives us a base on which to place our focussing or projecting lens. So of other cases in which the lantern has to be deflected. The end B of the board A B is of course supported by an upright of proper length, which may be hinged to it. The revolving portion of the stand can be quite well constructed of seasoned hard wood, if two layers are glued together with the grain across, and there will be little friction if a judicious use be made of black-lead.

Fig. 100

When work is done upon a table, there is one point to keep in mind. If it is necessary to cant up the optical beam in order to get a good position on the screen, it must not be done by canting the lantern itself, as in slide exhibitions. The *whole table* must be canted, by placing blocks under the front legs. Otherwise all adjustments for height will be destroyed, as apparatus is moved nearer to or farther from the lantern. The optical beam used for *physical* work must be parallel to the surface of the table.

N

In theatres it is seldom convenient to work upon a table, which would occupy too much space in the area, and be awkward to move about, as may be often needed. Very often it is more convenient to have two or three detached single lanterns than a combination ; and the lecture table is required for other and general purposes. The lantern is then best mounted upon a strong wooden tripod, more or less resembling fig. 100, with a steady adjustment for raising and lowering. On such a tripod should be mounted a revolving top similar to fig. 99, furnished with an adjustable wooden pillar to support the end. This is the method of work chiefly adopted in the Royal Institution.

91. Light for Working.—If an arrangement is at hand, as in the Institution just named, whereby all the lights in the

FIG. 101

auditorium can be turned up or down instantly and without mishap, nothing can be better, except for the one point immediately mentioned. But more homely appliances must often suffice ; and it is *distinctly better* for experiments which really tax the illuminating power of the apparatus, if the light turned up be only one gas-burner sufficient for the lecture table, inasmuch as the eyes are more sensitive and able to observe phenomena, when not allowed to perceive any bright light between.

An Argand burner, shaded as in fig. 101, will be found very effective in this way, shading the direct light at all times both from the screen and the audience, while giving perfect light when desired. When turned down to a rather small blue flame not in the slightest danger of going out, it will give an appreciable dim light over the apparatus, while leaving the room and screen practically in darkness. It can be mounted on either a bracket, or a fixed or movable pillar-stand.

Another most excellent lecture appliance is a burner known as the matchless or self-lighting burner, which turns

the flame down to a small blue jet enclosed in a metal vase. This also leaves the room in practically total darkness, with no possibility of turning the light out, and with the power of instantly turning it on full. It is advisable, however, to keep this also constantly shaded from audience and screen, during delicate experiments, that the sight of the audience may not be dulled. The effect which *continual darkness* (or semi-darkness) has upon the ability of the eye to perceive faint effects, is simply wonderful, and is not attended to in most lecture theatres to the extent it should be.

It is possible to arrange things in a permanent demonstration theatre or hall, so that the very act of switching off the electric current, or turning off the gas from the lantern, shall turn up the gas in either of the arrangements here described.

CHAPTER XIII

THE PROJECTION MICROSCOPE

ABOUT the close of the year 1881, I was strongly urged by several fellows of the Royal Microscopical Society and others, who knew my proclivities, to turn my attention to the improvement of the Projection Microscope, being assured that any instrument which would display objects *effectively* even on the scale of 600 or 700 diameters, would be an immense advance upon anything then obtainable. By one or the other of those interested, all the instruments then known were placed in my hands, and the subject never having till then engaged my attention, I was surprised to find how little had been done in that direction. Not one of them, with the best lime-light possible, would exhibit the bulk of those slides which any demonstrator with a serious purpose in view would desire to

place upon the screen. No such instrument as even the attachment described in Chapter XI., which was itself founded on the more complete instrument here to be described, was in fact then obtainable.

A brief examination of the instruments then accessible proved that the meagre results proceeded from want of appreciation of the conditions. The oxy-hydrogen radiant is a luminous surface as large as the thumb-nail. The light from this can never be condensed into a point, but only into an image of that surface, whose size depends upon the focus employed. With high powers, we *cannot* condense all the light upon objects, say even of 1 mm. diameter. The utmost concentration we can obtain, is a simple function of the relative foci of the original lantern condenser, and the substage condenser. But if we use for the latter a large lens of very short focus, then we get too high an angle, and most of the light crossing in and diverging from the object, never passes through the objective. If, on the other hand, we use a very small lens, most of the light never gets through this lens. Hence, each secondary, or substage condenser, must be specially constructed for powers of a certain range only, in focus and angle. Except for low powers, each substage condenser is almost necessarily composed of two lenses ; one of fairly large size, to take up and bring down all the cone of light, the other, to still further condense that light on the object, without employing an angle too great for the objective. There was further to be studied perfect protection from the heat, which is very great ; and simplicity of parts and manipulation, without which, work in the dark cannot be effectively performed.

The matter thus presented itself to me from the first simply as one requiring practical adjustment in these points. All the *principles* concerned had, in fact, been pointed out by the Rev. W. Kingsley so far back as 1852 ; so clearly that I was quite surprised to be unable, after some search, to find

any traces of his actual instrument, or any record of its per-
formance, or that it had ever come into use. This being so,
however, I had to begin *de novo*, and lost much time by
making my first experiments with diatoms. It was my friend
Mr. T. Curties, F.R.M.S., who guided me out of that unprofit-
able track, and gave me to understand that he should die
happy if he could only see upon a screen, bright and sharp,
'the tongue of a blow-fly six feet long. That,' he said, ' is
what we want.' As I knew already that I could give him
more than double these dimensions easily, I was considerably
relieved ; and the instrument was shortly afterwards com-
pleted. It was first publicly exhib..ed at a meeting of the
Royal Microscopical Society on Nov. 12, 1884, and again at
the Quekett Club a few days later, to the entire satisfaction
of the many experienced microscopists present on both occa-
sions.[1]

I shall content myself here with describing the projection-
microscope as constructed by Messrs. Newton & Co. from my
own designs, notwithstanding that since its introduction I
have seen one or two others catalogued which are stated to
perform well. I do not question this, but there are many
reasons for the course here adopted. No such instruments
were produced till some time after that here described ;[2] none
have been demonstrated in the same public manner ; none
have come into nearly such general use or met with such in-

[1] See *Journal, R. M. S.*, December 1884, p. 1006, and *Journal
Quekett Mic. Club*, March 1885, p. 118.

[2] One exception ought to be made, in fairness, respecting a German in-
strument. Particulars were published of a projection microscope designed by
Dr. Hugo Schroeder, before my instrument was exhibited, though not till after
it was completed. Dr. Schroeder's, which has been stated to perform excel-
lently, was therefore worked out in perfect independence of mine, as mine
was of his. With the exception of the concave parallelising lens presently
described, which has been generally used, and is mentioned by Kingsley,
there is, however, little in common in practical detail to the two instruments
and the cost of Dr. Schroeder's, which is far more complicated, was stated to
be about 200*l.*

dependent approval, especially in first-class public institutions; and, so far as I can learn anything at all about them—which it has been most difficult to do—their success has been in precise proportion to the degree in which the same general arrangements have been adopted, though I have not as yet heard of equal results having been obtained. I therefore confine myself to what I know and have myself openly tested in various public demonstrations. Moreover, everything in this chapter except the description and explanation of the instrument in detail, will apply equally to others in proportion to the efficiency of their performance.

92. **The Oxy-hydrogen Microscope.**—Fig. 102 gives a section of the instrument as constructed for the oxy-hydrogen light.

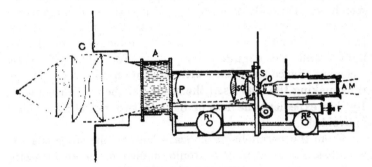

FIG. 102.—Oxyhydrogen Microscope

C represents the lantern condenser, which I prefer to make 5 inches in diameter and of triple form, so as to take up an angle of 95°, and bring the rays to a focus, if let alone, at about 6 inches in front of the front lens. If the microscope be required to fit an ordinary 4-inch lantern front, the arrangement must be slightly different, the lime being in this case pushed up so as to give an approximately parallel beam with the ordinary double condenser, while a third lens either slides or racks in the back-end of the microscope, so as to bring the parallel rays to a focus corresponding in character to the

above. The loss of light does not, I think, exceed 10 per cent. when thus constructed, but the edge of the field is not quite so well illuminated.

In the convergent cone of rays from the lantern condenser is placed a parallelising plano-concave lens P, giving an approximately parallel beam of about 1½ in. diameter. This lens is of highly dispersive glass, and therefore to a large extent corrects the chromatic effects of the lantern condenser. In the same position, nearly, is placed the alum trough A. I found it advisable to employ a full inch of alum solution, and, in addition, to form the second side of the cell of a *double* plate of glass, the two cemented together by Canada balsam. This layer of balsam absorbs any special balsam-heating rays which get through the alum.[1] With these arrangements protection from heat is perfect. Less than this is not real protection ; for the heat in the conjugate focus of a good lime-light is sufficient to ignite black paper. For ordinary purposes I cement the concave lens with balsam on the alum trough, thus making the lens itself the second of the two glass plates. By this expedient the loss of light at two reflecting surfaces is avoided.

From the parallelising concave lens to the stage is about 5 inches. Less than this would suffice for mere focussing purposes, with plain work only ; but this distance is not enough to produce much loss of light by scattering, while it allows of a really good-sized polarising prism being introduced when necessary, such as will show a polarised slide of ¾ in. diameter—none too much for rock sections. Also it appeared to me, from such experiments as I could make, that some achromatic condensers gave more light and worked better when not placed in parallel light, but just after allowing the rays to *cross* from the lantern condenser, without parallelising them at all. I therefore allowed for this, which is easily

[1] I should remark that I saw a layer of balsam employed to protect balsam slides years ago, but am not now certain by whom.

accomplished by having a spare alum-cell with a plane second side, instead of the concave lens. At all events, it seemed desirable to provide the widest possible range in the optical manipulation of substage condensers.

The rays which reach the substage condenser s c are thus approximately parallel. They really scatter or diverge very appreciably from the parallelising lens P, owing to the size of the radiant, *every point* in which necessarily sends out its own bundle of parallel rays from P. This is the great difficulty in increasing the light by a more powerful jet; which latter increases the luminous surface, but not the intensity in the centre, which alone can be condensed and made available on a *small* microscopic object. Some of this scattered light could be saved by allowing the rays from condenser to focus or cross, and then parallelising them by a *convex* lens; but an approximately parallel beam all along the barrel of the instrument has so many advantages as to far outweigh this in practical work. Where however it is absolutely certain polarised light will never be used, the distance from P to s c may be shortened with some slight gain in light.

In the parallel beam of light is placed the *substage condenser* s c, which focusses the rays on the slide by the rack R'. For low powers this condenser consists of one lens, which will brightly and evenly illuminate a slide of fully $1\frac{1}{4}$ inch diameter for a $2\frac{1}{2}$-inch power, while the same lens, racked back, answers for all powers as high as $\frac{8}{10}$ inch. Above that a double combination is preferable, and for $\frac{1}{4}$-inch or $\frac{1}{6}$-inch powers, one of these is made achromatic, or rather, with sufficient over-correction to correct the other lens as well. For immersion lenses, this last form of condenser is supplemented by a third very small lens of very short focus; the whole then closely resembling a Kellner eye-piece surmounted by a small hemisphere of crown, which was kindly suggested to me for such work by Dr. R. L. Maddox.

I however found some modification of the combination give better results.

All substage condensers fit easily from the front into a ring of the standard R. M. S. 1½-inch substage gauge. Thus, any substage apparatus approved by any microscopist, can be at least tested for projection purposes, and, if successful, adopted. A spot lens, which will do excellent dark-ground work on a certain class of objects, is inserted in the same way. The barrel of the instrument being now constructed open at the top, the substage condensers can with equal facility be inserted or exchanged from the back of the ring, without interfering with the slide or focussed objective; and this arrangement also allows of a condenser with iris diaphragm being employed, which is very useful in high-power work, as the best definition can only be obtained with a cone of light of some particular angle.

The Stage s cannot be too simple for ordinary work, even with high powers. A plain plate, with two simple clips capable of holding either a glass trough or a slide, is to be preferred, even for immersion lenses. One very good plan, preferred in practice by the majority, is to make the stage consist of a large rotating diaphragm plate, pierced with different apertures, ranging from $\frac{1}{16}$ inch, to a size sufficient to allow of the condenser-fitting racking out for manipulation. Another plan preferred by some, is to have a set of plates pierced with different apertures, sliding in dovetailed grooves, so as to be a hair's breadth below the surface of the outer stage-plate. This pattern allows the aperture to be changed without removing the slide. In practice, however, any other than the largest aperture is seldom needed; the higher power substage condensers confining the pencil of light sufficiently.

A mechanical stage is simply a nuisance for ordinary projections. It does not cost much, but is only useful to two classes of persons. The first consists of such as use the instrument for photographic purposes (for which it is admirably

adapted) and require the most precise and delicate adjustment of the object, for which they can afford *ample time*. The second class consists of biological demonstrators ; who may not only need equally precise adjustment, but also to pass parts of a slide in regular succession over the screen, and who likewise have no impatient general audience to grudge the time such manipulation involves.

The fitting or short tube—answering to the body of the compound microscope—which carries the objective o, and is screwed with the standard R. M. S. screw, is roughly focussed by the rackwork R_2, and finally adjusted for higher powers by the fine-adjustment F, substantially made on the pattern so well known in most 'histological' stands. This fitting slides into an outer tube, and it is advisable to have several, so that different powers may be ready screwed in place, and simply withdrawn or inserted.

98. Amplifying the Image.--It will often happen that the direct image from the objective alone will not give the best results. Suppose we want to exhibit an object double the size it appears by a $\frac{4}{10}$ lens. We may either double the size of the image shown by that lens, or we may use a lens of double power, $\frac{1}{5}$. But the results are different. By amplifying the image we double the *whole* image, or nearly so, as shown by the $\frac{4}{10}$, and preserve what people roughly understand by its 'depth of focus,' and the larger working distance ; whilst the $\frac{1}{5}$ lens will show a much smaller portion of the slide, and the light *cannot be proportionately condensed* into so much smaller a space, though it can be considerably more so condensed. Hence, while really minute and sharp sections or objects are usually shown better by a higher power, more distinct objects of larger size are often best shown with the amplifier, if more power is required.

The image is 'amplified' for ordinary objects by interposing a plano-concave lens A M between the objective and the screen. This lens fits into the end of a tube, which

slides into the body-tube carrying the objective, and must be guarded against any 'flare' or internal reflection from its sides. The effect of such a lens is to *lengthen the focus* of any objective in any given position; hence its use also increases the working distance. For photographic purposes, the amplifier should be corrected; but for ordinary projection a simple lens is sufficient. It is convenient to have a set of amplifiers of various foci, which give a great range of powers, and of working distances from the screen, enabling very similar results to be obtained under different conditions.

The use of an amplifier has another considerable advantage. Ordinary micro-objectives are corrected to a focal length of about 10 inches in England, and 6 or 7 inches on the Continent. If such lenses are used to project an image, say, 25 feet away, besides the mere greater magnification of any error, it is obvious that their 'corrections' can no longer be accurate. It is really wonderful that some lenses should perform, under such trying conditions, so well as they do. But now suppose some given lens is focussed on a slide, so as to project an image at its own proper distance of 6 inches. Our screen however is, we will say, 25 feet away; a distance I have found to give on the average perhaps the best range of general results, though shorter and longer are better for some purposes. We can select a concave amplifier of a focus which, placed in a certain position, *will bring the image to a focus on the screen without altering the focus on the object*, thus maintaining the 'corrections' of the objective at nearly their proper value. The late Colonel W. Woodward, U.S., was, I believe, the first to point out this fact, which is of great use in photo-micrography.

Any concave lens can be placed *somewhere* so as to focus a 6-inch or 10-inch focus on the screen, at any longer distance; but practically we are limited to a certain range. I have found generally useful quite a low power, which does this at about four inches behind the objective, and amplifies con-

siderably, being however chiefly valuable for the reason here explained. Such a length of tube also cuts off some of the outer and most indistinct portion of the field. The farther the lens is placed from the objective, the *more* the image is amplified, the *more* it is contracted or cut off at the margin, and the *less* the focus of the objective is altered from what it would be if used alone. We may therefore use the amplifier *nearer* the objective than its best 'correction' point, for the sake of a larger field; or *farther* from it, for the sake of more amplification; in either case at a slight sacrifice of the best performance of the objective.

Practically I find the most useful range of adjustment to be an objective-fitting and amplifier-tube which will allow the amplifier to be placed four inches from the screw-threads, or to be pushed in as close as two inches. The last will give as large a field as the objective alone; at four inches some of the outer portion of the image is cut off, but the rest is more amplified. Now and then it is useful to employ quite a long (six-inch) amplifier-tube, and to use a high-power lens there. The amplification then is very great; but only the central portion of the image reaches the end of such a long tube, which must be carefully guarded against 'flare' by being lined with black velvet.

Amplification by Eye-pieces.—Another way of amplifying the original image, is to employ an eye-piece, at the end of a tube-fitting of the ordinary length, instead of the short fitting just described. Optically, this method is more perfect than the other, and for photography far preferable, a sharper image being obtained, and a flatter field, with a sharp circular black margin to the disc on the screen. Practically, for ordinary purposes, an eye-piece entails more trouble; but undoubtedly it gives the finest projections.

Zeiss's well-known projection eye-pieces have lately made this method familiar, and need no recommendation for photographic purposes; but they are not suitable for ordinary screen

projections, owing to the small field-lens exhibiting so little of the image, which makes it very tiresome even to find the desired portion of a slide. It is, indeed, partly to their using only such a very small central portion of the image, that the excellence of the final image is due. The magnifying power is also too high in these oculars for ordinary use, being intended for a screen distance of a few feet only. For nearly all demonstration purposes, all of the image that can reach the end of a tube of ordinary length is quite good enough, if the eye-piece is properly constructed.

The eye-piece for projection, therefore, is one with a proportionately larger field-lens, and with an adjustable or *focussing* eye-lens, made achromatic. Such eye-pieces, of various powers, will give beautiful projections with the electric light; and if of proportionately low power, which for a screen distance of 25 feet should not exceed a double amplification, with the lime-light. In using them, the stop of the eye-piece itself is focussed sharply on the screen by the adjustable achromatic eye-lens, and then the whole arrangement is focussed by the fine adjustment so that the image itself also appears sharp. The focussing is much quicker, or more sudden, or sensitive, with an eye-piece, than when using an amplifier, or the objective alone.

The length of the body carrying the eye-piece must depend upon the set of lenses used. If they are corrected for the English tube, 10 inches is required. For the Continental length, a 6-inch body will be required, and is more compact. A draw-tube is not desirable. The body must be velvet-lined. It is as well to fit it with two concave amplifiers also, which will 'correct' lenses for screen distances of about 12 feet and 25 feet.

It is not well to screw objectives into separate long bodies, and change these with the powers as with the short bodies; but objectives may be readily changed either by using a triple nose-piece; or what is still better, by Zeiss's new sliding

objective-changers, costing 10s. each lens, and each of which
is adjusted by screws once for all, so as to centre its own
objective *exactly* in the axis of the substage condenser.

94. Projection with the Compound Microscope.—When-
ever a substantial microscope with focussing and centering
substage is at command, very good occasional projections can
be made with it by the aid of a simple lantern attachment,
embodying the foregoing arrangements as far as the concave
lens P, which delivers from the lantern a brilliant parallel
beam to the ordinary substage. It only needs for the sub-
stage to have added to it a tube-screen to receive the beam
and prevent stray light scattering, while a flat plate to prevent
scattering is also screwed on the nose of the microscope, which
will itself furnish all else that is required. I have designed
such an arrangement, which is perfectly effective, at a small
cost. For permanent work, however, a complete and solid
projection instrument will be found more satisfactory.

95. The Demonstration Image.—It must never be forgot-
ten that the projecting microscope produces its image under
peculiar and distinct conditions, which interpose some peculiar
difficulties. The first difficulty lies in the enormously greater
amplification necessary. This does *not* produce a proportionate
effect upon the spectator, owing to his greater distance from
the image ; but, on the other hand, any errors in the objective,
with their consequent woolliness in the image, *are* magnified
proportionately. A power of 1,200 diameters is considered
very high on the compound microscope, in ordinary work ;
but is a very moderate power for screen work. The apparent
depth or thickness of the slide is magnified also in the same
proportion ; and cannot be counteracted by constant changes
of focus as in private work, because the whole audience must
see the whole at once. Hence ' depth of focus ' is a very real
matter in lenses for projection.

The second difficulty is a consequent deficiency of light,
which makes it specially difficult to exhibit images of trans-
parent objects, such as diatoms. In these objects there is no

real black and white, but simply different thicknesses in a substance as transparent as glass. When we look through a compound microscope at such a diatom as *Arachnoidiscus*, for instance, we are looking apparently at an object a few inches across, with a superabundance of light. Now the lantern would project a screen image of even a foot across, as sharply as could be wished; but a very few feet away from the screen all the detail, though far larger than on the compound, would be invisible; and when to meet this we have amplified the image to, say, a couple of yards across, the lights and darks are naturally *diluted into shades of grey*. Again, to get a perfect or 'critical' image, the photographer stops off a great deal of light, which he can very well afford to do, because he can make up for deficient light by a longer exposure. But the demonstrator cannot do this. Whatever cannot be seen on his screen at the first moment, is seen no better by being left on for an hour. He *must have light*, and yet his image of any details must be large enough *to be seen at a distance*.

On the other hand there is one compensating consideration, in that a 'critical' image is seldom really necessary to him, and can rarely be appreciated at his distances even when produced, except of coarse objects. A certain *breadth or coarseness* of line is a positive advantage in an image to be viewed many feet away. Fortunately, also, the more serious the work in hand, the more favourable are the conditions. A class of thirty or forty people, really studying a biological subject, would be in a smaller room, and at a smaller screen distance. All could probably get well within 12 feet of the screen, where both more detail can be seen, and the image will be brighter and sharper. Detail can thus be well shown in a class-room, which it would be foolish to attempt with the same illumination before a thousand people. It is the *human eye* which fails, long before the microscope; so that an object can be shown quite successfully when the audience have opera-glasses to see the details with, which the eye alone cannot

distinguish on the screen when it is there. Opera-glasses are
thus used in German biological classes. Lastly, for important
demonstrations in colleges there is the arc-light, which not
only gives vastly increased illumination, but from a smaller
radiant, of which a larger proportion can be condensed upon
a small object, and from which a sharper image can be pro-
duced. The difference is exactly that which the ordinary
microscopist experiences when he changes the flat for the
edge of his flame. Hence the electric light gives not only
a brilliancy, but a sharpness, which cannot be obtained with
a powerful lime-light, and which is a marvellous tribute to
the perfection with which modern lenses are worked.

96. **Objectives.**—After the projecting microscope here
described was constructed, there remained the difficulty of
finding or constructing satisfactory objectives for it. The
greater part of the lenses which performed well upon the com-
pound instrument, broke down utterly upon the screen, partly
for the reason that when used in this way, direct or with
amplifiers, a field three times the usual diameter is employed,
while that field is not so flat as with an eye-piece. A lens of
$\frac{4}{10}$ focus will 'project' the whole of a blow-fly's proboscis ;
but every microscopist knows how little of this can be seen with
the same power on the usual instrument. For ordinary screen
work it is often important to cover a large field, if only for
'finding' reasons. I am afraid to say how many lenses passed
through my hands in the course of my search, kindly lent me
by friends from all quarters ; and the curious thing was that
price was found no criterion of performance. For moderate
powers, an excellent $\frac{4}{10}$ in Seibert's series of lenses was at
length found, but powers of 1½ inch and $\frac{8}{10}$ inch had to be
worked out upon the screen itself. For large objects to be
shown with a focus of about 2½ inches (this microscope ex-
hibiting up to 1¼ inch diameter perfectly well) we got the best
results from an old photographic 'postage-stamp' lens lent
me by my friend Mr. Washington Teasdale ; and with a little

alteration in the curves, such a lens, on the Petzval principle, does all that can be desired. For the common range of work with the lime-light, where results with lenses already possessed are not satisfactory, the following series is recommended, and will be found perfectly so :—

Focus	Diameter covered	Price
		£ *s. d.*
2½ inch (Petzval)	1¼ inch	0 12 6
1½ inch	¾ inch	2 5 0
$\frac{8}{15}$ inch [1]	½ inch	2 7 6
$\frac{4}{10}$ inch	$\frac{3}{10}$ inch	1 10 0

The first three of this series being worked out for projection *direct* to the screen, do not behave so well with an amplifier for anything critical, though one may be used; but for direct projection, though moderation of price has been studied in their construction, and especially since their formulæ have been further perfected by the use of the new Jena glass, the 1½ inch and $\frac{8}{10}$ inch are the finest lenses yet produced, being far superior in illumination, in definition, and extent and flatness of field, to all others constructed for the same purpose which I have been able to test, including both American and Continental lantern objectives of a very much higher price. The $\frac{4}{10}$ works equally well with or without amplifier, or with an eye-piece, and may be pushed up to 1,500 diameters, which means a blow-fly's proboscis 14 feet long.

Working with a proper projecting eye-piece, a much larger number of ordinary micro-objectives will do good work, only the best third of the field being used, and that much flattened by the field-lens. Almost any really fine lens will do fair work in this way. I mention the following as lenses I have actually tested. Zeiss's *aa* (1-inch) gives magnificent definition in the centre of the field, both direct and with an eye-piece, but is far from flat. Powell & Lealand's ½ inch of 40° is very crisp, and works well either direct, or with amplifier

[1] I am endeavouring to get this lens modified into an inch, which with the Reichert ⅓ presently mentioned, will give a more useful gradation of powers.

O

or eye-piece. Leitz's *new* formulæ give fair results. But the best dry lenses I have found at any moderate price are Herr Reichert's new series (termed by Mr. E. M. Nelson semi-apochromatics) No. 3 ($\frac{2}{3}$) 20s., No. 6 ($\frac{1}{6}$) 30s., and No. 7A ($\frac{1}{7}$) 36s., all which work beautifully by either of the three methods. The last is a truly wonderful lens at its price, and both it and the $\frac{1}{6}$ are far the best projection lenses I have been able to find of these powers. I may add here, that some really good lenses, when used with brilliant lights such as projection demands, give a ' mist ' over the image purely from *flare*, or reflection *in the lens mount*, and which is removed by careful blackening. I have drawn the attention of Herr Reichert and others specially to this, and am sure the point has not yet received the attention which it demands, now lenses are so often used for photographic purposes with these strong lights.

With the electric arc, Zeiss's apochromatics give fine results over the small field of his own projection eye-pieces, but *only* so used. They cannot be used with satisfaction direct, or with an amplifier.[1] The same in both respects may be said of the wide-angled dry lenses of Messrs. Beck. Few of these lenses, however, have the ready *adaptability* of the Reichert series for projection work. Messrs. Powell and Lealand's apochromatics are much better in this respect, and their $\frac{1}{6}$ inch of 0·95 N A, for its combination of exquisite definition with a very large flat field, appears to me at present *the most ideally perfect lens in the world*. Even at its high price of 11*l.*, it is well worth purchasing for constant histological projection work, of which (with eye-pieces) it will cover a great range.

Of immersion lenses, the best for projection at any mode-

[1] I have been greatly disappointed in these lenses for projection. They only exhibit a very small bit of the centre of their field in focus, and appear to be constructed chiefly with a view to photo-micrography. This seems to me a great practical mistake, and I moreover believe that certain conclusions of Prof. Abbe relating to the nature of the image of minute structure, some of which have been demonstrated to be erroneous by Mr. E. M. Nelson (*Quekett Club Jo.*, July 1890), are chiefly due to this character of his own lenses, and the fact that different zones of the image are in such widely different focal planes.

rate price is also Reichert's oil $\frac{1}{12}$ (really $\frac{1}{12}$) of N A 1·25, price 5*l*. 5*s*. only. In every optical quality a selected specimen has been pronounced on the highest authority to be scarcely, if at all, below Zeiss's apochromatics; and for lantern use it is far better, owing to its longer working distance and flatter field. It is only, and not greatly, excelled on the screen by Powell and Lealand's apochromatics. Leitz's $\frac{1}{12}$ oil lens is also an excellent projection objective of long working distance; both these have much more of the latter than Zeiss's $\frac{1}{12}$ of same N A. This quality is a great point in lantern demonstration. Of water-immersions, the best I have tried are Seibert's ($\frac{1}{16}$) and Zeiss's G ($\frac{1}{8}$), but I believe the last is not now made —more's the pity, for it was the best of his water series for this class of work.[1]

So far as the lantern and projection are concerned, it is a subject for regret that opticians seem now to have confined their immersion lenses of moderate price to $\frac{1}{12}$ focus; only the expensive apochromatics being now made of $\frac{1}{8}$ inch or 3 mm. focus. The latter would be a much more generally useful lantern focus, covering a larger field and giving more light. An old Zeiss oil-lens of $\frac{1}{8}$ focus, though far surpassed by more modern productions in other respects, gave me a field and brilliancy which no $\frac{1}{12}$ can possibly equal; and I venture to express the hope that increase in projection work may lead to the longer focus being made at a moderate price. Herr Reichert was good enough to send me for trial a 4 mm. oil-immersion made to a special order, with large glasses. The light passed by it was enormous, bringing many objects otherwise impracticable within the O.H. light. This lens could be supplied to order, where the most must be made of the lime-light alone. But 3 mm. would be more generally useful.

[1] I have no doubt there are many excellent lenses not here named, and take the opportunity of saying that I shall gladly at any time test any which the maker thinks likely, in definition, working distance, and flatness of field, to be suitable for projection purposes. I am only here describing what have actually gone through my hands.

In using immersion lenses, care must be taken to employ a *small* drop of fluid, else it will drain away by its own weight. Water lenses are convenient, but oil is far superior in brightness and crispness of definition. A good Reichert oil lens will work either direct, or with the low-power amplifier, as well as with an eye-piece, up to 10 or 12 feet distance.

97. Management of the Instrument. —Before using the Oxy-hydrogen Microscope, the alum-cell must be filled with a saturated solution of alum. To make the solution add common alum to hot water in excess, and allow the solution to cool, then filter the clear portion twice through ordinary filter-paper or blotting-paper. This solution may be used as often as desired, but must be refiltered if any sediment or turbidity appears, being used only in a *perfectly limpid* condition. When replacing the alum-cell in the microscope, the side on which the concave parallelising lens is balsamed should be farthest away from the light. It is as well to leave the brass stopper out of the cell when in use. As air-bubbles form on the inside surfaces of the glass, they should be removed with a camel-hair brush, as they impede the light, and sometimes would appear as images upon the screen. They always appear to some extent as the solution becomes heated.

Not the slightest fear need be felt for the most delicate slides on account of the heat ; but if preferred, the alum-cell may be emptied and refilled with a fresh solution after an hour's use, as it rapidly becomes hot. The cell should be emptied after use, and washed out with clean water, or alum slime may collect on the glass.

Great care should be taken to procure a good light, the full capacity of the best oxy-hydrogen jets being required for work with high powers.

The light from the lantern benig meant to be nearly parallel after leaving the concave lens on the alum-cell, the first step is to adjust the light to give this. This can be done after gradually warming up the lantern and condensers, by taking out the objective, mount, and sub-condenser, so as to leave

the course clear, and focussing on the screen, through the
alum-cell (by sliding the light to and from the condensers)
the surface of the lime cylinder, shown by the granulation of
its surface. This will be approximately the distance of the
lime from the condensers, and when that has been corrected
in use, as presently mentioned, a mark can be made on the
tray of the jet, to which it can be at once set in future.
Placing in position an objective, with its appropriate substage
condenser, the lime should also be most carefully *centred*.

Most of the substage condensers have their special func-
tions as marked. The lowest power is however used for *all*
objectives up to the $\frac{8}{10}$ objective; but for the $2\frac{1}{2}$ inch and $1\frac{1}{2}$
inch powers it is inserted in the *front* end of its fitting, in
order that it may be racked up almost close to a large slide,
and illuminate with its cone a large field, whereas with the
$\frac{8}{10}$ power it is placed in the *back* end of its fitting, being
focussed upon the slide. If the microscope is fitted with
the rotating diaphragm-stage, and the small holes are used,
always lift the spring-clips from its surface by the milled
head, before rotating the stage. The use of an aperture gives
a better edge to the disc when no eye-piece is used, but is not
otherwise necessary.

Let us now suppose the first slide placed upon the stage
(we are here considering the commencement of an exhibition).
Choose an objective for it (with its appropriate sub-stage con-
denser) of the *lowest* power that will show what is required;
bearing in mind also that, where possible, it is best to choose
one that well covers all that *is* wanted, without showing more
than is necessary. This being screwed into the fitting and
pushed into the socket, can now be focussed by the rack; the
screw fine-adjustment is only needed with high powers.

The illumination has next to be got right. It may
probably be but poor; and this must now be remedied by
racking the substage condenser backwards or forwards as
required. The best position will be almost instantly found,

and when found will be very little altered for the same objective, unless the thickness of the slides should differ very greatly. But the adjustment should be tested for possible improvement from time to time, and will require slight change with every change of power. This however is not all ; the position of the lime itself should now be adjusted more precisely, and *too much care cannot be devoted to these points.* The position of the lime is tested by sliding the tray of the jet slightly in and out. It will usually be found that a slight alteration improves the brightness of the object materially. The lime thus readjusted on an object, after the substage condenser has been adjusted, will be in its position for average work. But whenever the result seems not satisfactory with any slide, it is always worth while to try afresh whether the lime is in its best position ; and occasional adjustments of this and of the substage condenser will be well repaid.

There is one general rule in these occasional adjustments of the light, *without which no projection microscope can do its best* with varying powers, though so long as the same power is used all through, they are unnecessary. The lime will have to be pushed up *nearer* the lantern condensers, for lower powers, and drawn rather farther back with higher powers. The distance is not great ; but the difference in the light on the screen produced by these readjustments is wonderful. Now and then, after the lime has been readjusted, a very slight readjustment of the substage condenser also will still further improve the effect.

When the microscope is once started and precisely adjusted, no alteration will be needed whilst the same power is adhered to ; but whenever the power is changed, and especially whenever the substage condenser has to be changed, readjustment of the light should be tried for as described above ; also when, without changing the objective itself, an amplifier is either put on or taken away, the substage condenser will require re-focussing upon the object. The lime will require

frequent turning, and the best plan is to give a fresh surface for every slide.

This all sounds rather formidable; but practically the demonstrator does it all without thinking about it, in a second or two. It is done so easily that, although my experience has been only that of rare and exceptional occasions, I have found no difficulty in exhibiting fifty slides representing organs of insects, with powers varying from 300 to 1,500 diameters, during a lecture of an hour and a half, performing all manipulations whilst explaining the slides, and with no assistance whatever beyond that of a friend to hand me each slide in order, wiped clean, in exchange for the one just used.

Unless the operator's sight is unusually keen, an opera-glass will be found of very great assistance in focussing the image on the screen.

It has already been said that the lowest sufficient power should be preferred; but a certain 'scale' must be had to be visible on the screen, and experience must decide what is this necessary scale. It is not wise to attempt unknown slides without rehearsal, after which the power required for each should be marked on the label. Then a list should be made out of every object in turn, *with the power required for it*; and if the lecturer has to be his own demonstrator, it is generally possible, by a little alteration in the arrangement of the lecture, without any detriment to it, to bring most of the objects to be shown under similar power *more together* than at first, and so avoid too many sudden changes of objectives for single slides. A series of demonstrations should always be revised in this way, as an avoidance of needless changes not only saves trouble, and wear and tear of apparatus, but enables more time to be given in obtaining the *very best effect*, which cannot be obtained with a fresh power in a moment of time.

Often it is advisable to give a general view of the whole slide with a low power, and afterwards to magnify much more some portion of it. Sometimes it may suffice to add an

amplifier; sometimes a higher power gives better results. Suppose we had a section of human skin, exhibiting both the perspiration glands and ducts, and the touch-bodies which terminate the nerves (though it is not often both could be found in the same section). Probably a power of 1 inch would exhibit the first sufficiently well; but the $\frac{4}{10}$-inch amplified to 1,500 diameters would be needed for the touch-bodies, or even a good $\frac{1}{4}$-inch could be used with advantage. So the $\frac{4}{10}$-inch, amplified or not, would well exhibit the sting of a wasp or bee; but to exhibit the serrations of the barbed end coarsely, will require a $\frac{1}{4}$ or $\frac{1}{8}$.

98. The Screen.—A sheet is unfit for any work with high powers, unless stretched tight and white-washed. Paper-faced screens, and especially the whitened screens mentioned in § 67, are to be preferred, unless a plastered smooth wall can be utilised. For permanent demonstration work it is well worth while to provide the latter; the difference can hardly be conceived without trial.

For popular subjects I like a screen distance of about 25 feet, and up to 50 feet may be used easily, this distance however being chiefly adapted for common objects to be shown in a large hall. High-power 'class-work' is far better done, on the other hand, with higher powers at shorter distances — as short as will allow all of the class to see the screen. With a good $\frac{1}{8}$ homogeneous immersion, or a $\frac{1}{4}$-inch amplified, the cyclosis in *Vallisneria* can be shown to several hundred people pretty well, with a screen distance of 12 to 20 feet, but the oxy-hydrogen light is not sufficient to attempt such a subject in anything like a large hall.

Some amount of practice is needed before anyone can use properly even a table microscope; and it is equally necessary before anyone can produce with the projecting microscope what it is really capable of. Skill will however be rapidly attained; and when the operator can exhibit a flea, or the proboscis of a blow-fly, 12 to 15 feet long, sharply and

brightly on the screen, he has fairly grasped the powers of the instrument with the oxy-hydrogen light, so far as common objects are concerned.

99. **Spot-lens and Lieberkühn.**—The spot-lens is used exactly as a substage condenser, and is usually adapted for the $\frac{4}{10}$ objective with amplifier, the amplifier enabling this power to be used by bringing it farther from the slide. Polycystina are beautifully shown by it, but almost too small to be seen at any great distance. Many usual dark-ground objects do not reflect sufficient light, and only experience can decide what are available ; but some slides are best shown in this way.

The Lieberkühn is usually fitted for the $\frac{8}{10}$ or 1 inch power, which can be amplified if necessary. It slides upon the objective itself, and must be ordered with it when desired. In using it, all substage condensers are removed, that the parallel beam may fall direct upon the Lieberkühn, and the lime and the Lieberkühn must both be adjusted, to get a good effect. Portions of iridescent wings make beautiful objects, also some Foraminifera, but they should not be mounted on an asphalt surface, as, even after the alum-cell, there might be sufficient heat absorbed to soften this. Such asphalt slides are the only ones, owing to their powerful absorption, which it is unadvisable to leave in the rays for more than half a minute. When slides can be specially prepared, this is avoided, and the effect improved, by having a disc of black paper on the *back* of the slide, and mounting the object on the surface of the glass itself. The disc should be as small as will cover the object, in order that as much light as possible may pass round it to the Lieberkühn. The smaller of those slides prepared with iridescent butterfly scales, in imitation of bouquets, vases of flowers, &c., make very beautiful screen subjects for the Lieberkühn.

100. **Polarised Light.**—The addition of polarising apparatus largely increases the powers of the instrument. A polarising prism capable of rotation, and large enough to cover

a slide ¾-inch diameter, is arranged to be used in the barrel of
the instrument; the analyser is a square-ended Prazmowski
prism. It is needless to describe the arrangements in detail. In
the most complete form of the apparatus, the analyser is fitted
with a Klein's quartz plate, and a quarter-wave plate; and a
system of convergent lenses has also been arranged, somewhat
similar to that described on p. 343, which will exhibit the rings
in crystals, taking in both systems up to the angle of selenite.
The ordinary microscopic crystallisation slides make mag-
nificent displays in this form of the instrument. The loss of
illumination being very great with polarised light, about the
utmost limit of the *power* of the instrument, with the O. H.
light, will be to exhibit the rotating cross in one or two of
the larger starches, such as Tous-le-mois. The arc light will
of course go considerably farther.

101. Slides and Objects.—Organs and parts of insects
make excellent objects, if mounted flat; those mounted ' with-
out pressure ' fail, being both opaque, and impossible to focus
in one plane. The essentials are flatness in the preparation,
and neither too much nor too little colour. Experience will
soon teach the proper amount of the latter, and a suitable
slide can always be found amongst any decent stock.

Transparent objects of all kinds are the most difficult, and
histological slides especially so, unless stained well and to the
proper degree. Such sections must also be *thin*, and it is not
easy to purchase such, stained so as to give the best results.
Where good ' differential ' staining can be got in a thin section,
the object can generally be exhibited under the greatest
illumination, and the positive colour in the structure shows
distinctly; but with a clear preparation the substage condenser
must either be racked back from the position that gives most
light, or, what is better, if an iris diaphragm is fitted to it,
this must be contracted so as to reduce the cone of light, and
thereby get more distinctness in the phantom-like detail. To
take an instance : a section of skin with the sudorific glands

and other parts well stained, will probably bear the full cone
of light, and be both bright and sharp ; but if we have a slide
consisting of only a few of the glands themselves, teased out
and mounted separately, the full cone answering to the aper-
ture of the lens will confuse detail ; and it must be reduced to
a narrower cone in order to get the convolutions of the glands
distinctly. Amateur sections are generally far thinner, and
better in that respect than can be got from the trade mounters ;
but are seldom so well differentiated by staining as the work
of the latter.

It must always be seen, that whatever it is desired to
exhibit really *is in* the slide, satisfactorily, which is not
always the case. Let anyone, for instance, try to find a thin
section of skin which really exhibits clearly the ' touch-
bodies ' as stated on the label, and he will appreciate what I
mean ; but it is obvious he *must* find it, before he can exhibit
it. Beyond that, all will depend upon the thinness and the
staining ; for it is the want of *density* in the image that is
the chief difficulty in demonstrating such objects. Some
further remarks on this subject will be found in § 105 in con-
nection with the higher power of the electric microscope.

Botanical sections are beautiful objects, when thin and of
proper colour ; if too clear, they occasion the same difficulties,
and require us to diminish the cone of light in order to get
distinctness. To take an example from this class also : if they
could in any way be differentiated by staining, it would be
very easy to exhibit the punctated cells in a thin longitudinal
section of pine ; as it is, this is a very difficult object with the
lime-light, though not at all needing a high power. The cone
has to be contracted a great deal, when it can be managed ;
with the arc light, so much illumination is left with quite a
narrow cone, that it is quite an easy object.

Foraminifera of all kinds make excellent objects. Poly-
cystina project easily by transmitted light, and fairly well on
the dark field with spot-lens. Diatoms are unsatisfactory and

only some of the coarsest can be shown even imperfectly by the lime-light, as the stopping down of the light to get crispness impairs the brilliancy so seriously. A good $\frac{1}{4}$ or $\frac{1}{8}$ amplified does the best work with most of them.

With polarised light, besides the crystallisations already mentioned, all mineral sections which polarise exhibit excellently; also fish scales and most organic objects.

These details, by no means complete, will be sufficient to show how wide is the range of the projection microscope, even with oxy-hydrogen illumination.

102. **Living Objects.**—Pond life is always a popular sub-. ject, and the vast mass of objects can be shown with case in the projecting microscope. The larger beetles and larvæ are not really microscopic, but require a large trough in the ordinary stage of the lantern. For smaller objects a variety of glass troughs must be provided, which can be procured for 1s. each upwards. The troughs should be so thin as only to allow the creatures to move freely in the same plane; for free movement they must not be tighter than this. Often, for more minute examination, as of the internal organs of a water-flea, it is necessary to check the power of movement by somewhat compressing the animal. This can be done by using a live-box, or by slightly forcing the creature into a rather thin trough with the end of a sable pencil, or by placing it with a drop of water on one of the glass slips made with a concavity on one side, and covering it with a thin glass, held on by capillary attraction. Very small animals, such as rotifers, are often best dealt with by placing them in a drop of water on a plain glass slide, and covering them with a thin slip; or if the pressure would be too great thus managed, the creature may be encircled with a bit of cotton thread.

Glass troughs are very easily made to any thickness, by taking an ordinary 8×1 slip, and a thin piece of cover-glass, and cementing between them, with dried Canada balsam dissolved in benzol, the half of a vulcanised rubber ring. If

still thinner troughs are required, a thin ivory card, or piece of thick cartridge-paper, will give the required thickness. Botterill troughs, in which a rubber ring is pinched by screws between two glasses, are handy for greater thicknesses, and can be cleaned at pleasure.

The movements of living diatoms are easily shown, including *Bacillaria paradoxa*; these only need a drop of the water on a plain glass, with a slip of cover-glass held on by capillarity. *Volvox* is easily shown 8 or 10 inches diameter, requiring a trough with *thin* glass face, and enough fluid between the glasses to allow it to roll freely, else there will be no movement. Greater magnification is only hindered by the *thickness* of the globe baffling any focussing of its image with higher powers. Of infusoria, some—such as *stentors*—are easy objects; *Vorticella* is rather difficult. The chief difficulty is that their thickness and their motion make it hard to bring high power to bear upon many of them.

Hydra, water-fleas, cyclops, and the various larvæ of the gnat family, make good objects. The larva of the true gnat is very opaque, and too thick at the thorax to focus very sharply; but some of the ' blood-worms ' make capital objects. The *corethra* (' phantom ') larva is an excellent object, owing to its transparency, and so is that of the May-fly. The small worm found in clusters in the mud of a pond, called *Tubifex*, is a truly imposing object on the screen, appearing both in shape, size, and even colour, very much like a gigantic python. The microscopist will however readily multiply the list for himself, and will find the manipulation precisely the same that he is accustomed to.

For displaying the circulation of the blood in the foot of a frog, a frog-plate may be used ; but personally I prefer the homely and old-fashioned plan of employing a sole of thin cork, with a hole cut in it just large enough to show the necessary portion of the web. By tying a short, looped bit of thread round each toe, the foot can be held in position

by pins, passed through the loops so as to stretch out the threads and consequently the toes, with more facility than in any other way, and the stage clips hold the rough cork more securely than polished brass. One hint is however necessary, which applies to any other object where a *moist surface* is involved ; and the frog's foot must be moist, and the frog kept damp in his bag. *The objective must be warmed*, else the moisture will condense upon it, and baffle all attempts at an image. It may seem ridiculous to mention so simple and obvious a precaution ; but having myself been fairly beaten by such an oversight on one occasion, I know how easy it is for such precautions to be overlooked or forgotten.

Enough has now been said to indicate the range of power of the oxy-hydrogen form of the instrument. Beyond a certain point, the light fails us, or even the definition from so large a radiant as we must employ. With class-room distances averaging 12 feet, and fine histological slides, powers as high as $\frac{1}{12}$ immersion may be used even with this light, with or without an amplifier or eye-piece ; on the other hand only a few of the coarsest diatoms will exhibit sufficient distinctness, there being no real opacity in the markings. But with *general* opacity all over a slide the power available decreases ; and as a rule $\frac{1}{4}$ or $\frac{1}{8}$ inch, more or less amplified, is the highest power useful with this form of the instrument. Even such a lens can be pushed on some objects, which combine general transparency with opacity of detail, up to 2,500 diameters or more.

108. The Electric Microscope.—By employing the electric arc, the power of the projecting microscope is enormously increased, definition being improved, as already explained, together with illumination.

The general arrangements of an instrument constructed for an arc-light do not differ from those already described. But I found one alteration in detail to be absolutely necessary, and another advisable. As regards the first, much more

protection from heat is required. I was obliged to adopt a
trough at least three inches thick, and 5 inches in diameter;
and were any instrument ordered with a specially powerful
lamp, even another inch would be advisable, though three
inches of alum solution is practically sufficient up to nearly
3,000 candles. It is also desirable that the brass front should
be kept apart from the body of the lantern, if of metal, by
washers of non-conducting material, to prevent heat passing
by direct conduction, and to ensure that the alum be only
heated by actual absorption of the rays. In spite of all
protection, however, the heat from a powerful arc is so much
greater than from a lime, that every precaution should be
taken, and no slide at all 'green' or unsafe left on for too
long a period. Glycerine mounts are probably the most risky;
old and set balsam mounts I have never known injured.

The other change is advisable owing to the less handy
character of many electric lamps, which cannot be adjusted
so readily in focus as a lime-jet. The triple condenser is
replaced by a double-plano, since no lens would bear an arc
so near its surface as a lime is brought to the triple form.
The double 5-inch condenser brings the arc 6 inches from its
back surface, which is a convenient distance. The arc is then
adjusted to give a parallel beam from the first lens; and the
second lens of the condenser is made to adjust by a rack and
pinion, so that by its motion those changes are made in the
cone of rays which in the previous instrument are made by
moving the tray of the jet. When the lens is racked back a
smaller cone of rays is brought on the parallelising lens, just
as when the lime-light is drawn back. When Brockie's lamp
and a focussing stand are used, however, a racked condenser
is unnecessary.

These alterations make it advisable to affix the microscope
securely to the lantern, instead of sliding it into a nozzle. It
can however be easily removed, and another front, adjusted
to the same template, substituted for physical demonstration.

The instrument as thus modified, and fitted with polarising apparatus, is shown in fig. 103, which also shows Mr. Brockie's optical lamp.

In using the electric light, I very soon found that there was some difference in the effect of the substage condensers. Owing to the smallness of the radiant, and its greater distance from the condensers, the light is brought by the same lenses into a much smaller area ; and hence the same sub-condenser used for low powers, answers perfectly well up to $\frac{4}{10}$ power as well. In the higher powers also, lower angles may often be employed. This likewise tends to increase penetration and definition. What a microscopist understands by ' high resolution ' is quite unattainable with the lantern, since the dots on *P. Angulatum*, even magnified up to 5,000 diameters in nearly black and white, would be invisible a very few feet away from the screen.

104. The Electric Lamp.—On this head I need only refer to the preceding chapter. It was all-important to get rid of the double radiant, and this is fully accomplished in Mr. Brockie's lamp there described, while all necessities of centering and focussing are met by the screw-motion table on which the lamp stands.

105. High-power Demonstrations.—For high-power work, especially biological, I would repeat that a permanent screen or surface of fine plaster of Paris, smooth, and kept carefully whitened, is of the greatest assistance. The dark parts of the image are as dark upon it, while the bright parts are much brighter ; hence that *contrast of shades* is heightened whose dilution is one of the great difficulties we encounter. Such screens are used in German institutions, and enable results to be obtained which otherwise would be beyond the apparatus employed. Such a surface, and opera-glasses for the back rows, will do a great deal to extend the range of detail possible.

In the majority of cases, working with a good projection eye-piece is decidedly to be preferred. A really fine $\frac{1}{8}$ or $\frac{1}{4}$,

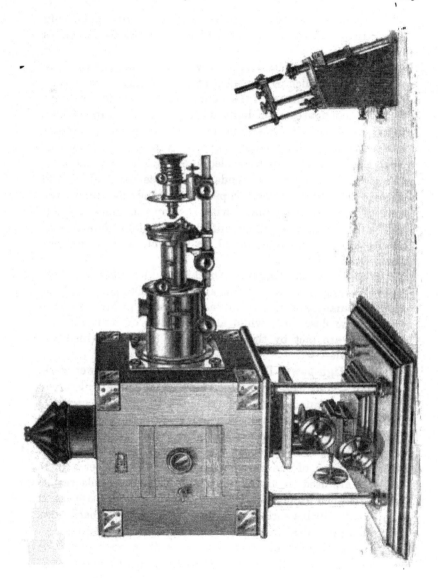

P

such as described in § 96, used thus, will give considerable
power, with more 'depth of focus,' and less trouble in
'finding.' The best general distance will be 12 to 15 feet,
beyond which the performance of every high-power lens
rapidly deteriorates. Even brilliance depends much upon
crispness, and therefore a Reichert's 7A ($\frac{1}{7}$) at 12 feet will
give both more light and better work (though the image is same
size) than his No. 6 ($\frac{1}{6}$) at 17 feet. When the highest power
is needed, it is usually better to use a good oil-immersion lens
than to increase the distance. This refers to the magnification
of minute detail; on the contrary, if the object be to exhibit
ordinary objects on a colossal scale, this is generally better
done by a screen distance of not less than 25 feet, with
amplifiers or high-power eye-pieces, or often by stretching
the distance to 50 feet or more. In this way a flea may be
shown 30 or 40 feet long with ease. But for histology, which
will always be demonstrated to moderate audiences, short
distances and high powers are far the best. Zeiss's projection
oculars will give good results with most *wide-angled* lenses,
where their very contracted field is sufficient for the purpose ;
but it will save time to centre the slide with one having a
larger field.

Ample light is important, and I would prefer 3,000 candle-
power to less. For a material point is to stop down the
cone of light from the substage condenser, with the iris
diaphragm, to the precise degree which gives the best result.
Mr. Nelson's experiments have determined that even on the
compound microscope this is only about three-fourths of the
angle of the objective ; in projection it will rarely exceed two
thirds. A cone will always be found that gives a distinctly
best result, focussed on the object. That is the chief point
about the microscopic manipulation.

With powers approaching 4,000 or 5,000 diameters, all
that has been said in § 101 applies with increased force.
Histological detail will depend, even more than with the

oxy-hydrogen light, upon thinness and good staining ; the more transparent the section, *the less cone can be used.* Biologists will therefore find it best to prepare their own slides, employing stains which, like carmine, gold, and silver, give density to the marking. German professors, I believe, are as a rule in advance of English in these matters, and in overcoming this difficulty, which is the principal one. In projecting blood-corpuscles, for instance, when the images are quite sharp on the screen, there is so little colour in them, that they are not easy to observe. Professor Stricker gets over this by treating the preparation with a 0·6 per cent. solution of salt in which is dissolved some fuchsine solution. In this red ground the amœboid corpuscles stand out white, and their movements are readily seen, while the red discs appear light yellow. Any such expedients are a great help to the screen image ; and doubtless as screen demonstration becomes more common, both such methods, and others of differentiating details of structure—such, *e.g.*, as the striations in voluntary muscular fibre—will be perfected or improved. The limit of power will be found, not in mere magnification, or mere brightness on the screen, but either in too little contrast of the image in its shades, owing to want of density, or woolliness owing to thickness of the section, or to the lens. Bearing these considerations in mind, few objects except microbes will be found out of the range of projection, and some even of these can be shown with a good oil-immersion lens.

106. **Management of the Electric Microscope.**—This is perfectly simple. The lamp is first adjusted at a distance from the back lens of the condenser which gives a nearly parallel beam from *that* lens alone : usually this is about 6 inches, but the exact distance may be obtained with each instrument. The arc is centred by the screw slides of the table or stand, and the front lens of the condenser is racked in or out, or the lamp screwed backwards or forwards, until when the objective fitting and substage condenser are re-

moved, a *central parallel beam* proceeds from the parallelising lens on the alum-cell to the screen. Thenceforth the procedure is precisely that already described for the oxy-hydrogen apparatus, only racking the front lantern condenser, or screwing the lamp-stand to and fro, instead of moving the lime-tray. Good centering is all-important. The substage condenser, in critical cases, must then be carefully *focussed on the slide.* And finally (the demonstrator here using a binocular glass unless his sight is very keen) the objective itself being focussed as accurately as possible, and the required point in the slide brought into the centre of the field, the iris diaphragm is to be adjusted till the best effect is found.

In using the projection microscope with the electric light, it is particularly necessary to remove any air-bubbles on the sides of the alum-trough from time to time. The obstruction to the light is not of so much consequence, but they interfere with a truly parallel beam, and usually focus upon the screen when the adjustment of the light is otherwise at its very best.

CHAPTER XIV

DEMONSTRATIONS OF APPARATUS, AND IN MECHANICAL AND MOLECULAR PHYSICS.

107. **Projection of Apparatus.** — Referring back for a moment to fig. 81, page 154, it will be seen that a gold-leaf electroscope, placed in the field of the lantern, upon a small table adjustable both for height and distance from the condensers, takes the place of an ordinary diagram or slide, and is then projected upon the screen in precisely the same way. There are some limitations and also some difficulties about such projections, which deserve a word or two.

In the way of limitation, it is plain that, except so far as any piece of apparatus may be transparent or semi-transparent, the projection can only appear as a black shadow, and fluids in tubes, however transparent, will also appear more or less opaque. For a large class of apparatus this matters little, however; especially as in many cases *motion* of some kind is the essence of the experiments. Thus, in the electroscope, the effect to be shown upon the screen is simply the divergence of the leaves, which is sufficiently clear. It is further obvious, that the *size* of apparatus to be projected in this way is limited by the field of the condensers; and that, in fact, the possibility of exhibiting a vast number of experiments by the projection method, depends simply upon the possibility of reducing the requisite apparatus to a sufficiently small size.

The chief difficulties are also two. The first is, that the object to be projected no longer lies in the same focal plane, and can therefore not be all truly in focus at one time. This difficulty is best overcome by using a projecting lens of longer focus than would be used for diagrams alone, 9 to 12 inches focus being most suitable. The objects are coarse compared with the small letters and lines of a diagram, and such a lens gives an amply large scale, while the difference in focus between various parts of the object is much less evident. With such a lens the difficulty about focus is much less observable than might be supposed, and a vast mass of apparatus, which need not be particularised, is perfectly well shown. Let us take, as a fair illustration, a radiometer. While in the electroscope the glass case may be neglected, and only the leaves focussed, in the radiometer even the active portion of the apparatus cannot all be in focus together, but the revolving vanes will occupy planes differing by one to two inches. Nevertheless the instrument, and the effect of revolution, will be shown upon the screen perfectly well.

The other difficulty is greater, and is too often allowed to spoil the projection altogether. It is especially difficult to

overcome with the Duboscq lantern, partly from the small size
of its condensers, and partly from the optical construction
already pointed out ; and to the former prevalence of this
lantern in lecture theatres, I attribute the little progress made
in this class of projections, until the Germans showed a more
excellent way. It arises from the fact that nearly all apparatus
has to be arranged, owing to its absolute thickness in the
direction of the optic axis, *farther from the condensers*, as
regards its ' average ' or practical focal plane, than a diagram
would be. We place the latter almost touching the front
condenser lens ; while in the apparatus the plane focussed
will probably be some inches away from it. Now this *quite
upsets the uniform illumination of the disc* ; a fact which
seems too often forgotten. If we are to have a good and
clear projection, the disc on which it appears must be as
carefully adjusted, as to centering of the light, and distance
of the light behind the condensers, as for a diagram. The
radiant has to be brought *nearer* the condensers, and even
then the cone of rays will not embrace so large a field as
the largest slide which can be shown. This is one reason
why the condensers of a demonstrating lantern, for exhibiting
solid apparatus, should be $4\frac{1}{2}$ to 5 inches in diameter.

In all work throughout the following chapters, and similar
experiments, the proper adjustment of the cone of rays from
the condensers, so as to embrace the apparatus, and finally
pass through the focussing lens, and give an evenly-illu-
minated disc *over the plane of the object*, is the chief thing
in order to obtain a good projection, and the objective itself
' focusses ' better under these conditions. The adjustment
involves some trouble, and hence is too often neglected, as
re-arrangement may be needed from time to time. A fair
average for a series of apparatus can be pretty easily secured ;
but the reason will be evident why the same adjustment does
not suffice for apparatus and diagrams, and why, therefore,
some form of double lantern is so desirable where diagrams

are habitually interspersed. Otherwise, the radiant must be readily adjustable in order to obtain good results. The practical importance of this matter in demonstrations cannot be exaggerated.

The inversion of the image is a third difficulty, but is met by the use of an erecting prism. Each must decide for himself how often this is necessary; the only practical inconveniences about it are the space required in front of the objective, and the time needed for adjustment. The loss of light, when properly adjusted at the smallest point of the pencil of rays, is not probably more than 40 per cent., and this (for most apparatus) leaves ample margin.

108. **Method and Scale of Experiment.**—Whilst, however, a vast number and variety of experiments, by reducing the size of the apparatus until it comes within the field of the condensers, can be demonstrated by projection, it is by no means the purpose of this work to urge that this should always be done. That is always a question for practical consideration; weighing on the one hand the saving in space and weight of apparatus, and on the other the comparative *effectiveness* of the direct and projection methods. In many experiments the direct method will remain the only one available; while in many more, where the method is optional, it will depend upon particular circumstances which is to be chosen. Let us take two illustrations from experiments connected with the *elasticity* of bodies.

Simple elasticity is easily illustrated in the lantern, by adjusting upon the table, concave side upwards, a spare (or cracked) meniscus lens from a condenser, in a cell or not and dropping upon the centre, from the top of the field, a well-tempered $\frac{1}{4}$ inch steel ball from a bicycle bearing. Or the concave bottom of a thick glass tumbler will answer instead of the lens. The ball will rebound nearly to the height it fell from, and the concavity will keep its motions within the field; and this small and simple apparatus will suffice. That

may be a convenience ; but few would question that for mere *effectiveness*, in such an experiment as this, a larger ball of ivory, clearly seen in its rebound from a metal plate, is to be preferred.

Take again the propagation of a wave in an elastic medium, as illustrated by the well-known apparatus shown in fig. 104. Using small glass balls, with wires for the suspending frame, this is very easily brought within the field of the lantern, the apparatus not exceeding, say, 4 inches in total width. That

Fig. 104

may be a great convenience and advantage, in storage or portability. But if not, then it becomes a question whether it is *worth while* to project apparatus made on such a miniature scale ; or whether larger apparatus, or a row of billiard balls in a trough, shall be employed in the usual manner, in view of the auditory.

All questions of adapting physical apparatus for projection, should be considered from this practical point of view.

109. Shadow Projections.—The screen method of demonstration is not, however, limited to small apparatus ; a great deal constructed on quite a large scale can be projected on the screen by a method I first found described by Professor Dolbear [1] in connection with the heliostat, and which I have found, with a very little modification, to be quite efficient with the lantern. Professor Dolbear condenses the solar beam by a lens of short focus, and in the rays diverging from this focus as from a point, the apparatus is placed, casting a *very sharp shadow* upon the screen. To show the immense range of this method, let us take the very simple apparatus illus-

[1] *The Art of Projecting.* Boston: Lee & Sheppard.

trating the equilibrium and parallelogram of forces. I pur-
posely select this, as probably almost the last experiment that
it would occur to anyone to demonstrate by this method. As
is well known, we arrange two pulleys H and K, over which
hang weights P and Q, drawing two flexible cords from the
point A, from which depends another weight R by the line A L,
the lines A B and A C measured from any point D on the per-
pendicular by lines D B and D C parallel to the cords, giving
the ratio of the weights P and Q, and A D that to both of the
weight R. Simply using rather thicker flexible cords than
usual, all this will be projected on the screen with the greatest
facility, and on a large scale ; while by supporting in a clamp
a plate of glass just in front, and in the plane, of the cords,
the parallelogram may be actually
traced out with a black brush, appear-
ing on the screen as drawn, and the
law verified by measurements.

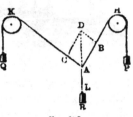

Fig. 105

It has been said that some little
modification is required to use this
method with the lantern ; but it is
very slight. We merely want to pro-
vide as small and intense a radiant
point as possible. When the radiant in the lantern is an arc-
lamp of moderate power, sufficiently sharp projections will be
obtained from the arc *direct*, removing all lenses from the
lantern front. An incandescent lime is too large for sharp-
ness, however, and the best method is to place on the front
the little 'pencil' attachment shown in fig. 95, p. 179, removing
the parallelising concave lens. The chief part of the rays
will then be passed as a *conical* pencil through one of the
holes on the front, the hole being reduced till the desired
sharpness is obtained.

The range of the lantern is immensely extended by this
method of projection, which has two advantages. The image
on the screen is not inverted ; and it can be made of any size

desired, within wide limits. The heights and other phenomena
of fluids in glass tubes are well shown in this way, and *large*
diagrams traced rather thickly upon plates of glass or mica,
demonstrate very well. A Sprengel air-pump can be excellently
shown in action by this method; also large siphons, a full-
sized pyrometer, and many experiments in conduction of heat
which require more length of conductor than readily comes
within the lantern field. 'Cartesian divers' are excellently
shown in this way. Often there will be a choice of the two
methods. Thus, the equilibrium of liquids in communicating
vessels, the principle of the hydrometer as on page 221, and
other experiments in hydrostatics, may easily be shown either
by apparatus made on a *small* scale, to come within the field
of the condensers; or with equal facility by larger apparatus
and this method of shadow projection.

I fear that this simple means of producing screen projec-
tions will be regarded with some scepticism, if not derision,
by those ignorant of it. I can only state that the sharpness
and precision of outline thus attainable will astonish those
who try it for the first time; and that in all cases where a
silhouette representation of an operation or piece of apparatus
is sufficient, as it is in a vast number of experiments, it is
perfectly satisfactory, and unequalled in its convenience for
dealing with *apparatus generally, of the usual size*, as it
comes to hand in most physical laboratories.

110. **Intermediate Projections.**—There is still another
expedient available. It may be desirable to produce a really
focussed image of some experiment or piece of apparatus,
rather than use the shadow method; and yet the lantern
condenser may be too small. If in such a case we have at
hand a lens six or seven inches diameter, and this gives
sufficient field,[1] we can adopt the arrangement shown in

[1] I have never tested this method with a lens of larger diameter than that.
It might possibly be carried farther, only there would be an obvious tendency
for the field to be less illuminated at the margin than in the centre. A seven-

fig. 106. We push in the radiant R so that the rays *diverge* considerably from the condenser C (removing the large lantern-nozzle, if there is one, as such a tube would cut off the diverging rays), and adjust the large lens L so that it collects them all, and converges them upon the focussing lens F, which projects an image upon the screen beyond S. The effect of this, of course, is to convert the double condenser into a triple one, with a much larger front to cover the object O. For many purposes this method of work is very convenient.

If the ordinary condenser is so deep that it will not bear the radiant close enough for this arrangement, it may be

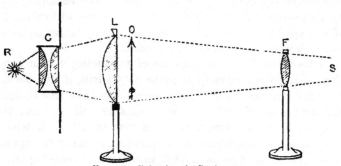

FIG. 106.—Enlarging the Condenser

better to remove the front lens of the lantern condenser, and especially if the large lens L be itself pretty deep in curve. It must of course be deep enough to converge the diverging rays from C through F when the latter is focussed, and if it is mounted with a shade round it to stop scattered light, the effect will be all the better. With large projections like this, the focussing lens F should be pretty long in focus—say 12 to 18 inches—and itself of a good size and with a marginal shade.

A vast number of projections illustrating mechanical and molecular physics, resolve themselves simply into projections

inch lens, or even six-inch, will however immensely increase the range of apparatus brought within the field.

of the necessary apparatus, in action, by one or the other of the above methods. It is both impossible and needless to make any pretence of a complete list; but we will run through a few typical experiments which may serve as specimens or suggestions.

111. Gravity. Atwood's Machine.—Pendulums and their phenomena are very easily projected by the shadow method; and so is the working of an Atwood machine, especially if constructed with some reference to this use—*e.g.* with a transparent scale, thickly divided. By a little modification, however, the law of acceleration may be demonstrated in a very superior manner. Let the descending weight consist either of a vibrating metal fork (the sound of which is of no consequence), or of a rigid pendulum, or of a piece of clockwork; either being furnished with a tracing point pressed lightly against a long perpendicular strip of smoked glass. The tracer should mark a *bold* line transversely across the strip of glass. When now this tracer-weight is made to descend by an additional weight as usual, its descent will cut a series of wave-lines, nearly of the same amplitude as regards width (quite so if clock-work be employed); but the *lengths* of the waves will be greater and greater with the accelerated downward motion, as will be seen upon the screen. The whole series will project by the shadow method; or measurements may be taken, and different wave-lengths projected in the slide-stage of the lantern.

With a small Cavendish apparatus as constructed by Mr. Vernon Boys, with quartz fibres,[1] the direct attraction of small masses can be easily projected on the screen.

112. Elasticity.—By using a small spiral coil, traction can be demonstrated; or a larger coil may be used with the shadow method. Torsion is projected by the vertical lantern or attachment, using a divided *glass* dial for the scale. Flexure can be projected in almost any way, and needs no description.

113. Cohesion.—This may be projected by the method of

[1] For full details see *Proc. R.S.*, xlvi. 253.

raising a disc attached to a balance from the surface of water, a small tank and the disc being brought into the field ; or a pencil of wood may be shown suspended by the cohesion of intervening fluid from the lower surface of another bar.

FIG. 107

114. Centrifugal Force. Such an apparatus as shown in fig. 107, or any other of the usual forms, is very easily projected, the rotating portion only being brought into the field, and the whirling-table supported as convenient. See also Plateau's method as on p. 226.

115. Hydrostatics. — For these projections, one or more square or cubical glass tanks should be provided. Using such a tank about 5 in. cube, the *upward pressure* of water is easily shown in the usual way by a smooth lead plate supported against the bottom of a glass tube. The principle of Archimedes and any of its applications are projected in a similar tank. The application of these principles to specific gravity, hydrometers, &c., may be shown by immersing three small test-

FIG. 108

tubes, A, B, C (fig. 108), each loaded with the same small weight of mercury or shot, either in larger tubes, or in three

divisions of a tank, filled respectively with alcohol, water, and heavy brine. Different fluids may also be projected in layers, in a test-tube or small tank. These are experiments which, to avoid any chance of misconception, should be made with the erecting prism, unless shown on a large scale by the shadow method. The *level* of liquids in differently shaped vessels, is best shown on the large scale : the balance of a small column by a large one can be shown equally well either way, if a prism be at hand. For pressure fountains the shadow method must be used.

116. **Waves and Ripples.**—The propagation, and crossing by reflection from one end of a trough of waves on the surface of a liquid, are easily projected by the shadow method in a trough a few feet long with glass sides. Using the vertical method, and a horizontal tank like fig. 117 with a glass bottom, smaller ripples can be shown by touching the surface with the point of a rod, but the effect is not very satisfactory ; it is better on the surface of methylated spirit than water. More distinct ripples are produced by *rapid intermittent* contact of a pointed wire, which may be produced either by a multiplying wheel actuating an arm, so as to give a rapid intermittent dip to the bent end of a wire attached to the arm, or by a bent wire attached to the end of a tuning-fork, electrically driven. By the latter, sharp ripples are readily produced and focussed, and by adjusting the starting point rather to one side (still better in one of the foci of an elliptical trough), interferences may be shown.

See also acoustic ripples in Chapter XVII., and by substituting a vessel of mercury for the funnel of the phoneidoscope shown in fig. 142, its surface occupying the position of the soap-film when the funnel is in place, beautiful ripples may be projected by touching the surface with the point of a wire, vibrated as just described,

117. **Capillarity.**—Capillary attraction is projected by dipping small tubes of different bores, fixed in a slip of wood, as

fig. 109, or two small glass plates inclined together and also fitted at the top in a strip of wood (fig. 110), in a small tank of water placed on the lantern stage. The tank may be of any

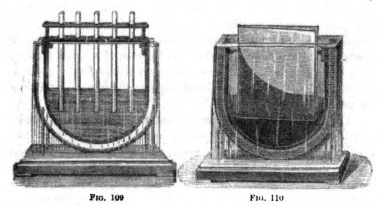

FIG. 109 FIG. 110

convenient shape, and the simple form shown in fig. 111, where the glass plates are mounted in a wooden frame to fit the usual slide-stage, will answer perfectly well. The reverse

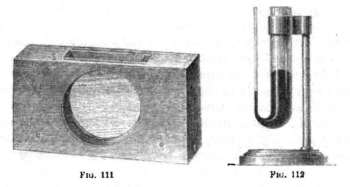

FIG. 111 FIG. 112

phenomena shown between glass and such a fluid as mercury, are projected by a small apparatus like fig. 112, about double the size there shown.

A pretty method of exhibiting capillary attraction has been described by Mr. G. M. Hopkins. A piece of wire-gauze with the wires about one-tenth of an inch apart is thinly varnished, and projected as a lantern slide, in any way that leaves the whole front of the gauze accessible. Then a few differently coloured fluids of almost any kind—aniline dyes answer very well—being provided in small saucers, with a clean hair pencil

FIG. 113

for each, a drop of fluid is introduced by the point of the brush into each separate mesh. This is easily done so as to exhibit a geometrical pattern, which when magnified has a wonderfully fine effect upon the screen. By ' drawing ' the brush over the meshes the effect is different, and will resemble that of Berlin-wool-work upon a large scale, the colour always running out to the edges of exact squares.

Experiments with fluids in tubes project better if the tubes can be somewhat flattened whilst red-hot. The flat sides are of course turned towards condenser and screen, the object being to get more surface and a nearer approach to one focal plane.

Endosmose is readily projected from the usual apparatus shown in fig. 118, using a nearly capillary tube, which is projected, and rather large membranous bag, and staining the internal fluid. If the tube is sufficiently small in proportion, the rise of the fluid in it will readily be seen in pro gress.

118. Surface Tension.—The tension of liquid surfaces is

best shown by projecting flat soap-films in circular rings,[1] the
arrangement of the apparatus being shown in detail at p. 327,
where the bands of colour are being projected. At present,
however, we are not dealing with colour, but simply with the
contractile power of the film. Having lifted a film from the
saucer, lay across it a loose thread of fine sewing-silk dipped
in the solution; this thread will also be projected, and it will
be seen that it may be moved about freely. Prick on either
side of the thread with the end of a small screw of blotting-
paper, and the tensile force on the other side at once draws
the thread into a curve as fig. 114. In the same way a loose
closed loop, pricked in the centre, is at once drawn out into

FIG. 114

a circle by the tension of the film. I the ring is carefully
flattened, and a straight thin wire wetted with the solution
laid across it near one edge, it will adhere; and if the film be
pricked in the small space between the wire and the edge of
the ring, the tension of the film will pull the wire more or
less towards the other side.

That the contractile force is greater the smaller the
bubble, is projected by blowing two bubbles, one of an inch
and the other of two inches diameter, at the open ends of a
twice-bent tube, furnished with a stop-cock between them,
and with two others which allow communication with separate

[1] The rings should be of wire about 1 mm. diameter, and 2 to 8 inches
diameter, and should be coated with paraffin, rubbed on them whilst hot.

Q

rubber blowing-tubes to be cut off. The two bubbles being projected and outer taps closed, on now opening the tap which places them in communication, the small bubble will expel its contents into the larger one.

The effect of surface tension on masses of fluid may be projected in various ways. A small circular vessel being focussed on the screen, it can easily be shown that it may be filled with liquid far above the level of the rim. In the cubical tank, the spherical shape taken by a mass of olive or castor oil, in a mixture of alcohol and water of the same specific gravity, may be projected as in fig. 115, direct. Even Plateau's experiments on the modified forms produced by

FIG. 115

rotation of the mass, may be partially projected in the same simple manner ; but to show the actual detachment of a ring of oil at a given velocity, the vertical method must be employed. The manner will suggest itself, but fig. 116 shows the apparatus as arranged by Stöhrer. The rays from the condensers fall at 45° upon the reflecting mirror s_1, to be directed upwards. In the field is placed the cubical tank G, with a glass bottom P, held by the screw m_1. By the screw m_3 is adjusted the revolving arrangement, consisting of a perpendicular rotating wire provided as usual with a small tin disc near the bottom to carry the sphere of oil, and a small pulley w at the top, by which this is rotated from the larger pulley w. By the screw m_3 the whole can be adjusted for height and in the centre of the field ; and in Stöhrer's apparatus revolution is effected by a thread e fastened to the endless cord which embraces both pulleys, but I myself should prefer a winch-handle. ⁓⁓ther up the pillar v, which is attached to the mirror-box

K, is fixed by the screw m_2 the ring R, which carries the focussing objective, bearing at the top another ring f, carrying the inclined mirror s_2, which reflects the image to the screen.[1]

119. Viscosity. — Very impressive experiments may be projected with a 2 per cent. solution of saponine. With care this will blow a bubble nearly 2 inches diameter; the best way is to clip a small glass funnel ¾ inch diameter mouth downwards in a universal holder, with a bit of rubber tube for blowing sprung on the small end; this is adjusted

FIG. 116.—Plateau's Experiment

[1] For details of these experiments and their practical management cf. *Taylor's Memoir*, xiii. and xxi.; *Phil. Mag.*, xiv. 1, xvi. 28, xxii. 286. In America, details may be found in *Smithsonian Reports*, 1865, p. 207. Three lectures by Mr. C. V. Boys on *Soap Bubbles* (S.P.C.K. 2s. 6d.) are published just as these pages go to press, and describe other attractive projection experiments in this branch of physics.

so that the bubble will be in focus when blown, and the saucer of solution is lifted to the funnel when required, and then withdrawn. If this bubble be pricked, it does not disappear as a soap-bubble would, but 'hangs in rags' to the funnel, as it were. And secondly, if the air be sucked rapidly out from the bubble, it does not contract smoothly, but hangs in folds like a wet linen bag.

That this is owing to extraordinary *surface* viscosity can be shown in a tank like fig. 117 laid on the vertical attachment, or less perfectly by direct projection in a cubical tank. Tanks like fig. 117 are made by cementing large metal rings or cylinders any required depth, on pieces of plate glass. The tank being supplied with saponine solution, it can first be

Fig. 117

shown by projection that a magnet suspended *above* the surface is readily moved about by another magnet. Being then lowered *to* the surface, hardly any movement can be produced. And being finally lowered *below* the surface, movement is free and easy again.

120. Cohesion Figures and Motions.—In such tanks as fig. 117 all the experiments usually known as ' Tomlinson's Cohesion Figures '[1] are readily projected by the vertical method ; also the movements due to varying tension caused by dropping camphor, alcohol, &c., on the surface of water. The water must be *perfectly clean* for each new experiment ; but cleaning or a fresh tank may often be dispensed with by neatly *tossing*, as it were, the contents of the tank perpendicularly out of it into a convenient receptacle.

Another class of cohesion figures are produced in an ordinary slide-tank projected direct, by filling with water or alcohol, and dropping on the surface, or against one of the glass sides, with a glass rod, solutions of aniline dyes. Still another class are produced by providing pairs of pieces of plate-glass, bevelled towards the inside surfaces, and between

[1] For details see *Phil. Mag.* 1861.

which is a film of vaseline or other viscid substance free from bubbles. This being put into any sort of a slide-frame, the glasses being kept together by a spring, on introducing a pen-knife between the bevelled edges and separating them, curious arborescent figures are projected on the screen.

121. Vortex Rings.—These may be partially projected in a tank, vertically or otherwise, dropping in milk or aniline dye. They are best shown, however, by using a vortex-box in the ordinary way, and sending the rings along a track illuminated by the full beam from the nozzle of the lantern. Rings thus illuminated are very impressive.

122. Molecular Strains and Forces.—With the usual precautions, the breakage of a Rupert's drop or Bologna flask in a vessel of water is very easily projected; and the apparently sudden annihilation of the drop is very curious.

Crystallisation is easily projected upon plates of glass. About 3 inches square is a convenient size, clipped at one corner in a 'holder' and focussed in the condenser field. A saturated solution of ammonium chloride, or urea, in water, or of magnesium sulphate in stale beer, crystallise perhaps most readily.[1]

123. Gases.—A great many of the phenomena of gases are readily projected, using the shadow method for larger apparatus. Apparatus is easily arranged on a small scale for exhibiting absorption, or the expulsion by heat of occluded gas. The whole of a manometer can be projected by the shadow method, or the scale portion only may be projected with the objective. A barometer, Sprengel pump, apparatus exhibiting Marriotte's law and its applications (including all sorts of fountains), are best shown large by the shadow method. Siphons can be projected either way. The action of an aspirator is projected in the condenser field with exceedingly good effect. After what has been said, the methods of arranging such projections will suggest themselves.

[1] See also under ' The Projection Microscope,' and ' Polarised Light.'

CHAPTER XV

PHYSIOLOGICAL DEMONSTRATION

124. The Projection Microscope.—As regards histological detail, the most important aid which can be derived from the lantern is in the form of a projection microscope (see Chapter XIII.). By furnishing members of a class with very inexpensive opera-glasses, a far greater amount of detail can be seen upon the screen, than is possible to the unassisted eye, which, as pointed out at page 191, fails before the microscope, and may be unable to perceive detail really upon the screen. Opera-glasses are thus used in Vienna, and by their aid a single demonstration not only saves much time, but enables the lecturer to use a pointer, and combine the demonstration with a *vivâ voce* explanation, which is found to be more effective than when demonstration under the table microscope is divorced from such explanation. The electric projection microscope, especially, will leave little to be desired as regards by far the larger portion of the histological demonstration to be done.

The simpler vital movements, such as circulation in the foot of a frog, or cyclosis in the cells of Vallisneria, as already stated, are also projected easily; even the lime-light making the latter visible to a class of thirty or forty, and the arc light showing it clearly in a larger room.

125. Mechanical Slides.—But the lantern itself is capable of wider application in this class of work. Dealing first with such simple matters as movable mechanical slides, even these are capable of being adapted to serious purposes, as may be shown by the ingenious construction described by Stein for exhibiting in graphic form the main facts of the circulating system. Two lanterns, or nozzles, are necessary, which will be furnished by any form of demonstrator's bi-unial. In one

of these is placed a representation of the heart, as at A (fig. 118), showing the ventricles and auricles, while the moving slide B, actuated by the winch K, occupies the other. This latter slide consists first of the foundation design shown in B, on which is painted in black ground a scheme of the distribution of blood in the human body, as seen enlarged in fig. 119. The portion *a* shows the circulation in the upper extremities, head, and lungs ; *b* that of the intestines and lower extremities.

FIG. 118.—Mechanical Slide for showing Circulation

The black space 1, 2, 3, 4 in B is filled by the picture of the heart in A, so that the points shown by 1, 2, 3, 4 coincide ; thus the two together make up the whole figure 119. The glass on which B is painted should be very thin. The movable portion of the slide is shown at C, and consists of the three toothed wheels *a'*, *h*, and *b'*, filled with glass. On *a'* are drawn many radial lines halfway from circumference to centre, and on *h* similar radial lines from the centre half-

way to circumference. These two discs are arranged one on each side of the upper part *a a* of the slide B, and are caused to revolve in opposite directions by a crown wheel working

Fig. 119

between them; this wheel is shown at s, with the rod *r′ r′ r′″* connecting it by the winch *f* with the handle K. The wheel *b′* simply gears into *a′*, and has complete waved radial lines: all these lines are cut in black ground and coloured red. The circular motion of these lines over the painted diagrams, as will be seen on reference to the enlarged diagram in fig. 119, gives a very graphic idea of the circulation as there depicted.

126. **Physiological Move-**ments. — The simplest optical demonstration of any vital phenomenon is that of the pulse by a small reflecting mirror

as in fig. 120. A disc of microscopic cover-glass silvered, about ¾ inch diameter, should have attached to the back two morsels of beeswax and one of cobbler's wax, and be so placed that the latter adheres to the spot on the wrist found to give the best pulse. A parallel beam, or preferably the focussed parallel beam from a small aperture in the pencil attachment (fig. 95), is reflected from the mirror A to the screen, and the reflected ray exhibits every beat by the oscillation of the bright spot.

This reflection is too simple to exhibit any characteristic pulse-trace, as taken by the sphygmograph. Some approximation to it can however be obtained by receiving the reflection from A upon a tilting or rocking mirror, capable of giving a motion to the spot of light at right angles to that given by the pulse-motion. Then this rocking motion should be given, backwards and forwards, so that the

Fig. 120.—Pulse Mirror

motion synchronises with the pulse-motion; when the break in the curve will be seen very fairly represented on the screen.

It is true that this break can only be followed for one pulse at a time, and not for many beats together as in a tracing. But there is a general remark to be made here respecting the true place and value in demonstration of direct projections. Exhibited thus, however roughly, they give *a sense of vivid objective reality* which can be imparted to a class in no other way, to 'tracings' prepared by any of the well-known methods, and which should immediately afterwards be projected upon the screen, using the tracings as ordinary scientific diagrams. To obtain such slides, either the revolving blackened cylinder so usual in tracing apparatus must be displaced for tracing on the flat, which is most

easily and simply done in ways too obvious to need description; or films of smoked mica can be bent round the cylinders, and afterwards unrolled and mounted between glass plates. To take the case before us: when the break in the curve has once been shown in actual motion on the screen by the pulse-mirror, and its method of production explained, it will be found that the meaning of the curve in any tracings subsequently projected will be instantly *realised* in a degree very desirable.

This will be still more the case if the process of tracing be itself projected, which can generally be done, by the ap-

FIG. 121.—Double Recording Apparatus

paratus devised by Marey. The usual means of transmitting vital movements to the recording style or point need not be described in detail, as it is well known that the two principal methods are the electric current, or Marey's tambour. By arranging an apparatus as in fig. 121, where the screw d adjusts upon the main pillar an electric receiving apparatus m in electrical connection at c, while the screw e adjusts another recording style actuated at g by the registering tambour n, whose membrane on the top is actuated by the varying pneumatic pressure conveyed into the receiving tambour by a tube at r, the motion transmitted electrically and pneumatically

may be traced upon the same blackened plate by the styles *a*
and *b* ; and if the plate and styles be adjusted in front of the
condensers, and focussed on the screen, the tracings will
appear as they are made. In some cases it may be well to
attach fine wires carrying small black discs to the ends of *a*
and *b*, and to exhibit the motion of these discs upon the
screen, before the clockwork tracing is made.

By employing the delicately-adjustable tambour devised
by Marey for the purpose, as the transmitting instrument in

FIG. 122.—Projection of Heart Movement

a pneumatic system, or two systems, the movement of the
heart may be shown from the outside of the chest upon the
screen, or simultaneously with a pulse-tracing. All that is
really necessary is to adjust the clock-work movement and
the traverse of the tracing point, to the size of the field
covered by the condensers of the lantern. As regards the
projection itself, it is only needful to secure an *evenly illu-
minated disc*, in the manner described on p. 115, for the focal
plane which is to be occupied by the blackened glass. This

is accomplished by focussing a plate of glass with a few lines
marked upon it, and adjusting the light for this; and then
making every smoked plate occupy the same position as nearly
as possible, throughout the series of demonstrations.

The movements of the heart have been projected by other
methods. The apparatus shown in fig. 122 is extremely simple.
A heart freshly taken from the living frog or other animal is
embedded in sufficient warmed wax to form a steady base,
and laid on the plate *a*. Above it extends a light lever, *f d*,

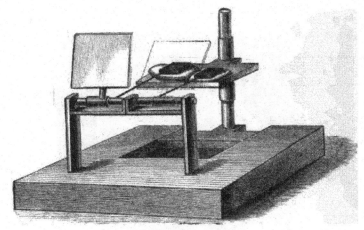

Fig. 123.—Czermak's Cardioscope

bearing an index-disc, *f*, at the end, or it may be a style; this
has a very sensitive joint at *d i*, which can be adjusted length-
ways over the heart by the screw *g*, and this and the other
screw *g* also serve to adjust lever and stand on the pillar *m*.
For some experiments requiring great delicacy, it may be
advisable to carefully *balance* the arm *f c*, or the somewhat
similar arms in fig. 121, so that their weight may not inter-
fere with the motion. Between the heart and the lever at *c*
is adjusted a small pillar *b* of elder pith, with a small point at
each end, which communicates the motion, the lower point

being sunk in the heart. The motions of the heart, which can be kept beating rhythmically by well-known methods, are thus readily projected, as shown by the disc on a point at *f*.

The same apparatus projects the contractile movements of pieces of muscle. The plate *a* is removed, and the arm *h* arranged *above* the lever *f c d*. To a loop on *h* is fastened one end of the muscle, and to a thread attached to *f c d* the other end ; when the contraction of the muscle will affect the lever as before.

Czermak's projecting Cardioscope employs the direct optical

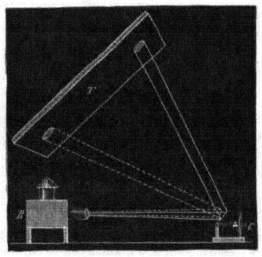

FIG. 124.—Action of the Cardioscope

method of the reflecting mirror. Small slabs of cork are laid on the pulsating body, so as to receive the motion without loss or suppression by weight, and resting upon these are the horizontal arms of very light levers bent at their pivots somewhat like an L, which communicate the angular motion to light thin mirrors. Fig. 123 represents such an apparatus with two slabs and mirrors, one slab being placed on the

ventricle of a heart and the other on the auricle. When the
auricle is compressed the slab sinks, and so does the mirror,
as shown by the dotted lines; whilst the slab on the ventricle
rises and the other mirror is elevated. The optical arrange-
ments are as in fig. 124. The focussed parallel pencils from
two small apertures on the lantern B fall on the mirrors of
the cardioscope C, and are reflected and focussed on the screen
T. The spots move in harmony, and one of course represents
the systole and the other the diastole of the heart, as the
mirrors rise and fall.

 Contraction of Muscle, which it has already been remarked
may be projected by the apparatus shown in fig. 122, may be

also demonstrated on the
screen by the telegraph of
Du Bois-Reymond, the general
scheme of which will be seen
in fig. 125. On the base gg'
the pillar D is fixed, and sup-
ports a pair of forceps A, which
can slide in and out of the
tubular socket or handle B,
being fixed at any length by
the screw s. The other pillar

Fig. 125.—Muscle Telegraph

can be fixed at a movable distance on the base by the screw z.
This pillar carries a little pulley from which projects a radial
arm a' carrying at the end the index-disc d. Over the pulley
passes a thread, which carries at the end a small capsule or
bucket b for weighting, and at the other end has a hook x.
One end of a frog's muscle properly prepared with its nerve
is held in the forceps A, and the hook is passed through the
tendo Achillis, the distances are properly adjusted, and the
bucket weighted with small shot, so that the slightest con-
traction pulls the thread and raises the index-disc in the
direction of the arrow. By binding screws at s' and x wires
can be connected for applying a galvanic current. By this

simple apparatus, making the scale cc' of glass, the different effects, both in kind, and roughly in degree, of continuous, making, breaking, or intermittent currents can be projected.

127. Blood-pressure.—Most experiments of this class can be demonstrated upon the screen, preparatory to exhibiting their tracings in the same manner. Fig. 126 is a general sketch of Ludwig's Kymographion, which makes use of the mercury or ∪-tube manometer. The normal level of the mercury is da. In the blood-vessel cc is tied a ⊤-shaped end of the short limb of the ∪-tube, the space between the blood-vessel and the mercury being filled with a solution of sodic bicarbonate to prevent coagulation. To the surface of the mercury in the long limb Ludwig applied floats, bearing at the top an arm f carrying a tracing-point which makes the trace on the blackened plate c as the pressure of the blood depresses the mercury in one limb to a variable point a' and of course raises the column in the other tube to b. We have only to remove the clockwork and blackened plate, and if desirable the float and style as well, and place behind the manometer a black board or card with a slit cut in it sufficiently large to display the

FIG. 126.—Ludwig's Kymographion

long tube. The tube and slit being then focussed, the rise and fall of the mercury will distinctly appear upon the screen, either inverted, or correctly if an erecting prism is employed. Fick and Bourdon's instrument, employing a spring instead of the mercury column, may be projected with equal facility.

128. Electric Currents.—The currents in living tissues— as in muscle or nerve—can be demonstrated on the screen in more than one way. In many instances the matter resolves itself into the simple projection of a galvanometer, or the reflecting galvanometer may be employed ; projecting also if desired,

on another part of the screen, and from the other system of a demonstrating bi-unial lantern, the preparation itself, in order to show the arrangements. The time will not, however, be far distant when every medical school and college will possess an adequate projecting microscope; and with such an instrument these feeble currents may be shown directly by Professor M'Kendrick's modification of Lippmann's capillary electrometer, which can be easily constructed by any person at all accustomed to scientific manipulation. A piece of narrow and thin glass tube *a b* is taken, the ends bent up to form small cups, and the middle drawn into a very fine capillary bore. Immersing one end in mercury covered with dilute sulphuric acid, this is so drawn into the tube that a very minute portion of dilute acid is brought into the centre at *c* between the two columns of mercury, and a platinum wire is

introduced into the mercury at each end. To secure a sensitive instrument, perfectly *clean* glass,

Fig. 127.- -Capillary Electrometer

acid, and mercury are necessary; and the slightest air-bubble must be avoided. The instrument is then carefully mounted on a glass slip as a slide for the microscope, and it will be better to lay over the capillary portion a piece of thin cover-glass, and fill the space between, surrounding the tube, with Canada balsam, which optically abolishes the glass tube, and enables the thread of mercury with its break of acid to be sharply focussed. Placing the slide on the stage of the microscope, and connecting the wires with the nerve or muscle through non-polarisable electrodes, after the manner of Du Bois-Reymond or otherwise,[1] the current will produce a movement,

[1] Details of all these arrangements must be sought in some of the numerous text-books devoted to such matters. I have taken several from Professor M'Gregor-Robertson's *Elements of Physiological Physics;* but it is no part of my purpose to describe more than bears upon the projection of them, and may make *that* portion of the subject intelligible to those whose special business it is to deal with it.

clearly projected on the screen by a power of about 1,200 diameters.

I must content myself with these representative experiments in a branch of demonstration with which I can necessarily have little practical acquaintance; but they will suffice to indicate to those who are familiar with the subject, the applicability to it of the projection method. That method will be found more and more convenient, by reason of the number who can simultaneously receive the same instruction, the more it is practised.

CHAPTER XVI

CHEMISTRY

OF course the only chemical experiments adapted for public projection are of the qualitative, and most of them of the 'popular' class. Of that scrupulously accurate quantitative work which forms so large a part of modern chemistry, the lantern can take no cognisance. It can only impart a popular knowledge of those general phenomena which comprise what the majority of people understand as chemistry; but even this has its value as a part of general education, and as giving some intelligent understanding of a great deal that goes on around us.

129. **Tanks.**—The major part of such experiments may be classed under the general head of 'reactions.' Nearly all of these which give any conspicuous phenomena, are better shown in the lantern, and with the advantage of employing a great deal less weight or bulk of material. The apparatus most frequently required will be some sort of tank, with parallel glass vertical sides, whose contents will exhibit on a small scale the desired reaction, and which takes the place

in the lantern of an ordinary slide or diagram. As these tanks frequently require to be washed clean for other experiments, one of the best methods of constructing them is that shown in fig. 128, where a piece of *smooth* vulcanised tubing bent into a semi-circle, is squeezed between two glass plates by screws through the corners, so as to make a water-tight vessel easily taken to pieces for cleaning, and unaffected by most chemicals. Or the plates may be mounted between outer plates of metal or ebonite, which enables plain or unperforated pieces of glass to be used. Pieces of thick solid

rubber cut to shape may also be used between the plates, but require more pressure and are not so safe. If a little more solidity is desired for the compressed tubing, the latter may be filled with fine sand after being screwed up to the proper tension.

Such tanks may be of any size and thickness of content, and a sufficiency should be provided for the proposed series of experiments. Or the glass plates

FIG. 128.—Tank

may sometimes be more conveniently introduced into some such wooden frame as was shown in fig. 111, p. 223; and the rubber tube then squeezed into place rather tightly, will readily give a water-tight tank, only the glass and rubber coming into contact with the fluid.

Occasionally it will be needful to employ tanks made entirely of glass, cemented together, according to the nature of the solution. For aqueous solutions, those sold as zoophyte troughs for microscopic use are convenient, and may be had of almost any desired size; but for spirituous solutions marine glue must be replaced by other cements, such as are used in

optical prism bottles. Isinglass with a little acetic acid answers very well in most cases.

130. Test-tubes.—Very often a small test-tube answers all purposes as well as any tank, besides being cleaner and using less material. The rather flattened form of test-tube sometimes available is, for obvious reasons, better than circular tubes; but even in the latter any ordinary reaction can be exhibited perfectly well.

131. Experiments.—It is perfectly useless to attempt a list of experiments in detail, but a few representatives may be given, with one or two practical hints.

In *precipitations* it will usually be found expedient to employ solutions more than usually diluted, as the faintest opacity is projected on the screen with a conspicuousness that would hardly be credited without trial. Suppose, for instance, we want to exhibit the precipitation of silver from solution of its nitrate by hydrochloric acid. It will be found that this is *better* shown by a weak solution of one, two, or three grains per ounce; and anyone who has never before attempted this method will be astonished at the apparently dense masses of cloud which will be formed in such a solution, by a single drop of the acid introduced at the tip of a glass rod.

In reactions involving *liberation of gas* the same remarks apply. Minute bubbles are so magnified, and appear so black upon the screen, that solutions adapted for giving what would be called *very slight* reactions, or often a mere trace, give the best results. This fact makes the lantern method peculiarly useful for exhibiting reactions involving the more expensive chemicals. Such an experiment as the formation of calcium carbonate by blowing carbonic acid into clear lime-water, is very much more impressive projected, than when shown in any other way.

The usual *test-reactions* are very readily shown, in tanks of litmus or other test solutions; but these are better made pretty strong, in contradiction to the preceding, in order to

give sufficient colour on the screen, which is the chief thing to be studied, and will depend upon the thickness of the tank: hence a tank of proportionate thickness enables any strength of solution to be used which may be suitable to the reaction. There is also room for ingenuity, in so arranging an experiment as to give the reactions in an attractive or striking manner. Thus, a tank may be filled with the well-known infusion of red cabbage, the top of the tank being long enough to extend all along the diameter of the condensers. Then, if we add a drop or two of potass solution at one end, of alum solution in the centre, and hydrochloric acid at the other end, the purple, green, and crimson colours will appear simultaneously.

The reactions formed by adding potassic ferrocyanide to salts of iron, copper, bismuth, &c., are very impressive. Most of them are better shown with dilute solutions than the foregoing.

Electric reactions are easily shown by filling a tank with sodium sulphate, coloured with cabbage or litmus, which projects as a blue solution. If the terminals of a small battery are then introduced, the acid and alkaline reactions will appear at the poles.

The action of heat upon salts of cobalt is prettily shown in the lantern by coating a glass plate with a saturated solution of the chloride in a solution of gelatine. The rosy tint will gradually change to a blue in the heat of the lantern. This may be varied by using with the plate a photographic slide, which if judiciously chosen will give a curious apparent change from day to moonlight ; or if a design be sketched with a weaker solution, the gradual visibility of the so-called sympathetic inks can be readily exhibited.

The main facts of popular ' domestic chemistry ' are readily demonstrated. *Bleaching*, for instance, may be illustrated by filling a tank with a solution of indigo in dilute sulphuric acid, and projecting the tank upon the screen. By adding a solution of calcium chloride, the colour will gradually disappear.

Antiseptic operations may be illustrated by a tank filled with sewage water, concentrated and rendered darker, if necessary, by evaporation. To this may be added a strong solution of potassic permanganate ; when the gradual clearing of the tank will be conspicuously shown. The difference between pure and 'hard' waters can be demonstrated by showing that the 'hard' water, on adding certain reagents, gives precipitates which are not formed in distilled. If the water contains much lime, a crystal of oxalic acid may be tied to a thread and dipped into it, when distinct opaque threads of calcium oxalate will stream from the crystal, not apparent when distilled water is used.

In all tank projections the same pains should be taken to get an evenly-illuminated disc, and by the same methods, as described in Chapter XIV. And any chemical apparatus or appliances may be readily projected, either by the focussing lens, or by the shadow method as described in that chapter.

182. Larger and Vertical Projections.—Some experiments and reactions are required to be shown upon a large scale, or on a more considerable flat surface of solution as a field. For such cases Professor Ferguson has given the arrangement in fig. 129, which enables vertical projections to be made with scarcely any addition besides the lantern itself, to apparatus which every chemical demonstrator has constantly at hand. The diagram almost explains itself. The lantern and radiant are so arranged that a somewhat diverging beam proceeds from the final lens, L, of the condenser. This is received on a mirror, M, adjustable at an angle of 45°, at the end of an arm sliding, and fixed by a screw, on the stem of a chemical retort-stand. Above it is arranged a large retort-ring holding a spherically-shaped glass dish s s, containing the fluid, and above is adjusted the small vessel containing the reagent, with a dropping-tube. The focussing lens—from the lantern itself, or otherwise—fits into a ring above at I, and a second smaller mirror *m* reflects the rays to the screen. The glass vessel s s

must be chosen so that the under surface may form a lens of suitable focus to act as its own condenser, and give proper convergence to the cone of rays. On this the excellence of the projection will chiefly depend, as will be understood from preceding chapters; any further remarks it is to be hoped will be unnecessary, except that a sheet of blackened card should be interposed between the apparatus and the screen, so as to protect the latter from all scattered light. This last is the only objection to the arrangement, but is not great if the condenser beam, mirror, &c., are carefully adjusted. If however it be at hand, projections of this kind are better shown, and more quickly adjusted, with a vertical attachment, in cells resembling fig. 117.

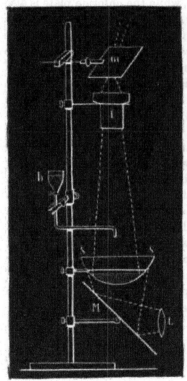

FIG. 129—Vertical Projection

Any demonstrator will be able from these hints to elaborate any number of experiments according to his own requirements. The chief point is to ascertain by trial *on the screen* the most effective strength for his various solutions. The phenomena of crystallisation, &c., belong to a previous chapter, and those of electro-decomposition will be touched upon later.

138. **Photography.** — The formation, development, and fixing of a photographic image is rather an attractive lantern

demonstration, and easily carried out by anyone practically experienced in photography. A developing glass tank must be provided of proper size, and the plate cut small enough to dip easily into it. This plate should be a *chloride* plate and not a bromide, which is too opaque, while the chloride plate is also so much less sensitive as to be more manageable. A suitable negative being provided, and superposed in a proper frame upon the chloride plate, may be exposed in the parallel beam from the condensers, time 5 to 15 seconds, according to the power of the jet. The developing tank is then placed in the stage, with a plate of ruby glass between it and the condensers, and a plate of glass with some black diagram being placed in it, in the position the photographic plate will occupy, is focussed. This being withdrawn, the plate is taken from the frame and placed in the tank, upside down of course. The developing fluid, previously arranged for instant use, is then poured in, rather a weak preparation being used. Ferrous oxalate is best, as its own red colour will allow the ruby plate to be then withdrawn and so allow more light to pass. The image will then gradually appear, and when of the desired strength, the plate can be washed and replaced in another tank of fixing solution, which will show the film gradually getting clear. If a tank be provided with waste-pipe and tap, the same may be employed throughout the whole operation.

CHAPTER XVII

SOUND

A LARGE number of experiments in acoustics are of necessity incapable of projection : those for instance which depend entirely upon the hearing, cannot be demonstrated by another sense. But so far as it is desired to show that the phenomena

depend upon motions, and especially rhythmical vibrations, they are for the most part capable of being thus demonstrated. In some cases projection is upon the whole less effective than the direct observation of large apparatus, but may enable the phenomena to be shown with smaller and less expensive apparatus : in others there is perhaps little choice : in others projection is distinctly superior, or may be the only method practically available.

134. **Wave Motion.**—The best method of showing the nature of the motion of the particles of air in a sound-wave,

FIG. 130.—Crova's disc

is to project it by what is usually called a Crova's disc, constructed as follows. A circular transparent plate 18 to 18 inches diameter is so mounted on an axle that it can be rotated with one of its horizontal radii across the condenser-field, and the radial portion there focussed as a slide. The plate is blackened, and in the centre is struck a circle 6 to 8 mm. diameter, which is divided into twelve divisions, as fig. 181. Taking a scale divided into, say, eighths of an inch (it may range from one-twelfth to one-eighth according to size), take a radius of from 2 to 8 inches, and strike a circle through the varnish, from one of the divisions on fig. 181, cutting a pretty bold transparent line (too fine a scratch will not be bold enough upon the screen). Extend the compasses

another division of the scale—be it one-twelfth or one-eighth
—and strike another circle from *the next point* on the little
divided circle. Extend another division of the scale, and strike
from the next point of the circle in the same direction, and so on
round and round fig. 181, extending radius each time, till the
disc is filled, which will require going round fig. 181 two or
three times.

In using this disc, when finished and mounted, a cap or
plate is placed on the lantern with a horizontal slit
A B, and inspection will show how the revolution of
the disc with its eccentric circles, over such a slit,
will represent by the motion of bright dots focussed
upon the screen the successive condensations and
expansions in a series of aërial waves.

FIG. 131

185. **Bells and Liquids.**—The fact that a sounding bell
is in a state of vibration, is best projected by adjusting a thin
goblet in the field of the lantern, with a small pith ball hung
from a wire stand so as just to touch it. On now drawing a
violin bow across the edge of the goblet, the enlarged image
of the ball will be seen to be thrown away by the vibrating
glass.

The thinnest glasses should be chosen for all acoustic ex-
periments. About 8 inches across is the best average size.[1]
To ensure steadiness, a good plan is to cut off the feet, and
cement the stems into solid blocks about three inches square
and one inch deep, cast in lead or type-metal. This is easily
done with plaster of Paris mixed with a little powdered char-
coal, made up with gum-water. Fixed in such heavy feet, all
the phenomena are more easily obtained.

The nodes of a bell are best shown by the ripples in con-

[1] For ripple phenomena next mentioned, some pains should be taken to
get good glasses. At any shop where high-class ware is sold, a certain num-
ber should be selected of various shapes, which are thinnest and seem to ring
most clearly. Then, by experiment before a window, those which give ripples
best and most readily are easily selected. As a rule quite different glasses
will give the best results with different liquids like mercury, water, and alcohol.

tained liquid. These may be projected in various ways.
If a thin and pretty shallow bell-glass can be found, about 5
inches diameter, on a short leg or foot, the latter may be
cemented to the centre of a massive plate of glass, and placed
on the vertical attachment. The field lens should be removed
from the latter, as the bell when filled with liquid will form
its own converging lens. The bell being filled with the liquid
selected---water, alcohol, ether, or carbon di-sulphide---the
surface is focussed by a scrap of paper thrown on it and after-
wards removed, and the bell excited by a violin bow, or in

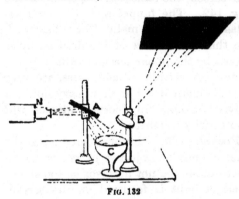

FIG. 132

many cases the finger
rubbed with resin
will suffice. In this
case the fluid must
be clear.

But on the whole
reflected images are
preferable. Fig. 132
shows a very simple
arrangement, pro-
vided a ceiling, or
any kind of overhead
screen can be utilised
for the image. Slightly diverging rays are reflected downwards
from the nozzle of the lantern or optical front N, by the plane
mirror A, arranged so as not to scatter the light beyond the
surface of the liquid in the goblet or glass C, and the reflected
rays are focussed (for the surface of the liquid) upon the ceiling
or screen D. Instead of rays from the nozzle N, the parallel
or slightly convergent beam from condensers may be employed.

In this case the best effect is produced by employing water
blackened with writing ink, so that rays reflected from the
surface alone may be utilised. A violin bow is neither neces-
sary nor desirable, being far too energetic ; the resined fore-
finger dipped in the water is ample, and the nodes will follow

its motions round the circle. With a glass carefully selected, very fine effects are obtainable in this way. With a suitable glass, circular ripples of quite another character, but of great beauty, may often be obtained by pressing the finger very hard upon the rim while drawn round *slowly*, so as to produce a 'groaning' kind of note. And with some glasses (see note on page 249) very similar ripples to these last, but more evanescent, may be produced by tapping some particular point on the goblet or its stem with a metal rod.

For a perpendicular screen, the easiest arrangement is the apparatus shown in fig. 142. The funnel and its frame are withdrawn, and the glass in its square metal foot substituted, arranged for height so that the surface of the fluid occupies the position usually taken by the phoneidoscopic film.

The vibrations in mercury, with a suitable glass, are very fine when projected by this method. For this heavy liquid a bow is sometimes advisable, and only certain glasses will vibrate readily when so heavily weighted.

186. Trevelyan's Rocker.—The vibrations producing the note of this apparatus are easily projected by cementing a small mirror on the face—it should not however be too small. A small parallel pencil of light is focussed on the screen, either from such an apparatus as was shown in fig. 95, or the rays being made parallel from the condensers, a small aperture may be placed in the stage of the optical front, and focussed by the lenses of that arrangement. The rocker may then be arranged so that the mirror meets the pencil at an angle of nearly 45°, throwing the pencil upwards, whence it is re-reflected by the adjustable plane mirror to the screen. The motionless spot will, when the rocker is in action, be drawn out into a line of light ; and by turning the plane mirror sideways, this will further be analysed into a sinuous line, making the individual vibrations visible.

187. Vibrating Rods.—All the leading phenomena of these are easily projected. König's apparatus for showing

longitudinal vibrations in a metal rod fixed at its centre, by
the repulsion of an ivory ball suspended so as to touch the end,
may either be projected entire by the shadow method, or the
end of the rod and the ball only may be focussed in the field
of the condensers. Another method is to show the action of a
glass strip whilst under strain, upon polarised light, as described
in § 209, page 362.

The transverse vibrations of rods are easily projected by
their shadows alone. For all rod experiments, I have found
it most convenient to screw a small parallel vice upon a piece
of blackened board, which by a slot and thumb-screw can be
adjusted at any height upon another piece of blackened wood
furnished with a foot. In such a vice, rods can be fixed at
any height, or angle, whether to project their shadows, or
beads or mirrors on their ends. A slender knitting-needle
projecting 8 to 4 inches will give a very good fan-like shadow
when 'sprung' in the field of the condensers and focussed ; or
the shadow method will equally answer for larger rods.

Nodes and segments are well illustrated by a long piece—
say two feet— of very thin steel, such as clock-spring, slightly
loaded at the tip. This being very flexible will show divisions
readily when tapped and 'stopped' at proper intervals; and
the motion being slow, is easily followed on the screen when
projected by the shadow method.

But the superposition of harmonic vibrations upon the
fundamental is best projected by Wheatstone's kaleidophonic
apparatus. A straight steel wire about 1 mm. or less in
diameter, and projecting 8 or 10 inches from the vice, in a
nearly horizontal direction, I have found best. To the top
is attached a silvered bead about $\frac{1}{4}$ to $\frac{3}{8}$-inch diameter, by
Prout's elastic glue or otherwise.[1] The bead is adjusted to

[1] The larger the bead, the larger the spot; but I find this size gives the
best results. As I have had some trouble in finding suitable beads, it may be
well to state that they can generally be obtained of theatrical costumiers, such
as are found round Covent Garden. Enough of the end of the rod to go

the height of the optic axis, and the rays from the condensers slightly converged so as to be condensed into the space that will be occupied by the transverse vibrations of the bead, which must never *leave* the illuminated area, but otherwise the more light is condensed upon it the better; an area 2 inches diameter is about the thing. The beam may be managed in several ways. The lantern may be deflected parallel with the screen, or a little more, so that the rays fall nearly at right angles upon the rod, which must always be pointed to the screen; or the light may be thrown back nearly straight towards the end of the rod by the plane mirror; the object focussed upon the screen with the loose lens being the luminous spot reflected by the spherical bead, this will be equally bright, and the apparent motion the same, either way. The surplus light should, however, be stopped by a black screen if convenient. The rod may now be bowed near its base with a violin bow well resined, or struck at various points with a wooden stick; and by either method all possible varieties of beautiful harmonic scrolls will appear rippling over the screen in lines of light.

188. **Tuning-Forks.**—The vibration of a common c 256 fork is easily projected in shadow upon the screen. Or it can be impressively shown by focussing in the field of the lantern a small glass filled with water to the brim. On striking the fork, and touching the surface of the water with both vibrating prongs, water will be splashed off in both directions, producing much more effect on the screen than would be supposed.

Employing *sympathetic* vibrations excited by another fork in unison, the vibration of a fork can be projected by the simple arrangement shown in fig. 188, consisting of a rectangular wooden framework on which is reversed (*i.e.* the fork

through the bead, should be heated in a Bunsen burner, and bent at right angles, and the bead fastened on this portion with the glue. This applies to all the rods subsequently mentioned.

downwards) the resonance-box of a fork mounted in the usual manner. The top of the frame has an aperture to allow the fork to come through. A smooth spherical ball of pith or light cork, varnished, is hung as in the figure from an eye at the side, and the frame adjusted so that the ball barely touches the fork, which is focussed on the screen. On now sounding another fork in unison, also mounted on a resonance-box, the fork, focussed will be thrown into vibration, and the ball will be driven away as shown on the screen. (For conditions of success see next paragraph.)

189. **Doppler's Principle.**—By the same simple means Doppler's principle or law (that the colour in light, or the pitch in sound, depending solely on the *frequency* of the periodical impulses falling upon eye or ear, pitch is heightened when a vibrating body approaches, and falls when it recedes) can be demonstrated, provided the necessary conditions of accuracy be attended to. These have been well described by Professor A. M. Mayer.[1] He found

FIG. 133

c forks of 256 vibrations the most suitable, and provided two in exact unison, a third fork of 254 giving two inferior beats, and

[1] See *American Journal of Science*, April 1872.

a fourth of 258 giving two superior beats. The essential point is *exactness* in the tuning of these forks and their cases. It was found quite insufficient to tune two forks in apparent unison, as one has the power to some extent of coercing the other to its own note. The only effectual plan was found to be, tuning both forks *so as to give the same number of beats per minute* with another slightly different, which can easily be done. The boxes can of course be tuned by measurement. With forks thus tuned, and turning the open ends of the cases towards each other, one fork will excite the other and throw the ball off, when as much as 60 feet apart. The ball should be 5 or 6 mm. in diameter, smoothly fashioned out of cork, and varnished, which gives it more ' life.' It is suspended by a fine silk thread, and pains taken to suspend it accurately, so that however it may revolve by torsion, it may hang nicely against the fork. The frame should also be fixed steadily.

Nothing more need be said as to the effect of unisonal vibrations ; and the illustrations of Doppler's principle will almost suggest themselves.

a. Taking the unisonal fork, and *walking* steadily up with it from a distance (Prof. Mayer detached the fork from case, striking it, and then placing it on case for the resonance ; but it may be more convenient to keep it on the case, and excite with a bow), the approach is sufficient to so destroy unison that the fork in the lantern does not respond *until the demonstrator stops*. The same in receding.

b. Taking the 254 fork and exciting at some distance, there is no response. There is still none when slowly walking. But on *swinging* the fork and case towards the lantern with approximately the right velocity—between 8 and 9 feet per second for 2 beats difference—the fork responds and the ball flies off.

c. A *backward* swing produces the same effects with the 258 fork.

140. **Lissajous' Method.** — Ever since it was devised by

that ingenious physicist, the optical method of M. Lissajous
for observing the vibrations of a fork has been preferred
where possible. The simplest arrangement is shown in
fig. 134, where a small aperture is placed in the stage of the
optical front, and the rays from the condensers being made
parallel, the aperture is focussed on the screen, giving a very
nearly parallel pencil of light ending in a sharp spot. This
proceeds from the nozzle N, and is reflected from a small
mirror A attached to a prong of the fork, the other prong being
similarly loaded. The reflected ray is re-reflected back to the
screen by the plane-mirror B, when the spot should be re-

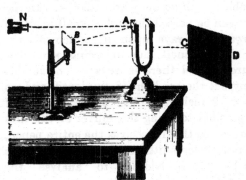

focussed to allow for
the extra distance
from A to B, which
blurs the original
image (this re-fo
cussing, or else an
allowance for extra
distance caused by
reflections, should
always be attended
to in this class of
experiments). On
now exciting the

FIG. 134. ·Lissajous' Method

fork, the spot is drawn out into a line of light; and if
then the plane-mirror B be slightly turned in its socket
(which is better than holding it in the hand) the line is
drawn out into ripples C D, showing the single vibrations
separately.

Very fair ripples may be projected in this way. But they
will be much more brilliant if the pencil attachment (fig. 95)
be employed, whereby much more light is sent through a
small aperture on the front. This aperture is then focussed
by a loose lens. But the best use of this focussing lens
demands some consideration, according to the circumstances,

and still more so in projecting compound figures to be presently described.

141. Management of Acoustic Pencils of Rays.—When the light is brilliant and the pencil nearly parallel before focussing, as from an electric lantern, it is generally more convenient to first focus the spot on the screen, and then adjust the forks or other vibrating apparatus *beyond* the lens, or between it and the screen. There will be abundance of light, more room for adjusting apparatus, and the figure will be projected of the greatest size, which with forks is desirable.

But in projecting reeds as presently described, the greatest size may be undesirable; or light may be deficient. In the latter case, more light can be passed through a small aperture by somewhat *converging* the rays upon it, which diverge again. Suppose we use a pencil thus diverging somewhat from a $\frac{1}{4}$ inch aperture (indeed there is always considerable 'scattering' when any but the arc-light is employed) and we are employing mirrors $\frac{3}{8}$ inch diameter, which is a good average size. It is possible to bring the mirror of the first reed up near the aperture, so that it receives the entire pencil, and even the second mirror loses little of it; and even if the plane-mirror has to be used in addition to 'analyse' the result—as in showing ' beats '—there will be room for all this within the conjugate focus of a suitable lens, let us suppose one of 6 in. diameter and 14 to 18 inches focus. The focussing lens is thus placed *beyond the apparatus*, and next the screen. In such a case the result may be more brilliant thus arranged.

But there is a point to be remembered. The reflected pencils *diverge* by the vibration of the mirrors; and the focussing lens acts upon *these* divergencies the same as upon others. The effect is to *reduce the size of the figure* on the screen; which may be either an advantage, or disadvantage. If the lens focussed the actual vibrating mirror, there would be no figure at all, focussed in this way; but inasmuch as the lens

s

focusses the aperture, some way *behind* the mirrors, the effect on the size of the figure is intermediate, and variable. The figure is least converged or shrunk when the vibrating mirrors are as far as possible from the aperture and nearest the lens ; it is smallest under the contrary conditions. It is also less reduced, the longer the focus of the lens.

It will be seen that this choice of method gives a large amount of control over the scale of the figure. It will also easily appear, that for the second method a large lens of long focus is best ; but that for the first, a smaller lens of moderate focus is better, as it converges the pencil upon the mirrors before the rays have scattered so much.

142. Lissajous' Figures.—The compound figures produced by two sets of vibrations have always had a strong fascination for both demonstrators and students ; but they are seldom seen well projected except with large and expensive apparatus. I therefore give some space to simpler and inexpensive devices, while a word or two may suffice for the more elaborate..

Two large electrically-mounted forks, one with adjustable weights for varying the pitch, and both furnished with mirrors, will of course produce all the phenomena with facility, and need no explanation.

Plain forks are best made large, with prongs not less than 12 inches long and $\frac{3}{4}$ to 1 inch wide. They can be made inexpensively by bending up bars of rolled steel, any precise note being immaterial. One should have two hollow sliding blocks of metal with set-screws, to adjust for various intervals, and these must both be of the same weight. As mirrors, silvered circles of micro-glass may be used, balanced of course on the other prong, unless similar mirrors are attached to both. The most convenient method of mounting such plain forks, so as to be excited by a violoncello bow (the best method) is the simple wooden frame adopted by Prof. Weinhold (fig. 185). The rectangular frame R R is slotted on the top and side, to adjust and fit by the screws $b\ b$ the blocks

in which the forks are inserted. The course of the incident
pencil oa between the mirrors s_1 and s_2 will be seen from the
diagram, any adjustment being easily made before tightening
the screws, by either turning the perpendicular fork a little
on its axis, or moving the horizontal one in its slot. Another
block and slot k is provided for using both forks perpen-

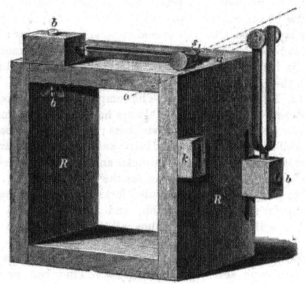

FIG. 135.—Mounting for Two Forks

dicularly, the block k taking one out of the line of the other.
It will be seen that with this arrangement both forks can be
readily bowed by assistants, and will be firmly held.

A very simple apparatus is shown in fig. 136, as made by
Miller, of Innsbruck, from a design by Prof. Pfaundler. Two
flat steel springs, F F, are mounted in a manner that needs no
further explanation than the diagram, one being adjustable in
position, and having a sliding weight. Both are furnished with
mirrors. The springs may be bowed, or are readily set in motion

s 2

by twitching with the finger. As far as regards the projection, this is cheap and efficient, but is not audible ; it has the

FIG. 136

advantage, however, of producing the figure by motions of the same kind as a couple of forks.

For projecting the figure only, the apparatus shown in fig. 137 has been devised by Pfaundler, who described it in the ' Proceedings ' of the Vienna Academy (of Sciences) and figures it in his ' Lehrbuch der Physik.' The vibration of two springs s, s', set rectangularly to each other, one variable by a weight, L, is given to two discs, D D', with slots which also cross at right angles.

FIG. 137

The spot of light where they cross, evidently moves in a path compounded of the two motions. The discs are arranged in front of the condensers, the spot being focussed as an ordinary diagram, and the springs twitched. Stöhrer has constructed a more complicated apparatus for giving the same motions to two discs by a wheel and gearing, methods of which will

suggest themselves; and Miller of Innsbruck has constructed
a machine in which two discs are *rotated*, partially overlap-
ping each other, each with a white circle cut excentrically in
black varnish, the idea being essentially the same. The
principle of the harmonograph has also been applied to trace
the figures by two pendulums on a smoked glass in the stage
of the lantern, and such an instrument can be obtained of any
optician.

Coming back to vibrating mirrors and a pencil of light,
Professor Dolbear describes an arrangement he has adapted
to a horizontal whirling-table, in which two friction-wheels
rolling on opposite edges of the disc, by cranks fitted to
them, actuate two mirrors
mounted on rocking-pivots,
over opposite sides of the re-
volving table.

Mr. G. M. Hopkins, of
New York, uses two mirrors,
each of which is mounted as
at м on the middle part of two
parallel strained wires, а в,
in the manner first used for
other purposes by Professor
O. Rood. Two such wires
will impart to a mirror good

Fig. 138

vibration, if properly strained, and the period may be varied
by attaching another wire, *a b*, with loads at the ends w w
(fig. 138) to the back of the mirrors, so that it can be varied
in angle (as *c d*), such an alteration altering the period of
vibration. One pair of wires is of course strained vertically
and the other pair horizontally, in parallel planes. Such an
apparatus is easily constructed; but it is very difficult to get
exact ratios with it, and difficult to arrange for the pencil of
light to 'clear' both pairs of wires.

But by far the best, most effective, and most comprehensive

apparatus is one of *reeds* mounted with mirrors, as shown in
fig. 139, which I was able to arrange for Messrs. Newton
& Co. with the help of Mr. G. Neilson in the speaking part
of the apparatus, it being particularly difficult to make
any range of reed-notes vibrate on a closed box of conve-

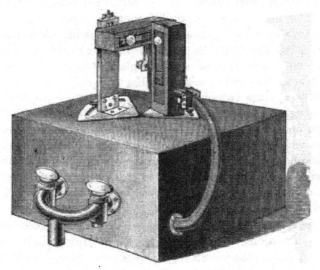

Fig. 139.—Lissajous' Apparatus of Reeds

nient size.[1] I at last partially overcame the difficulty
by supplying the boxes with wind through *short* rubber
tubes of large diameter, from large intermediate wind-chests

[1] I feel bound to state that the idea of this construction was not mine. It
was suggested to me entirely by seeing such a reed apparatus named, in a
catalogue of the apparatus to be sold of Mr. Thomas Harrison of Manchester.
Mr. Harrison having left England, I could learn nothing whatever about the
arrangement, except that it had been constructed by Dr. Mann, to whom there-
fore the first design of such is due. Long after, when my own was completed,
and much time and experiment *de novo* had overcome the chief difficulty by
quite different means, I succeeded in discovering a description of the ap-
paratus of Dr. James Dixon Mann in *Proc. Manchester Lit. and Phil. Soc.*
xvii. 91. It was not, however, capable of exhibiting beats, or other scroll
figures ; one reed-box being fixed horizontally.

which form the base of the apparatus ; after which Mr. Neilson succeeded in bringing the speaking-boxes into small and compact form.[1] The wind is supplied to these chests (two divisions of one box) by a Y-tube with a stopcock on each fork, the trunk of the Y being connected with the bellows. Each short rubber tube is furnished with a pinch-cock. The reeds are severally mounted upon identical bevelled wooden slides, so that any note slides into dovetails, and forms for the time the front of its box ; and each is mounted with a mirror of silvered glass, $\frac{5}{8}$-inch diameter, attached to its free end by a small pillar of cork. *After* being fitted with mirrors (which load them), the reeds are fairly tuned—excessive accuracy is not required (see *g* hereafter). The reed-boxes are adjustable round vertical axes coincident with the vertical diameters of the mirrors, whether the boxes are in the horizontal or perpendicular position. One retains a perpendicular position ; the other can either be similarly placed, or fixed in a horizontal position rectangularly to it, being clamped in either by a screw.

As regards the action of the apparatus, if it be confined solely to Lissajous' figures, the pencil of light might be reflected direct to the screen from the second mirror, as from a pair of forks. But being desirous of projecting open ' scrolls ' also, after Tyndall's method, and especially in the case of ' beats,' I adopted the arrangement shown in plan in fig. 140. Omitting all details of focussing, the pencil of light from the lantern L is reflected from the mirror on the first reed-box, R, to that on the second, R R, and is thence reflected

[1] Dr. Mann's arrangement was quite different. He used much larger boxes or speaking-chambers, with *open* apertures for the supply of wind. The supply-tube came direct from the bellows, with a nozzle at the end contracted to about one-third the size of the hole in the reed-box, and ending with a free space of half an inch between this nozzle and the hole in the box. Had I found his arrangement described earlier, I should probably have adopted both it, and the ingenious inventor's conclusion that it was indispensable ; as it is I prefer (perhaps naturally) the smaller boxes as more easily adjusted, and the closed supply as more certain and using less wind.

to the plane-mirror M, which can be revolved on the perpendicular pivot P. Thence it is reflected in the direction of the screen at s, and it will be manifest that a slight revolution of M opens out the scroll.

This arrangement also enables us to combine any two sets of vibrations in *harmonic addition*, as well as rectangularly. Rectangularly an octave gives the well-known 8-figure ; but if both reed-boxes are fixed perpendicularly and a scroll opened out by rotating the mirror M, the harmonic combination is exceedingly instructive, as is also the optical representation of any slight departure from unison, or any other intervals.

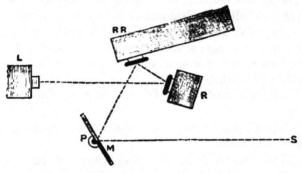

FIG. 140.—Plan of Apparatus

Such an apparatus is far the best for the projection of compound figures, being superior to the most expensive forks in many respects. For its efficiency, it is also far the cheapest. It possesses the following advantages, which are not found in combination in any other apparatus so far as I know.

(a) It projects with ease *all* compound figures and scrolls. To project beats, all that is necessary is to fix the reed-box R R (fig. 140), perpendicularly, the same as the other, insert a second reed in unison with R, and having tuned (see *g* below) rotate the mirror M, to give the scroll. When scrolls are not wanted the mirror M is simply left unmoved.

(*b*) All the notes are audible ; more so than with forks.

(*c*) Any note within the speaking range of the boxes can be added at any time for a few shillings.

(*d*) Any interval can be changed for any other (so far as notes are provided) in half-a-dozen seconds. A complete set would comprise a lower c (for tenths and twelfths), two c's (for unisons and beats), and the diatonic scale from c to c.[1] A convenient ' small ' set would be the four notes of the common chord, with a duplicate of the lower c. This will give unison and beats, third, fourth, fifth, and octave.[2]

(*e*) There is absolutely no trouble in manipulation. Any-one blowing the bellows, and having adjusted the pencil of rays once for all, the demonstrator has only to substitute notes as required, and manipulate a pinch-cock. If the pencil is awkward to manage, a black card with a circular aperture may be interposed between the first mirror and lantern, to confine it within bounds. The mirrors are so near each other, that little light is lost, and the projection is brilliant.

(*f*) The angular motion being great, the figure is on a large and bold scale.

(*g*) Most important of all : the notes *can be tuned in operation, with the greatest nicety.* There is no tiresome tuning, or loading with wax. The pitch *varies with the wind-pressure,* within more than sufficient limits, and the hand on one or other of the pinch-cocks on the tubes will either keep any phase of the figure ' steady,' or cause it to pass through the transitional forms with any rapidity desired.

With this apparatus, Lissajous' figures become a delightfully easy and effective projection.

[1] For audibility, however, a range of notes from G to c is better than C to c, and this scale was therefore adopted.

[2] We have some hopes of still further simplifying the apparatus by making one of the reeds *variable* in pitch by a rack-work ; but the experiments on that point are not concluded at the date of this.

148. Kaleidophonic Figures.—The usual Lissajous' fig-
ures, but not beats, can be projected by Wheatstone's
kaleidophonic method. There are three ways of preparing
rods in order to produce them. The most certain, and the
best where frequent demonstrations are in view, is to prepare
rectangular steel rods, which vibrate in the requisite propor-
tions. Square steel about 2mm. square is always procurable,
as also is rectangular steel about $\frac{1}{16} \times \frac{1}{8}$ inch in section.
By filing down these and mounting each with a bead, all the
intervals can readily be obtained. Secondly, a piece of thin
round rod may have several inches at the top end bent
back into a loop, like a lady's hair-pin. Cementing a bead
on to the bend at the tip, by screwing in the vice so that
variable lengths of the longer stem project, various figures
will be obtained ; but they are not so true as by the previous
and following method. Thirdly, a straight piece of rather
thick clock-spring or similar steel is prepared, so that about
six inches at the tip may have its section at right angles
to the remainder, which should be some sixteen inches long.
This may be done by cutting the steel in two, and making a
saw-cut half an inch down the middle of the long piece, into
which notch the other piece fits and is brazed ; or the steel
may be heated red-hot in a Bunsen burner just at that point,
and twisted sharply round at right angles with a pair of
pliers. The top end should be somewhat tapered, and tipped
with either a bead, or a segment of a hollow sphere of bur-
nished aluminium, which will give bolder projections. By
nipping the longer stem in the vice at various points, which
can be marked, all the intervals can be produced ; either with
a bow, or by striking the rod, they may be shown either with
or without harmonic vibrations superposed.

144. Vibrations of Strings.—For showing the various
loops described by a string at different points, there is no
method to equal Tyndall's, of employing a thin ribbon of
planished silver or other metal—aluminium would now be the

best—and illuminating the whole by the lantern beam sent *along* the string at a small angle. For a multitude of figures a very thin and narrow ribbon rather closely twisted will be best ; for fewer and more distinct figures, a broader one with only a few twists. A large fork is almost indispensable for such experiments, but may be quite a rough one, as before described. An electrical fork is of course much the best and most convenient, and may be obtained for about 5*l*.

Very good figures may however be also displayed by employing the covered string of a violoncello, on which silvered beads are strung, mounted on a sonometer and vibrated with a bow. (Covered strings give much larger figures, not being so tightly strained.) Any single bead can be projected ; and I have found it quite possible to project in this way the figure described by the G string of a violin ; but the effect is hardly worth the time taken in arranging the experiment.

145. Harmonics, and Melde's Experiments.—These experiments are certainly *best* shown direct, on a large scale, with an electrical fork, and using strings either steeped in fluorescent solution, in violet light from the lantern, or what is still better, painted with Balmain's phosphorescent paint. Or the shadow method may be employed, when the arcs and nodes will be enlarged. But it may be useful to know that they *can* be demonstrated by projection with quite small and inexpensive apparatus, using a common c fork of 256 vibrations, or the G above it, and a cord of fine sewing-silk only 6 inches long from point to point, exciting the fork with a bow. I have found the best practical limits of weight to be between 10 and 80 grains for this small scale. A much more convenient apparatus could easily be constructed in which, instead of using weights, the other end of the silk should be attached to a helical spring, the tension of which could be varied as required by a lever. Quite a small fork—say c 256—could even be fitted in this way to act electrically, bringing

all within a few inches compass, upon one base, at a very small expense.

146. Vibrations in Air, Membranes, and Plates.—Any membrane which is pretty transparent, vibrated in any manner so as to show the nodal lines by powder strewn on its surface, can be projected in the vertical attachment or lantern. Goldbeaters' skin is clear, but the wrinkles in it project as lines, and on the whole, varnished vegetable parchment answers best; unless it be a very thin film of mica, which is flat, thin, quite transparent, and best of all.

The vibration of a membrane covering a capsule into which sound is conveyed by a tube, may be shown in several ways. The simplest is to adjust the capsule so that the membrane stands in a vertical plane, and to hang against it a light pith ball. The ball will be thrown away when the membrane vibrates, and this can easily be projected.

A more elegant method is what Professor Dolbear has called the opeidoscope. The membrane may be stretched over one end of a mere pasteboard tube, into the other end of which notes are spoken or sung. To its centre is cemented a small mirror of silvered micro-glass. This receives a pencil of rays from the lantern, which after reflection is focussed as a spot upon the screen as usual. Upon singing into the tube the spot will describe a figure, which may possibly take any of the Lissajous forms, though this is rare except as to the circle or oval. Sometimes the mirror will not happen to be placed ' happily ' on the membrane to show figures ; in that case, pressure near the edge of the membrane with the end of a knife, will probably so shift the nodes and vibrating portions as to remedy this. For my own use, I have devised an instrument which is very handy in such experiments. A brass tube about 4 inches long and 2 inches diameter is tapered to an inch at one end to receive strained over it a rubber speaking-tube, at the other end of which is a mouthpiece ; and to its centre is attached a stud, by which it is fixed

horizontally in one of the sockets of a pillar-stand, so as to be adjusted at the height of the optic axis of the lantern. On the large open end, fit any of several short brass tubes, over which are strained membranes of very thin rubber, held by elastic bands catching in grooves cut round the ends of these short tubes. On these membranes mirrors are cemented; and by stretching the rubber a little one side or the other, or by changing one of these caps for another, a good position is sure to be readily obtained. This is a very simple, easy, and elegant experiment.

147. Manometric Flames.—Another method is by König's manometric flames, which are projected easily, and better seen in some respects than by direct vision. They can be projected even by the simple apparatus usually sold, with capsule and revolving mirror upon one base-board; in which case the focussing lens must be of long focus, and stand between the revolving mirror and the screen. The lantern itself has no place in this experiment, the flame only being focussed; and it is necessary that this be enclosed in an opaque chimney of some kind, only open towards the mirror, in order that the screen and room may be as dark as possible. I have got fair results this way; and if more brilliance be required, it is easily obtained by 'enriching' the gas, passing it through benzoline, or over naphthalene heated by a Bunsen burner in the albo-carbon manner. The flame will be very greatly brightened by this expedient.

Fig. 141

But it is very much better to have the capsule and jet

mounted independently as in fig. 141, K K being the capsule, *a* the sound tube, *b* the gas-tube, and *c* the flame. This must be shaded in all but the one direction as before, and the focussing lens brought next to it, whilst the revolving mirror comes on the other side of the lens. The flame is thus shielded from the draught of the revolving mirror, and this latter receives the rays in a more favourable manner. The gain in brilliance is very marked, and with 'enriched' gas very fine projections will be obtained.

With a revolving mirror of double the usual height—in fact sufficiently tall to embrace the usual three flames on an organ-pipe for showing nodes, the projection method has an advantage over the direct. Using a focussing lens for each flame, the lenses may be easily adjusted to somewhat *converge* the images, so that they may be brought as close together upon the screen for comparison as may be desired.

A concave spherical mirror of about three feet focus, rotated on a vertical axis, will also give detached images, but the revolving mirror is cheaper and more convenient. The best and most brilliant method of all, however, is that devised by Mr. C. V. Boys, who projects such phenomena through a circle of lenses fixed round the edge of a revolving disc.

Sensitive flames are easily projected in the same way with enriched gas.

Tyndall's *sensitive smoke-jets* are very effective projected by the shadow method—much more so than viewed direct, the smoke-shadows being very distinct upon the screen.

148. The Phoneidoscope.—Mr. Sedley Taylor's phoneidoscopic figures may be projected in various ways. A soap-film may be taken up even on the end of a lamp-chimney, and if arranged so as to be projected, will show figures under the influence of sonorous vibration. Or the ordinary phoneidoscope may be used, reflecting a converging beam from the condensers down upon the film by the plane mirror, and focussing upon

the ceiling or an overhead screen. But a better and more complete apparatus is one which Mr. C. Darker arranged for me, as shown in fig. 142. The figure almost speaks for itself. The plates, with apertures of various shapes which carry the films, and which before use are blackened, heated, and then coated thinly with solid paraffin, are laid upon the mouth of a funnel, whose narrow end has an elbow over which is strained the speaking-tube, the whole being arranged in a simple frame which can be inserted in, or removed from, a sort of box open at one side. The edge of the funnel is pierced with apertures to allow air to escape from under the film. By slots in a board at the back, two inclined plane mirrors are adjustable in position,

Fig. 142.—Lantern Phoneidoscope

and can also be turned on axes. The nearly parallel beam from the condensers, falling on the first mirror, is reflected down upon the film; from this it is reflected again to the second mirror, and thence reflected out in a horizontal direction, where is adjusted the focussing lens, which focusses the film upon the screen. Thus the whole works direct towards the ordinary screen, and can all be adjusted before a lecture, which

is a great advantage. Sometimes a black card or other screen may need to be adjusted at the side next the screen, to prevent any but the reflected rays which form the image from passing the apparatus; this will suggest itself. The mouth-piece I have found it advisable to construct as in the section (fig. 148), with a membrane of thin india-rubber across it. This does not interfere with the true sound vibrations, while it prevents the film from being prematurely ruptured by any actual blast of air which might result from unskilful management of the voice. Recipes for the solution

FIG. 143

will be found in Chapter XX., and a good film will often last a quarter of an hour. Besides the usual apertures, a hexagonal one should be provided; for these about two inches in diameter is a good size. The beautiful figures, and the gradual change in colour, make this one of the most fascinating of all lantern experiments.

Withdrawing the funnel and laying larger plates with apertures and films upon the box itself, beautiful figures may also be obtained by exciting a tuning-fork, and simply holding the open end of the resonance-box towards the open side of the box under the film. These figures are very powerful in their vortex motions, and perfectly stable. A cornet blown towards the box under such a film will also excite powerful vibrations. A thin film of mica stretched on a frame and dusted with lycopodium, and placed instead of the soap-film, will also show very strong nodal lines.

As already remarked, the same apparatus is very handy for exhibiting surface ripples, or in fact any bright *surface* projection by reflected light.

149. **Chladni's Figures.**— These may be projected in several ways by the aid of the vertical attachment, using of course plates of glass, with ground and polished edges. (*a*) A

plate held at the centre may be arranged so that one quadrant of it projects into the field and is projected. (*b*) A smaller plate may be clamped in the centre, at the end of an arm projecting from outside the field. (*c*) The figures may be formed apart and then projected whole. (*d*) A plate held at one edge may be vibrated in the field, by a bow, or by a string attached to it and rubbed with resined fingers, or by a resined string drawn through an aperture in the centre. (*e*) Or vibration may be communicated to it from some other vibrating apparatus in any of the recognised ways. (*f*) Or on one corner of a large plate may be cemented a ring of rubber, within which water is poured an eighth of an inch deep—a favourite experiment of Professor Morton. When the plate is bowed, a beautiful network of waves will be projected.

150. Columns of Air.—Kundt's dust-figures, showing the nodes and segments of air in a glass tube, may be formed in any way and then projected, or the tube may be placed in the field of the vertical attachment and the dust shown in vibration. A very convenient method is to plug one end of a tube, and insert a short whistle of appropriate pitch into a cork in the other. Any of Mach's experiments may be projected in the same way. Square tubes cemented together of flat glass plates are worth the trouble of construction, the figures being so much more accurately focussed upon the flat glass.

The projection of tracings upon smoked glass from tuning-forks, membranes, &c., is so obvious and simple as to require no more than mention.

T

CHAPTER XVIII

LIGHT:

REFLECTION, REFRACTION, DISPERSION, AND COLOUR

THE phenomena of Light not only lend themselves most readily of all to demonstration by the lantern, but in studying them we best acquire a mastery of the various manipulations of beams and pencils of light required in the demonstration of other subjects. For this reason, the demonstrator in other departments, though he may not himself desire to perform purely optical experiments, will do well to read and understand what is said respecting their details and methods, for the sake of the hints which these may give him in handling his tools.

151. Rays of Light.—The image-forming power of rays of light, the inversion of images, and the relation of the size of the image to the distance from the aperture or lens by which it is formed, cannot be better shown than by the experiments described in Chapter I., pp. 2, 3.

That rays are really reflected from ordinary bodies may be easily shown by removing everything from the nozzle of the lantern, and receiving the full parallel beam, or still better a slightly divergent beam, at an angle of about 45°, on a large piece of card, on which is pasted red surface-paper with a ' dead ' surface. On holding another white card as a screen some little way off, it will be seen that a strong red light is thrown upon this by the reflected rays; and other colours will display similar effects. The colours should be as rich and ' full-bodied ' as possible, but a glossy surface should be avoided, that it may be clear the effect is produced solely by scattered reflection.

152. Scattered Reflection.—That we only see *things*, not

light, and only see them by scattered reflection, may be shown
by the simple experiment represented in fig. 144. A confec-
tioner's glass jar A, about six inches diameter, is covered with
a flat glass plate B, after dropping in a bit of smoking brown
paper which has been dipped in a solution of saltpetre. The
plane-reflector C is adjusted to throw down the whole beam
from the lantern (either crossed from the objective as drawn,
or the parallel beam may be used). A cloudy light fills the
jar. Taking off the plate and blowing the smoke out, dark

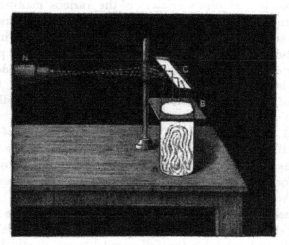

FIG. 144.—Scattered Reflection

spaces appear, showing that where no solid particles reflect
light to the eye, we see nothing. Or the jar may be filled
with clear water, which is also nearly invisible; but on
stirring in a teaspoonful of milk, the same lambent light
illuminates the whole room. The black particles of soot,
equally with the white (or supposed to be white) particles of
milk, reflect *white* light.

158. **Law of Reflection.**—This is simply demonstrated with
the plane-mirror A B, arranged as in fig. 145 near the nozzle

T 2

N of the lantern. A wire pointer c is easily affixed to the centre of one side of the mirror by sticking it in a piece of cork E, which has a groove cut in one side, by which it is attached to the mir-

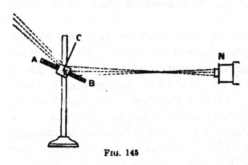

Fig. 145

ror. Letting the beam from a horizontal slit in the optical stage strike the centre, it will be readily seen that if it impinges at right angles it is reflected back ; but that at any other angle, the angle (measured from the normal or perpendicular, as indicated by the pointer) of the reflected ray is equal to that of the incident ray. A whiff of smoke near the mirror will show the beam brightly if required.

154. Use of Parallel Beams.—This experiment being an example of a large class, in which we want a distinct pencil or beam of light, it is well to consider the various methods of manipulation in order to produce it. The figure shows the simplest, which will answer for many experiments, but not for all. A horizontal slit is here placed in the stage of the optical front. This slit may be of black card, or in zinc or brass, or in a disc of thin metal fixed by a spring wire in one of the wooden frames used for polariscope slides, the standard size for all slides used in the optical front being $4 \times 2\frac{1}{4}$ inches. Or an ' adjustable slit ' made to fit the stage may be used. For this experiment a *broad* slit should be used, not less than 8 mm. wide. A beam so produced is not parallel, but sufficiently so for many purposes.

With the electric light, or a good mixed jet, it is better to remove the objective, place a slit or aperture on the front of the open nozzle, and use the ' parallel beam ' through this.

With the arc this will be very sharp and clear. Parallelism is of course obtained by pushing the arc-light or the lime forward into the principal focus of the condensers ; or with a Duboscq lantern by pushing in the condensers so that the arc is in their focus.

The lime-light does not give such an accurately parallel beam, owing to the greater size of the radiant ; there is more or less divergence from the aperture, so that nothing like a sharp circular spot (in the case of a circular pencil) would appear on the screen. Should the nozzle in work have an ordinary slide stage behind it, then by placing in this also (whether it be the stage of the optical front or the ordinary stage of the lantern) a slit, or circular aperture, as the case may be, rather larger than that on the front of the nozzle, the pencil will be sharpened considerably, and rendered very nearly parallel. We may call this the *sharpened* parallel beam.

But the mere parallel beam is not sufficient for all cases. When a figure has to be produced on the screen by the *motion* of a luminous spot, that spot must be *sharp* and defined, if the figure is to be so. Circular pencils are always employed in these cases, and should first be rendered approximately parallel, by adjusting the light in the focus of the condensers. If then the detached focussing lens be adjusted to *focus the aperture* on the screen, we have all the necessary conditions. The beam itself is as nearly parallel as can be, and the little light that is scattered by divergence is brought back and utilised by the lens, and all sharply focussed. The long-focus lens, if one is at command, usually produces the best results. We will call this arrangement the *focussed* parallel beam. An arrangement for greatly increasing the brilliance of such smaller beams and pencils has been shown in fig. 95, p. 173.

155. Angular Motion Doubled by Reflection.—It will readily be seen on being pointed out, that any angle through which the mirror is turned is *doubled* by the angular motion

of the beam of light, which also acts as a very long *pointer* working without weight or friction. Experiments to illustrate this will be found under ' Sound ' (§§ 136, 140, 146), and ' Physiology ' (§ 126). It is also illustrated in any experiment with the reflecting galvanometer.

156. **Reflected Images.**—The images produced by multiple reflection between parallel surfaces may be illustrated by focussing a small aperture or narrow slit upon the screen, and interposing a very thick piece of plate-glass in the path of the rays at a considerable obliquity. Reflection between inclined surfaces is best illustrated by the *Lantern Kaleidoscope* (see fig. 76, p. 146). The nature of a virtual image of an object, appearing to send out rays as if it were a real object, is well shown by turning the lantern somewhat away from the screen, placing a slide in the ordinary stage, and withdrawing the objective front from the nozzle. Near the front of the nozzle adjust the plane-mirror so as to reflect the rays to the screen, and in their path interpose the loose focussing lens, a long-focus one being most convenient. The slide will be focussed on the screen quite distinctly, as if it were really situated behind the mirror.

157. **Refraction.**—This is best exhibited by a rectangular tank, partly made of tin, with the two sides and one end made of glass, and covered with a piece of tin in which a few slits are cut in different places. The tank should be two inches between the sides, and about 12 inches square is enough for an ordinary room, but for a large hall 18 inches is better. The sides should either have circles blacked out as shown in fig. 146, or tin sides may be cut out, so as to support the glass.[1] The tank is filled exactly to the centre of the circle with water. To show the course of the rays there are two methods. (*a*) In the water may be stirred a *very* little milk or a very little eosin or other fluorescent dye ; and the air

[1] The circle is chiefly to illustrate the usual diagram explaining Snell's law.

space above may be filled with a whiff or two of smoke ; or, (*b*) a piece of white card or painted tin leaned a little slanting against the farthest side, will answer the same purpose and avoid scattering any light. Arrange the lantern with a horizontal slit on the nozzle N, and parallel beam alone if the tank is brought close for a single experiment ; but it is often more convenient to have it farther away, when the focussed beam should be employed. By the plane-mirror adjusted on its stand behind the tank, the beam may be first thrown down perpendicularly ; then through a slit at F near the end of the tank, when it will be seen that the ray is bent down or re-fracted ; and finally by tilting the lantern a little behind, the rays may be sent into the tank through the glass end at B, just above the water, when it will be seen to be far more bent down, to C. In both

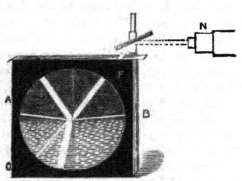

FIG. 146.—Refraction

cases the reflected portion of the rays will also be seen.

158. **Total Reflection.**—By having a slit in the bottom of the tank covered with a piece of glass, the rays may be easily sent up from water into air, when it will be seen that the rays are then refracted away from the perpendicular, the ray in either case being exactly reversible. The arrangement will be very similar to that shown in fig. 147, which depicts the apparatus adjusted to demonstrate total reflection. By tilting the bottom reflector the curiously instantaneous character of the transition from transmission to total reflection within the water, is readily shown.

A beautiful experiment in total reflection is known as the

'luminous cascade,' depending on the fact that if we can send
a nearly parallel beam of light 'end on' into a stream of

FIG. 147

water as it issues
from a horizontal
orifice, it is reflected
from side to side,
except as regards
small dust particles,
which apparently
convert the stream
into one of living
fire. In front of the
open nozzle some

sort of close vessel must be arranged, transparent at the back
and with the issuing orifice in front, while there must be

FIG. 148. – Cascade

another orifice by which to keep the vessel supplied with water

under pressure. A two-necked glass receiver, as shown in
fig. 148, will answer very well, blacked all over except for a
circle of four inches diameter opposite one orifice. This is
supported as at A. The orifice is a short piece of glass tube
fixed in cork, upon which the light will be condensed. Several
feet higher the supply of water must be placed (a bucket will
suffice) connected with the receiver by the tube B, and the
receiver is filled. On withdrawing a cork from the glass tube
at the orifice, the water will issue in a smooth stream, when
the radiant can be adjusted to give the best effect. Various
colours can be imparted to the stream by placing different
coloured glasses in the slide stage of the lantern.

Instead of this primitive apparatus, a vessel of tin, with
one glass side to go against the lantern flange, and an orifice
opposite, may be constructed. Such a vessel will be supported
more steadily, and the light can be more precisely adjusted
through a plane glass ; while the pencil attachment shown
in fig. 95 may be used to give more brilliance.

159. Prisms and Lenses.—The permanent deviation of a
ray or beam of light
by a prism is best
shown by placing a
small aperture in
black card or metal
in the stage and
focussing on the
screen (or a hole in
the plate of aper-
tures focussed by
the loose lens will
do equally well), and
interposing in the

FIG. 149.—Spectrum

path of the rays a thin prism, often called a wedge prism,
which will show no conspicuous colour. Such a prism may
be made by cementing a wedge-shaped glass cell, and filling

it with water. A trough of this kind is very convenient for absorption experiments also.

That lenses bend rays of light in the same way may be shown, by passing the same beam of light through the *edge* of a large lens, and also by the experiments described in Chapter I.

160. Dispersion.—With a glass prism of 60°, or a prismatic bottle filled with carbon disulphide, colour phenomena become conspicuous, while the deviation of the rays is far greater. The simplest arrangement for projecting the spectrum is shown in fig. 149. A slit (from 1 to 3 mm. wide) is placed in the optical front, and focussed on the screen. The prism is placed just beyond where the rays cross, when the image of the slit will be greatly turned aside, and converted into a spectrum.

Note on Deflected Projections.—Fig. 149 only gives the essential apparatus. The lantern may be turned aside on a bare table, and the prism-stand adjusted thereon in its place. But in this class of experiments, which include also *reflected* rays (as those from a soap-film later on), it is on the whole most convenient to employ such an arrangement as fig. 99, where the slit is first focussed on the screen, then the prism placed in position, and finally the whole arrangement, including the lantern, rotated until the spectrum comes again upon the screen. In this particular case all the apparatus would still be in the optic axis of the lantern ; but often a focussing lens has to be placed on one side of this, *e.g.* to focus the soap-film (fig. 179, p. 327). In this case the sliding cross-piece c d, of fig. 99, affords all the necessary accommodation.

Another way of producing the spectrum is to project parallel rays through a vertical slit on the open front of the nozzle, the objective being removed ; and to focus it with the loose lens. Which plan is adopted will often depend upon the manner in which the lantern was left arranged from any preceding experiment—a consideration which will often vary precise details.

With regard to the width of the slit, as the spectrum may be
regarded as an infinite number of images of it, differently de-
flected according to their colours, *the narrower the slit the purer
the spectrum,* especially at a small screen distance. But with
the simpler experiments a wide slit gives much more brilliance,
without any obvious confusion at a good screen distance (which
spreads out the colours more), and as much as 6 mm. wide
may sometimes be employed with advantage.

161. **Minimum Deviation.**—It will be found that there is
one position of the prism which refracts the rays least, called
the position of minimum deviation. This is the proper position
for the prism. Now and then, however, it may be desirable
to turn the prism more round in order to get the greater
length of spectrum thus produced.

162. **Different Colours Differently Refracted.**—Newton's
two experiments to prove this are both striking, and both
easy. For the first, we place a *short* slit—say a square aper-
ture 3 mm. long each side in the stage, and project its
spectrum in the ordinary way, with a prism bottle. Behind
this, we adjust at the proper height the glass prism with its
refracting edge *horizontal,* screening stray rays if necessary
by a black card pierced with an aperture. The rays are now
again deflected either up or down, according to the position of
the glass prism ; and as this is moved along in the rays of the
spectrum from the first prism, from the red end, it will be seen
that the rays are refracted more and more as we get towards
the blue end.

Newton's other experiment is particularly elegant, depend-
ing on the fact that if each colour has its own degree of
refrangibility, it must also have its own angle of total re-
flexion ; violet rays being (because more refrangible) totally
reflected at an angle which allows red rays to pass. To per-
form it with the lantern we arrange as in fig. 150, removing
the objective, and placing a perpendicular slit at N, on the
front of the nozzle. Through this we send a *sharpened*

parallel beam (p. 277). The figure is a ground-plan of the apparatus. As close to the nozzle as convenient are a pair of right-angled prisms, P and P², their hypotenuses or reflecting sides together, and kept close by a rubber band round them near each end ; but a film of air must be preserved between them, which a morsel of tissue-paper will secure if needful. In the paths of both direct and reflected rays are two focussing

FIG. 150. -Newton's Experiment

lenses F and F, adjusted so as to focus the slit N, and beyond each of these is a prism bottle B or B², adjusted to give a spectrum. They are shown as throwing these on two separate screens at right angles to each other, s s and *s s*, but it has lately been suggested to me [1] that by turning the prism B the other way, both spectra would be thrown upon the one screen

[1] By Mr. John Cox, M.A.

s s. All being adjusted, the double prism, P and P², is turned round the perpendicular axis till all the rays pass through to the prism B, which throws its spectrum as usual. Let them now be very slowly turned in the direction of the hands of a watch. Then, just as the film of air arrives at the ' critical angle,' as it is called, the violet rays being totally reflected *leave the spectrum* s s and appear at *s s*. On continuing to turn, all the colours in succession do the same.

The fact that lenses disperse light in the same way, convex lenses bringing blue rays to a nearer focus than red rays, is very readily demonstrated by placing in the stage a piece of black card with two apertures pretty close together in a horizontal line, one covered with deep red, and the other with blue gelatine, and focussing the parallel beam sent through them by the top edge of the loose lens. The two images will not both focus on the screen at the same time, or at the same level.

163. Composition of White Light. Colour a Shadow, or Suppression.—These two connected facts may be shown by numerous experiments. Arrange as for the simple spectrum, but not deflecting the lantern from the screen. The prism A being duly

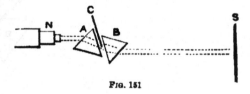

Fig. 151

placed before the nozzle N, or in front of the loose lens if that is employed, place in front of it a second prism, or bottle B, with its refracting angle turned the other way. This second prism gathers up again all the coloured rays, and recomposes a white image of the slit on s. If we now introduce a black card c at one side (the second prism being placed as far from the first as will gather up all the rays, and the card kept close to the second one), we suppress or stop off part of the colours, and the image of the slit at once becomes

a coloured one. This also illustrates the important fact, that prism analysis will always give us the *correct composition of whatever light there is* passing through the prism.

If instead of the card, a thin prism ground to a fine edge is used, the intercepted portion of the rays will be simply deflected, instead of suppressed, and a second image of the slit, complementary in colour to the other, will appear by its side upon the screen.

A more obvious and mechanically simple method is to provide seven small pieces of looking-glass, each about 2 inches long by ¾ inch wide, mounting them with wax on small

Fɪɢ. 152

wooden feet. These are to be arranged on a piece of blackened board A, supported by a stand, and so arranged that the row together, at some little distance from the prism P, about covers the whole width of the spectrum-band at that spot. Each mirror is then adjusted to throw its strip of colour on the same spot on the screen s. On taking away one or more mirrors, and so suppressing any of the colours, again we *get* colour, whereas all the colours gave white.

A better method of recompounding the colours is to use a cylindrical lens, which can easily be so adjusted between the prism and screen as to focus the slit again in an image which appears sharp and white. The cylindrical lens should be rather long in focus, from 10 to 15 inches, to produce a good effect ; the usual short-focus cylindrical lenses make the slit appear much too broad. A large cylindrical jar full of *warm* water (else moisture will condense upon it), may be

made to answer, but a lens is best. A coloured image, or, with a wedge-prism, two complementary images, may be produced as before.

But if a large convex lens—say 6 inches diameter and 14 or 15 inches in focus—forms part of the available apparatus, it will answer just as well as a cylindrical lens. The top and bottom of the lens may be screened with black card so as to leave a horizontal stripe 2 inches deep, all across the centre ; but even this is not necessary, as the rays from the prism will only strike the centre. With this lens exactly the same experiments may be performed.

Another method is adopted by Professors Eli Blake and Ogden Rood, the coloured rays from the prism being received at a distance of three feet or more upon a strip of the thinnest silvered glass procurable, about 18 inches long

FIG. 153.—Rocking spectrum

by 8 inches wide. This can be flexed by the hands so as to reunite the colours in a white reflected image ; or the plate may be bent in a simple frame by a screw ; or a cylindrical mirror may be employed such as is used for producing caricature images.

The next two methods depend upon persistence of vision, any impression upon the retina remaining for nearly half-a-second (the eighth of a second so often mentioned does not nearly represent the fact with most people). The rays from the prism P (fig. 153) are received on the plane-reflector R, in its vertical socket, in which the mirror must move *easily*.

Then a rocking motion is given, and as this motion becomes more rapid, the spectrum becomes *white* over all the middle portion. If the hand is unable to rock the reflector with sufficient rapidity, a stand may be employed which will impart the motion mechanically by a short arm from a multiplying wheel.

A most instructive experiment is that so well known as 'Newton's disc.' A circular card which can be rapidly rotated on its centre is painted in sectors with the principal hues of the spectrum in their due proportions, either in one sector of each colour, or several sets, fig. 154 showing the disc painted in four sets. This is arranged facing the lantern, and *all* the light from the nozzle is made to just cover the

disc and no more, the lantern being so placed that the audience can see the face of the disc. When this is rapidly rotated, it appears white.[1] Newton's disc can also be obtained as a transparent slide for

FIG. 154 FIG. 155

the ordinary stage of the lantern, the cost of the latter arrangement with the wheelwork being about 12*s.* 6*d.*

If now sectors of black paper are fastened, with drawing-pins, on the card disc, or gum on the glass, so as to cover up any of the colours, by so suppressing these again we *get* colour. Or we may rotate just in front of the nozzle of the

[1] If the colours are not properly painted, of course the white will not be perfect, and a disc should always be tested before purchase, or at least before use. But a beautiful white *can be got* by this method, and it is the brighter the more brilliant the colours. It is true the disc often appears a poor grey as usually shown, by the general light of the room; since each portion of it can only reflect at most about one-eighth of the spectrum; hence the grey, which is merely a deficiency of light. But by keeping the room dark, and concentrating a bright light on the disc, with a good one the white is all that can be desired.

lantern another card, in which are cut two radial slots as in
fig. 155, so that the slots cross the nozzle and let flashes of
light through intermittently. Cover the nozzle itself with a
similar slot, taking care of course that the slots come just
where the rays cross from the objective. Then while the
Newtonian disc is rapidly rotated, let the other intercepting
disc also be rotated, at first slowly. The flashes by degrees, as
their speed increases, will not allow all the colours to mingle
their impressions during each, and so the disc will appear
coloured, till at last it will stand out almost distinctly in its
real colours.

From all these experiments it will be readily shown and as
readily understood, that for a 'pure' spectrum we
must employ a narrow slit. The narrowest slit
gives its own spectrum. That a broad slit gives
many overlapping spectra, is demonstrated by using,
instead of a single slit, a double slit arranged as
in fig. 156. At top and bottom there will be a
comparatively pure spectrum ; but over the greater
portion of the band the two will overlap, diluting
the colours by mixture ; the two slits here may be Fig. 156
regarded as the edges of a single wide slit.

164. The Rainbow. — The way in which a rainbow is
produced by the prismatic dispersion of each rain-drop was
shown by Antonio de Dominis, in an experiment easily
adapted to the lantern. A glass bulb blown on a small tube,
and from $1\frac{1}{2}$ to 2 inches in diameter, is filled either with
water, or with some other fluid of higher dispersion, or a
glass ball ground and polished would do, to represent our
spherical rain-drop. This bulb B is placed in a Bunsen
holder c, in front of the lantern, which must be turned
towards the spectators. The objective is removed, and the
parallel beam sent through a circular diaphragm with an
aperture the same diameter as the bulb ; and surrounding
the nozzle, or at least the beam, is a screen of white card or

paper s, with a similar aperture cut in that. It must not be forgotten to adjust a small black screen behind the bulb B, to prevent any direct rays from incommoding the audience and spoiling the effect. By the refraction, reflection, and dispersion of the bulb, a prismatic circle R will be formed upon the screen,[1] and it will be evident that wherever a colour—say blue

Fig. 157.—Rainbow Experiments

—reaches the screen, an eye whose pupil was at that spot, or in its precise direction, would *see blue* from that particular drop of rain represented by the bulb.

165. **Variation in Dispersive Power.**—This may be shown

[1] This experiment cannot be performed with less than the lime-light; but if any difficulty be found with that, it will be easily surmounted by using the *focussed* parallel beam (p. 277) and the attachment described on p. 178.

by what is called a polyprism, of glasses ranging from crown to double-dense flint; but a cheaper and equally effective apparatus can be obtained of glass plates cemented together as in fig. 158, the outer strips, forming a V of about 60°, being about 6 inches long by 2 inches wide. They may be cemented together with marine glue, in which case water, salt and water, and sugar of lead and water, will give considerable differences in dispersion; but by using glue or isinglass mixed with bichromate of potash or chrome alum, and then exposed well to sunlight so as to become insoluble, they may be filled with water, any medium solution, and carbon disulphide, or monobromonaphthalene, which is equally dispersive and less volatile.

Fig. 158.—Trough prisms

166. Achromatism, and Compound Prisms.—That refraction and dispersion are not necessarily proportional, is very readily shown by a prism of dense flint glass, of an angle which exactly neutralises the colour produced by the trough of water, when its refracting angle is placed the reverse way, or at the top. It will be seen that there is still left a very considerable amount of *refraction.* It will be evident that the reverse may also be done, and the refraction might be neutralised while still leaving prismatic dispersion; and both phenomena are excellently illustrated by a very convenient apparatus devised by Professor Weinhold and shown in fig. 159, of one third the real size, fig. 160 giving the details more clearly. One of the rods on the stand carries by the screw *k* a flint-glass prism of 20° angle, and the other by another screw *k* two crown-glass prisms of about 26° and 45°

(the exact angles of course depend upon the glasses employed).
When the flint glass prism is used with the thick crown
glass prism, as at A in fig. 160, the apparatus gives refraction
with achromatism; when the thin crown is used with the flint,
as at B in fig. 160, there is dispersion with an undeflected
beam. Black screens *s* can be adjusted to stop off any stray
parts of the beam; or if it be desired, by adjusting one prism

FIG. 159 FIG. 160

half of its height higher than the other, the effect of each
prism separately, and of the combination, and of the unde-
flected beam, can be shown together, this arrangement being
shown at c, fig. 160.

More simply, a pair of small prisms to show achromatism,
as made for the Science and Art Department, and sold for 5s.,
may be simply bound round with a rubber ring and stood

on end in the path of the beam, the effects of each prism
singly being first shown.

Compound disulphide prisms are very useful for many
experiments with the spectrum. Fig. 161 is the usual form,
the space B being filled with carbon disulphide, or monobromo-
naphthalene, and the ends G, of light crown glass, correct-
ing the deviation. Similar prisms of smaller size may be

FIG. 161 FIG. 162

constructed with the new highly-dispersive Schott glass instead
of fluid ; and such a prism fixed in a mount at the crossing
of the rays from the optical objective, is exceedingly con-
venient for many purposes. Another useful compound prism
may be made on the general principle of fig. 162, a single crown
prism of light glass, G, separating two cells B of dispersive
fluid : such a prism may be made of nearly double the disper-
sion of a prism bottle, with only the deviation of one, and

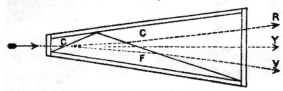

FIG. 163.—Wernicke's Prism

with much less loss of light ; or it may be made like Thollon's,
with one cell of fluid only, of greater angle. The most
generally useful in projection is a direct prism, which for all
simple and rough experiments saves deflecting the lantern.

Another improved form of direct prism for projection is
shown in fig. 163, as constructed by Messrs. R. & J. Beck for
Professor S. P. Thompson, according to a method suggested
by Wernicke. Cinnamic ether has the same *mean* refractive

index as one of the new Jena glasses, but is widely different for the blue and red ends of the spectrum. A prism is therefore constructed by placing a very wide-angled prism F of the glass, in a cell of cinnamic ether C C, closed by rectangular glass plates. The yellow ray is undeflected, but the red rays R and violet rays v are dispersed by the *second* face of the prism F as well as by the first, as shown in the diagram. This prism gives very great dispersion, and much better *definition* than carbon disulphide, while the rectangular ends are an advantage. The cost of one not quite 4 inches long is about 5*l*. 10*s*.

167. Transparency Reciprocal with Reflection and Refraction.—It is interesting to show by experiment that in proportion as we abolish reflection and refraction, by approximating the refractive indices of the portions of a mass, and of the surrounding medium, it becomes more transparent, or less visible. A screen of blotting-paper may be arranged between two lanterns, one on each side, and a portion of it either wetted or oiled. It will be seen that the treated portion appears *darker*, or reflects less light, to a spectator on the same side as the lantern illuminating it; while if this be darkened and the screen illuminated on the other side, the same portion appears *brighter*, because the light passes through instead of being reflected. If we arrange a screen of thin paper with a grease-spot of two inches diameter in the centre, between the rays from the bare radiant in the lantern and the most powerful gas-flame or oil lamp that can be procured, adjusting positions and distances so that the audience can see when the surface appears evenly illuminated, we shall have an experimental demonstration of Bunsen's photometer.

An elegant experiment with a mass of powdered glass will make this still more clear. A bottle must be prepared like a prism bottle, but with parallel sides; or a fair result may be got with one of the scent-bottles ground and polished to two

parallel flat sides, such as may be bought for a few pence
almost anywhere. Either is nearly filled with coarsely
powdered glass. For the bottle with plane sides it does not
matter what this glass is, if homogeneous ; with the other
bottles, it is best to purchase one or two others *of the same
make*, and having heated one nearly red-hot and quenched
it in cold water, to pound it up. The powdered glass sold
ready-made, generally varies too much in density for this
experiment. This powdered glass, in the cell or bottle, is of
course opaque to the beam from the lantern. The bottle is
now to be filled with a fluid of the same refractive index as
the powdered glass. This is easily prepared by mixing in the
required proportion benzol (which is less dense than glass)
and carbon disulphide (which is more so). This is done by
trial and error, and when the required density is obtained (if
the powdered glass is reasonably uniform in character) the
bottle appears clear, or at least transparent. This, however,
is not all. It has been shown how dispersion varies in
different substances. Owing to this, the refractive index can
only be brought precisely the same, for *one* colour of the
spectrum. We therefore place a rather wide slit on the
lantern nozzle, and focus its image on the screen ; then
interpose the cell filled with the glass and fluid. The image
will now be seen, still sharp for the colour which happens to
be exactly corrected—let us suppose a green slit may appear
on the screen—while the rest of the spectrum will be diffused
round this in a nebulous haze, of the complementary colour
to that of the slit.

168. **Anòmalous Dispersion.**—The remarkably anomalous
proportions dispersion sometimes assumes can be illustrated
on the screen ; but after further experience resulting in occa-
sional failure, I am bound to confess that with the lime-light
the experiment is hazardous and difficult. I formerly described
the use of a prism bottle in a trough with parallel sides, but
this is too uncertain to be trusted, and I have abandoned it. I

find the best arrangement to be as shown in fig. 164, a glass trough such as is used for aquatic animals under the microscope, having two thin glass plates A C, B C, cemented with great care, so that there may be no leakage, but that no surplus cement may hinder the fluid filling the 'knife-edges' at the ends, C, of the end cells. On the outside of the cell over C a stripe must be very carefully blacked, of the exact width that will cover the cemented ends of the glass partitions, so as to leave exposed the extreme 'knife-edges' of the cells, and no more. A slit being placed on the nozzle (the optical front not being used) and a parallel beam sent through it, is focussed on the screen; and just where the rays are most concentrated, the cell is placed with the side C to the lens, shading one of the

FIG. 164

end cells with a card, and letting the rays pass through the other *up to the edge*. The whole cell is filled with alcohol, and with a pipette are dropped into the end cells, drop by drop, a few drops of saturated solution of fuchsine in the *same* alcohol. It will be evident that the alcohol cell A C B exactly neutralises the refraction and dispersion of the *alcohol* in the other cells; but as the fuchsine is added the colours separate from the slit, red coming *between* blue and yellow. If the solution is too strong, only red passes : if too dilute, there is no visible dispersion. The use of the double cell is, that if the first be made too saturated, the other may be tried ; and for the same reason it is well so to adjust the glass partitions, as shown in the figure, which is the actual size, that the two may be of somewhat different angles, as 25° and 35°. The most brilliant jet should be employed, in order to work through as much as possible of the fuchsine, the effect being chiefly produced at the thinnest part of the cell. Often the

effect can be coaxed out of an apparent failure, by simply
covering up, not only the other cell, but the thicker part of
the one employed, so as to diminish the preponderance of red
light which passes through, and may drown the much fainter
blue and yellow. Success in the experiment depends chiefly
upon a brilliant light, exact and *clean* finish of the cells, and
the proper amount of fuchsine.

169. **Subjective nature of Colour Sensation.**—The most
striking proof of this is an experiment shown in fig. 165,
which depends upon *fatiguing the retina* with any given
colour-sensation. The nerves when thus fatigued becoming
less responsive, and
this being equiva-
lent to some sup-
pression of that par-
ticular colour, pro-
duces the sensation
of its complemen-
tary, though the
screen may be white.
Removing all but
the condensers, hold
over the open nozzle
N a black card

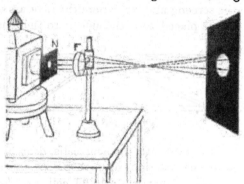

FIG. 165.—Subjective Colours

pierced with a circular aperture which, focussed by the lens F,
gives a disc of 18 or 24 inches diameter upon the screen. In
the centre of the bright disc insert a drawing-pin as a mark,
and let the spectators fix their eyes on this steadily while
30 is slowly counted—then suddenly remove the card,
lighting up the whole screen. The retina being fatigued over
the region of the previously bright disc, that spot will appear
darker than the rest of the screen.

This done, merely to explain the *principle* of the experi-
ment, it is repeated with a coloured disc, holding a piece of
red glass together with the card over the nozzle, and bringing

both away together ; the result of retinal fatigue is now a *green* disc when the screen is lit up—if the glass be blue, the result is an apparently *yellow* spot. Instead of the open nozzle and loose lens, the aperture and glass may be inserted in the ordinary stage of a lantern with the objective on ; in that case the stage-spring should be held back, in order that the card and glass may be withdrawn instantaneously and without dragging.

A more beautiful experiment is to project the *spectrum itself* on the screen, through a disulphide prism. A rather wide slit should be employed (brilliance more than purity being required) and the 30 must be counted deliberately, so as to give the full time. Also, at the word the nozzle should be covered over, and the gas in the room turned up, the lantern light itself being often rather too brilliant. The complementary spectrum will then appear upon the screen.

Any light—even an Argand burner—will perform these instructive experiments ; but it may be well to remark that in every audience there will be a percentage who do not perceive the phenomena, either from colour-blindness, or from unusual endurance of their nervous system, or from not keeping the eye steadily fixed on the index spot, since it is essential that the image on the retina remains fixed in the same place.

Contrast deceives sensation in the same way. Arrange a powerful gas-burner (only one) or it may be a less brilliant lantern (as a gas or oil-lantern, used with an oxy-hydrogen one) rather nearer the screen than the lantern, and considerably to one side. Throw on the screen a strong light from the experimental lantern, with a coloured glass in the stage or held over the nozzle. After a few seconds hold rods, or a card with pattern-apertures cut in it, in the coloured rays. Where the shadows fall, the screen is free from coloured light, and is illuminated by fainter *white* light from the other source. But the shadows will appear by contrast strongly tinged of the complementary colour.

170. Absorption Colours.—The only real standard of colour being the composition of its spectrum, many most instructive experiments may be made to show that natural colours are caused by the suppression of certain colours through absorption by the molecules of the substance. The most convenient arrangement is that in fig. 166, the objective of the lantern being removed and replaced by a perpendicular slit, either adjustable in brass, or it may be cut in a cap of black card. (We shall simply speak of the slit on the nozzle in future.) Through this the light is sent 'parallel,' and focussed by the loose lens F, beyond which is the prism P throwing the spectrum B C. Over *half* the slit a coloured glass may be held— suppose a deep red. It will be seen that more or less of the spectrum is cut out or obstructed, as from C to A, and that the glass is only transparent to the

Fig. 166.—Absorption

red rays. The light is *no brighter* in the red, and therefore no other light is turned into red; it is simply that the other colours are cut out from the full spectrum. Other coloured glasses will show the same thing; and it will be observed that some glasses cut out *bands* in the spectrum. Very instructive pieces of various colours can be selected with a small pocket spectroscope, and these glasses will show by their composition how *mixed* most colours really are, as we find them, and how different is a really pure *coloured light*, of a definite refrangibility, from the light reflected or transmitted by ordinary pigments or other coloured substances, which is

shown by the prism to be generally of a most composite character.

Another experiment may be made. Go up to within a yard or two of the screen, and hold up a large piece of coloured glass in the rays. It will be seen that in some rays it casts a perfectly black shadow—it is *opaque* to light of that colour—but in other rays it is more or less transparent.

With more colouring matter, absorption increases, and it is instructive to prepare a few cells of wedge shape, or wider one end than the other, and fill them with coloured solutions. Placed as in fig. 166, it will be found that often the apparent *colour* changes when a thicker cell is used ; a colour only slightly obstructed by a thin layer, being completely obstructed by a thicker layer. These experiments may be varied *ad libitum*.

That the surface-colours of bodies are largely transparent colours, or remainders left after other colours have been absorbed by a layer of the surface molecules, is shown similarly, by holding large flowers with good masses of colour in the rays of the spectrum ; or the coloured prints sold with floral magazines will answer very well. Each colour, in some rays, will appear bright and natural ; in others dull grey, and in others *black*. The monochromatic lights mentioned further on have the same effect.

171. Transmitted and Reflected Colours.—Surface colours are, however, not all due to transparency, and hence there is sometimes a great difference between the colours a substance reflects and transmits. This is specially true of metallic and semi-metallic bodies, and may be shown by a film of gold-leaf mounted as a slide. It appears green by transmitted light. Deflect the lantern parallel with the screen, condense all the light from the condensers through the open nozzle on its surface, at an angle of 45°,[1] and focus the *reflecting* surface with the loose lens, and it is yellow. The aniline dyes used for

[1] Exactly as the soap-film, fig. 179, p. 327.

red ink, poured over glass, dried, and treated in the same way, are red by transmitted light, mostly yellow-green by reflected light. Thin silver deposited on glass appears blue by transmitted light, though it apparently reflects all the rays.

172. **Complementary Colours.**—The primary meaning of complementary colours has been illustrated already by the two coloured images of the slit, produced by deflecting part of a spectrum by a wedge-prism, before re-uniting it by a lens into a white image of the slit on the screen (see p. 286). Two complementaries of this kind contain between them the whole spectrum of white light, and may be varied *ad libitum* by the wedge-prism, and also by using a quartz plate and double-image prism as in Chapter XXII. But much less than the whole spectrum will produce white, which may be shown by cutting out a kind of comb in black card, the teeth and spaces being about half an inch wide. Held in the spectral rays proceeding from the re-uniting lens, this cuts out half of them, but the image of the slit is still white. And it can be shown that even *pairs* of colours produce white, by re-uniting the spectrum with a lens, either spherical or cylindrical, of not less than 14 inches focus and 6 inches diameter, so as to have the spectrum 'spread' considerably before re-uniting it on the slit image. Then close up to the lens must be fixed a slip of wood with a deep saw-cut along its top surface, in which black cards with apertures cut in them can be made to stand and be adjusted at pleasure. A slit in the red, one rather wider in the green, and a broad band in the violet, will give a white of three colours. A rather narrow slit in the red, and one double the width in greenish-blue, will give a white of two colours. A narrow slit in orange-yellow (just the red side of the D line) and a rather broad band in full blue, also give white. And the eye is here also deceived, for it cannot distinguish (except in brightness) between these two-colour whites, and that consuming the whole spectrum. Nor can the eye distinguish—as may be shown in the same

way—between a blue or a green containing nearly half the spectrum, and a pure blue or green.

178. Composite Colours.—The results of compounding colours have not been what are popularly supposed, blue and yellow, for instance, making *white* and not *green*. A great many striking experiments may be made in compounding colours, and especially blue and yellow. Holding a blue glass over the slit as in fig. 166, it will be seen that it transmits blue and green ; a yellow glass transmits yellow and green : green therefore remains when both media are superposed, and it appears that the two produce green as the result of successive *subtractions* by the blue and yellow. But using good blues and yellows separately, in the stages of a bi-unial, and allowing the discs to overlap, their *addition* makes white Glasses which do this can be found, or the blue may be a cell of neutral or slightly acid copper sulphate ; and the yellow of potash bichromate, or picric acid (both fluids highly poisonous). The copper and bichromate make, on the other hand, a nearly pure *green* by absorption ; and a drawing in red and yellow chalk illuminated by this light, appears done in *black* On the other hand, a cell filled with a solution of copper oxide in strong ammonia, and one of the bichromate of potash, can be so adjusted in strength, or in thickness of solution by wedge-shaped cells, that one transmits nearly all of the spectrum stopped by the other. These will also give a good white when their separate *discs* are superposed, but when the *cells* are superposed, stop all the light, and the screen is nearly dark. The same may be done with a cell of potash permanganate, and a green glass selected by trial ; and there is in Chance's glasses a shade called ' signal green,' which, when superposed on a full red, also practically stops all the rays.

Experiment with the spectral colours shows that blue and yellow are more really ' compound ' colours than violet or green. Neither of the latter can be made by compounding

any pure spectrum colours ; but blue can be compounded (in the manner described in § 172) out of a narrow slit in the green between the *b* and ᴇ lines, and a broad band in the violet over the ɢ line, rather to the violet end. Yellow can be compounded in several ways. With the spectrum colours it is done by rather a wide slit in the red, and a wider slit in the green extending a little to each side of the *b* and ᴇ lines. Another way is to project the spectrum, and from another lantern, or other nozzle of a bi-unial, to throw on it the image of a slit covered with red glass ; this slit being shifted along the spectrum, will find a position over the green which gives a good yellow. Thirdly, Lord Rayleigh superposed on a film of gelatine stained deep blue with litmus (which cuts out yellow and orange), one stained yellow with aurine (which stops blue and violet). The two stop all but green and red, and the result is yellow ; which is remarkable as yet another result of blue and yellow films superposed. A better combination, however, also due to Lord Rayleigh, is a cell of litmus solution, cutting out yellow and orange only as before, and bichromate of potash, which stops blue; the two allow to pass the green and red, and give a remarkably good yellow, while the colours themselves are so pure, that if a small round aperture be focussed on the screen, the prism will disperse this into two nearly sharp discs, one red and one green.

174. Monochromatic Lights.—These may be obtained fairly pure in many ways. The most convenient *yellow* is from combustion of sodium. A spirit lamp with a salted wick, or a bead of fused salt in a platinum wire loop in a Bunsen burner, will give a fair light, as will gas or hydrogen passed through a saturated solution of salt. For a large light, for a hall full of people, a quantity of tow with salt well rubbed into it, soaked in methylated spirit, and burnt in a wire basket over a vessel of water, gives a striking effect, all faces appearing black and ghastly. A brighter light is obtained by combustion of the actual metal, as presently mentioned.

Glass coloured with copper oxide is pretty pure *red*. Ammoniated copper gives a fair *blue*; but a much better plan is that discovered by Mr. H. G. Madan, of superposing Chance's signal green, which stops all red, on a rich cobalt-blue glass, which transmits little but red and blue. The two only transmit rays between F and G. *Green* is obtained by superposing blue and yellow glass, or by the copper and bichromate as just described.

In all colour experiments, it has to be remembered that deeper tints are needed in proportion to the brilliancy of the light used in the lantern.

CHAPTER XIX

THE SPECTRUM

175. Continuous Spectra.—The continuous spectrum is easily projected in the manner already described in Chapter XVIII. But when the object is to illustrate the principles of spectrum analysis, it is advisable to pay special attention to several points, which it has not been hitherto necessary to enforce. Always with the arc-light, and generally with the oxy-hydrogen, it is advisable to use *two* prism-bottles, or else the cinnamic ether direct-prism of high dispersion. A convenient plan is to have the two bottles set, either in a box with open ends, or on a piece of black board, in shallow cavities retaining both at the proper angle of medium deviation.

In most typical experiments, it is permissible to *converge* more light upon the slit, by adjusting the latter at the focus of either an ordinary or cylindrical lens.

And thirdly, special care must be taken that the spectrum

is *equally focussed* upon the screen, from end to end. To all 'line' work of any kind this is particularly essential; and it is never the case unless the lens is specially adjusted for it. The simplest method is to hold a fine wire across the slit; and then to adjust the lens for focus, and *incline the lens*, until the shadow of the wire appears as a black line equally sharp from one end to the other of the spectrum.

176. The Light.—A jet of the most powerful kind should be used, with plenty of pressure and the very best limes. Only thus can respectable results be obtained with the oxy-hydrogen light.

The arc-light requires modification. The positive carbon (crater) must be the *lower* one for spectrum work; and both carbons should be perpendicular and in line. The Brockie lamp can be used without difficulty, by inserting a wedge-shaped block under it so as to bring the carbons upright; and the current may be reversed by providing an extra special carbon-holder for the lower pole, which must protrude considerably. The lower carbon cannot then feed up to the usual stop, and therefore the focus will have to be adjusted from time to time, by the screw motion of the table. Spectrum experiments do not, however, require any very great accuracy in focus-keeping; and most demonstrators prefer a simple *hand* rack-regulator, moving the two poles in due proportion, and which, with a screw table as described in Chapter XII. will answer all purposes, at a small cost. Such hand-regulators are certainly best for the large excavated carbons presently mentioned, and allow of the length of arc being varied with much greater facility.

177. Simple Absorption.—For solutions, thick glass cells, including some made of a wedge shape, are very convenient, as showing the effect of stronger and stronger absorptions in coloured media. With the two prisms and the spectrum nicely focussed, the definite and local character of colour-absorption may be contrasted with the general absorption

x

produced by holding a piece of glass more or less smoked in front of the slit. Coloured glasses may of course be used *ad libitum.*

A very small piece of glass containing didymium or erbium, or a small bottle filled with solution of didymium sulphate, held in front of the slit, gives remarkably sharp and characteristic absorption lines, though it can be shown by simple projection that the medium appears nearly clear.

The analysing power of even absorption spectra, is well illustrated by comparing the absorption of genuine port or claret, with dilute alcohol artificially coloured. A cell filled with diluted healthy blood, and another containing blood poisoned by carbonic dioxide, is another instructive example.

Ordinary vapour-absorption is best shown by heating an ordinary sealed tube of iodine, or by a test-tube filled with nitrous oxide, prepared by pouring nitric acid upon a few bright copper turnings in the tube. There are other vapours which, with a trifle more trouble, give good spectra; but they are too well known to those specially concerned to need mention here. Most *coloured* vapours give good phenomena, with more of the line or fluted character than is shown by the majority of liquids or solids.

178. **Line Spectra.**—These are given with greatest facility by the electric arc. For bright-line spectra, the positive carbon need not be larger than usual, but should have a small hollow made in it; and the current should be of rather high E.M.F., so that the arc may be long. The metallic vapour will, however, lengthen the arc considerably. The comparatively dark *arc* should be brought into the focus of the condensers, when the line spectrum of the metals shown will appear between two continuous spectra thrown by the carbon points. Sodium, lithium, silver, copper, zinc, and thallium are the metals usually employed. If only sodium or lithium lines are desired, they are fairly shown by soaking carbon poles,

cleaned by boiling in acid, with solutions of the chloride salts, which are better than the metals for small currents.

Caution.—In all such experiments as these, or in vaporising metallic sodium in the lantern, even with the oxy-hydrogen flame, care should be taken to *cover the condensers with a sheet of thin glass*, otherwise particles of melted metal or oxide splutter on to the condenser, and fuse into its surface. Many a condenser has been ruined in this way. The sheet should be curved as in petroleum lamps, to prevent its cracking.

By employing salts of the metals, excellent line spectra can be projected with the oxy-hydrogen flame, the most convenient arrangement being the lamp shown in fig. 167, devised by Edelmann. It is practically an upright 'safety' jet, a stream of oxygen passing up through the centre of a larger stream of coal-gas, supplied by the taps at H and O. The whole can be raised or lowered by the plate *t* on the stand or pillar s, and at the top is a nozzle N, on which can be placed a hollow cone, *k*, of carbon. The inside of this cone is covered with a paste composed of

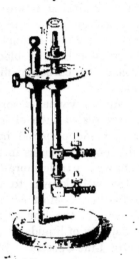

Fig. 167.—Edelmann's Spectrum Burner

the salt rubbed down smoothly in a mortar with picric acid, ammonia, and alcohol; as many cones as desired being prepared beforehand. This is an excellent method for bright-line spectra, such a burner being easily adjusted in the focus of the condensers, and the coloured flame emerging from the top of the carbon cone being very brilliant.

Mr. E. Cleminshaw, F.C.S., improving on Bunsen and Debray, places in the lantern a similar jet, but with a larger

internal bore $\frac{1}{8}$ inch diameter for the hydrogen, surrounded
by oxygen. Hydrogen is made in a bottle with zinc scraps
and dilute hydrochloric acid, the chloride of sodium, lithium,
or calcium being dissolved in the water to saturation; and
to assist the rush of gas and carry up more of the spray of
the liquid into the flame, either hydrogen or coal-gas is also
passed through the liquid by the ordinary wash-bottle method.
When the oxygen is properly adjusted, the lines are pretty
bright. Bright lines may also be shown upon the continuous
spectrum, by *melting* the chlorides of the alkalies, upon the
surface of a hard lime cylinder, and using this in the ordinary
way.

The brightest method of projecting the sodium line with

Fig. 168.—Combustion Lantern

the oxy-hydrogen flame is that adopted by the late Mr.
Spottiswoode. A jet for burning the two gases is furnished
with a hollow chamber in the course of the hydrogen tube.
Into this chamber is introduced some metallic sodium, and
the chamber is heated in a Bunsen burner; the gas then
carries over with it a copious supply of sodium vapour, which
burns with intense brilliance at the orifice of the jet.

The lines of some alkaline earths may also be excellently
shown by a simple apparatus devised by Prof. Weinhold, and
shown in figs. 168 and 169, fig. 168 being a plan one-third
the natural size, fig. 169 a perspective view on a smaller
scale. The body is a small cubical lantern, with a door at the
back fastened by the catch g, and with a nozzle on the front

into which slides a metal tube, enlarging at the front end into a long cone r, and at the back end bearing a plate with a slit s. The cone r is made to extend nearly to the lens which focusses the slit; the latter being made thus, to slide out, because it will need cleaning pretty frequently. To the door at the back is attached, by a projecting piece, a metal ring, in which can be supported capsules, b, for the burning substances.

In using this combustion-lantern, as I venture to term it, it is arranged in front of the ordinary lantern, in the optic axis, with the door open as in the second figure, so that the light from the optical lantern can be passed through the slit s, and enable the latter to be focussed on the screen, with its spectrum all in focus as described in § 175. The optical lantern may then be turned off or removed. The powder used is then placed in the capsule b, in a little heap, a piece of cotton wick about an inch long is stuck perpendicularly into it so as to be half-buried in the

Fig. 169

powder; the wick is lighted, and the door shut; Prof. Weinhold advises soaking the wick in lead chromate. As soon as the flame reaches the powder it flames up, and gives excellent line-spectra, though for a short time only.

Prof. Weinhold recommends the following mixtures as effective. For sodium lines: 3 parts sodium nitrate, 1 part

potassium chlorate, 1 part shellac. For calcium: 2 parts
chalk, 1 part potassium chlorate, 3 parts shellac. For
strontium, 4 parts strontium nitrate, 1 part potassic chlorate,
1 part shellac. For barium, 4 parts barium nitrate, 1 part
potassium chlorate, 1 part shellac. The shellac to be powdered
separately from the salts, which are also to be rubbed down
to powder, and the two mixed previous to use with a horn or
wooden spoon.

These methods are superior in effect to the use of glass
rods, or sticks soaked in solution; besides which, the manipu-
lation of such sticks in a jet is a very difficult operation.

177. Reversed Spectrum Lines.—The absorption by vapours
of the same rays which they emit is usually shown by sodium.

FIG. 170.—Reversal of Sodium Line.

As a dark line depends upon the absorbing vapour being less
bright than the light of similar wave-length emitted by the
radiant, this experiment, of all others, is shown with marked
superiority by the electric arc.

Fig. 170 shows the most widely known arrangement, as
adopted by Dr. Tyndall, except that *two* prism-bottles would

be used. In front of the slit E through which parallel rays are sent from the condensers, is a Bunsen burner, G, in the flame of which is held an iron or platinum spoon *l* containing a good pellet of sodium, which should burst into vivid combustion with some white vapour. In front of the sodium is arranged a screen s with an aperture, to shade off all direct sodium light from the screen—hence this experiment is not well adapted for a direct prism. The light from the slit has all to pass through the sodium flame before it reaches the

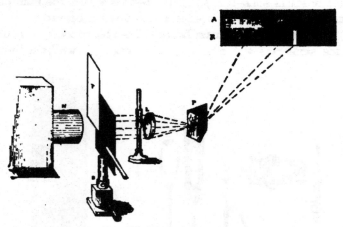

Fig. 171. - Reversed Sodium Line

lens, L, and a dark line D appears in the orange-yellow of the spectrum.

By modifying the arrangement as in fig. 171 (after Müller) detaching the slit from the front of the lantern and placing the burner B on the opposite side of it from the focussing lens, the lens L and prism P (really two prisms) being as usual, both spectra can be shown together. For introducing by hand another tin screen T between the Bunsen-flame and the condensers, the radiating arc light is cut off from the upper part of the slit, and consequently half the spectrum on

the screen shows the *radiation* R, and the other half the *absorption* A, from the same sodium flame.

But the simplest, easiest, and best method is to produce the vapour between the carbon poles themselves. To do this with certainty, the positive carbon must be considerably larger than usual, and this is another reason for employing a hand-regulating lamp for spectrum experiments ; besides which, the distances have to be adjusted by trial, which is more conveniently done by hand. I doubt if better and more certain reversals have ever been demonstrated than by my long-time friend and correspondent in these matters, the Rev. P. R. Sleeman, of Bristol ; and for sodium the arrangement adopted by him, as shown at A, fig. 172, is probably the best possible. The figure is actual size, the lower carbon being ¾-inch diameter, with a groove ⅛-inch wide cut in the end, round a centre of ¼-inch diameter. In this groove small pieces of sodium are

FIG. 172.—Carbons for Reversals

placed (not too much). As soon as the upper carbon touches the centre, the metal is volatilised. It will be seen at once how and why, by this arrangement, as soon as the arc is struck, the vapour is comparatively cool, and well outside of the incandescent carbon. A very little adjustment of the carbons brings out the reversal conspicuously. The ordinary 'cup,' as in B of the same figure, will however answer very well, and for more refractory metals like lithium is preferable, the heat of the arc itself being needed to volatilise them.

The guiding principle, in reversal experiments, is to get a *short arc*. If we use carbons as in B, and separate the carbons to give an arc of good length, we get the *bright* lines and comparatively dull carbon poles ; then, as we lower the

negative carbon and shorten the arc, the bright lines fade and we gradually get *dark* lines.

Weinhold's combustion-lantern, shown in figs. 168, 169, would probably give good dark lines by keeping the door open at the back, and sending the rays from the arc through the flame ; but I have not been able to test it in this way.

With the oxy-hydrogen flame, direct reversal is more difficult, and is practically confined to the sodium line. I gave [1] the arrangement in fig. 171 for this light, after fairly successful trial ; but I have since found that my success was due almost entirely to the powerful jets employed, and that even with these, such an arrangement cannot be depended upon, the Bunsen-flame being not cool enough in proportion, and so nearly in focus with the slit as to overpower the yellow portion of the radiation spectrum. Mr. E. Cleminshaw was quite justified in some criticism to this effect at the Physical Society,[2] and I was very glad to find that his arrangements gave better results than my own. They are as follows. (a) The Bunsen burner and sodium-flame are placed at the *focus or crossing point of the lens*, where the rays pass through the smallest space, and can be passed through a small flame where the vapour is most dense. The screen is then easily shaded from direct rays, and the sodium-flame is *not focussed on the screen*. The latter is the great advantage of this method. A spirit-lamp may be used instead of a Bunsen burner, but with metallic sodium, not with salt. (b) If the sodium-flame is used between the slit and the lens, after vivid combustion has been produced, the Bunsen flame is cooled by passing into it, along with common air, a portion of carbonic dioxide, generated in a bottle as usual, and with two vent-tubes, so that the supply can be graduated. (c) Another plan is to arrange a spirit-lamp with four wicks, with a jet of oxygen in the centre. Using oxygen in the flame, the bright

[1] *Light : a Course of Experimental Optics.*
[2] *Proc. Physical Society*, vii. 58.

lines are produced; then, on shutting it off, the dark band will usually be seen. Such a lamp may also be used between the lime-light and the slit; but the flame should be as far from the slit as convenient, in order to be out of focus. I have found that the brightness of the radiation spectrum may also be increased by condensing the rays from the condensers upon the slit by means of a lens.

Absorption may be clearly projected by other methods. Makers of physical apparatus prepare sealed glass tubes about ¾-inch diameter (which must be of strong and hard combustion-tube), in which are placed some small portions of clean sodium in an exhausted atmosphere of hydrogen (in order to prevent oxidation of the sodium). If this is carefully heated and held in the rays of the spectrum, it will be found to cast a shadow in the orange rays, but not elsewhere. Sometimes it can be so heated as to show dark lines if held over the slit, but this is rather a doubtful experiment. Or it will cast a shadow in the rays from a Bunsen sodium-flame.

Mr. Cleminshaw has devised another pretty experiment of this class. Using any apparatus for producing a brilliant sodium-light in the lantern itself, as recently described, it is adjusted so as to give a bright yellow disc on the screen about five feet in diameter by projection through the condensers. A Bunsen burner is then adjusted in the lantern near to the condensers (protected by a glass) and the orifice about half an inch above the lower edge of the lenses. On holding a carbon rod, or bunch of asbestos fibre, or other medium impregnated with salt, in the flame, a distinct shadow will be cast upon the screen.[1]

[1] Mr. Sleeman informs me that by an arrangement somewhat similar to this, but using an ordinary incandescent lime to give the spectrum, and using a bunch of asbestos fibre squeezed into the lower end of a glass tube filled with a saturated solution of salt, the brush thus constantly fed being held in the flame in front of the lime, he has obtained sometimes a fair reversal of the D line. I have had no opportunity of trying this method since it was suggested to me.

Lastly, we may employ Bunsen's well-known apparatus, in which hydrogen is generated by zinc in diluted acid, saturated with sodium chloride, coal-gas being also passed through the liquid to assist effervescence and carry more spray into the exit pipes. One burner is of slit form, and when the supply of air is adjusted gives a hot and brilliant sheet of incandescent sodium vapour. The other is cylindrical, and has placed over it a conical mantle which checks combustion, and causes a cooler flame, also coloured with sodium. This flame appears nearly black against the brighter one ; and shading both with a metal case or chimney only open in front, both flames are readily projected on the screen by a single lens.

FIG. 173

180. **The Invisible Spectrum.**—Only one or two key experiments need be mentioned here for demonstrating the existence of invisible heat-waves beyond the red, and invisible actinic rays beyond the violet of the spectrum.

Calorescence is best shown by Tyndall's experiment of passing the invisible heat rays through an opaque solution. The safest of his arrangements with the highly inflammable solution of iodine in carbon disulphide, and which need give rise to no uneasiness, is to employ a box or lantern with an open circular aperture in front, and a reflecting mirror

behind the arc-light to throw out a parallel beam. If from the aperture a tube of the same diameter, silvered and polished on the inside, extends for two or three feet, the heat is kept from scattering. (Condensing lenses are unsuitable for this experiment, as glass is a powerful absorbent of invisible heat rays.) A thin globular flask with a neck, about 4 inches diameter, is filled with the solution and held in the parallel beam; at its focus black paper and other substances will be ignited.

This method is not very suitable for the oxy-hydrogen light, because the lime does not radiate much heat to the back, where the mirror must be placed. The best method is to hold or adjust the globular flask, of the thinnest glass, five or six inches from the naked lime. It is all the better if a reflecting tube occupy the space between, as it will concentrate the heat considerably; and the densest and hardest limes must be used, these being much superior in radiating power. A powerful jet of $\frac{1}{10}$-inch bore will make the whole lime incandescent, and give enormous heat, which will be quite sufficient at the conjugate focus of the flask. So near the lime, however, I strongly advise the employment of carbon tetra-chloride as the solvent. It does not give an absolutely opaque solution like carbon disulphide, a little violet struggling through; but this is hardly perceptible, and the solution is not dangerous, as disulphide so close to the lime most certainly is. This will be found a very inexpensive, simple, and effective arrangement.

The energy of nearly invisible actinic rays may be shown either by taking a photograph through several blue glasses; or by exploding (with the usual precautions) at a rather long conjugate focus of the condensers, through similar nearly dark glasses, thin glass bulbs filled with chlorine and hydrogen gases, obtainable from the makers of physical apparatus. Explosion will be prevented by red or yellow glasses, but will at once take place through the blue, even with a good lime-light; but if there is any difficulty, burning

magnesium may be employed. White glass lenses are much superior for these experiments, as with the following.

181. **Fluorescence.**—Many experiments in Fluorescence, of great beauty, are easily made with the lantern. For those which depend chiefly on the conversion of the *invisible* rays at the violet end of the spectrum into blue light, it is advisable to have a radiant of high actinic power, such as the arc, or burning magnesium ribbon; and even then the effect is heightened if a quartz condensing lens and prisms can be employed, as crown glass, and still more carbon disulphide, strongly absorb these rays. Lenses and prisms of fine ' white ' flint, however, also give very good results. A temporary magnesium light can be got with little trouble by passing three ribbons through a brass tube, an assistant watching the combustion through a darkened glass, and feeding the ribbons accordingly by hand. The end of the tube should be in the focus of a large condensing lens, and the whole be fitted up separately, since magnesia makes a great mess in an ordinary lantern. Sulphur burnt in oxygen gives a strong actinic light, and even in air is sufficient for some effects.

With any such light, if a sheet of paper or card, washed repeatedly with a saturated solution of quinine sulphate in water acidulated with sulphuric acid, is pinned on the screen so as to cover and extend beyond the visible spectrum thrown through even a glass prism, a visible extension of the violet light will be produced, especially if the brighter part of the spectrum be shaded off to prevent the feeble light being over-powered. A glass tank some inches long, with flat ends, filled with the same solution, will mark the cone of light passing through it from a large lens by a beautiful sky-blue fluorescence. Solution of æsculin, or a decoction of horse-chestnut bark, also gives a brilliant blue.

The reciprocity of absorption and fluorescent power in the beam is shown by first showing the extension of the visible spectrum as before, and then interposing the tank of quinine ;

the fluorescent rays, being now taken up in the cell, no longer have the power to excite fluorescence on the screen. This is further illustrated by the fact, that in all tank experiments the fluorescent glow rapidly becomes feebler as the light passes deeper into the fluid, and that in any of the following experiments, the fluorescence may be stopped, or nearly so (depending upon there being *sufficient* absorption) by interposing a tank of the *same* substance in solution. But it is not so with different substances. Thus, if we have a tank of quinine solution, with a fluorescent cone of light traversing it, we stop this fluorescence by interposing another tank of the quinine, which, in becoming fluorescent, robs the beam of the power to similarly affect the second tank. But if we interpose a cell of uranine solution, its brilliant green fluorescence does not do so, but the quinine cell is fluorescent as before.

Amongst substances which fluoresce well in the electric light or magnesium, are turmeric in castor-oil (green), tincture of stramonium, fustic steeped in alum solution, camwood steeped in castor-oil (this oil, though not fluorescent itself, seems able to excite the property in several other substances) and æsculin. Of the latter a grain in powder should be shaken into a confectioner's jar filled with slightly ammoniated water, placed in the lantern beam : beautiful blue fluorescence will be seen by reflected light. Even a few bruised fragments of horse-chestnut bark thrown on the water will do the same.

There are plenty of substances which fluoresce magnificently by the ordinary lime-light, however. Even quinine will show fairly in a tank, with a good jet. A solution of nettle or any other green leaves (chlorophyll) in ether. methylated spirit, or benzol, which is green, fluoresces blood-red. A cube of greenish-yellow uranium glass fluoresces a bright and lovely green. Fluorescein, or any of its derivatives, such as eosin, or uranine, fluoresces *brilliantly* in even gas-light, and it is a beautiful experiment to scatter as much as is taken on the very end of a penknife, on the surface of a

large glass jar of slightly ammoniated water, in the rays of
the lantern. Beautifully brilliant arborescent green streams
descend through the water. Chrysoline does the same, and is
perhaps a purer green than the uranine. A few drops of almost
any red ink will show the phenomena fairly well.

Green, or rather greenish-yellow, is the commonest and
strongest fluorescent colour, and for designs painted in it
there is ample choice. The best way is to prepare a thick
size or thin glue from gelatine, and dissolve fresh some
uranine in the fluid. This can be laid on with a broad pen
or brush, and then dried, so as to give a little body of colour.
Such will shine brilliantly in almost invisible blue light.
Barium-platino-cyanide will be equally brilliant, but is far
more expensive. This is best rubbed up with gum-water. A
substance called thallene by Professor Morton, prepared by
him from petroleum residues, has probably the brightest
fluorescence, of the same yellow-green. Professor Morton
kindly wrote to me that this is best prepared by grinding up
with rather thin varnish of gum-damar in benzol. Slight and
unknown *impurities* often impart splendid fluorescence to
various organic compounds, which are destitute of it when
really pure.

Other colours are more difficult to get, and I have not yet
obtained any of them brilliant enough to use in designs. In
cells, chlorophyll has been already mentioned for red.
Magdala rose fluoresces orange-red, but was expensive, and
is now almost impossible to obtain, being gone out of fashion,
which is capricious as to these aniline colours. The best red
I yet know of was brought to my notice by Mr. Sidney
Jewsbury, of Manchester, and is a solution of azo-resorufin,
$(C_{24} H_{16} N_2 O_7)$ in slightly ammoniated alcohol—methylated
will do. Little must be used, one grain is enough for a large
cell. In this substance the fluorescence is rather masked by
the natural colour of the solution being also red; but by
treating with bromine, a compound is obtained giving a *blue*

solution, but also a red fluorescence, though rather more dull. Cyanosine (methyl-tetraiodo-fluorescein) Mr. H. G. Madan tells me gives a fine orange fluorescence. It too must be dissolved in alcohol. And Mr. Jewsbury tells me that fifteen parts glacial acetic acid and one part essential oil of peppermint, heated to nearly boiling point, give a red fluorescence. Saffron in alcohol fluoresces red-brown.

Of blues, the sodium salt of B-naphtholsulphonic acid fluoresces rather more powerfully than quinine. Nearly all the petroleum *lubricating* oils fluoresce blue more or less, and samples can be found that do so rather powerfully with the lime-light. Such give the strongest blue I know as yet, but not sufficient for designs on paper. The amido compound of phthalic acid fluoresces a *bluish*-green, but best in electric or magnesium light.

182. Phosphorescence.— This phenomenon is readily shown by exposing a large sheet of card coated with

Fig. 174.—Tyndall's Phosphoroscope

Balmain's luminous paint to the beams of an electric lantern or burning magnesium, interposing something to cast a distinct profile or shadow. After some 50 or 60 seconds' exposure, if the room is darkened, the exposed surface will be seen to emit light.

A set of tubes containing powders which phosphoresce of different colours can be obtained for about ten shillings; and if exposed to the same kind of light (the lime-light will practically answer if about 3 minutes' exposure be given, or the tubes may be previously excited by sunlight) will glow with their proper colours when the room is darkened.

The connection between phosphorescence and fluorescence

may be exhibited by Becquerel's phosphoroscope; but Tyndall's apparatus is simpler and more effective. A square box A, shown in plan in fig. 174, is fitted either with an arc lamp or magnesium burner, as already described, at c, and in one side is a perpendicular slot B, all else being closed except a sight-hole for regulation of the light. Outside the slit, on a vertical axis, the wooden cylinder D revolves rapidly, driven by bands E E from a multiplying wheel. The cylinder is painted over with some strongly fluorescent substance. Professor Tyndall used uranium glass powdered and laid on with gum, but uranine in gelatine is much easier to use, and even more effective. On rotating the cylinder, if there were no persistence of effect, no radiation would be visible, the cylinder being only directly illuminated through the slit; but owing to the duration of the vibrations set up by this momentary illumination, the whole cylinder glows with the characteristic fluorescent light.

CHAPTER XX

INTERFERENCE OF LIGHT

183. Propagation of Waves.—This may be illustrated by revolving the edge of a blackened glass disc, round the edge of which is traced a sinuous wave-line, in front of a coarse grating of perpendicular lines scratched on another piece of blackened glass, after the method of Crova. But a slide which I devised projects the phenomena in a manner both simpler and better. It is shown in fig. 175. The grating A of perpendicular lines scratched (pretty coarsely, and one-sixteenth of an inch apart) on black-varnished glass, is inserted flush with the surface of the slab of wood c which holds the slide together, and which has an aperture cut behind

the grating. In the top and bottom edges of the slide are cut longitudinal grooves, B B, the whole length ; and in these grooves slides a panoramic strip of glass about 18 inches long which is also black-varnished, and has the form of the wave traced boldly through it. On drawing this sliding-piece along, the wave will appear in motion ; and if one or two of the perpendicular scratches be distinguished by extra width, or a wash over it of transparent colour, it can be pointed out upon the screen that every single dot only moves up and down, and that the wave-motion consists in the similar motions of successive dots being a little later in time.

Fig. 175.—Wave Slide

I constructed another single-wave slide in another manner, bending a piece of wire round a glass tube into a helix, about $\frac{3}{8}$-inch diameter and $\frac{3}{4}$-inch pitch. Removing the core-tube, the straight ends of the wire were then brought in to coincide with the axis of the helix, and the whole mounted in a wooden frame so as to be revolved by a small winch-handle, in an aperture just a little larger than allowed the whole helix to be seen in profile. This being placed in the stage and projected on the screen, on turning the winch an apparently plane wave in black appears in motion, which may be continued *ad libitum*. By affixing two or three bits of very fine wire as spurs here and there, or a morsel or two of wax, the purely transverse motion of any given point may be shown in this slide also ; and it may further be used to illustrate the propagation of a *circular* wave.

184. **Interference of Waves.**—The slide partly shown in

fig. 175 was however chiefly designed to illustrate inter-
ference, which it does in a manner superior to any other.
Instead of the one simple wave-glass just described, when
demonstrating interference the sliding part is divided into
three strips as shown in fig. 176, kept together edge to edge
in one plane by a light binding or frame at each end, which
is cemented to the two outer strips, but allows the middle one
to be moved endways. On one outside strip of blackened
glass is cut a wave, and on the other a wave of double the
length ; and the middle strip has a wave of each length,
as shown in the figure. It is convenient to colour over the
long waves red and the short ones blue, with transparent
colour. All the
waves are first
shown in similar
phases, pointing
out that two vi-
brations of the
short ones take
place in the same
time as one of the
long ones. Then

Fig. 176.—Interference Slide

by drawing along the centre strip half the length of the longer
wave, it will be *seen* how this measured retardation of one
pair of waves brings the long (red) waves into opposite phases,
whilst the short ones (blue) are still in the same phase.

The superposition as well as destruction of vibration may
be shown by such a model as is used at the Royal Institution.
A wave is cut in the top of a board standing on edge. Any
number of thin rods sliding perpendicularly in the same plane
in a light framework, with narrow spaces between, are cut
of such a length that, when standing on a flat surface, their
tops give a similar wave. When the frame of rods is placed
so that the longer rods stand on the hollows in the top of
the board, the profile at the top is horizontal, or the wave is

destroyed ; but when so placed that crest is superposed on crest, there is a wave of double the height. Every arrangement is projected on the screen quite sharply by the shadow method (§ 109). The balls at the top of a Powell's wave apparatus are easily projected in the same way.

185. Thin Films.—The readiest methods of demonstrating the interference of light are by reflection from the two surfaces of thin films. When the lantern is worked upon a table, a small black tray about 12 inches diameter may be partly filled with water, may be laid down in front of it, and the lantern either canted up behind so that the parallel beam from the flange nozzle comes down at an angle upon the water and is thence reflected rather upwards to the screen ; or the long-focus lens may roughly focus the surface upon the screen,

being adjusted in the rising reflected rays ; or the beam may be deflected downwards from the nozzle by the plane mirror, and received and re-deflected in their upward path by another plane mirror, the surface being focussed. Then dipping a rod in oil of turpentine, and letting a drop fall upon the water, it rapidly spreads into a thin film, which produces beautiful colours upon the screen.

Fig. 177.—Film of Oxide

A wide-mouthed goblet of water may be placed in the phoneidoscope apparatus shown in fig. 142, the surface of the water occupying the place of the soap-film. Only very thin and fresh oil of turpentine will show colours readily in a confined space like the goblet, the glass preventing the spreading of the film sufficiently ; but benzol containing a very small quantity of Canada balsam or turpentine in solution will act very well in such an apparatus.

Thin films of oxide show the same phenomena very readily. placing a polished steel plate on a light tripod with a spirit-lamp underneath, in the apparatus shown at fig. 142. If the polished plate is first slightly warmed uniformly, and smeared

with a film of solid paraffin, then wiped nearly off again, coloured rings will be exhibited more readily.

186. Soap Films.—These offer the most impressive demonstrations. Plateau's solution is made by dissolving 1 ounce of soda oleate in 40 ounces of distilled water, and mixing this with 30 ounces of Price's best glycerine. This is violently shaken up at intervals for several days, and then filtered clear at as cool a temperature as practicable. Whenever the solution becomes turbid, it must be filtered again, and must always be brilliantly clear for use, and all vessels (such as saucers) made scrupulously clean. In very cold weather, however, the turbidity thus caused may be removed by gently warming the solution and all the vessels used. I think a little Marseilles soap ($\frac{1}{4}$ ounce to the above quantity) somewhat toughens this for the variable English climate ; and for immediate use a little gelatine added to a small quantity of Plateau mixture will add toughness, but it decomposes, and therefore will not keep. A Royal Institution recipe, not nearly so tough, but which is free from streakiness and gives the black effect rapidly, consists of five volumes glycerine and six volumes of a 3 per cent. solution of *potash* oleate, a 'soft' soap. I am however indebted to Herr Dähne, of Dresden, for a still handier method, which he has worked out with care, and which allows the solution to be mixed as required, even in a test-tube, from separate ingredients kept in stock. Keep in bottles (1) a *saturated* solution of soda oleate in distilled water, carefully neutralised and filtered clear in the cold ; (2) distilled water ; (3) Price's best glycerine, tested free from acid. Then the liquid is mixed variously as follows, according to the purpose in view :

(*a*) For greatest *toughness* or lasting properties (not always desirable, as extreme toughness is apt to produce a ropy or streaky appearance) : take one volume oleate solution, one volume glycerine, and two volumes distilled water.

(b) For beautiful coloured bands, quickly developing : one volume oleate, ¼ volume glycerine, and four volumes water.

(c) For rapid development of the black spot : one volume oleate, five volumes water, and only a trace of glycerine.

To use soap solutions we require a little apparatus, in the shape of wire rings. They are best made of iron, or tinned iron wire, with a stem bent at right angles from the junction, which must be soldered and then smoothed carefully off. Some about 2 inches diameter, as A (fig. 178), are used by nipping the stem horizontally (with the ring turned upwards in a Bunsen holder as at C: some about 3 inches diameter are inserted in small wooden feet as at B. Before use the rings should be made hot, and then rubbed with solid paraffin, which will run into a thin coating, and prevent the wire from cutting the films. Rings up to 4 or 5 inches diameter, dipped in a saucer of 'tough' solution and carefully lifted, will take up a film.

Fig. 178.—Rings for Soap Films

Bubbles are best blown by a small glass funnel with ground edges, about an inch in diameter, to which is attached a small rubber tube for the mouth. With a tough solution I have blown a bubble over half a yard in diameter; and if a clean saucer be carefully soaped to the edge, and all froth avoided, a bubble nearly that size may be blown upon the saucer itself. A smaller size is however safer; and if the parallel beam from the lantern nozzle is deflected downwards upon this and reflected to the screen, fine colour-fringes will appear. If two or three stands, such as B in fig. 178, be

placed in a row, bubbles 9 or 10 inches diameter can be easily
placed upon the rings, and the parallel (or slightly divergent)
beam being sent through them all, will produce a very fine
effect.

Flat films produce the best optical phenomena. Taking
one up by the apparatus c in fig. 178, the whole arrange-
ments are as shown in fig. 179. Here L is the nozzle of an
ordinary lantern with the objective on, but the parallel (or
rather slightly *convergent*) beam from the open flange nozzle
is better; the rays
striking on the soap-
film A. The lantern is
deflected nearly par-
allel with the screen,
and the film A stands
at an angle of 45°
with the beam, so as
to *reflect* the rays to
the screen, on the
way to which they
are focussed by the
loose lens F.[1] Bands
of colour speedily ap-
pear across the film,
which gradually pass
upwards (the image

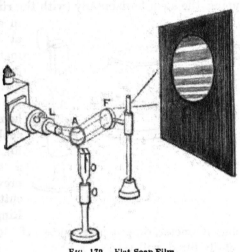

FIG. 179. –Flat Soap Film

being inverted) as it thins, until at length a yellowish-white,
and finally the grey-black appears, after which it soon breaks.

[1] This experiment being typical, the arrangements should be noted. On a
table, the pieces of apparatus will be simply arranged separately, standing as
figured. With a revolving stand and board such as fig. 99, the holder bearing
the film A will stand on the longitudinal board ; and the cross-piece C D (fig. 99)
being brought to that spot, the lens F will stand on that at the required
distance. This general arrangement governs all experiments where focussing
has to be done *after* the deflection of the rays, by reflection or otherwise, has
been effected.

Sometimes the heat of the lantern will destroy the film too rapidly. In that case an alum cell in the slide-stage will remove the difficulty.

Horizontal bands being caused by the action of gravitation on the film, if we can make the gradual thinning take a circular form, the bands will become annular. This is effected by a beautiful modification of the experiment often employed by Lord Rayleigh, and which is very easy if any sort of bellows, or weighted bag filled with air, be at hand, to furnish a slight blast. Even the breath will answer, but needs some practice and a thin rubber balloon to steady the pressure. Connected with the air-blast (a gentle one) by rubber tubing is a piece of glass tube drawn into a small but

A B

Fig. 180. —Rotating Films

not capillary orifice : one of the ‘fillers’ sold for use with fountain pens answers excellently. This is fixed in another small Bunsen holder, and adjusted so as to direct a blast at a small angle with the surface of the film. Adjusted near the edge as at A (fig. 180) the above is converted into a single whirling vortex, which shows rapid and magnificent gradation of colour : adjusted as at B, a little to one side of the centre, the stream divides into *two* vortices, in which the play of colour is still more rapid. This experiment never fails to ‘bring down the house.’

187. **Films of air—Newton’s Rings.**—Two squares of plate glass, with rounded edges, cleaned and polished, are readily

worked together till they show beautiful air-films. It is well
then to keep them together with spring wooden clips, one at
each corner, pinching one corner in the Bunsen holder, and
projecting exactly as the soap-film in fig. 179. The slightest
additional pinch between finger and thumb alters the colours,
thus leading up to Newton's experiment.

It is not easy to get a *good* pair of Newton's rings, which
under pressure give true circular figures. The usual three
screws are too few, causing distortion; six screws, with another
at the *centre* of the back glass, give better figures. If the
back glass is black, or some dark colour, the effect is better ;
the colours not being diluted by the reflected light from its
bottom surface. The rings are projected exactly as the soap
film. It is most convenient to have a stud projecting from
the circular frame, which fits into the socket of one of the
pillar-stands.

If a wedge-prism (not too thin) be interposed between
the focussing lens and the screen, if will be shown that in
the deflected image the number of rings is very greatly in-
creased on one half of the image.

By rapidly interposing in turn a red and a blue glass
between the lantern and the glasses, it is shown that the red
rings are larger than the blue ones ; but it is better to have a
red and blue glass framed so as each to occupy half of the
space in an ordinary lantern slide-frame. Holding this as
close as possible to the lenses, but so as to allow the reflected
rays to escape to the focussing lens, one half the image will
exhibit the red and the other the blue rings. It must be rather
a light blue glass.

Having another pair of glasses, of which the lower one is
platinised on the surface (silvering reflects too much light,
and overpowers the rings), and adjusting the glasses so that
the light from the lantern falls on them at the polarising
angle, the reflection from the first or *glass* surface of the
film of air can be totally abolished by placing a Nicol prism

on the nozzle of the lantern and turning it into the proper position (see Chapter XXII.) and the disappearance of the rings, though there is light upon the screen, will demonstrate that the reflection from *both* surfaces is necessary to their production.

Finally, the light destroyed by interference can be shown by spectrum analysis of a slit crossing the rings. In blue or red light such a slit would give an appearance like B or R in fig. 181. It has been shown already that in blue light the bands B are closer than in red light, in which they appear comparatively as at R. If, then, the slit across the rings is dispersed into a spectrum, the largest and smallest rings must be connected by curved lines somewhat as in fig. 181. The arrangements for the experiment are shown in fig. 182. The slit may be cut out of black paper and fixed to the front of the glasses, as at L, being illuminated by the parallel beam from the flange nozzle of the lantern N, the slit being focussed by the lens F and dispersed by the prism P as usual. In this case the lantern must be turned quite away from the screen, and the light fall on the lenses very nearly normal, as shown in the figure; else the incident light will not be able to get down to the film and out again through the slit, owing to the thick glass. An easier way is to place the slit on the nozzle of the lantern, with the parallel beam sent through it, and, bringing the glasses as close to it as possible, to focus the *reflection* of the slit in the glasses. A spectrum will in either case appear, crossed by beautiful parabolic dark bands.

FIG. 181

A soap film is easily analysed in the same way, using the

second method described. In this case a fresh film should always be taken up after all arrangements are made, as the bands are most numerous when the film is thickest. They will be seen to shift as the film thins, but care must be taken to avoid a current of air on the film as far as possible.

The colours of a film of condensed vapour are readily projected according to Reade's method. A plate of glass is rubbed with soap, and then nearly cleaned off with a chamois leather ; the plate is then adjusted in the Bunsen holder. Then taking a piece of rubber tube about a foot long and ¾-inch in bore, this is gently breathed or blown through, with the other end directed against the centre of the soaped side,

which is projected like the soap film. Coloured rings will appear on the plate. One precaution is necessary, however : as the experiment depends upon the condensation of the breath by *cold*, an

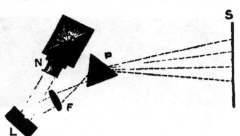

FIG. 182.—Analysis of Rings

alum trough must be placed to intercept the heat of the lantern, and the plate must be cold when placed in position.

Any piece of tolerably flat iridescent glass may also be projected.

That light is destroyed by interference, even with films too thick to exhibit colour, may be shown by analysing the light from a slit, as in the analysis of the soap film, from the film of air between two pieces of plate glass *pressed* but not *rubbed* together ; or by carefully splitting a very thin film of mica, and bending it round a blackened convex surface ; the reflection from this will itself give a slit, or rather a line of light, if placed in the parallel beam. The spectrum will be crossed by a number of dark parallel lines ; more and thinner,

in proportion to the thickness of the film, thicker and fewer in proportion to its thinness.

188. Thick Plates.—Newton's experiment with a thick concave glass mirror is pretty easily projected with a good light, using a large mirror optically worked on both sides, of 2 to 4 feet focus. This is to be slightly dulled on the surface by laying on a film of milk and water; milk alone is much too opaque. A radiant point must now be adjusted at the centre of curvature, so that the incident rays are reflected back and focussed in the same point. With the arc light the best plan is to place a rather small aperture on the lantern-nozzle, and converge through it all possible rays from the condensers ; then upon a screen of white card adjusted over the aperture, with a small hole in the centre for the rays to pass through, beautiful interference-rings will be seen, which will be very brilliant if all is adjusted properly. The same plan may be adopted with the oxy-hydrogen light ; or the naked jet may be brought out of the lantern, and adjusted with the incandescent face to the mirror, and the back to the screen. This latter will thus be shielded from the direct light from the lime, further stopped back by a small circular stop behind it if necessary ; while the rings formed in the air in the plane of the lime can be fairly focussed on the screen, if the light is very brilliant, with a *large* lens.

189. Fresnel's Prism. — The interference bands from Fresnel's inclined mirrors are practically impossible to project upon a screen. Even with his bi-prism, they are rather difficult with the O. H. jet, but easier with the arc light. The best arrangement is to use the optical front, with the objective removed and replaced by the plain nozzle, carrying an adjustable perpendicular slit. In the optical stage is placed a cylindrical lens, about 5 inches focus, and 2 inches diameter, mounted in a wooden frame. This is to condense a large amount of light upon the slit, light and lens being so adjusted that the parallel beam is focussed upon the slit. From

the slit the light diverges and falls upon the bi-prism, which should for this experiment be about 2 inches square, so as to intercept the whole pencil of light at a convenient distance from the slit. Perpendicular fringes will appear on the screen. Sometimes they appear more plainly by interposing a red glass; and are made more conspicuous by interposing an *achromatic* focussing lens between prism and screen, at considerably more than its focal distance from the prism; the lens then projects the bands in the focal plane of its own conjugate focus. Much depends upon the screen distance, brilliance of the light, and angle and workmanship of the bi-prism. A small angle gives the broadest fringes, and I was only able to obtain visible results with the lime-light by employing a fine prism ground for the purpose by Mr. Ahrens, of very small angle.

With this the fringes were amply conspicuous for a good-sized class-room, but would require the arc-light for a large lecture theatre. This is one of the few cases in which an *achromatic* focussing lens gives far superior results, the bands being more sharply defined. An achromatic of about 8 inches focus and $3\frac{1}{2}$ inches diameter is the most suitable for this particular experiment.

FIG. 183

A smaller bi-prism, about an inch square, may be obtained for about 5s., and will project visible fringes with the arc light; but for the O. H. jet must be used in another way. It may be mounted in a short cell which fits into the nozzle of the optical objective, and will thus divide the image of any object in the stage into two, which cross or overlap each other. That object in this case is a black card $4 \times 2\frac{1}{4}$ inches, cut into equal stripes as in fig. 183, or the bright lines may be scraped away on blackened glass. A few slides of different gauges should be prepared, as the best effect is produced by

different widths at different distances. On focussing the
slits upon the screen, conspicuous colour will be seen where
the images overlap, and that these are due to interference is
readily shown by covering up half of the bi-prism.

190. **Billet's Lenses.**—If difficulty be found in procuring
a good bi-prism, similar results can be obtained with the arc-
light by employing a convex lens cut in half, and the two
halves separated by a small distance, filled with a strip of
some opaque substance. The section is of course arranged
perpendicularly, parallel with the slit. Such a split lens is
easily mounted on any sort of stand, and is used in place of
the bi-prism. I have not however found it give sufficiently
distinct fringes with the lime-light. A lens of about 2
inches diameter and 6 inches focus is perhaps as effective as
any.

191. **Diffraction.**—There is not light sufficient, unless
with a powerful arc, to show on the screen the spectra from a
single slit ; but gratings, either original or photographed, give
fine projections. Of straight-line gratings on glass, copies of
Norbert's 8,000 lines to the inch pattern are most generally
useful, but the 6,000 also gives fine projections. It is sufficient
to place a metal or card slit about 2 mm. wide in the optical
stage, and focus on the screen ; then hold the grating in the
rays. Two gratings crossed give beautiful crossed spectra,
using a small hole instead of a slit. The effect is much
brighter if the aperture is used on the open optical front
with all the light from the condensers converged upon it as
far as possible, or with the attachment shown in fig. 95, and
is focussed on the screen by the loose lens. With this aid,
the diagonal spectra will be seen, as well as the primary
crossed ones. By interposing coloured glasses the spectra
may be reduced to coloured images of the slit, the red ones
being farthest apart.

A circular grating, used in the same way to diffract a
small round aperture, gives circular rainbows. I have had

magnificent gratings cut upon glass by Mr. Clarke, of nearly
3 inches diameter, which project brilliant spectral rings,
using a large focussing lens. A piece of coarse perforated
zinc held near the grating affords further beautiful pheno-
mena.

Wire gauze can sometimes be procured fine enough to
give perceptible spectra, using a large lens and a piece 6 inches
square; and spectra can often be obtained by diffracting through
a piece of the finest cambric, carefully selected, or through
the web of the feather of some fowls and birds.

Circular halos are produced by diffracting a circular aper-
ture through a glass dusted with lycopodium powder, or any
similarly small spores; on one condition. The ' resolution '
of a grating depends upon the number of lines or dots brought
into use, and a dusted plate 3 inches diameter will not give
distinctly coloured halos on the screen. But plates 6 inches
diameter, used with a lens not less, and holding the plate
close to the lens, so as to pass the rays through the whole
effective surface, give really fine halos. These dusted plates
are best prepared by shaking the spores through fine muslin
from some little height, upon clean plates which have been
washed with water containing a few morsels of gelatine. If
gently breathed upon, the spores will be caused slightly to
adhere; and after the surplus has been shaken off, a circular
mask of black card should be laid on the surface to preserve
from contact, another clean glass plate laid over this as a
cover, and the two bound all round with gummed slips of
dark paper, like lantern slides. Such plates should be of
thick glass, or the pressure of the fingers may bring the
plates into contact and spoil the even distribution of the
spores. Gratings and dusted plates can be mounted in
frames and used on stands if desired, but the hand is practi-
cally sufficient.

192. **Reflecting Gratings and Striated Surfaces.**—An
ordinary photographed glass grating will project very fair

spectra by reflection; but much more brilliant spectra are projected if it be silvered, or by gratings ruled on speculum metal. Formerly the best of these were by Mr. Rutherford, of New York, but for years past those ruled by a machine constructed by Prof. H. Rowland have surpassed all others. The gauge of these ranges from 10,000 to 80,000 lines to the inch, the 17,000 gauge being about the best; and they can be obtained from Mr. W. Brashear, of Philadelphia, of various sizes; and either ruled on a plane surface, or one slightly concave, so as to give a focus without lenses. The condition of projection is exactly the same as with transparent gratings; the *slit* must be focussed on the screen as reflected by the surface, and only diffracted by the ruling.

FIG. 184

One of those metal buttons constructed by the late Sir John Barton, and known still as ' Barton's buttons,' whose surface is divided into hexagonal or other portions, each of which is ruled with fine lines in a different direction from its neighbours, will yield beautiful projections, the spectra being all arranged in the directions of a six-pointed star. The ' focussed parallel beam ' from a small aperture is intercepted by the grating, which reflects the spectra on the screen.

A fine piece of polished mother-of-pearl also gives beautiful diffraction colours by reflection, the colours shifting as the plane of the pearl is a little altered in position. The easiest way of doing this is to provide a small tablet of thin blackened wood, D, with a boss, B (fig. 184), on the back, into which is fixed a tube, T, fitting into the sockets of the pillar-stands. The pearl, or any other object, such as a small haliotis shell, is easily held on this by a couple of elastic bands. A peacock-

feather stitched with black thread on a blackened card, can be projected in the same way. The colour of the peacock eye will change as its plane is altered ; but as the colour is uniform and not in spectra, in this case the colour must be produced by a thin film. (I believe a portion of the pearl colour to be of the same character.) The plane is readily shifted by turning the pillar a little ; and the object can be readily rotated in its own plane by turning the tablet round in its socket.

198. **Perforated Plates.**—Perforated zinc will give interesting diffraction phenomena if the light is brilliant. Every gauge procurable should be purchased ; then discs should be cut out and mounted in 4 × 2¼ wooden frames, for the optical stage, and spring wires bent circularly will keep them in place. Blackened perforated cards will answer, but the heat is apt to ignite them. Placing one in the stage, and focussing it *rather beyond the screen*, the interference of the various small pencils of light passing through the apertures in the card will produce coloured effects, rather brilliant a few feet from the nozzle, where they may be shown by holding a sheet of cardboard. Different gauges should be tried for the best results. But still better are produced if another frame and plate be introduced, at a distance varying from ⅛ inch to some inches in front of the other, and either the same or some other gauge, which experiment must determine; for every difference in the power of the radiant, and in the screen distance, will determine gauges and distance between the plates which give the *best* effect. Sometimes a piece of gauze as the front plate will give a good result ; as a rule, the finer gauges of zinc or card give the best, and the coarser of two different plates should be the posterior one. A little adjustment of plates and focussing will produce beautiful coloured patterns on the screen, the pencils from the first set of holes being diffracted by the second. If one of the plates is mounted in a rotating frame like fig. 195 (p. 348), and

z

rotated, some very peculiar effects may be produced. In these experiments the light in the lantern should be carefully adjusted to its best distance from the condensers.

Another beautiful method of projecting perforated plates or cards I adapt from Prof. Dolbear's ' Art of Projecting ' with the heliostat. The effect is, indeed, largely due to a strong prismatic dispersion by the edges of the lens ; but the beauty of the result makes the experiment worth a place. The radiant is drawn back in the lantern, so that the rays from the condenser cross in a focus 5 or 6 inches in front of it— about at the end of, or slightly within, the flange-nozzle, answers very well. Adjust in the optic axis another lens of about equal diameter and of deep curve, such as one of the condenser-lenses themselves, at a distance which gives a luminous disc 6 to 10 feet in diameter. Now hold a piece of perforated card or zinc (very coarse is best) in a position easily found, either in front of or behind the second lens ; the result will be most gorgeous chromatic patterns. Instead of a simple plate a revolving Kaleidotrope (p. 144) may be used, when the effect will be magnificent if the zinc is of coarse pattern. As already stated, however, it is only partially due to diffraction.

CHAPTER XXI

LANTERN POLARISING APPARATUS

194. **The Elbow Polariscope.**- The simplest and cheapest polariscope for lantern work consists of a bundle of thin glass plates as a polariser, arranged at the back of an elbow, as in fig. 185. The end N of the elbow is made to fit on the flange-nozzle of the lantern, and the elbow is of course so constructed that nearly parallel light from the condensers entering at N falls upon the glass plates G at the polarising angle of 56°.

The other end of the elbow at B has a screw-collar, into which screws the B collar of the optical front (fig. 94), with stage, objective, and nozzle. Into this nozzle fits, so as to rotate easily, an analyser, usually a Nicol prism. The whole apparatus is shown in fig. 186, and is commonly known as the lantern polariscope, or elbow polariscope. It is also useful and convenient as a table instrument for many purposes, if a plate of finely-ground glass is fitted into the end which fits into the lantern ; and will perform in a most efficient and satisfactory manner all ordinary experiments, which do not re-

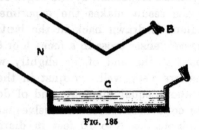

FIG. 185

quire the rotation of the polariser, at a very moderate expense. In using this instrument, it is placed on or in the flange-nozzle with the elbow lying horizontally, so that the lantern has to be deflected from the screen ; because the optical portion of the instrument must be preserved in a horizontal direction. To keep it from turning round in the flange from its own weight, there is either a slot fitting over a pin, or a simple bayonet joint.

The Nicol prism analyser will per-

FIG. 186.—Elbow Polariscope

form all ordinary experiments, but its performance should be examined. A Nicol of proper proportions will, with the objective described in Chapter XII., just 'cover' (*i.e.* give a polarised field over) slides of the standard London pattern,

z 2

which have a disc 1⅜-inch diameter in 4 × 2¼ wooden frames. A shade more may be sometimes covered.

Some improvements have lately been made upon the Nicol prism. Prazmowski's prism, as further improved by Messrs. Steeg & Reuter, is a rectangular parallelopiped, cut from edge to edge instead of from corner to corner (thereby giving a pencil of double the area) and with the section at right angles to the optic axis. This utilises better the two refractive indices, and moreover the joint is made with linseed-oil instead of balsam: the total result being a shorter prism, of wider area and more angular field. It, however, requires more than double the spar, and on account of the work, is about three times the price of a Nicol of similar area. A simpler and cheaper improved prism was devised by Professor

FIG. 187

S. P. Thompson, and is made by taking an ordinary crystal of spar a very little longer than would suffice for a Nicol, and cutting the ends off so as to slant the reverse way, at the lines A B, C D (fig. 187). Had the spar been made into a Nicol the joint would have been along the dotted line A D; but the considerably shortened piece is now cut along B C, the section being thus nearly at right angles to the optic axis (shown by the arrow), as in the Prazmowski. This prism is not so good as the latter, but is simple and easy to make.

A complete apparatus should be fitted with analysers showing the various methods of polarising light. A tourmaline is easily mounted in a small cell which rotates in the nozzle of the objective. Some tourmalines exhibit very little appreciable colour upon the screen, but such are unfortunately now becoming very scarce and costly. An analyser of thin glass is easily constructed as in fig. 188, the plates being fixed at the polarising angle in a tube whose end N fits into the nozzle. An aperture, R, at the side of the tube enables the

reflected rays to be used as well as the transmitted; and
thus one image may be thrown upon the screen, and the
complementary image at the same time upon the ceiling, if
there happen to be one. Thin micro-glass is sold at per
ounce in 1½ × ⅞ size, and twenty-four such plates, selected
for flatness, make the best analyser, and will answer very well
for a home-made instrument, both images being surprisingly
good if the glass is flat. The
plates may either be mounted
in a round tube, by cutting a
cork which fits the tube
obliquely at the proper angle,
and cutting the glasses into

FIG. 188

ovals round a shape made to the cork section, after which
the cork is hollowed through longitudinally into a tube;
or rectangular glasses may be fitted into a square tube, with
a round nozzle at the end.

A double-image prism should also be provided, unless two
are combined in a Huygens apparatus, when one of these
will of course suffice.

195. **The Nicol Prism Polariscope.** — The elbow in-
strument has two inconveniences: the polariser is fixed; and
the lantern has to be de-
flected, which is awkward,
more especially if diagrams
are required between the ex-
periments. The most perfect
instrument is unquestionably

FIG. 189

that in which the polariser, as well as analyser, consists of a
Nicol prism. It was formerly the custom to have two prisms
of nearly equal size for polariser and analyser, and such an
arrangement is still employed at the Royal Institution. As I
long ago pointed out, however, in all ordinary experiments we
have to focus the rays by some sort of objective; and it is mani-
fest from fig. 189 that just as many rays get through a small

prism as a large one (if not too small to transmit the smallest diameter of the pencil). The conveniences in manipulation are so great, while the absorption of light is less, that so far from a large analyser being an advantage, where such are used the screen effects are *inferior* to those constantly obtained by more modern and improved instruments. I add to this, as Professor S. P. Thompson once remarked at the British Association, that it is ' almost a sin ' under present circumstances to throw any large prisms away as analysers, when they are so badly wanted at the other end !

To cover the standard slides, a Nicol is required as polariser not less than 1¾ inches clear diameter or field, and 2 inches is of course better still. Fig. 190 on the opposite page is a section of a complete apparatus, as I arranged it for my own use. It was constructed for me in the first place by Mr. Darker, and with some slight alterations Messrs. Newton & Co. have since made many instruments after the pattern here shown, which has also been very generally adopted by other opticians, as best fulfilling the requirements of the demonstrator at the smallest expense compatible with a Nicol polariser. The references will explain the construction, and the external appearance of the portion of the apparatus in front of the polariser is the same as that of the front part of the apparatus shown in fig. 194. The stage aperture should be made large enough to take quite a thick wooden frame, with another frame containing a quarter-wave plate or an even film : sometimes the instrument is made with a separate aperture or stage for a quarter-wave plate, between the ordinary working stage and the polariser. The crystal apparatus can all be removed or added in a few seconds, and I prefer the analyser mounted with differently-sized collars at the two ends, one of which fits the nozzle of F for ordinary work, and the other of which, when pushed in, can be adjusted to the proper position for crystal-ring projections to pass through it. A quarter-wave plate can be inserted if necessary

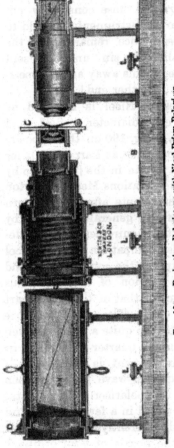

FIG. 190.—Projecting Polariscope with Nicol Prism Polariser.

B is the baseboard, with dovetail or other slides at the sides, in which all the pieces can slide easily, but with fair accuracy.

L L, L are screws to or fix the pieces when placed in their proper positions.

P N is the polarising Nicol, mounted in cork in a brass tube. This is adjusted in an inner tube truly in the optic axis. The outer tube is turned by four handles round the centre, arranged at the polarising axes, and with differently-shaped heads (as round and square) so that the position of the polarising plane may be known in the dark.

D is a divided circle or flange. The Nicol is protected by a glass plate G at the front end; at the other end may be either another plate, or a slightly concave lens L, to parallelise slightly convergent rays from the condensers.

S is a spring slide-stage.

F is the focussing power with rack and pinion. S and F together

are practically the optical front of Fig. 94, adapted to this instrument. The nozzle of F fits all the apparatus.

A N is the analyser, here shown as a square-ended linseed-oil prism by Steeg and Reuter. In ordinary polarising experiments this analyser fits into the nozzle of F.

C is a system of three convergent lenses, with a circular stage and springs for crystals whose brushes are to be shown in highly convergent light. It fits into, and is revolvable in the nozzle of F, or is instantly removable. When in use a second very similar system is brought near the crystal, nearly bringing the rays to parallelism. This is finally done by the field lens H, and the brushes are finally focussed on the screen by the lens K, the rays from which cross in the analyser. By varying the distance of H from the convergent system, and having two different lenses K, a wide variety of foci and sizes of disc for these brushes can be readily obtained.

between H and K. The whole instrument is about 24 inches long.

For convenience at different distances, it is well to have a polariscope fitted with several powers. I have a second back lens of 6-inch focus, as well as the usual 5-inch back lens; then, by removing the front lens of the power when needed, there will be a range of powers of about $3\frac{1}{2}$, 4, 5, and 6 inches. They are easily adjusted by screwing in a lengthening ring or adapter. Another plan often adopted is to have a concave amplifying lens mounted in front of the instrument. which amplifies the image precisely as described in § 93. Chapter XIII.

An alum-cell may be used in the ordinary lantern-stage with this polariscope, but is not really necessary. The glass caps protecting the Nicol should be removed for a few minutes after lighting up, in order to allow the dew to escape which will at first form on the end surfaces. In ordinary work the stage and power S F is pushed close up to the end of the polariser, and not kept apart from it, as here shown for clearness. Occasionally a tube of fluid may be inserted between the polariser and the stage, then the stage with power is drawn forward sufficiently to allow of this.

It is very easy to adapt a *low* microscopic power to this polariscope, by fitting a tube into the nozzle of F with a slot or slide-stage at the point where the lenses F condense the light into the smallest area. In the other end of this tube slides (for focussing) a power of about two inches, and the analyser. Such a power will exhibit many fine rock sections or ordinary micro slides, which the ordinary $3\frac{1}{2}$-inch power is unable to do. But for anything like real microscopic work. resort must be had to the polarising microscope described in Chapter XIII.

Great care should be taken of fine calcite prisms. The ends should be cleansed only with a clean, round-nosed camel-hair brush, often called a 'sky-brush' at artists' shops. If

absolutely necessary to apply chamois leather, it should be a piece of the softest, well beaten till free from dust, carefully washed, and finally cleansed from all soap and grease in alcohol. The polariser should always stand with the balsam-joint perpendicular when the instrument is put away, else the weight of the top piece of spar may produce 'thin film' colours in the balsam layer.

Unfortunately Iceland spar has for some time ceased to be imported, and been very scarce, so that it is doubtful if material could at this moment be found for another large prism, except the two specimen blocks in the British Museum. This has confined opticians to smaller pieces. Mr. Ahrens has constructed an ingenious prism of *three* pieces as in fig. 191, the arrow showing the optic axis. These form admirable polarisers, and only need spar of half the usual length for the same sectional area: but every one of several I have tested fails as an analyser, the edge of the wedge producing a perceptible though faint duplicate image, and the latter being distorted. He

FIG. 191.—Ahrens' prism

has constructed also several polarisers of two inches square or more, made in four separate prisms, which have been used by Messrs. Newton & Co. for polariscopes and given satisfaction. I have, I think, tested every prism so made ; and the lines of junction being out of focus were not distinguishable, while the whole polariser was of less length than width. Unfortunately spar has lately failed even for these prisms, so far as projection instruments (other than microscopes) are concerned, and this has caused attempts at constructing 'direct' polariscopes in other ways. The most obvious expedient is a bundle of glass plates in a tube as in fig. 188, only larger, using the transmitted light; but unless so many plates are used as to absorb much light, it is difficult to get

a dark field. But all practical purposes have lately been secured by a polariser described by Delezenne, and which gives a field of any size at a very moderate expense.

196. Direct Reflecting Polariscopes.—The principle is simply that of bringing the reflected beam from an elbow polariscope, by another reflection, back into the original direction of the rays from the lantern. It has been applied in practice in two different ways. Mr. Ahrens has constructed a combination shown in fig. 192, where T R is a totally reflecting prism of glass, so cut that its end faces are normal

FIG. 192 FIG. 193

to the horizontal incident, and the emergent rays, which are totally reflected midway at the polarising angle ; then these rays falling on the polariser P of black glass, or two or three thin plates with a black glass at the bottom, also at the polarising angle, are reflected in a horizontal direction into the instrument. This polariser is efficient, but two objections to it are the needless expense of so large a glass prism, and that the absorption in so large a mass is very perceptible.

A cheaper and upon the whole better arrangement was adopted by the Rev. P. R. Sleeman. In this the parallel beam is first reflected by the silvered mirror s (fig. 193), and then

re-reflected into a horizontal direction and, polarised by
the pile P with a black glass at the bottom. This arrange-
ment can be made cheaply and readily of any size desired.

It will be observed, that while the horizontal direction of
the beam from the lantern is preserved in the Delezenne
polarisers, it is necessarily deflected several inches to one
side of the axis of the flange-nozzle. In the first instruments
made on this principle, the beam was brought down *below*
the nozzle; but this makes the apparatus rather deep, and
requires a deep case for packing. To avoid this the polariser

FIG. 194.—Direct Reflecting Polariscope

was turned sideways; but that was found awkward, and also
necessitated a large case. To meet these objections I advised
reversing the polariser so as to deflect the beam *upwards*, and
Messrs. Newton & Co. now construct their instruments as
in fig. 194. It will be seen that it is then rendered quite
compact, and requires no larger a case than the Nicol prism
polariscope. All the front portion is precisely the same as in
the instrument shown in section in fig. 190.

Such polarisers are liable to the same objection as the
elbow form, not being capable of rotating the polarised beam.
This can, however, be effected through a simple expedient
suggested by Professor S. P. Thompson. If we cause the po-
larised rays to pass through a mica quarter-wave plate (§ 211)

whose planes are at an angle of 45° with the plane of polarisation, the beam becomes circularly polarised ; and if in front of this mica plate we place another quarter-wave plate which can be rotated, the beam again becomes plane-polarised in any plane we please, according to the position of the second mica plate. Such an arrangement of two quarter-wave plates can either be mounted in front of the polariser (the second one in a divided circle with four spokes as usual), or a slot may be provided before the slide stage, in which one mica is placed mounted in a frame, and the other in a rotating frame like fig. 195.

The 'bright field' produced in this way is as good as that of the Nicol polariser ; but if the two quarter-wave plates are gauged as usual, by the sodium flame, the dark field will show a perceptibly reddish tinge—the 'tint of passage.' This is not pleasant, and I consider it better to choose a mica film *very slightly* thick, when the little residual colour will be blue, which in the faint light will not appear perceptibly inferior to a true black.

197. The Rotating Frame.—The greater part of subsidiary apparatus will be best mentioned as required, but

FIG. 195.—Rotating Frame

one item should be mentioned here, as in continual use. It is a frame of standard size, in which films or other preparations can be *rotated* whilst in the slide-stage of the polariscope. This is effected quite simply by a small pinion gearing into a circular rack ; and the preparations, which are cemented in balsam between two glass discs the same size as those used for slides mounted in wood, are kept from falling out of the brass cell by a spring. Several of these rotators will be found very serviceable, the cost being only about 4*s*. 6*d*. each.

CHAPTER XXII

POLARISED LIGHT

198. Double Refraction.—This can be demonstrated in a simple rhomb of calcite, by employing the 'focussed parallel beam' (p. 277) from a pin-hole aperture on the flange-nozzle. The spar ought not to be less than four inches long if the separation is to be easily visible, though its other dimensions may be quite small, such as half an inch in the side. A wider separation is shown by placing an aperture in the stage of the optical front, and a double-image prism on the nozzle, focussing the aperture as small discs upon the screen.

199. Huygens' Experiment.—For this a pair of double-image prisms are mounted somewhat as in fig. 196, N fitting into the nozzle of the optical front, in front of the power. The first prism A is mounted in this tube, the second prism B in a cell which can be rotated easily. The two prisms must be chosen to match, and a slot or stage s should be provided between them. Focussing the aperture, the alternate disappearance and augmentation of the images will be seen on rotating the front prism. The slit

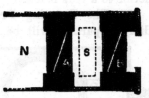

FIG. 196.— Huygens' Apparatus

s is for the insertion of a film of selenite between the two prisms, which will give the beautiful phenomena of complementary colours. Inserting rather a larger aperture in the stage, so that the pair of discs somewhat overlap, it will be shown that the two overlapping colours always produce white. It is well to have a small slide in which are mounted two such selenites, one giving a green and red, and the other blue and yellow.

By taking out the front prism and substituting the Nicol prism—all these parts being made to fit, for obvious reasons —one half the phenomena will be suppressed, and the demonstration analysed and simplified.

200. **Tourmalines.**—The phenomena of tourmalines are simple and convenient illustrations of the essential phenomena of polarisation. Light brown or neutral tint tourmalines are far the best; green ones appear coarse and unpleasant. One plate about an inch long and $\frac{1}{4}$ inch wide should be cemented with balsam in the centre of a glass disc and mounted in one of the standard wooden frames, and another about $\frac{3}{4}$ inch long and $\frac{1}{2}$ inch wide mounted on another loose disc, to be used in the rotator (fig. 195). These different shapes and sizes exhibit one crystal plate clearly over the other. The

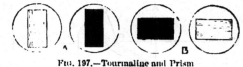

Fig. 197.—Tourmaline and Prism

two plates are placed together in the stage of the optical front, and the crystals focussed as an object on the screen : then as the front one is rotated the gradual darkening will be seen, until total extinction is produced when the two are crossed.

These phenomena will be simply correlated with those presented by the calcite, by leaving in the stage the rotating tourmaline alone, and placing on the nozzle a single double-image prism. It is better if this be not one of the Huygens pair, but constructed of two pieces *of spar* after the manner of Wollaston or Rochon, so as to give double the separation (such an arrangement gives too much colour to be desirable for Huygens' experiment). A plate of thin metal should be placed in the stage with the tourmaline, having a round aperture which just clears the rotating crystal and no more; and the discs from this aperture should stand clear from one another on the screen. Let the tourmalines first stand vertically, as at A (fig. 197). Then one image will be transparent

and the other black ; but on rotating the crystal, this will reverse as at B ; or it will be also reversed by rotating the prism to a position at 90° angle with the first.

201. Piles of Glass.—The effect of these is most conveniently demonstrated by mounting a pile of from twelve to twenty plates, B C (fig. 198), of the thinnest and most colourless glass that can be procured, in a frame screwed to the edges B C of two triangular pieces of board B C D, which are screwed to a base-board B D, and whose angles are such that a horizontal ray E F striking on the glass, is reflected at the polarising angle to G, while the unreflected portion (*i.e.* of common light) is transmitted to H. The thin glass analyser (fig. 188) would answer the same purpose, but its arrangements cannot be seen in the same way, and moreover it should be used *with* the present pile. First placing the glass pile in the position of the figure, the base-board B D on a table-stand, and the rotating tourmaline in the stage of the

Fig. 198.—Glass Pile

optical front, it will be shown that when in one position the tourmaline image is black on the screen by transmitted light, and transparent on the ceiling or overhead screen by reflected light ; and that rotating the tourmaline 90° reverses this. Rotating the pile 90° (easily done by laying the pile on its *side* B C D) the images are also reversed. Using an aperture and the double-image prism, in the same way, the pair of discs will be alternately light and dark according to the positions ; and then substituting the Nicol, it will be shown how one half the phenomena are suppressed or turned aside by this piece of apparatus. Finally, substituting the glass analyser (fig. 188) still with the aperture in the stage, it will be seen how the transmitted beam is either reflected or again

transmitted, according as the analyser pile or the separate pile vary in position by 90°.

In all these demonstrations of the fundamental phenomena of plane polarisation, the polariscope itself has not been employed; the optical front has sufficed, with the pieces of apparatus described. These are equivalent to a polariscope, and form a convenient method for also illustrating of what that instrument essentially consists, and its various possible forms.

202. **Polarised and Common Light.**—The best illustration of the probable nature of the transverse vibrations of common and polarised light, will be found in the actual projection on the screen, by any of the apparatus described in Chapter XVII., of Lissajous' unison figure *in a state of transition, i.e.* passing from planes though ellipses into circles, and so back to planes at right angles to the former. Such a transitional orbit will represent the probable nature of the vibrations of common light. If, with the reed apparatus, the orbit then be ' steadied ' at any one form, that will be a vivid illustration of either plane, elliptic, or circular polarisation.

203. **Interference Colours.**—At this stage the polariscope will be arranged for use, and the analyser turned to that position which gives extinction, or what is called the ' dark field.' If now the rotating tourmaline be placed in the stage, in two positions the field is still dark; but directly the tourmaline is placed at all obliquely to the polarised plane, the vibrations of the polarised beam are ' resolved ' into others obliquely inclined to them, so that the tourmaline appears a *light* image on the field. No other phenomena appear, because, of the two rectangular vibrations into which the original plane is resolved, one is absorbed by the tourmaline.

But if a thin slice of a non-absorbent crystal like selenite or mica be placed in the stage, mounted so that its polarising planes are at an angle of 45° with the original polarised plane and that of the analyser, both the re-polarised beams get through, just as in the Huygens experiment, only not appre-

ciably separated, owing to the thinness of the crystal. When these beams, polarised in rectangular planes, are again resolved by the analyser, we have two similar sets of waves brought into interference, since one set has been retarded more than the other in the slice of crystal. If the retardation does not exceed a few wave-lengths, therefore, we get colour, and this is complementary in positions of the analyser differing by 90°.[1]

It is usual to show this by a selenite giving red and green images, and yellow and blue. The two may be mounted in one slide. That no interference is produced whilst the vibrations are in rectangular planes, is shown by removing the analyser. On adding this and rotating, the complementary colours appear. But when the analyser is in an intermediate position, no colour appears, one ray from the selenite being then suppressed by the analyser, and the other transmitted without modification.

That the phenomena of interference are essentially similar to those of a thin film (only that in a selenite the retardation is that of the *difference* of two paths through the film, while in a ' thin film ' one of the rays is retarded by twice the whole thickness, so that the selenite or mica is much thicker than a ' thin film ' producing the same retardation), is best demonstrated by spectrum analysis, just as the Newton's rings and soap film were analysed. A plate of crystal ground concave or convex exhibits Newton's rings, which are readily analysed by placing a slit in a thin plate of metal across the slide in the stage, focussing, and interposing a prism (the compound direct prism is much the handiest for such experiments). The slit across a Newton's ring slide shows precisely the same

[1] It must be understood that this work is solely concerned with practical experimental conditions. No attempt is made or intended to explain phenomena, or even to show their relations, further than the order of experiments may do so. For some elementary explanation the reader is referred to my treatise on *Light : a Course of Experimental Optics*, or other systematic treatises on the subject may be consulted.

parabolic fringes, and across a plain flat film exhibits straight
interference bands crossing the spectrum. And just as the
prism showed bands in the spectrum of a film of mica too
thick to show any colour, so a slice of selenite or mica 1 mm.
to 2 mm. thick will show numerous bands crossing its
spectrum, though the image of the slice appears colourless.

204. **Coloured Designs.**—Since colour depends on thickness
of the film, studied variations will of course give corresponding
variations of colour. The simplest case is a film of selenite
split from common samples; this is nearly always irregular,
and therefore shows variations. The Newton's rings caused
by concave grinding have been already referred to. A slice
ground into a wedge, of course exhibits straight bands. Many
slides can be procured prepared in selenite, exhibiting
coloured stars, butterflies, birds, flowers,
chameleons, church windows, &c., show-
ing complementary colours in different
positions of the analyser.

I consider mica preparations, however,
more really instructive, and many of them
can be prepared by the demonstrator
himself, as this crystal splits more readily
into even films. They can be prepared
in two ways. Such simple patterns as

Fig. 199.—Mica Design

fig. 199 may have their outlines partially cut through a
rather thick sheet of mica, and layers of variable thickness
split off and lifted by a fine needle-point. The design will
then be displayed in various colours, care being taken to
find the polarising axes, and mount the mica so that these
stand in the proper position. But a better plan is to split
the mica into thin even sheets, and cut out geometrical
patterns from these, to be superposed one on another (taking
care that the polarising axes of all the superposed micas lie
in the same direction, unless purposely differentiated). The
films are then cemented on one another between two glass

discs, with dried Canada balsam dissolved in benzol, as used by microscopists. Such designs have clean and sharp edges, and are far neater and more transparent than the former.[1]

205. Crossed and Superposed Films.—The most instructive mica preparations of this kind are wedges built up of successively narrower strips, first designed and constructed by Mr. C. J. Fox, F.R.M.S., and which I, therefore, have always described as 'Fox wedges.' They are especially valuable as showing the effect of *crossed* films. If a film gives a colour due to a retardation of say one wave-length (or any other), and a second film of the same thickness be crossed upon it at an angle of 90°, the polarised ray that was most retarded in the first, is least so in the second, and it will be the same as if *no* film were there. This is well shown by a pair of similar wedges built up of eight steps each. When they are crossed, along the diagonal set of squares each step is crossed by the same thickness, and is therefore black. One of the wedges is mounted in a rotator, and then produces very various effects according to position, for it will soon be seen that a film mounted in a position to give colour (that is, its planes at 45° with the plane of the polariser) has those planes (or 'axes' as often called) *crossed* 90° simply by reversing the side placed next the other wedge. When the wedges are superposed parallel, in one position the gradation

[1] The films must be very carefully laid down in superposition in the cold, the balsam being only of a slight creamy consistence, and no air-bubbles being left between the films. The preparation, thus laid down and centred on one glass disc, must then be left for some days to dry, before fresh balsam is placed on the top and the cover-glass applied. This too must be left some days, under a very small weight, to dry round the edges, then baked at not much over 100° F. till hard enough for cleaning. These precautions are necessary to prevent the films from slipping out of place. The mica axis should be scratched on every piece, but these scratches practically disappear when finished, the balsam being so nearly of the same refractive index. For further details of mica work, the reader may refer to my paper on 'Optical Combinations of Crystalline Films' in *Proc. Physical Society*, 1888 (reprinted in *Phil. Mag.* for May 1888), or to my *Light*, published by Macmillan & Co.

in thickness is doubled, while in that rotated 180° it is counteracted, and a *flat* tint is produced equal to the sum of the thickest band and the thinnest; and if then one wedge be turned over, in one position the whole appears black.

The most important and useful preparation is a long wedge built up of twenty-four films each $\frac{1}{8}$ wave thick.[1] This gives the first three orders of Newton in $\frac{1}{8}$ wave gradations. The twelfth band being $1\frac{1}{2}$ wave thick, if another plate of mica of uniform $1\frac{1}{2}$ wave thickness be superposed, with its axes crossed, the twelfth band will appear *black* on the dark field, and on each side of it will appear, apparently, a wedge resembling the original one, starting from its thin end. Finally, if a slit be inserted in the stage with the wedge, crossing all its films, spectrum analysis through the prism will show exactly what waves are destroyed by interference in each thickness. By having mica or selenite plates of one or more waves, to superpose (the same way) on the Fox wedge, these interference bands may be demonstrated up to any desired order of colours.

Various and beautiful phenomena may further be shown on the screen by *rotating* an uniformly thick mica or selenite plate (commonly called an 'even' film or superposition film) over some other preparation, because in one position the resultant will equal the *sum* of the two films, and in another

[1] A film by which one of the rays is retarded $\frac{1}{8}$ wave more than the other, is called an $\frac{1}{8}\lambda$ or $\frac{1}{8}$ wave film, and so we have quarter or half-wave, one wave, two waves, &c. This can however only be precisely the case for any one spectral colour at a time, and the adjustment is usually made for the yellow ray, as being brightest and of medium wave-length. Taking then a whole-wave film, or the eighth band in Fox's wedge, one yellow ray is retarded exactly a wave, and the dark field would therefore in monochromatic light give this band perfectly black. But of the red and blue, which are greater and less in wave-length, a very little must be transmitted in white light, and these residuals make the band (or a whole-wave plate) of a dull plum-colour, known as the 'tint of passage,' or transition-tint, between the first and second of Newton's orders. All other thicknesses have similar residuals, which are the same in all interference colours; these films, and especially the Fox wedge, being the most perfect means of demonstrating them analytically in detail.

position rotated 90° will equal their *difference.* If the foundation be a star of differently coloured points, or with the points arranged with polarising axes in different directions, the result of rotating an even tint superposed will be very different on each. Or such an even film may be rotated over a film ground concave to show Newton's rings. If it equal the thickness at about the middle of the radius, when crossed the ring at that point will be black in the dark field ; and on rotating the film, the rings will change colours in a beautiful manner. The same will be the case with mica preparations built up of concentric squares or circles successively smaller in size (fig. 200).

For crossing, superposing, and rotating with other preparations, superposition films giving a good red and green, and a good blue and yellow, should be provided ; and also a half-wave plate, which gives the complementary in any case—*e.g.* the dark field becomes light and the bright field dark, when a half-wave plate is employed. This is ingeniously applied in two selenite designs which are very amusing. In

Fig. 200

one, the bust of a lady is composed of a nearly half-wave film, with the result that when the analyser is rotated 90° a fair woman is metamorphosed into a dark mulatto ; in the other, the figure of a miller with a sack of flour, becomes apparently a sweep carrying a bag of soot.

Home-made preparations should be mounted in their mahogany frames with rather stale putty, in which is mixed a little red powder of some sort.

206. **Crystallisations.**—Substances which can be crystallised in thin films on glass plates, if managed so that the films are of suitable thickness, give magnificent projections. Watery solutions are generally flowed over the discs, and in many cases, *e.g.* potassic chlorate, a little gum arabic in the

solution increases the size of the crystals. When dry, those which do not dissolve in balsam should be covered with another glass cemented down by balsam in benzol, which adds to the transparency. Acetates are generally fugitive, as are some others ; but the vast majority give good results, tartaric acid and salicine being particularly fine. Salicine should be used in saturated solution, with a little alcohol mixed in the water ; the fluid is dried gently over a lamp to a clear amorphous film ; and on more strongly heating this, especially if aided by a few pricks with a sharp needle, the beautiful rosettes with rotating crosses crystallise out. Occasional breathing on the film will produce circular ripples. Several others can be treated similarly. Many of the most beautiful crystals for the microscope are too small to show effectively in the polariscope, but are gorgeous objects for the polarising microscope described in Chapter XIII.

Another class of beautiful crystallisations are formed by *melting* the substance between two glass discs, and allowing the film to cool. Such are benzoic acid, cinchonine, santonine, succinic acid, cinnamic acid, &c., chiefly more or less organic in character. A splendid variety of beautiful slides are easily prepared from crystallisations.

It often proves interesting to an audience to project coarse specimens of the precious stones, compared with imitations in glass. The difference illustrates that between crystalline and non-crystalline bodies.

Crystallisation on the screen is a beautiful experiment, easily shown by melting benzoic acid between two glass discs held in a pair of forceps over a spirit lamp, and then quickly placed hot in a frame made for the purpose, and so into the stage. The splendid coloured needles quickly begin to shoot out on the dark field. Another way is to flow a strong solution of urea in gum-water, heated in a test-tube, over a *warmed* disc, and to place this in the stage, which is held back as open as possible, in order to touch the wet film with

a small crystal held in the end of a tube; if the conditions are hit rightly, which can only be done after practice, the effect is very fine. In the polarising projection microscope, the best plan is to purchase two or three slides of the fatty acids prepared for this purpose; they have simply to be gently warmed till the crystals all melt away, and placed on the stage, when they crystallise out again as the slide cools. The same slide can be used dozens of times over with no further treatment.

207. Mineral Sections.—Every one of these can be well exhibited in the polarising projection microscope, but only the coarse-grained specimens are bold enough for the polari- scope. Among those I know to be effective, are the coarse sandstones, granites, perthites, zeolites, cross sections of small stalactites, and labradorite. Some minerals show interesting and extraordinary differences in figure as well as colour, when cut in different planes. Labradorite cut in one direction, shows little but a coloured film; in another, beautiful straight coloured stripes; and in a third, beautiful bands of rotational colours (§ 213). One kind of granite (often called 'graphic' granite) resembles ordinary granite cut in one plane, whilst in another it displays marking almost like an Arabic inscription.

208. Organic Substances.—Nearly all substances with definite structure show double refraction when cut into plates or films. For the lantern polariscope, the best objects are plates of thin horn, pieces of thick bladder, and quill. If quills are split up one side, and placed in boiling water, they become soft and can be flattened out; but a quill pen just as it is, pushed through the stage, will show the phenomena plainly. Where there is fibre in a definite direction, as in a quill, one polarising plane always lies that way, and the other at right angles. Therefore if the quill be placed parallel to or across the polariser, the field remains dark, and the best effect is produced at an angle of 45°, as with crystalline films.

Shrimp and prawn shells, and the larger fish scales, make good objects. With the polarising microscope, all the usual organic preparations are available, and starch can be fairly shown even with the oxy-hydrogen light, and excellently with the arc.

209. **Strains.**—The effects of strain or tension are most easily shown in glass. The usual wooden press frames sold for the purpose exhibit the phenomena distinctly enough, but the pressure is insufficient to do so with the beauty they are capable of. I therefore constructed a frame of solid

gun-metal, with a screw turned by a powerful T-key, as in fig. 201, the glass being compressed between the convex surfaces of c and A. To avoid any twisting strain on the polariscope-stage, it is better to have a screw at *both* ends of the slide, and to

Fig. 201 Fig. 202

use two keys, when one twist balances the other, and more pressure can be put on. The glass should be compressed even to breaking, if possible; for the most brilliant chromatic fringes are produced under the greatest strain. Before breakage, however, the stage with the press in it should be rotated 45°, in order to exhibit the great difference in the optical results in that position.

The same press, arranged as in fig. 202, with a narrower piece of glass resting against two pieces of brass B B as abutments, c pressing between them as before, gives the optical

effect of strains of another character, resembling that produced by pressure on the centre of a beam.

Clear jelly compressed from above in a glass trough, will produce similar effects; but a simpler experiment is to cut a strip of thin india-rubber about 2¼ inches wide, pass it from side to side through the stage, roll each end round a rod of wood, and then strain the ends apart. The best effect is of course in the 45° position, as the polarising planes are in the directions of greatest and least strain. A simple bar of glass about half an inch square, passed through the stage, can easily be bent with the fingers alone, so as to show coloured fringes upon the screen.

Heating a piece of glass from one point, by the local expansion and strain it produces, exhibits the same effects. A disc of glass may be heated in a pair of forceps over a spirit-flame (keeping the flame at the same point only) and placed in the stage; the dark field will be illuminated by fringes. A better method is to provide a rectangular sheet iron shell open at both ends, and with a square aperture through each of its sides. In this can be placed a square of thick glass held in a bottom bar of wood, so that the plate stands between the two apertures; when a nearly red-hot bar of iron can be pushed in to rest on the top edge of the square. Beautiful fringes will appear instantly.

In plates of glass highly heated and suddenly chilled round the edges, these effects of strain are permanent and very brilliant. Many shapes are procurable, but the simpler ones of square, circle, oval, and triangle are most instructive; and the oval particularly so, as illustrating by analogy the phenomena of a bi-axial crystal.

Nearly all massive pieces of glass commonly procurable, such as ink-stands, glass stoppers, paper-weights, &c., show these latter phenomena. A section of thick glass tube, ground and polished, rarely fails; and many optical *lenses* show a conspicuous black cross, so that the lenses of the polariscope

itself need to be very carefully tested. The projection of such
a doubly-refracting lens (only too easy to find) illustrates well
the necessity for such tests in delicate instruments.

The alternate compression and dilatation caused in glass
by sonorous vibration, can be readily demonstrated in the
polariscope, after the method of Biot. A strip of plate glass
about ¼ inch thick, two inches wide, and four to six feet
long, is required; and the sharp edges of this should be
rounded or smoothed by a file, or emery-cloth, moistened with
turpentine. The strip should be screwed up exactly at the
middle, between the two cork-lined jaws of a wooden vice on
the tops of a short pillar, so that the strip is horizontal, with
its faces in a perpendicular plane. The portion of the polari-
scope containing the stage must be drawn forward from the
polariser, so as to leave a clear space of about an inch, and
through this space, so as not to touch either the front or
back part of the instrument, the strip must be adjusted to
cross the field, as near the point held in the vice as possible,
this being the node of the bar. The polariser and analyser
are crossed, for the dark field, at 45°, from their usual position.
The other end of the bar is now to be swept between the
thumb and fingers holding a wet flannel or other woollen
cloth, so that a shrill musical note sounds from the glass.
At once light flashes on the screen, and if a chilled glass, or
selenite, be placed in the stage and focussed, the colour will
change at every note. If the polariser is kept in its usual
position the glass strip must cross at an angle of 45°; but
the arrangement described is more convenient.

210. **Composition of Vibrations.**—The method in which two
vibrations in rectangular planes may be compounded into one
resultant vibration, can be illustrated on the screen in two
ways. One is to project Lissajous' unison figure, by any of
the apparatus described in Chapter XVII., showing in suc-
cession the plane orbit (converted to another plane orbit at
right angles when one of the reeds or forks is altered half a

vibration in phase), the elliptical orbit, and the circle. The other plan is to arrange in front of the condensers a small pendulum apparatus made for the purpose, *drawing* the figures in white on a slide of glass covered with a film of blue printer's ink. This is projected in action on the screen, so that the eye follows the tracing. Other methods with pendulums are plentiful, but cannot be called projections.

Having thus shown that rectangular vibrations in the same phase compound into one plane vibration at an angle of 45°, and that difference in phase of half a vibration results in a plane vibration at right angles to this (which in polarisation reverses all chromatic phenomena), also that vibrations differing a quarter-vibration in phase result in a circular orbit, and intermediate differences of phase in elliptical orbits ; that all this is so in the phenomena of polarised light is simply demonstrated. The fourth band in Fox's wedge (§ 205) giving half a wave difference of phase in the two rays, and the second band and sixth band a quarter-wave difference, the matter can be tested, large films of similar thickness being examined in the stage. The half-wave film does reverse the phenomena, changing the bright field to dark, and the dark to light, and causing the complementary colour in any design when it is placed in the stage. The quarter-wave plate also restores light to the dark field, but in a different manner. The analyser cannot now quench the light in any position. The field is always evenly illuminated [experiment], and so far the field might appear to be one of common light. If an aperture be placed in the stage with the film, and the double-image prism employed as an analyser [experiment] it will be seen that the two images are always alike in brilliancy. Nevertheless, by placing any selenite or other preparation in the stage after the quarter-wave [experiment], it will be seen that the light is polarised somehow, for the design shows colours, with tints simply differing by a quarter of that one of Newton's ' orders ' to which it belongs.

211. Quarter-wave Plates.—The light is in fact *circularly polarised* by the compounding of the two vibrations as they leave the film; and therefore, although the analyser again analyses the circular motion into two rectangular ones, it is quite indifferent at what part of the circular orbit it does so. A mica of this thickness, known as a 'quarter-wave plate,' is therefore in constant use for many experiments in polarisation.

It has been pointed out [1] that the colour cannot be quite the same all round the revolution of the analyser, except for the homogeneous light to which the thickness is adjusted; and when this is yellow (as usual), in white light a very slight residuum of orange appears in one position, and of bluish-grey in the other, owing to the longer and shorter wave-lengths not being in precisely quarter-wave relations.

The direction of the principal axis (that which joins the centres of the two systems of 'brushes' in mica presently described) should always be marked upon the plate in some way. One way is to make diamond scratches on the edges of the glass discs containing the film, at intervals of 45°; or the principal axis may be scratched across the diameter of the mica itself before mounting. I prefer the latter, which is quite unnoticeable unless carefully looked for. Such a film, in unmounted discs, can then be used in any position in the rotating frame (fig. 195). But as two definite positions are constantly required in this class of experiments, I prefer to mount two separate plates, each as large as can be inserted in a standard frame, permanently, one with its axis perpendicular, and the other at 45°. They can be put into thinner frames this way, and are always ready adjusted, which is convenient when only one stage is provided.

The effect of a quarter-wave plate obviously depends upon its axes being at an angle of 45° with the *preceding planes* of polarisation. It is readily seen that the plate, if placed with

[1] See note to p. 356.

its axes parallel to and at right angles with the plane of the polariser, is by itself totally inoperative, the polarised beam passing through in its own plane unobstructed, and therefore unresolved further. But it is very different if there precede the quarter-wave in the stage a selenite or other polarising preparation, in the usual position, the quarter-wave coming *after* this latter. The plane-polarised beam, let us suppose polarised in a perpendicular plane, is, by the selenite or other preparation, now *already* ' resolved ' into two planes at right angles to each other, but at 45° angle with the original plane. Therefore the quarter-wave, whose own axes are perpendicular and horizontal, being at 45° angle with those of the selenite, now *again resolves each of these*. The demonstrator should get these different actions of a quarter-wave plate thoroughly understood, and must at least understand them himself clearly.

It is easily shown that any film whose thickness is an *odd* number of quarter-waves, gives substantially the same phenomena, particularly in homogeneous yellow light. But with increasing thickness the amount of *residual colour* from all but the yellow waves, increases also.

Circular polarisation by reflection from silver, or in a Fresnel's rhomb, can be easily projected, in a manner too obvious to need description, but is not a very effective experiment, unless in a complete course of lectures.

212. Rotary Polarisation.—But the effect of a quarter-wave plate coming *after* some other preparation should be worked out further. The axis of the plate is to be vertical, as just now observed, and it resolves again (into perpendicular and horizontal) the rays which passed through the first crystal plate. For simplicity let this be a simple ' even ' film. *Each* of the first crystal's sets of vibrations, is now resolved again, separately, into horizontal and perpendicular with a quarter-wave difference of phase. So resolved, one compounds into a circular orbit in one direction, and the

other into a circular orbit *in the other direction.* [This may be worked out with pendulums, or a pendulum slide.] The analyser deals with these two circular waves always *meeting,* at whatever point it intersects their common circle; and *at that point* the two contrary tangential motions destroy each other, and the radial vibration alone is left. This radial vibration will be barred by the analyser, whose plane is at right angles to it; and thus any *homogeneous* colour may be cut off, and the field made dark, by some position of the analyser. This is best shown by a sodium-light. But the wave-lengths *differ* for different colours; and so it comes to pass that in rotating the analyser, one colour is cut off after the other, and *the residuals* give in succession, apparently, and more or less perfectly, the different colours of the spectrum. Thus it happens [experiment] that when rotating the analyser, instead of only two complementary colours and two colourless positions, as usual with a plate of selenite, we have in succession all the colours (more or less) in beautiful gradation. About one half to two waves for the first crystal gives the best approximation to a complete spectrum of colours.

Using a double-image prism as analyser, and an aperture with the two films in the stage of a size to give two overlapping discs, it will be seen that, through all the gradations, the two discs are always complementary, and make white where they overlap.

Still further, since the direction of the circular orbits depends on the *relation* of the rectangular planes in each plate; *reversing* either the foundation-colour plate, or the quarter-wave plate, will reverse the order of colours which appear as the analyser is rotated in any given direction. A plate of mica or selenite cut in half, and mounted with one half reversed, or a quarter-wave plate treated similarly, will demonstrate this. In two positions of the analyser the plate will appear all the same colour; but as the analyser turns

from these, the colours change, in contrary orders in each half, from one end of the spectrum to the other.

213. Rotational Colour Experiments.—These phenomena open the way to singularly beautiful experiments. If the quarter-wave plate is superposed upon a selenite or mica wedge, the bands of colour will appear to move across the screen.[1] Superposed upon the concave selenite, as the analyser rotates the rings expand or contract, with fine effect. If the quarter-wave is used in a rotator, it will be shown that after rotating it 90° the order (expansion or contraction) is *reversed*. Or if the analyser be kept stationary, and the quarter-wave itself is continuously rotated, the rings alternately contract and expand, as the quarter-wave is gradually added to, or subtracted from, the thickness of the rings.

The exact nature of what takes place is best shown by spectrum analysis. Placing a slit in the stage with a selenite

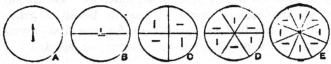

FIG. 203.—Quarter-wave Preparations

or mica thus circularly polarised by the rotational method, and interposing a prism (direct prisms are far the best for these experiments) the colours destroyed by interference appear as dark bands in the spectrum ; and as the analyser rotates, the bands travel along the spectrum. On reversing either quarter-wave film or colour-plate, the direction of this motion reverses.

Mr. Fox demonstrated these phenomena by superposing a quarter-wave plate with its axis as at A (fig. 203) on a

[1] In all rotational colour experiments it is understood that the quarter-wave comes between the pattern-plate and whichever part of the polarising apparatus *is rotated*. It will act similarly next the polariser, provided this latter is rotated instead of the analyser.

geometrical design prepared in mica, the whole cemented down as one slide. Inserted in the stage with the A plate next the polariser, this plate has no effect,[1] and the ordinary complementary colours appear ; but with A next the analyser, the rotational colours appear. Mr. Fox's slides were pieced together as a mosaic, the portions being cut out of different thicknesses ; but I have produced much better effects by designing patterns which could be *built up* by successively smaller and smaller films, each laid down in the centre. This construction gives a better gradation of colour in the different parts of the design, and some of the tints thus obtained are magnificent. For use superposed on his wedge, the same gentleman prepared a quarter-wave in two halves as at B, the effect of which is that in the upper and lower halves the colours pass along the wedge in contrary directions.

I myself devised what I think are still more beautiful effects, by reversing alternate *sectors* of the quarter-wave, as at C D E. Either of these superposed on a concave selenite, or on concentric rings or squares of mica, causes simultaneous expansion and contraction of the bands in *adjacent sectors*. By placing *underneath* the colour-design an even film in a rotator, and rotating this slowly as the analyser is rotated, the foundation colours themselves are beautifully varied, as already seen, and the result is a kind of optical chromatrope of great fascination. The eight-sector plate shown at E is most suitable for concentric squares. Or any suitable geometric design (*i.e.* some kind of eight-pointed or four-pointed star may be laid down on such a plate as E, and have a single plate A superposed on it ; then if the *analyser* is rotated it will be as if E were not there ; but if the *polariser* is rotated, the contrary sector rotations of E will come into play. If E be superposed upon an even colour-film, simple contrary rotations in adjacent sectors will be seen.

[1] Unless, as in the preceding note, the analyser be kept stationary and the polariser is rotated instead.

By superposing upon a colour-film cut into strips which are reversed, a quarter-wave plate also cut into strips reversed, the strips crossing the others at right angles, and blacking out the margins of the preparation, a chess-board pattern can be made without any great difficulty, which shows contrary rotations in adjacent squares.

Very beautiful effects are also produced by superposing D on E, or a quarter-wave made in twelve sectors, upon a square of chilled glass,[1] in either of its principal positions.

I have also constructed a design built up as a kind of circular wedge, the circle being divided into twenty-four sectors, each one in succession being one film thicker than its predecessor. When a single quarter-wave is superposed upon this, the result is of course an apparent revolution of the colours round the centre ; but this is still better shown by making the quarter-wave of two concentric parts with axes reversed as in fig. 204, when the outer portion apparently revolves in the contrary direction to the inner portion. If the circular wedge itself is crossed (as regards axes) upon a preparation of circular rings, or a concave selenite, the result is a series of beautiful black spirals starting from the centre ; and upon these, again, fig. 204 may be superposed. Again, if a sector-plate in its depolarising position (axes at 45°) be placed in the stage as a foundation, and fig. 204 be superposed, the alternate areas resulting will be black and white in contrast ; and in whatever position the *second* plate be placed, on rotating the analyser to a corresponding position, this effect will be seen. Hence the operation of Professor S. P. Thompson's quarter-wave rotator for the polarising plane (p. 847).

FIG. 204

A very instructive method of showing the remarkabl differences of result from superposing films in different ways,

[1] For details see the paper in *Proceedings of the Physical Society* already referred to.

B B

is to prepare two similar *double* wedges, the thicknesses of mica successively increasing from each end, so that the thickest band is in the centre. The bands should be about $\frac{1}{18}$ to $\frac{1}{20}$ inch wide, and as long as possible. Crossed, these of course give a very beautiful floor-cloth kind of pattern, with either the colours of the added films, or two diagonals of black squares. On superposing a plate of A, B or C (fig. 203), C being prepared not only with the quadrant sectors as drawn, but another plate with the sectors on lines arranged diagonally, most extraordinary differences in the phenomena will be observed.

The most beautiful of all the mica preparations I have devised, however, so far as spectacular effect upon the screen is concerned, are composed of two geometrical designs, each circularly polarised by a quarter-wave film, and then superposed. The two may be similar, or different ones designed in relation to each other, such as a design composed of straight lines with one composed of circles or curved lines. The first is of course circularly polarised in the ordinary way; but these rotational colours are again resolved, recompounded, and again circularly polarised by the films in the second design; and the result is a transition and play of colour unrivalled in magnificence, and apparently inscrutable till its components are analysed. This is not all. If every now and then the original *polarising* plane be rotated a little, the relations of all the axes are altered, and so are the colour variations, until when the polariser stands at 45°, the first of the two patterns (being in the same plane) becomes quite obliterated, and only the second single design is left upon the screen.

214. **Quartz Rotation.**—A plate of quartz cut transversely to the optic axis exhibits the same rotational change of colour, showing that plane-polarised light is resolved in its interior into two circular waves. The best thickness for an apparently complete range of colours is $7\frac{1}{2}$ mm., which also gives the 'transition-tint' between first and second orders. If an

aperture be placed with the quartz in the stage, and the double image used, the two overlapping discs will always be complementary.

215. Effects of a Revolving Analyser.—By employing an analyser which is *swiftly* rotated, at the rate of 8 to 10 revolutions per second, as described by Mach and the late Mr. W. Spottiswoode,[1] many of the preceding phenomena which are ordinarily exhibited in succession during the revolution of the analyser, can be made to appear on the screen simultaneously. In Mach's arrangement the light from the polariser, after passing through a stage in which any plate of crystal can be placed, immediately traverses an analysing Nicol, close to whose face either a square aperture or a slit can be attached. The analyser with its aperture occupies one end of a tube revolved by a multiplying wheel, at the other end of which is a prism of glass, to deviate the beam somewhat from the optic axis of the instrument. The effect is that, on revolving the tube, what would have been a central spot, by persistence of vision now becomes a ring of light on the screen. In Mr. Spottiswoode's apparatus, for the Nicol and deviating prism is substituted a double-image prism, giving one central image and one considerably deviated, thus giving both the central spot and the ring. Beyond the analyser, in either construction, is a lens to focus the aperture. The radial deviation in both cases is arranged to be in the plane of polarisation of the analyser, and rotates with the latter.

If now we use the square aperture alone, focussed on the screen, it is plain that the ring image will be bright at two opposite points of the circumference, and dark at the two

[1] Mach's instrument is described in detail in *Pogg. Ann.* cxlvi. (1875) p. 169; and in Müller-Pouillet's *Lehrbuch der Physik*. Mr. Spottiswoode's is described in *Phil. Mag.* xlix. (1875) p. 472. There can be little doubt that the latter was constructed, except as to the substitution of the double-image prism, upon a prior brief notice of Mach's which had appeared in the *Proc. Vienna Academy*, Jan. 4, 1875.

intermediate points where the analyser is crossed. If we place a plate of selenite in the stage, say red and green, we shall have red at two opposite points, green at two opposite intermediate points, and no colour at the four points of 45°, all graduating smoothly. If we use in the stage a quartz cut transversely to the axis, we shall have the rotational colours, as a spectrum round the ring, twice repeated. We have simply what, in the ordinary way, would be *successive* appearances of the image of the aperture, simultaneously appearing round a ring.

Mach further added to his apparatus, next to the deflecting prism, a direct-vision dispersive prism, so placed that its dispersion is also in the plane of polarisation of the analyser; whilst a slit is attached to the latter, instead of the square aperture. Thus in any given position we have a radial spectrum, whose violet end should be towards the centre to equalise the fainter light; and on rotating the whole arrangement, we now have as the foundation a circular spectrum, with the violet towards the centre. If we place in the stage a plate of crystal too thick to show colour in the ordinary way—say 1 to 2 mm. thick—our ring spectrum will be continuous in the two azimuths of 45°, but will be crossed by interference bands (appearing on the ring as concentric arcs) along the horizontal and perpendicular diameters, while the dark bands in the one diameter will be opposite the bright coloured bands in the other.

Finally, Mach places in the stage a plate of quartz cut transversely to the axis—say 8 mm. thick. We have already seen (§ 214) the gradual passage of the interference bands, on rotating the analyser, along the spectrum of such a plate. With the revolving apparatus it is manifest that this must be translated into a circular spectrum traversed by black bands in the form of beautiful continuous bold spirals. This last experiment is one of peculiar beauty.

216. Bi-quartz Effects.—Crystals of quartz being found

which rotate the colours in opposite directions, if a plate be composed half of one, and half of the other, of the proper thickness, it is a very sensitive test of any optical rotation, as the purple transition-tint seen all over in one position of the analyser, changes towards blue in one half and red in the other, on the least rotation. Such is therefore used to demonstrate the rotation of fluids.

Another useful and more sensitive bi-quartz preparation is that shown in fig. 205. In the portion B, the wedge B is of say right-handed, and A of left-handed quartz, the effect of which is a black band across the centre where the thicknesses are equal (*i.e.* in the dark field) and coloured bands on each side. In the half C D the wedges are reversed. The consequence is, that on the least additional rotation in one direction by any substance used with the wedges, or the least rotation of the analyser, the bands move in opposite directions, and the distance the analyser has to be rotated to bring them back, is a measure of the rotation due to the substance examined.

FIG. 205.—Bi-quartz Wedges

Plates of quartz may be obtained in which both right- and left-handed crystallisation occurs, and such are very beautiful objects. Amethyst is a quartz crystal with the contrary crystals arranged in narrow parallel bands, and such are still more beautiful, but a large one is very difficult to find : one that will cover a standard-sized disc is a gorgeous object. Plates about ¾ inch diameter can be obtained without difficulty. Any clean quartz crystal of good size which is a *violet colour*, is almost certain to exhibit either amethyst or cross-crystallisation, and should be cut up into polariscope specimens.

Other crystals can be obtained which rotate the beam, and most of them in bi-quartz form. They are, however, all

small, and really more suitable for the polarising microscope. Cinnabar and periodate of soda are among the best.

217. **Mica Registers of Rotation.**—It will be obvious that a bi-plate of mica circularly polarised, as previously described, may be used exactly as a bi-quartz. But far more effective as a screen demonstration is a mica preparation devised by Prof. S. P. Thompson, consisting of twenty-four sectors, in each of which the principal axis or polarising plane is *radial* to the circle. It is obvious that when the analyser is crossed, the horizontal and vertical sectors must show a black cross,

while the others show gradual transition towards the full depolarising effect of the film at 45°. Hence the best thickness is either half-wave or $1\frac{1}{2}$ waves, as this gives the greatest transition from dark to light. With the black cross vertical, if now any substance exerting rotary power be introduced, the cross is conspicuously rotated, showing vividly what Prof.

FIG. 206.—Thompson's Rotation Register

Thompson calls the optical 'torque' or torsion of the beam.[1] Of course the rotated cross becomes more or less coloured, owing to the differing rotation of the various colours, but the effect is none the less simply evident.

Any large crystallisation showing a 'rose' with rotating black cross, may be used in a similar manner.

218. **Rotation in Fluids.**—Many fluids may be used to demonstrate this, in a tube about 20 cm. long and two inches diameter, with flat glass ends screwing on. This tube should be arranged to rest in two supports fixed on a base-board which can be dropped into the polariscope between the

[1] See *Proc. Roy. Inst.* xii. 474, or *Nature* xl. 232, 257.

polariser and the stage s (fig. 190), the latter being drawn forward sufficiently to allow of this. Oil of lemons, which will require about one pound (cost 10s.) to fill such a tube, will exhibit a nearly complete rotational spectrum, like the quartz plate ; and saturated syrup, or oil of turpentine, a very visible change of colours, in the fluid itself. By placing a bi-quartz in the stage, rotation may be shown in plain cells containing only one to two inches of fluid.

The operation of the saccharometer is easily shown by introducing the bi-quartz or any other apparatus (such as Laurent's semi-circular half-wave plate) and arranging (as can easily be done) that an index shall rotate with the analyser round a divided glass plate in the stage, which is focussed on the screen. The index is first adjusted to zero, and then the degrees of rotation necessary to bring back the bi-quartz to equilibrium after a tube of strong sugar syrup is introduced, can be seen. Also, by having a second tube of half the length, it can be demonstrated that the rotation is proportional to the length of the column of fluid ; and by filling one of two tubes with a one-half dilution, that it is proportional to the strength.

219. Electro-magnetic Rotation.—For lecture purposes this is generally shown with a bar of Faraday's heavy glass, having rectangular polished ends ; other heavy glass has somewhat less effect, and common glass, and many fluids and gases which show the same phenomena, do not do so with sufficient prominence for public demonstration. A bar of Faraday glass three to six inches long, and from half an inch square, will suffice. This should be placed in a circular tube of annealed iron, and if the bar be square, all the vacant space be filled with annealed iron wire, and the whole surrounded by an insulated coil of wire. This being introduced between the polariser and the stage, and the analyser crossed for dark field, on passing a pretty good current through the coil, light will appear on the screen. It will depend upon the length of glass and the current, whether any perceptible

colour is visible ; but with a bi-quartz the effect is generally very evident with a moderate current. Thompson's mica sectors (fig. 206) may also be used.

Dr. Kerr's experiment, showing that plane-polarised light is rotated if reflected from the polished pole of a magnet, is too sensitive for successful demonstration, unless with apparatus of the highest class and the arc light.

220. Rotation of Common Light.—If the light employed is powerful enough to exhibit interference-bands on the screen with Fresnel's bi-prism (§ 189) this can be exhibited after the manner of Profs. Abbe and Sohncke. It is only necessary to cover one-half of the bi-prism with a plate of left-handed, and the other with a plate of right-handed quartz, of 1·88 mm. in thickness. This thickness rotates yellow light 45°, and therefore if quartz rotates common light at all, the two interfering rays are brought into orbits differing by 90° in azimuth, when they cannot interfere. It is demonstrated that this is so, because the bands vanish accordingly.

221. Ring and Brushes in Crystals.—For use with the simpler forms of lantern polariscopes, like fig. 186, plates

FIG. 207.

of crystals are cut transversely to their optic axes, and mounted in wooden sliders as represented in fig. 207. By having a frame made of the usual 4 × 2¼ size, consisting of two thin metal plates with a circular aperture in the centres, separated by a strip of wood along the top and bottom edges, and leaving a space for the small slide as a centre strip between, this can be placed in the usual stage, when it will be seen that the plate of crystal (unless it be a circularly-polarising one) has no double refraction at all in this direction ; the dark or light field, in the parallel beam of plane-polarised light, remains as it was before the crystal was inserted.

With convergent light it is of course different. For the simpler polariscopes a crystal-stage is provided, which consists of a tubular fitting like fig. 208. One end A fits into the nozzle of the objective, from which the analyser is withdrawn, the latter now fitting into the other end B of this crystal-stage. In the centre at s is a slot or stage with springs, large enough to receive the crystal sliders, which are about an inch wide; and the stage is so placed that the crystal occupies the spot where the cone of light is of the smallest diameter. With the low convergence from the usual power alone, the convergent (or divergent) light passes through the crystal and analyser straight to the screen, and needs no focussing lens whatever, the fringes appearing simply as shadows. The rings and brushes are shown as perfectly in this simple and inexpensive way, as in any other; but the choice of bi-axial crystals is limited, as only very small angles will allow both systems of rings to be brought into the field together. Practically, only nitre, cerussite, glauberite, and some

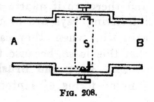

FIG. 208.

small-angled adularias are available, on this account; uniaxials of course are all available. It is customary to prepare plates of other bi-axials cut across *one* axis, to show *one* of the systems of rings; but beyond one or two, such are of little interest.

With the optical arrangements shown in fig. 190, however, any angles up to 60° or 65° can be shown.[1] The system of converging lenses c is inserted in the nozzle, and the rays after crossing in their focus and becoming divergent are collected by the second system. This refraction has however been too violent to project defined figures by mere shadow fringes; and

[1] By interposing cedar-oil, as used for homogeneous immersion objectives between each face of the crystal and the adjacent lenses, larger angles can be collected if deemed necessary.

they have to be focussed by another power, as they appear at
the back of the last lens. All sorts of focal arrangements
have been employed, but I prefer that described on p. 343, for
the sake of the easy range of foci and scale which it gives.
The whole apparatus can be adjusted, and a crystal focussed, in
less than a minute, both axes of selenite being easily shown in
one field. A great variety of crystals are prepared by Messrs.
Dr. Steeg and Reuter, of Homburg vor der Höhe, who practi-
cally supply the scientific world with these objects, and from
whom a list can be obtained. Their crystals are mounted in
plates of cork $1\frac{3}{8}$ inches square. For home-made plates or
mica preparations, I myself prefer the usual microscopic 3×1
slips, because stored so easily in the usual racked boxes.
But a stage with springs, as shown in fig. 190, will accommo-
date all alike with equal facility. In demonstrations, the
front optical apparatus is fixed so as to leave about an inch
between the two convergent systems ; a crystal is inserted,
and then brought up close to the second system by racking
out the ordinary focal power. The fringes are then focussed
by the rack and pinion on the front.[1]

Plates of some bi-axial crystals *crossed* are very fine.
Mica is easily prepared thus. There should be at least
one specimen of crystals in which the rings for red light are
at right angles to those for blue in the same crystal. Such
are Brookite—which is however expensive (for a good one)
and shows considerable red or orange colour—and the triple
tartrate of soda, potash, and ammonia, which is clear. Unfor-
tunately it, like many ' soft ' crystals, gradually oxidises when
mounted in balsam, and thus becomes cloudy. A mounting

[1] If the apparatus is properly adjusted, the crystal figures will be perfectly
and evenly illuminated *all over the disc.* Should either the centre or the
margin appear dark, the apparatus is faulty, unless the adjustable field-lens
H (fig. 190) has been accidentally placed wrongly whilst varying its position
to alter the focal power. Ample margin for all necessary adjustments is pro-
vided in my apparatus. With only medium-angled bi-axials, the front lens of
the collecting system may often be unscrewed and removed with advantage.

medium which will preserve these crystals clear is much to be desired. When clear, by placing in the stage gelatines carefully selected to absorb all but the blue and red rays, the two systems of rings can be shown crossed on the screen if the light is brilliant. The *axes* are shown easily.

Airy's Spirals are produced by a right-handed quartz, cut perpendicularly to the optic axis, superposed upon a left-handed one. The two need not be of equal thickness, and plates containing cross-crystallisation will show the spirals naturally, wherever the two forms happen to overlap each other.

It ought to be noted, that crystals which can be shown in both forms of polariscope, require to be much *thinner* for highly convergent light than for the low convergence method. A thick plate of nitre will fill the field, with low convergence; for high convergence it must be very thin, and the two axes will appear very close together in the centre of the field. Most mica commonly obtainable has an angle of about 45°.

Mitscherlich's Experiment, showing that a crystal of selenite, when heated, gradually becomes uni-axial, and with further heat becomes again bi-axial with the axes at right angles to the former direction, is easily demonstrated with the apparatus described. I employ a slide devised for the purpose; but it is sufficient to procure a strip of brass or copper about 4 × 1 inches, the same thickness as the crystal, drill and file a hole through the centre which just admits the latter loosely, and bend up rather more than an inch of each end, so that these ends stand well away from the crystal stage like ears, when the strip is held by the springs. Then bend a piece of thin card round one edge, so as to cover both sides of the centre of the strip, and cut through both cards a hole rather smaller than the crystal; thus the card, as it embraces the brass with the crystal in it, keeps the latter in place. All this being adjusted on the stage, and the rings focussed as usual, a lighted spirit-lamp is taken in hand and applied alternately to the projecting ears. At first a slight mist generally appears,

but this soon passes off, and the heat is applied till the desired effect is produced. One crystal will last for many demonstrations.

Circularly polarised crystal figures are produced by placing a quarter-wave plate in the ordinary stage. The black brushes then disappear, nebulous lines taking their places ; while the rings are dislocated half a wave in each alternate quadrant. The rings may instead be *analysed* circularly, by fitting a quarter-wave plate on either side of the focussing-lens, κ (fig. 190), with the same results. If the rings be both polarised *and* analysed circularly, the brushes disappear entirely, and as the analyser is rotated, the quadrants (or halves in bi-axial rings) *slide* by each other, producing in the two principal positions unbroken rings with no brushes or interruption whatever. If at this point the quarter-wave be rotated *with* the analyser, the unbroken character of the rings is retained throughout all the rotation ; showing the perfectly circular character of the polarisation.

Spiral Figures were discovered by myself,[1] in a search after phenomena which should more distinctly show the relation of bi-axial to uni-axial crystals, and of the two axes of a bi-axial to the prismatic axis—or, in short, that the axis of a uni-axial was simply a case of the coincidence of two axes. For obvious reasons this was most likely to be brought about by the two circular waves concerned in rotary polarisation ; and it seemed worth while to seek for such demonstration, since when polarised and analysed circularly, one single axis of a bi-axial gives as unbroken a circle as a uni-axial. I sought for phenomena which might show that each axis of a bi-axial was only one sex, as it were, of a combination, *both* of which were found in a uni-axial. This is shown by placing in the ordinary stage of the polariscope a quartz plate 7½ mm. thick, and introducing between the crystal and the analyser a

[1] See *Proceedings of the Physical Society* for November 12, 1881, or *Phil. Mag.* January 1882.

quarter-wave plate. The result is that a plate cut to exhibit one axis only of a bi-axial, shows one spiral figure surrounding this axis. A plate cut to show both axes, exhibits a few turns of a spiral round each axis, after which the two spirals embrace each other, and proceed concentrically round the whole field. With a low-angled bi-axial cut thin, in highly convergent light, the two spirals enwrap each other nearly from the first. And finally, in a uni-axial the *two separate spirals* are visible, showing that both elements of the bi-axial remain and are combined in what is simply a limiting case. By applying the arrangement to Mitscherlich's experiment with a heated selenite, the gradual drawing in of the figure, but preservation of the *two* spirals through all, can be simply demonstrated.

A quartz pláte alone in highly convergent circularly polarised light, projects a double spiral, as pointed out by Mr. Airy. The above experiments prove that this is owing to its peculiar properties enabling it to show its *own spirals* as a uni-axial crystal.

A column of fluid of adequate rotary power, such as a column of oil of lemons 20 cm. long, employed with a crystal instead of the quartz plate, will exhibit exactly the same phenomena, thus affording proof that the molecular constitution of the fluid resembles that of the quartz. The polariscope I have described projects through the column of fluid, crystal, and convergent lenses, &c., brilliantly and with ease.

It will be very interesting to point out, that by thus modifying the polarisation in different ways, rays of the same convergence can produce with the same plate of crystal, either rings with brushes, rings dislocated, unbroken rings without any brushes, or spirals.

222. Artificial Crystals.—It has been seen that a plate of crystal circularly polarised, roughly represents the rotary phenomena of quartz. Reusch, by employing a preparation built up of many thin films of mica successively rotated on

each other by an aliquot part of a circle, found that *all* the phenomena of quartz, either in parallel or convergent light, are *perfectly* reproduced. Such a preparation treated as a crystal gives the crystal fringes of quartz exactly, and two of opposite rotations superposed, give Airy's spirals.

Plates of mica of equal thickness crossed at right angles, after Norremberg, as the plates become thinner and more numerous, give a gradual transition in convergent light from bi-axial rings, to the circular rings and four-armed cross of a uni-axial. Two crossed give of course the four rings of a crossed bi-axial; twenty-four of about ½ wave thickness, give effects quite undistinguishable from those of a calcite crystal.

Plates of mica of various thicknesses crossed in different ways [1] give very beautiful and complicated figures in convergent light, which may still more be varied by crossing very *thin* films between much thicker ones, or interposing plates at an angle of 45° to the others.

Mica-selenite combinations after Norremberg, built up of elements consisting of two parallel micas, with a selenite between them either parallel or across, these triple ' elements ' being superposed in various ways and number, crossed or parallel, give in highly-convergent light the most beautiful projections. With no geometrical design whatever from the hand of man (except the crossing of films in various ways), the most exquisite coloured patterns are produced by convergent polarised light, some of them looking more like the most brilliant designs in squares of Turkey carpet than anything else.

223. Polarisation by Small Particles.—The blue colour and polarisation produced by all reflection of light from sufficiently small particles (as in the sky), may be easily demonstrated by Tyndall's method, a large glass tube with

[1] For details of such crossed preparations, see my paper in *Proceedings of the Physical Society*, entitled ' Optical Combinations of Crystalline Films,' reprinted in *Phil. Mag.* May 1888.

flat ends being supported horizontally in front of the polariser, filled with suitable vapour, and the parallel polarised beam sent through it. The particles in the tube then act as *analyser*, so that the phenomena can be observed by all spectators in a direction approximately at right angles to the tube. In one position of the polariser, light is copiously reflected to such spectators, while it is invisible to anyone looking down upon the tube. When the polariser is rotated 90° the light is extinguished horizontally, but reflected above and below. A better method, however, is to interpose between the polariser and the tube a large plate of selenite or mica, when the tube will glow with the usual colours.

Such a tube should not be less than $2\frac{1}{2}$ or 8 inches diameter, and 18 inches long. Professor Tyndall generally preferred, having exhausted the tube, to introduce sufficient nitrite of butyl vapour in air to depress the mercury-gauge $\frac{1}{20}$ inch, and to add sufficient hydrochloric acid vapour in air to depress the gauge a further $\frac{1}{2}$ inch. He also employed vapour of carbon disulphide, amyl nitrite, and other compounds. But it is very much easier, and saves the trouble of exhausting and a great deal of rather delicate manipulation with air-tight and expensive apparatus, to employ a whiff of tobacco smoke, which is perfectly effectual. Instead of using the parallel beam from the polariser, very fair results can be had from the Nicol analyser in the nozzle of the optical front, but the polarised beam does not then, of course, fill the tube so completely.

It is however easier and more convenient in every way, to show the phenomena in liquids, which can be conveniently done in a large rectangular glass trough or cell. Far the best method, however, not only for economy and convenience, but for its truly magnificent effect, is one for which I was originally indebted to Mr. John Thomson of Dundee. For this beautiful experiment we require a glass jar with foot, which should be about $2\frac{1}{2}$ inches diameter, and is shown at

J, fig. 209. This is filled with the fluid holding small particles
in suspension, which may at a pinch be prepared by adding
a trace of soap, or even of milk, though both of these give too
great coarseness of particles for fine effect. A few drops of
a solution of five grains gum mastic, or common resin, in one
ounce of alcohol, stirred into the water, answers excellently.
as will a few drops of French polish diluted in alcohol; but I
have found the finest blue from stirring a teaspoonful of the

solution of coal-tar
in alcohol sold as
Liquor Carbonis
Detergens, into *hot*
water. The jar
should be clean.
and the emulsion
filtered into it, to
avoid as much as
possible ordinary
reflection from dust
particles. Lord
Rayleigh often uses
a mixture of ex-
tremely dilute so-
dium thiosulphate
with extremely di-
lute hydrochloric
acid, a mere trace

FIG. 209

of each being sufficient. The advantage and disadvantage of
this method is, that the effect is progressive, and finally passes
beyond the stage of polarisation. However, the jar being filled
with the fluid, the plane reflector R is arranged over it at an
angle of 45°, so as to throw the light from the polariser N (here
shown as the Nicol analyser) down through the jar. Behind
are arranged two reflectors M M of plain looking-glass, enclos-
ing the jar within an angle of about 100°, which give by reflec-

tion two images of the jar, formed by rays at right angles
with those direct from the jar to the spectators. The great
advantage of this method is, that the spectators only need
to be about the same *height* as the jar, to receive perfectly
polarised light all round; and the complementary effect
can always be seen at the same moment in the mirrors, so
that when the jar extinguishes direct light, the mirror
images are bright. This having been demonstrated, we
finally cover the top of the jar with a large quartz plate Q.
The jar itself will now glow with all the rotational colours
as the polariser is rotated; *differently-coloured* images
being seen at the same time in the mirrors M, and the
whole forming a demonstration of indescribably delicate
beauty. It is convenient to have the mirrors hinged
together like a book, and to stand both jar and mirrors on
a circular piece of board, if no higher support be needed, in
order that the whole may be turned to face in succession all
sides of the room.

CHAPTER XXIII

HEAT

A NUMBER of experiments showing the effects, nature, and
qualitative relations of heat are easily capable of projection.
Some specimen examples may suffice.

224. **Expansion.**—As regards the expansion of solids,
Gravesande's ring and the various socket forms of apparatus
need no remark. Any ordinary form of pyrometer is readily
projected in action by the shadow method (§ 109); or a small

mirror of silvered micro-glass may be cemented to the index, and by it a small parallel beam focussed from an aperture reflected to the screen; the deflection of the spot, with any decently good instrument, will show the effect even of the warmth of the hand. Or a series of small thermostatic compound bars is easily constructed, whose action can be projected in the field of the condensers.

In liquids, any thermometer with a transparent scale can be projected, using the erecting prism. That the expansion is due to greater separation of the particles, and lowers the specific gravity, is easily shown by paraffin oil stained with aniline colour, in a U-tube, as in fig. 210. One leg of the tube is surrounded by a much wider tube fitted on by a cork at the bottom. The liquid in both tubes stands at the same level; but on filling the large tube with boiling water, the levels being in the field of the condensers, it will be seen that the liquid in the heated leg stands considerably higher than in the other.

Holding a flask of very thin glass with a very small tube neck, which is filled with coloured liquid, in a larger vessel, and projecting the part showing the level in the tube, on pouring hot water into the outer vessel, the curious effect is produced of a momentary *sinking* of level, as from *b* to *a* (fig. 211) after which the fluid rises as expected, thus showing the expansion of the *flask* before the liquid itself is heated, and the subsequent superior expansion of the liquid.

FIG. 210

The expansion of air can be projected in any way, but is perhaps most readily shown by providing a flask with a tube of almost capillary bore, and introducing a drop of any coloured fluid when the air is warm, which will be drawn some way down the tube. On projecting this, any difference of temperature will move

the index fluid. Or a differential thermometer may be
projected.

Fig. 211 Fig. 212

225. Convection Currents.—The simplest apparatus for
projecting currents produced by the lowering of specific
gravity, is a mere test-tube held in a Bunsen holder and
heated as in fig. 212.
If the tube be flattened,
the effect will be better
still ; or a flattened flask
can be similarly pro-
jected. To make the
currents more visible, a
few particles of exceed-
ingly fine sawdust from
heavy wood may be
placed in the water, or
particles of blotting-

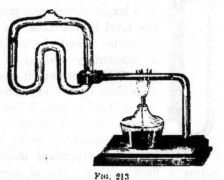

Fig. 213

paper rubbed up in a mortar with water ; Mr. H. G. Madan
uses a crystal or two of magenta coated with gum-water and

c c 2

dropped into the vessel, from which coloured streams will proceed. The little apparatus shown in fig. 213 will both show convection currents, and illustrate their every-day application to hot-water systems of heating. A few small bubbles or particles of sawdust show the movement well in this apparatus.

226. **Evaporation.**—Boiling in a small flask is easily projected, and by the well-known apparatus in fig. 214, boiling up a flask of water, which is closed with a cork and then inverted in the field of the lantern, the familiar experiment of producing ebullition by the application of cold water, is also shown. The loss of heat in evaporation may be projected either by wrapping the bulb of a thermometer in a piece of rag moistened with the liquid, or by applying a moistened plate to the face of a thermopile, the galvanometer in connection with which is projected direct, or by a reflected pencil. (See § 240.)

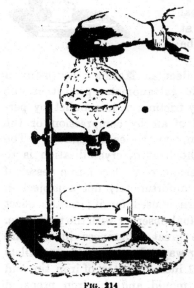

Fig. 214

227. **Conductivity.**—To show the different conducting power of various metals and other substances, nothing more is necessary than to modify the well-known apparatus of Ingenhouz (in which rods of the substances project from a trough filled with boiling water, which heats the inner ends of the rods simultaneously), so that the rods project from the *bottom* of the trough, and their lower ends at least stand in the field of the condensers. Glass balls of equal weight being attached by wax softened with a

little tallow to the ends of the rods, will be seen to drop off in succession. They will appear to pass upwards on the screen, unless the erecting prism is used.

The conducting power of a metal is projected by constructing Despretz' apparatus within the compass of the lantern, as in fig. 215, the bulbs of the thermometers resting at equal distances upon a bar heated at one end. The scales should be of glass.

FIG. 215

228. Mechanical and Molecular Motion.—By using a thermo-pile with any suitable galvanometer projection, the heat generated in any body by friction, or in a bullet by percussion, or in a closed vessel of air by compression, or the cold produced by rarefaction, can be easily shown. The readiest way of exhibiting the heat of crystallisation is to project the tube of an air-thermometer placed in a vessel of the solution. Radiophony is unfortunately not a projection experiment, though the lantern is used for it; as the effect is perceived only by an individual observer with the telephone.

229. Specific Heat.—The great differences in this are best projected in the following way. Prepare balls or bullets of equal size, about $\frac{3}{4}$ inch to 1 inch diameter, of iron, tin, and lead; the two latter cast in a mould, and the iron prepared in any way; or zinc will answer instead of iron and can also be cast. Each ball is furnished with a small wire hook or handle. Prepare also a flat cake of soft wax about $\frac{1}{3}$-in. to $\frac{1}{2}$-in. thick and say $6 \times 2\frac{1}{2}$ inches superficies, in a frame formed by bending round a strip of tin or thin brass. The composition of the soft wax should be about 4 parts by weight of beeswax and 8 parts of tallow, varied a little by experience as required; and the cake is best formed on the surface of

boiling water, and left to get cold. The cake is supported horizontally in the field of the lantern, and a cold bullet laid on its centre is focussed on the screen and then removed. The three bullets to be used are heated in boiling water long enough to be certain they have all acquired the temperature of 212° F. The leaden one is then taken out first by its handle, and after shaking off the water, gently placed on the centre of the wax ; then the tin one similarly laid about 1½ inches from it on one side; and lastly the iron or zinc one the same distance on the other side—all appearing on the screen. Though much heaviest, the leaden bullet will scarcely sink at all into the wax ; while if the softness and thickness of the plate are well calculated, the tin ball will sink much deeper, and the iron or zinc one will make its way entirely through, and drop into some vessel placed to receive it. The softness of the wax is to be adjusted, according to the exact size of the balls and thickness of the cake, to secure this result.

230. **Spheroidal State.**—A very shallow silver dish about three inches diameter is supported with its convex side upper-most over an annular Bunsen burner in the field of the lantern, and the burner adjusted to bring the surface to a dull red heat. Taking up in a small sponge some water as hot as the hand will bear, and squeezing out drops to fall upon the hot dish, the rebounding of the drops, like peas, will be clearly projected.

Reversing the dish to its usual position, and placing the whole lower, and more in front, the beam may be slightly converged from the condensers and reflected down upon it, and a focussing lens adjusted to focus the object upon the ceiling, or a small overhead screen, at a similar angle. The dish being heated as before, nearly boiling water is dropped into it by degrees from a syringe or pipette, till a fluid drachm or more has collected. The water will become a flattened globule, in ceaseless motion, the edges especially

forming beautiful curves, and the surface breaking into sym-
metrical ripples, which the lens will focus on the screen. On
turning out the burner the movement will gradually decrease
in energy, until suddenly contact is established, and the
water bursts into a cloud of steam.

Arrange in the field a smaller silver dish about two inches
diameter, which has had the bottom carefully flattened for
about one inch in the centre, convex side uppermost as in the
first experiment. By carefully adjusting a small ring on the
end of a wire about 1 mm. above its surface, and heating the
basin and in a much less degree the wire, hot water darkened
with ink or other dye can be gently delivered from the pipette
so as to be held in place by the small ring thus immersed
in it. Projection on the screen will then demonstrate that
there is a small clear space between the silver and the water,
through which the light from the lantern passes.

Heating of the water is desirable in these experiments, in
order to avoid cold water lowering the temperature of the
metal underneath to a point which will not maintain the
spheroidal state.

281. Radiant Heat in the Spectrum.—The demonstra-
tion of dark heat rays has already been mentioned under
Calorescence, in § 180. The quantitative examination of the
spectrum demands expensive apparatus in the shape of a
complete train of prisms and lenses in rock-salt (which alone
will show the real heat maximum in the ultra-red region),
and a sensitive thermo-pile of the linear form, guarded by a
narrow perpendicular slit. Only the general scheme can
be given here in fig. 216, where s is the slit of the lantern
through which come parallel rays produced by a rock-salt
lens in the lantern itself, A is the salt focussing lens, B the
rock-salt prism. Then V B G R representing violet, blue, green,
and red rays, the thermo-pile will show the greatest heat at
about P, and will cease to give evidence of it at o, nearly as
far from R as the violet rays are. For these experiments a

sensitive thermo-pile, and sensitive galvanometer, must be
employed. The needle of the latter may either travel over a
horizontal glass dial, projected in the vertical attachment, or
a pencil from an oscillating mirror may be employed.

With glass lenses and a disulphide prism, the demonstra-
tion must be comparatively rough. The maximum heat will
now be generally found in the red itself, and the galvano-
meter with perpendicular glass dial (fig. 220) can be made
sensitive enough to project all that can really be shown with
such apparatus.

It is usual to employ two lanterns or two nozzles, one
giving the spectrum in which the thermo-pile is moved, and

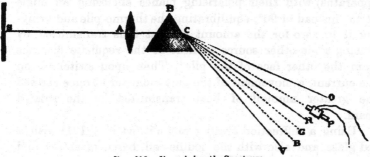

Fig. 216.— Examining the Spectrum

the other projecting the galvanometer movement above it ;
if two nozzles are employed on one concentric lantern, this
must be so adjusted that the common radiant is at the proper
focal distance for each of the two sets of condensers. On the
whole, a second lantern for the galvanometer is most con-
venient. It is also convenient to have at disposal two
galvanometers, one very different from the other as regards
sensitiveness. (Also see next section.)

232. Identity of Light and Radiant Heat.—By similarly
using a thermo-pile, the double refraction, polarisation, and
depolarisation of heat rays are readily shown. If luminous
heat rays are employed, the thermo-pile has simply to be

placed in the rays marked out by their luminous effects. If non-luminous rays are to be demonstrated, the positions are first marked from the luminous rays ; after which a cell of iodine dissolved in carbon disulphide or tetra-chloride is interposed, and the thermo-pile introduced into the marked positions, the galvanometer instantly responding. When the polarised beam is cut off by the analyser, and the latter is at zero, the introduction of a plate of crystal between the crossed Nicols, at once causes a vigorous movement. In proving electro-magnetic rotation of the dark beam, Prof. Tyndall employed, for the sake of the greater increase of transmission in that position, the two Nicols (or other apparatus) with their polarising planes enclosing an angle of 45° instead of 90°, equilibrating the thermo-pile and bringing it to zero for the amount of heat thus transmitted, by placing some other source of heat at the requisite distance from the other face of the pile. Then upon switching on the current, a movement of the galvanometer at once showed the greater amount of heat transmitted by the rotated beam.

Using a diffraction grating and slit (as in § 191) with a red glass, and also with the iodine-cell, bands of action and extinction as in the case of light, are readily shown by the thermo-pile. It is just barely *possible*, with a fine slit on the thermo-pile, to show heat fringes with a Fresnel prism ; but so very difficult and uncertain is a clear result, that I abandoned the experiment with regret. Probably others with more skill in this sort of manipulation, and more opportunities with the arc light than have been possible to me, may have greater success. For such experiments, the radio-micrometer recently perfected by Mr. C. Vernon Boys, on the principle of d'Arsonval's thermo-galvanometer,[1] gives both more delicacy in recording small variations of tem-

[1] The fundamental principle is the suspension of a thermo-electric closed circuit by a torsion-fibre in a magnetic field.

perature, and more precision as regards points of action, than any thermo-pile I can conceive of. This beautiful measuring instrument might also be employed in the preceding experiments, but is so delicate, and so rarely available for general lecture purposes, that I must only refer concerning its construction and use to the inventor's own description.[1]

<hr />

CHAPTER XXIV

MAGNETISM AND ELECTRICITY

THE fundamental experiments in magnetism and electricity can be projected in a manner so obvious as not to require any detailed treatment. As a rule the needful preparations will consist simply of reducing the apparatus to a rather small scale, when the projection will take place under the general conditions described in Chapter XIV. Only a few experiments need be given here for the sake of illustration, or of various remarks for which they afford occasion, and which may be useful in other instances.

238. **Polarity.**—A compass needle mounted either upon a small foot, or upon a graduated glass plate, projected with the vertical attachment, will readily show direction, attraction, and repulsion. Two light soft iron wires hung from the same point by silk threads attached to one end of each, in the field of the condensers, as a magnetic pendulum, will also exhibit repulsion.

With the glass-bottomed trough filled with water in the vertical attachment, and a number of magnetised steel needles stuck perpendicularly in small cork floats, Prof. Mayer's symmetrical figures, formed by such needles when the pole of

[1] *Proc. R. S.* xlii. 191, and *Phil. Trans.* clxxx. 159.

a magnet is held over the centre of the trough, will be pro-
jected on the screen.

Magnetic torsion may be projected in the same way, with
any form of torsion balance whose graduated dial is of glass.

284. Magnetic Induction.—Clamping an annealed iron
rod 3 inches long by the centre in a small Bunsen holder
horizontally across the field of the condensers, it will be
readily shown that it supports a key, or one or more pieces of
iron, at one end, when the other is touched by the pole of a
strong magnet. And using iron filings or small bits of wire,
it can be shown that induction takes place, though the.
magnet does not actually touch.

Induction by the earth's magnetism is projected by the
usual experiment of attracting or repelling the pole of a com-
pass needle (placed on the vertical attachment) by the lower
end of an iron bar held approximately in the magnetic meridian.
Or a dipping-needle may be projected direct, and similarly
affected by the end of an iron bar.

285. Magnetic Curves.—These project in the vertical
attachment, simply laying a plain sheet of glass over the
magnet laid on the face of the condenser, sifting filings upon
the glass, and if needful tapping the plate a little. Using a
horseshoe magnet, the modifications caused by different
armatures between the poles may be shown. Elevating the
glass plate sufficiently, duplicate similar poles may be brought
up endways under it and the different character of the curves
projected: or the lines of force as modified in the neighbour-
hood of a space screened by sheets or plates of soft iron may
be shown.

286. Dia-magnetism.—Only an electro-magnet will give
sufficient power for this class of experiment. A sufficient
size for the magnet will be a cross section about $\frac{3}{4}$ inch square,
built up of bent pieces of well-annealed hoop-iron, the total
length of each limb about 4 to 6 inches; or it may be more,
as it is quite unnecessary for the lower part of the magnet to

be in the field. There should be $1\frac{1}{4}$ inches clear between
the two poles, and after all the plates are firmly screwed to-
gether and the ends filed flat for the usual pole-pieces, the
magnet is wound · until the coils come nearly into contact.
With such a magnet, two to four bichromate or Grove
cells will give ample power for most experiments, using either
small discs, or bars of metal or other substances $\frac{3}{4}$ inch to 1
inch in length, for projection.

The same apparatus may be used to show that a cube or
disc of copper suspended between the pole-pieces, and rotated
by twisting the thread, is almost immediately stopped as
soon as the current is switched on.

For experiments on flame and vapours, however, a
magnet must be constructed differently, with the limbs much
farther apart, in order that the flame or vapour may be
introduced beneath the pole-pieces. The vapour of iodine
dropped upon a piece of heated metal is easily projected, and
the repulsion will be plainly distinguished. It is unnecessary
in dia-magnetic projections, that more than the magnetic
pole terminals should be seen in the field.

The various heaping of liquids, according to their mag-
netic character, is fairly visible in profile; but by turning the
magnet so as to lie horizontally on the vertical attachment,
the heaping of liquids in a thin watch-glass will be con-
spicuously shown by the strong refraction produced at the
inclined surfaces.

287. Static Charges.—Most simple phenomena of this
character are demonstrated by projecting an electroscope,
especially of the gold-leaf kind, as shown in fig. 81. Static
induction is readily shown in the same way. All the usual
experiments with suspended pith-balls, chimes, feathers, hair,
&c., are too obvious to need any explanation. Any apparatus
which cannot be reduced to the size of the condensers, or the
lens in fig. 106, may generally be projected by the shadow
method (§ 109).

Quantitative measurement is more difficult, but. Prof.
Mayer has lately used a pendulum electroscope in a form that
makes a most sensitive electro-
meter. He suspends a gilt
pith-ball 1 cm. radius (built up
of small pieces cemented) a
distance of 364 cm. from the
ceiling, by two silk fibres
.fastened 52 cm. apart and
meeting at the ball, behind
which a scale is arranged. A
brass ball of the same size is
mounted on a glass rod, var-
nished while warm with
paraffin wax. A force of only
one dyne acting on the sus-
pènded ball deflects it 13·3
mm.; and charging both balls
in contact so as to give the
same charge to each, the
charge C on either was found
in absolute electrostatic units
by the formula

$$c = D \sqrt{\frac{d}{1 \cdot 3}}$$

where D is the distance in
cm. between the centres of
the balls, and d the deflection
from the vertical in cm.
When D is over 5¼ cm. the
law of inverse squares was
demonstrated within 1 per
cent; and by using a proof-

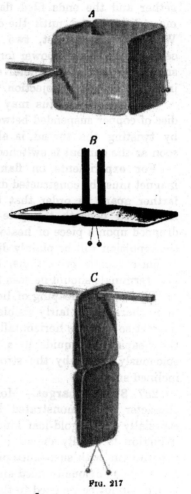

Fig. 217

plane, Coulomb's law of distribution on the parts of a cylin-
drical body was verified with close approximation. Such an

apparatus is in fact *too* sensitive for most lecture purposes; but diminishing this by using shorter fibres, and adjusting a horizontal strip of glass behind the ball, divided as a scale, many useful quantitative experiments may be made in a very simple and easy manner.

The mere fact that the density of a charge is greater at the ends of a conductor than in the middle may be shown by Prof. Weinhold's very simple apparatus (fig. 217). Four pieces of paste-board with rounded sides and edges are covered with tinfoil, and fastened into a box-like shape by strips of ribbon also covered with foil, or by thick foil itself. To the middle of one angle are suspended by conducting threads a pair of small pith-balls; and close to the middle of the opposite angle are fastened two sticks of sealing-wax as insulating handles. The whole apparatus is shown at A. If both handles are so held that the plates take the form of B, and the apparatus is given a small charge, a little divergence of the pith-balls will be observed; but if now the handles be so turned that the plates take the form of C, the divergence will be increased very considerably. The apparatus may be made quite small, but is more effective if the pieces are about six inches square, when it can be projected by the shadow method (§ 109).

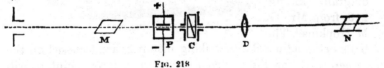

FIG. 218

238. Static Electrical Stress. — Dr. Kerr's experiments showing by optical methods the state of stress produced by electrical charge in di-electrics, are easily projected, fig. 218 being a general sketch of the arrangements. The rays from the lantern pass through a polarising apparatus, M, and then through a glass cell, P. In this cell are arranged two copper plates a very small distance apart, say from $\frac{1}{8}$ to $\frac{1}{2}$ inch, which

can be charged + and − by connecting with the coats of
a Leyden jar, or the terminals of a Wimshurst machine. The
space between the plates is focussed on the screen by the lens
D, the rays passing through a second analysing Nicol, N. If
the plates are vertical or horizontal, the Nicols are set at an
angle of 45°, but crossed to give the dark field. The cell is
best filled with carbon disulphide. On charging the plates,
the field at once becomes bright, and if the charge is increased
splendid colour-effects are produced, as with glass in a state
of mechanical stress described in § 209.

With charges sufficiently powerful, similar stress can be
shown in glass itself, pierced so that the terminals may come
within a small distance.

At c may be introduced a compensator of quartz to
measure the optical effect of charges, themselves measured by
any sufficiently accurate electrometer.

239. Static Discharge.—The sparks from a jar or battery,
or Wimshurst machine, are best projected by a little apparatus
arranged for the
field of the lan-
tern, and which
needs no descrip-
tion beyond the
diagram in fig.
219, from Mr. G.
M. Hopkins.[1] The

Fig. 219

balls being adjusted for striking distance, are focussed on the
screen, and the light then reduced to as low a point as will
just barely make them visible. The place of the image of
the discharge-spark upon the screen is thus *localised*, which
in this case makes just all the difference in a screen demon-
stration, and renders it very satisfactory; the form of the

[1] This diagram and figs. 225, 226, 227, 231, 232, are from articles by
Mr. Hopkins in the *Scientific American.*

spark being more clearly seen than most eyes can discern it in the brilliant spark itself.

To project the *oscillating* character of the discharge, as pointed out by Dr. O. J. Lodge in his own demonstrations, we require a battery of considerable size or capacity, and must introduce into the circuit a number of coils of wire. A quarter-inch spark is a good distance. Having at hand several large coils of wire, and introducing one after the other into the circuit, the spark will be found to give at each addition a lower note ; and when this reaches a certain lowness of pitch, it is broken up if focussed on the screen and then reflected from a rotating mirror. A better apparatus, however (since the breaking-up of the spark can only be seen at one precise moment), is to project it through a number of lenses of the same focus ranged round the edge of a rotating disc, at slightly different radial distances, as devised by Mr. C. V. Boys. By this means the effect cannot fail to be projected upon the screen, and there is less loss of light also than when the mirror is employed.

The *heating* effect of the discharge is effectively shown by a simple form of air thermometer employed by Prof. Weinhold. Through a dry cork (which is sufficient insulation) in a small bottle are passed wire terminals, connected by a rather narrow strip of tinfoil in the shape of a U. A bent glass tube also passing through the cork is drawn out into a small bore, and then the bottle being slightly warmed and the tube dipped in coloured liquid, as the air cools it draws in a small portion which serves as an index. Projecting this, on making discharge through the foil, the air in the bottle is sufficiently heated to move the drop of fluid conspicuously upon the screen.

240. **Current Electricity.—Galvanometers.**—In the vast majority of experiments, the existence or calling into action of a current will have to be demonstrated by projecting the movement of a galvanometer, which can be easily done in various ways.

Where great sensitiveness is not required, a perpendicular glass dial and multiplier coil arranged as in fig. 220, which represents one constructed by Stöhrer of Leipzig, will be far the most convenient and simple, needing only to be placed in front of the condensers and focussed.

With care in balancing the needle, this arrangement can be made amply sensitive for all ordinary induction or direct current experiments, and also serves to illustrate the action of the needle telegraph.

Another good galvanometer of this kind, shown in fig. 221, was constructed, and has been used with success in many of his lectures to large audiences, by

FIG. 220.—Lantern Galvanometer

Prof. S. P. Thompson. Here the coil A B C D is wound horizontally, and to the centre of the needle N S is attached, at right angles, a very light perpendicular index or pointer, the needle and its pointer being so mounted that the centre of gravity

FIG. 221.—Lecture Galvanometer

is very little below the pivot E. Long or short coils may be used, and this pattern has the great advantage that it may be used as an ordinary lantern slide.

In using any kind of 'face' galvanometer, should the face

D D

happen to lie in or near the plane of the magnetic meridian, it will be necessary to counteract the 'dipping-needle' effect by adjusting a bar-magnet somewhere near, preferably underneath the table.

The most sensitive and precisely calibrated astatic galvanometers are chiefly needed for very feeble thermo-pile currents, as in investigating the heat of the spectrum in its colder regions, or calorific interference bands (see Chapter XXIII.). Such a galvanometer is easily projected in the vertical manner, provided the base and dial-plate are of glass.

The lecture galvanometers most generally used, however, where comparatively but not excessively small currents are to be demonstrated, are of the *reflecting mirror* class. For ordinary experiments, one of the dead-beat types is most convenient; but I am only here concerned with the projection, which is capable of a much better result than is generally seen. A dim and very nebulous spot on the scale seems to satisfy most demonstrators, and is perhaps sufficient for a small audience. But it is very much better to use a small lime-light lantern for the index-pencil, and, omitting any lens in the galvanometer itself, to employ the 'focussed parallel beam' (p. 277) from the pencil attachment shown in fig. 95. An aperture and lens should be chosen which, focussing on the scale, gives a sharp and brilliant disc over its whole width (about a quarter of an inch is a good average), and this should be crossed by two wires arranged X fashion. The great superiority of this method will not fail to be appreciated when once seen.

It is quite needless to describe in detail how every form of current induction, either by other currents or by magnets, is demonstrated by the galvanometer.

241. **Mutual Action of Currents and Magnets.**—The general rule to be observed in devising apparatus to project the wide range of phenomena discovered by Arago, Ampère, and Faraday, is always to select the most *simple* arrangement.

Take for illustration Oersted's fundamental experiment of the deflection of a magnetic needle by the current; it is per-

F1 ;. 222.—Oersted's Experiment

fectly easy to arrange an entire fixed apparatus, and project it by the vertical method. But the truly scientific demon-strator will rather prefer to place the bare needle first in the focal plane, and bring over his wire inde-pendently, as in fig. 222, simply because his ex-planation will thus be better *understood*, which is his object.

FIG. 223

Ampère's experiments showing the attraction or repulsion of parallel cur-rents may be shown by any of the usual apparatus made on a small scale; but here again the same rule applies, and it is better to confine the set apparatus to the movable portion, and bring up the other current independently, as in fig. 223, which is an arrangement by Prof. Forbes. A small arrow may be fixed to the wire which is held; and in this way

D D

there is no room for misunderstanding. The arrangement known as Roget's Spiral gives another very elegant illustration of the attraction of parallel currents. The wire carrying the current is wound into a vertical helix, suspended at the top from one terminal, and dipping at the bottom into mercury, which forms the other terminal. The coils should be not less than an inch in diameter, and wound closely enough to be very easily movable: then on passing the current the coils draw more closely together, which is very conspicuous upon the screen. If more powerful action is needed an iron core may be introduced, as in the figure, but this will rarely be necessary.

Any of the usual apparatus for showing the rotation of currents, magnets, or galvanic cells, is easily constructed small enough for projection, and need not be further dwelt upon.

FIG. 224.—Roget's Spiral

For many electro-magnetic experiments it is convenient to arrange two parallel horizontal brass rods projecting from beneath the front of the condensers, communicating with binding screws, as devised by Mr. G. M. Hopkins. Then small pieces of apparatus, such as here shown, connecting with metal spring hooks underneath, have only to be laid on the rods and pushed home to one side, to be in contact. Fig. 225 illustrates the simple magnetic effect of a current, the wire being wound into a small coil at the top of each

pillar, and then bent downwards in the middle between. The little trough of iron filings can be lifted up first, before the current passes, with no result; afterwards the filings will adhere, and show an evident tendency to range themselves at right angles to the current.

To explain the construction of an electro-magnet, two small solenoids of insulated wire are arranged across a small frame as in

FIG. 225

fig. 226, being wound in contrary directions. They should be wound so much apart that the turns can be clearly seen. A stout needle may be first introduced into each, and a *magnetised* needle, suspended at one end by a thread, may be shown to be equally attracted by either; then on passing the current, it will be attracted by one and repelled by the other as shown in the figure. Withdrawing the needles, and introducing a small horse-shoe of annealed iron wire (fig. 227), we have an electro-magnet, whose

FIG. 226

whole construction is clearly seen, and which will support a nail or other piece of iron easily.

Magnetic hysteresis can be shown by any electro-magnet small enough for the field of the lantern, or by a larger one

in shadow. On switching off the current the armature will be seen still attached, with even a considerable load ; but on striking the core sharply with a small hammer so as to re-

lease the molecular rigidity, it at once falls.

The attractive pull of a solenoid upon a magnetic core is an important phenomenon, being so widely employed to regulate arc-lamps. It is very easily projected, fig.

FIG. 227

228 showing one of Prof. Forbes's arrangements. The solenoid A, here in conventional connection with a battery, is arranged across one half of the condenser ; and the soft iron core B is

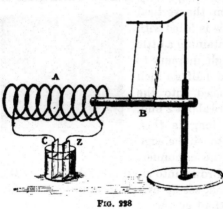

suspended by threads so as barely to enter one end. In order that the iron core may be able to enter far enough, it is well to prolong it by a non-magnetic wire brazed to one end, so that the whole may balance by the threads; or the core may be supported in the middle of a much longer glass

FIG. 228

tube, whose ends are suspended by threads attached far outside the solenoid, so as to give ample motion. Directly the current is switched on, the core is drawn into the coil. A still simpler

apparatus may be made by taking a piece of 'quill' glass tube 4 inches long, and winding one half of it with two layers of insulated wire. Provide a soft iron wire $2\frac{1}{2}$ inches long, which slides easily in the tube. Fix the tube horizontally across the condensers, and place the iron core in the uncovered end, so that one end rather projects. Turning on the current, the core will be drawn into the coil, and the two ends will be seen projecting slightly at each end. It is easy to construct two small 'differential' coils in the same way.

242. Thermo-Electricity.—Seebeck's fundamental experiment is easily projected by simply placing it upon the vertical attachment. The current from two single wires about 6 inches long, of copper and German silver, simply twisted together at one end and united by a drop of solder, can be easily shown by a decent projection galvanometer. Any experiments with the thermo-pile also afford illustrations.

243. Current and Capillarity.—Kühne's beautiful experiment is easily projected, using a very shallow watch-glass or a plano-concave lens on the vertical attachment. The hollow is filled with dilute sulphuric acid containing a little chromic acid, and enough mercury to form an oblate spheroid half an inch across or more, introduced into the centre. A bright iron wire about 2 mm. diameter and 6 inches long is then introduced so as just to touch the edge of the mercury, when the circumference

Fig. 229

ence of the spheroid is thrown into rhythmic vibration by the changes in surface-tension, set up by the intermittent contact and consequent intermittent current.

Another simple apparatus is shown in fig. 229. The white portion a represents mercury in the glass tube, and the dark part b dilute sulphuric acid. On sending a current through the whole, it will be seen that the mercury rises or

falls in the centre leg according to the direction of the current.

Or two open ends resembling *a* may be connected by a horizontal tube about 1 mm. bore, and filled with mercury, except that in the centre of the horizontal tube is introduced 2 or 3 mm. in length of the dilute acid. Behind the tube is a glass divided scale. This represents for easy projection Lippmann's capillary electrometer, being simply on a larger scale the apparatus shown in fig. 127, p. 240. Very moderate currents will readily cause motion of the acid index-spot upon the screen.

The beautiful experiments of Profs. A. W. Reinold and A. W. Rücker, showing that an upward current retards, and a downward current hastens the thinning of a liquid film, are projected in exactly the same way as an ordinary soap-film, described in Chapter XX. The usual liquid, however, thins too slowly. It is usual to employ potash oleate, but solution (*c*) on p. 326 will answer very well.[1]

Fig. 230

244. Effects of the Current.—The decomposition of acidulated water is easily projected by a simple cell as shown in fig. 280. Inverting a small test-tube filled with fluid over each wire, the approximate volumes of the two gases will be shown. By similar apparatus slightly modified as required, the decomposition of solutions of various salts is projected in the same way. In this experiment, as in many

[1] See for details, *Proc. Phys. Society of London*, vi. 857. It only need be said here that the films are easiest managed as cylinders, formed between metal rings or short cylinders, which form terminals for the current, the whole being enclosed in a glass case to exclude dust and draught.

others, whether or not the image should be erected by a prism will depend much upon both the lecturer and the audience.

The *heating* effects of the current may be shown by carrying a coil of platinum wire through water and boiling it; or by making a piece of platinum wire incandescent as usual. The last method, however, and the effects of heat in increasing resistance, are not as a rule projection experiments, and therefore need not be further referred to.

Fig. 231

Incandescence as shown in electric lamps is best projected by Mr. Hopkins' method, of showing in the field of the lantern the apparatus itself by *as dim a light* as will make it just visible on the screen, and then sending the current through, when the light itself will be also in focus. Fig. 231 is a simple little arrangement for an incandescent lamp, and fig. 232 gives an equally simple at-

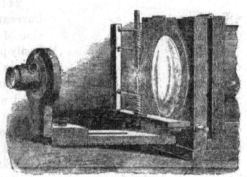

Fig. 232

tachment for projecting the carbon points and arc. No regulator at all is needed for the latter, as anywhere within an inch or two will project equally well by this method; and there being no mechanism to be worked, a smaller current will give

good results. Lamps can, however, only be thus projected by
a lantern whose light can be readily and considerably lowered;
for while a *dim* projection of the non-luminous parts very much
adds to the effect, any brightness in that part of the image
utterly spoils it. If the carbon-points themselves are too
brilliant, a small diaphragm may be placed over the objective,
and the light in the lantern increased accordingly. Another
advantage of this method is that the poles are projected sharply
and uncoloured, owing to the employment of the achromatic
lantern objective. Ordinarily the arc (in lantern) is projected
by the condenser alone, passing the rays through an aperture
small enough to tone down too great brilliance.

With regard to the mechanical or *motor* effects of the
current, their elements have been already mentioned in § 241.
If adequate range of current be at command, however, a
model made in such skeleton form as to show the essential
arrangements distinctly, may be projected in motion; the fewer
skeleton coils producing slower motion, and so enabling the
action to be better followed. A model of a Gramme ring with
such open skeleton coils can thus be projected in action very
clearly, or can be reduced by a brake down to a visible rate if
required.

Of the *optical* effects of the current, the rotary power has
been already described in the chapter upon polarised light.
Whether the luminous effects *in vacuo* can be projected, de-
pends chiefly upon their brilliance, the size of the lens, and
the darkness of the room; the primary apparatus itself
needing to be carefully shielded from view. De la Rive's
rotating arc can be projected fairly well, if the apparatus is
in good order; and it depends upon its size and that of
the audience whether this method, or that of direct vision,
is to be preferred. As already pointed out at the commence-
ment of Chapter XIV., considerations of this kind must in
many cases govern the choice of method; and they apply
to electrical experiments with especial force. The more

massive and costly the apparatus at hand, and the more fixed, as it often is in large public institutions, the less will projection be needed, because more can be sufficiently seen without it. The more cost, and portability, and storage have to be studied, the more will this method come into play. On such considerations I would refer again to the passage just cited.

CHAPTER XXV

SCIENTIFIC DIAGRAMS

IT is no part of the intention of this work to enter into the photographic production of slides for the lantern, which is of course the best method of reproducing any printed diagram suitable for the subject, or reducing any carefully made drawing upon white paper or card. Such drawings should be made in black Indian ink, care being taken to make any lettering or shading as *even* as possible, when a reduced photograph is certain to have a good effect. But ordinary diagrams may readily be prepared by much simpler means.

245. **Drawings in White Outline.**—These are very effective for suitable subjects, and easily prepared. A glass plate should be warmed, and whilst warm rubbed with a piece of paraffin, which should then be nearly wiped off again. Then hold the plate over the smoke of burning camphor till sufficiently black. On this black ground simple straight line or free-hand diagrams are readily traced, but the plate should be dropped into a sort of little socket or well slightly below the surface on which the hand rests, that a straight-edge may be held across it without touching.

When curves or circles have to be struck, it is better to cover the glass with an even coat of photographer's black varnish, or, still better, the black varnish used by slide-painters. The drawing can be best executed before the varnish has

become so dry as to be chippy. A small bit of horn should be laid on the surface to support the leg of a pair of compasses, and points should be provided of different fineness. Any little injury to the black ground can easily be touched up last of all.

There is however an objection to an opaque black ground for diagrams, that a pointer can . scarcely be seen upon it. This objection may be removed, and the brilliance of white-line diagrams still secured, by using for the ground a thin film of blue printer's ink, laid on evenly with a dabber. The lines will appear quite as distinct upon this, while the pointer can be seen quite well upon the blue ground.

246. Drawings in Black.—Processes for making these are very numerous. Some employ a film of sugar solution, or of photographer's 'mat' varnish, upon which it is said pencil drawings can be made, but I have never found these very satisfactory, and they are troublesome. The following are very simple, easy, and effectual.

For ink drawings, take a clean glass square, simply *lick* it all over with the clean tongue, and let it dry in the air. The imperceptible film of saliva thus communicated will entirely prevent any ink from 'spreading' on the glass from a fine pen-point, the best of which are the crow-quill steel pens sold for map-drawing. The plate may be laid over any drawing, and a copy traced, or any free or ruled drawing may be made, with common writing-ink in which a lump of sugar is dissolved, or any of the syrupy 'copying' inks. These lines are not sufficiently black ; but when dry, if a little finely powdered lampblack be rubbed lightly over them with a morsel of cotton-wool, sufficient will adhere to the sticky lines to make an opaque drawing.

Those who prefer, and are skilful with, a fine sable or camel-hair pencil, will find Indian ink 'take' perfectly well on a glass plate over which has been flowed water containing a very small quantity of gelatine.

A photographic dry plate—chloride is better than bromide

—fixed without exposure, answers exceedingly well for ink drawings, and is convenient for those who have photographic material at hand.

Or the diagram may be simply *scratched* on a sheet of gelatine about as thick as thin card, with steel needle-points of appropriate fineness. This is a very convenient process, because the gelatine may be fixed with drawing-pins over a diagram to be copied, and can be thus traced *exactly*. When finished, a little fine lamp-black, or black-lead, gently rubbed over the lines, will make them a good black. Care need only be taken to discard pieces already soiled or scratched, and to keep the gelatine clean. Gelatine flowed on glass and dried may be treated in the same way.

For more finished and permanent diagrams, the best method is undoubtedly one largely practised by Dr. Dallinger, the drawing being made on very *finely-ground* glass, such as is used for the focussing-glasses of the best cameras. For some work a still finer glass called 'matted' glass, etched with vapour of hydrofluoric acid, is better even than this, but is sometimes difficult to procure. Dr. Dallinger made many exquisite drawings with black-lead pencil alone, which is capable of most delicate and yet solid shading *if the glass is fine enough*. The main secret is to use the very hardest pencils, except for shading, when as soft as H B may be used, and to keep a very fine point. The points are cut very long to begin with, by a sharp knife; dressed up on a piece of emery paper or rough ground-glass; and kept constantly dressed sharp while in use, by an occasional rub on a piece of finer ground-glass kept at the side. Close and repeated working over gives the solidity of shading, but *black* should not be attempted. If very black outlines are wanted, they should be put in with Indian ink used in a fine and hard mapping-pen, or, better still, with a fine sable brush. The latter will put in lines as fine as a hair, and I have seen exquisite drawings of Floscularia made by Mr. Underhill in

this way, the Indian-ink lines being laid in as fine and clean as if printed from a steel plate. To do this, however, the plate must be perfectly free from the least greasiness, and it helps a little to put a very little ox-gall in the last wash of water given to it. Water-colour may be laid on also if desired, or pencil shading be added to the ink lines. When the drawing is finished, it is held at one corner, and a varnish of dried Canada balsam dissolved in benzol flowed over it. The varnish should be about as thick as cream, but the exact consistence does not matter much. Pour it on freely so as to cover the whole plate quickly, pour off at one corner till it nearly ceases to drop, then cant that corner up to flow rather back again, and then cant other sides up a little : a very few trials will teach the operator to do this so that the varnish sets level, and free from ridges or waves. Then protect from dust and leave the varnish to dry; all the grain of the glass will disappear, and the slide be perfectly transparent. When dry, it is mounted with a mask and cover-glass as in § 248. Anyone with the least capacity to draw upon anything, can produce beautiful slides in this way with the greatest ease ; and the process is equally adapted for simple line diagrams, or the most finished representations of microscopic detail.

247. **Printed Diagrams.**—It may often happen that a scientific lecturer has at his command, through acquaintance with a publisher, or perhaps because the blocks belong to his own works, wood engravings which are exactly suitable to illustrate his subject, not only in detail and treatment, but also in size. It is well to know that such may be converted into excellent lantern slides, by a simple method which occurred to myself quite accidentally. I had collected or prepared, as I thought, all the slides for a lecture I had promised to give, when I came across several engravings I was very desirous to introduce, only the very day before the date. There was no time to photograph them, or to attempt imperfect copies ; but it suddenly occurred to me to ask the printers for *proofs on*

thin clear sheets of gelatine. These were taken for me, the gelatine used being very thin, such as is used for wrapping up Christmas crackers, but uncoloured. The printer's ink we found should be rather stiff and fine : with such ink, and what is called a ' hard ' impression, the result was perfectly satisfactory, and the slides, prepared in an hour or two, were as good as photographs.[1] I have since resorted to the same method on several occasions, and whenever there is available material, can thoroughly recommend it as rapid, inexpensive and perfectly satisfactory. The gelatine film appears after a little to settle into ' crinkles ' between the protecting glass plates ; but this is of no consequence, and in no way affects the appearance upon the screen. The only objection is an almost imperceptible tendency to a slight thickening of the lines. By those at all familiar with mica work for the polariscope, even this and the ' crinkling ' may be avoided, as I have myself since avoided it, by splitting *very thin* films of mica, cutting them into 3¼-inch squares, and taking the proofs upon these.

Even proofs upon some samples of very thin tissue-paper (as much freedom from ' grain ' as possible is the main thing) will make passable slides for a sudden emergency, if the proof is afterwards fastened to a glass plate by the balsam and benzol varnish already mentioned. This makes the tissue nearly transparent, and the amount of grain visible in the paper is the only defect, which with some papers is very slight.

248. **Mounting Slides.**—What are called ' masks ' should always be used in mounting slides ; that is, circles, ovals, or cushion-shapes cut out of the centre of 3¼-inch squares of thick black paper or thin card. Such can always be obtained of opticians or lantern-dealers, and a mask should be selected to suit the diagram. A drawing on glass (all glasses being 3¼

[1] Merely to indicate the class of illustrations, I may mention that the subject was ''The Eye as an Evidence and Example of Evolution,' and the diagrams exploited related to points of histology and comparative anatomy.

inches square) should have a mask laid on the face, and then another covering-glass, cleaned and dried, which will be kept from contact over the visible portion by the mask. The double plate is then secured by an edging of thick dark paper twice coated with gum-arabic. The way to do this is to cut the gummed paper into strips 6½ inches long and ½ inch wide, cutting off the corners, and corresponding notches out of each side at the centre. A strip is first licked on the *ungummed* side, and then on the gummed, and laid with gum uppermost on the table. One *corner* of the double glass is then placed on the strip at the middle notch, the glasses inclined down each way, so that the gum may stick all along two edges, and the strips are then bent over and worked down with the finger and thumb. The other two sides are treated in the same manner with another strip, and the slide is completed, any smears of gum being cleaned off when all is dry.

A proof of an engraving on a sheet of mica or gelatine is mounted between two glass plates in a similar way, the mask being laid on the printed side. The card masks may be used for mica films; but the crinkling of gelatines is less apparent if the mask be cut out of plain dark paper, which is thinner. This is, however, only for appearance, the most conspicuous crinkles having no effect on the screen.

INDEX

E E

PRINTED BY
SPOTTISWOODE AND CO., NEW-STREET SQUARE
LONDON